Renaissance Art Reconsidered

An Anthology of Primary Sources

Edited by Carol M. Richardson, Kim W. Woods and
Michael W. Franklin

Blackwell Publishing in association with The Open University

THE OPEN UNIVERSITY
Walton Hall, Milton Keynes, MK7 6AA, UK

BLACKWELL PUBLISHING
350 Main Street, Malden, MA 02148-5020, USA
9600 Garsington Road, Oxford OX4 2DQ, UK
550 Swanston Street, Carlton, Victoria 3053, Australia

First published 2007 by Blackwell Publishing Ltd in association with The Open University

5 2010

Library of Congress Cataloging-in-Publication Data

Renaissance art reconsidered: an anthology of primary sources / edited by Carol M. Richardson, Kim W. Woods, and Michael W. Franklin.
 p. cm.
 Includes index.
 ISBN 978-1-4051-4640-1 (hardcover : alk. paper)—ISBN 978-1-4051-4641-8 (pbk. : alk. paper) 1. Art, Renaissance—Sources. I. Richardson, Carol M. II. Woods, Kim W. III. Franklin, Michael W.
 N6370.R375 2007
 709.02′4—dc22

 2006036531

A catalogue record for this title is available from the British Library.

Set in 10/12.5 Minion
by SNP Best-set Typesetter Ltd, Hong Kong
Printed and bound in Singapore
by C.O.S. Printers Pte Ltd

The publisher's policy is to use permanent paper from mills that operate a sustainable forestry policy, and which has been manufactured from pulp processed using acid-free and elementary chlorine-free practices. Furthermore, the publisher ensures that the text paper and cover board used have met acceptable environmental accreditation standards.

For further information on
Blackwell Publishing, visit our website:
www.blackwellpublishing.com

For information on
The Open University, please visit:
www.open.ac.uk

Renaissance Art Reconsidered

Contents

Notes on Contributors

Tim Benton is Professor of Art History at The Open University, having contributed to OU courses since 1970. His prime field of expertise is the history of modern architecture and design.

Jill Burke is Lecturer in Renaissance Art History at the University of Edinburgh. Her research focuses on the relationship between artistic and social change in fifteenth- and early sixteenth-century Italy, particularly Florence and Rome.

Elizabeth Cleland trained at the Courtauld Institute of Art. She is currently a Senior Research Fellow at the Metropolitan Museum of Art, New York, and has published on fifteenth-century tapestries, their designers, function and audience.

Rembrandt Duits is Assistant Curator at the Photographic Collection of the Warburg Institute. He specializes in Renaissance material culture, primarily of Italy and the Low Countries.

Mike Franklin is Course Manager in the Faculty of Arts at The Open University. He is a graduate of the OU.

Catherine King is Professor of Art History at The Open University and is a founder member of its Arts Faculty. Her research field includes the representation of artistic identities in Early Modern Europe, and patronage and the feminine in the Italian Renaissance.

Angeliki Lymberopoulou is Lecturer in Art History (late and post-Byzantine art) at The Open University. Her research focuses on the art produced on Venetian-dominated Crete (1211–1669) and its social context.

Diana Norman is Senior Lecturer in Art History at The Open University. She has written books on Sienese art and culture and is the author of numerous articles on late medieval and Renaissance Italian art.

Carol Richardson is Lecturer in Art History at The Open University. Her research focuses on Rome and the patronage of the College of Cardinals.

Thomas Tolley is Senior Lecturer in History of Art at the University of Edinburgh. He is author of *Painting the Cannon's Roar: Music, the Visual Arts and the Rise of an Attentive Public in the Age of Haydn* (2001), and of a forthcoming study of visual culture in later medieval France.

Paul Wood is Senior Lecturer in Art History at The Open University. He is co-editor, with Charles Harrison and Jason Gaiger, of *Art in Theory 1648–1815*, *Art in Theory 1815–1900* and *Art in Theory 1900–2000*.

Kim Woods is Lecturer in Art History at The Open University. She is a specialist in northern European sculpture c.1400–1550 and author of *Imported Images* (2007).

Preface

This anthology was devised to serve the needs of Open University students studying the third-level course 'Renaissance Art Reconsidered', but we hope its usefulness will extend to the wider community of academics and students as well as dedicated art-history enthusiasts engaged in Renaissance studies. With its pan-European focus, this is an anthology with a difference. It includes documents connected with making, locating and viewing Renaissance art from England to Italy, France to Crete. The documents selected concern not only painting, sculpture and architecture but also a range of other art forms including prints, illuminated manuscripts and tapestries. Some of the extracts are well known through their inclusion in existing anthologies (edited by David Chambers, Creighton Gilbert and Wolfgang Stechow). Almost none of these anthologies is now in print, however; so we thought it important to repeat some of their documents here.

Few anthologies are the work of a single person and this one is no different. Its existence is a credit to the collaboration of colleagues at The Open University and elsewhere: Tim Benton, Michael W. Franklin, Catherine King, Angeliki Lymberopoulou, Diana Norman, Carol M. Richardson, Paul Wood and Kim W. Woods (all The Open University); Elizabeth Cleland (Metropolitan Museum of Art, New York); Thomas Tolley and Jill Burke (University of Edinburgh); Alixe Bovey (University of Kent at Canterbury); Rembrandt Duits (Warburg Institute). The editors would like to thank Kate Clements, who edited the text for consistency, and the staff at Blackwell Publishing, Oxford, and Jayne Fargnoli at Blackwell Publishing, Boston, for discussing the initial idea with us and helping bring it to fruition. Margrit Bass (Copublishing) at The Open University has been the crucial link between the authors, editors and publishers and has contributed to the project throughout with humour and enthusiasm. As a significant number of the extracts included in the anthology are translated from their original languages, the

work of the translators has been particularly important to this project. We are especially grateful to Ria de Boodt, Jill Burke, Isabelle Dolezalek, Rembrandt Duits, Dimitra Kotoula, Susanne Meurer, Rahel Nigussie, Gerald Schmidt, Jeremy G. Taylor, Dario Tessicini, Thomas Tolley and David Ward.

Introduction

Primary sources bring art and the context in which it was created to life. They are not simply the springboard for research but also the bedrock to which scholars must continually return to check generalizations and avoid modern misconceptions. As Martin Kemp memorably put it, 'a well-provisioned base camp is essential before launching more speculative expeditions into unexplored territories.'[1]

Although the main source for the history of art must be the works of art themselves, written material of all kinds – literary, personal, educational and legal – provides important contextual information about artists, patrons and dates and the broader intellectual, cultural and economic networks that help explain particular features of a work of art. As the precise goal of art historians changes, it is necessary to re-examine familiar documents as well as explore newly-accessible documents, for they can reveal new insights and new meanings. To a degree the three parts of the book reflect the changing emphases of modern art history. The first is concerned with the hard work of making works of art. The second considers where they were produced, and the networks and connections between artists and their customers in Europe. The third focuses on viewing, whether in the context of patronage, theory or religious practice.

While a picture might speak a thousand words, a document of a thousand words often can seem to say very little about a picture. The range of textual sources included in this anthology is wide and varied. Some of the more obvious kinds of sources for the history of art, such as contracts, appear throughout the book, as they often offer new insights into the context in which art was produced – where it was made and who ordered it or used it,

[1] M. Kemp, *Behind the Picture: Art and Evidence in the Italian Renaissance* (New Haven and London: Yale University Press, 1997), p. viii.

as well as how it was made. The sources available for studying the history of art extend beyond artists' contracts or treatises, and include letters, diaries, wills and other primary sources. Together these historical records enable us to build a fuller picture of a very different culture in which works of art were created, the meanings and values with which they were imbued, the people who viewed them and the places in which they were displayed or used.

In this collection, for instance, the presentation of documents relating to the production of Sienese altarpieces alongside those relating to Cretan icons highlights some interesting truths. Despite the traditional identification of the 'Renaissance' with Italy, contracts during this period are remarkably similar across the whole of Europe. This marked consistency of legal and civic legislative practice begs the question 'Why do works of art created by different artists or workshops differ so greatly from one side of Europe to the other?' More often than not what is revealed is a continuity of practice stretching back to preceding centuries and as far back as Greek and Roman antiquity. The concerns of artistic skill and allusions to antique sources that are mainstays of the 'Renaissance' are certainly in evidence, but so are less overtly 'Renaissance' features such as conservative attitudes of town councils keen to protect their markets and ensure continuity with the past. It has been the express intention of the editors and contributors to include documents which reveal both the artistic continuity and the artistic diversity that existed during the Renaissance period. The dynamic juxtapositions presented in this anthology offer an opportunity for readers to reconsider Renaissance art.

Part I

Making Renaissance Art

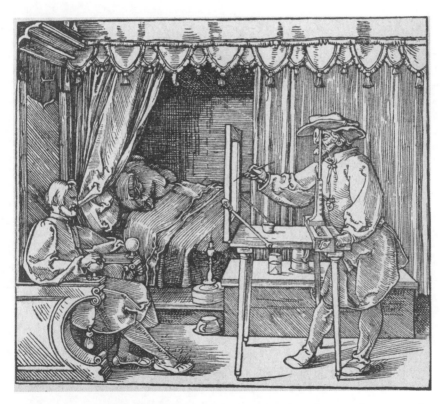

Albrecht Dürer, An artist drawing a seated man, Woodcut, from *Underweysung der Messung mit dem Zirckel und Richtscheyt (Instruction in the art of measurement with compasses and ruler)*, Nuremberg 1525, British Library, Department of Printed Books, C.119.h.7

Drawing and Workshop Practice

1.1.1
Cennino Cennini on drawing

Cennino Cennini (c.1370–1440) was a Florentine painter who worked at Padua in the late fourteenth century and may have composed his treatise on art, *Il libro dell'arte* (*The Craftsman's Handbook*) at the Paduan court. The manuscript was still being copied in Florence in 1437, so the book has relevance for the early part of the fifteenth century. Cennino provides guidance on the programme of study for young painters and the use of drawing for masters working in fresco. He values drawing as an intellectual exercise. [CEK]

Source: Cennino Cennini (1960), *The Craftsman's Handbook: The Italian 'Il libro dell'arte'*, trans. D. V. Thompson (New York: Dover Publications), pp. 4–5. Reprinted by permission of Dover Publications, Inc.

How You Begin Drawing on a Little Panel; and the System for It

As has been said, you begin with drawing. You ought to have the most elementary system, so as to be able to start drawing. First take a little boxwood panel, nine inches wide in each direction; all smooth and clean, that is, washed with clear water; rubbed and smoothed down with cuttle such as the goldsmiths use for casting. And when this little panel is thoroughly dry, take enough bone, ground diligently for two hours, to serve the purpose; and the finer it is, the better. Scrape it up afterward, take it and keep it wrapped up in a paper, dry. And when you need some for priming this little panel, take less than half a bean of this bone, or even less. And stir this bone up with saliva. Spread it all over the little panel with your fingers; and, before it gets dry, hold the little panel in your left hand, and tap over the panel with the finger tip of your right hand until you see that it is quite dry. And it will get coated with bone as evenly in one place as in another.

How to Draw on Several Kinds of Panels

For that purpose, a little panel of old fig wood is good; and also certain tablets which tradesmen use, which consist of sheep parchment gessoed and coated

with white lead in oil,[1] following the treatment with bone according to the system which I have described.

What Kind of Bone is Good for Treating the Panels

You must know what bone is good. Take bone from the second joints and wings of fowls, or of a capon; and the older they are the better. Just as you find them under the dining-table, put them into the fire; and when you see that they have turned whiter than ashes, draw them out, and grind them well on the porphyry; and use it as I say above.

How You Should Start Drawing with a Style, and by What Light

The thigh bone of a gelded lamb is good, too, and the shoulder, calcined in the way described. And then take a style of silver, or brass, or anything else, provided the ends be of silver,[2] fairly slender, smooth, and handsome. Then, using a model, start to copy the easiest possible subjects, to get your hand in;

[1] The *Liber illuministarum pro fundamentis auri et coloribus ac consimilibus*, Munich, Staatsbibliothek, MS. germ. 821, compiled about 1500 at Tegernsee (Oby.), contains (fol. 33) a rule for these, quoted by Ludwig Rockinger in 'Zum baierischen Schriftwesen im Mittelalter,' *Abhandlungen der historischen Classe der Königlichen bayerischen Akademie der Wissenschaften*, XII (1872), 1te Abteilung, p. 18. A translation of this rule follows:

'White parchment tablets are made in this way. Take calf parchment, and put it on the stretcher, and stretch it well; and dry it thoroughly in the sun. And do this thrice. And then take thoroughly powdered white-lead, and mix it with linseed oil until it comes out thin, while still preserving the white color of the white-lead. And paint that calfskin with that liquid color. And then dry it in the sun. And do this nine times; and by all means of the same thickness[?] And one coat is not to be applied unless the previous one be thoroughly dry. This done, you will shape up as many leaves of this calfskin as you wish, and make tablets. And you can write on them with a lead, tin, copper, or silver style, or even with ink, and erase the letters with saliva [not *salvia*, 'sage,' as in ed. Rockinger] and write again. And when all the whiteness has disappeared, whiten them again with white-lead and saliva like the ordinary tablets, or with scrapings of shells, bones, or powder of calcined bones, and saliva.'

[2] A convenient device is to obtain from a jeweler an inch or two of silver wire of the same caliper as a pencil lead. This can then be used in place of the lead in a propelling pencil, and needs only a little shaping of the point to make an admirable 'silver style' at trifling expense.

and run the style over the little panel so lightly that you can hardly make out what you first start to do; strengthening your strokes little by little, going back many times to produce the shadows. And the darker you want to make the shadows in the accents, the more times you go back to them; and so, conversely, go back over the reliefs only a few times. And let the helm and steersman of this power to see be the light of the sun, the light of your eye, and your own hand: for without these three things nothing can be done systematically. But arrange to have the light diffused when you are drawing; and have the sun fall on your left side. And with that system set yourself to practice drawing, drawing only a little each day, so that you may not come to lose your taste for it, or get tired of it.

1.1.2
Alberti on drawing figures

Leon Battista Alberti (1404–72) was the illegitimate son of an exiled Florentine merchant and banker. He studied at the University of Bologna where he acquired a passion for Latin texts and culture. He took minor clerical orders and earned a living as a secretary for senior ecclesiastics in the papal court in Rome. In Florence in 1428 he met Brunelleschi, Donatello, Masaccio, Ghiberti and other artists who were active there. *On Painting* was written in Florence first in Latin in 1435 and then in Italian in 1436. Here Alberti outlined a somewhat idealized programme explaining how painters should make narrative pictures. He recommended that drawings should be used both to establish a composition based on linear perspective and also to study the figures. These figures should 'tell' a story through their positions in the composition and by their gestures. Different kinds of drawings should be used to build up the detail of the figures in the painting – starting with anatomical studies and ending with the drapery and clothing. [CEK]

Source: Leon Battista Alberti (1991), *On Painting*, trans. C. Grayson, intro. and notes M. Kemp (Harmondsworth: Penguin), pp. 72–3.

So far we have spoken of the composition of surfaces. Now we must give some account of the composition of members. In the composition of members care should be taken above all that all the members accord well with one another. They are said to accord well with one another when in size, function, kind,

colour and other similar respects they correspond to grace and beauty. For, if in a picture the head is enormous, the chest puny, the hand very large, the foot swollen and the body distended, this composition will certainly be ugly to look at. So one must observe a certain conformity in regard to the size of members, and in this it will help, when painting living creatures, first to sketch in the bones, for, as they bend very little indeed, they always occupy a certain determined position. Then add the sinews and muscles, and finally clothe the bones and muscles with flesh and skin. But at this point, I see, there will perhaps be some who will raise as an objection something I said above, namely, that the painter is not concerned with things that are not visible. They would be right to do so, except that, just as for a clothed figure we first have to draw the naked body beneath and then cover it with clothes, so in painting a nude the bones and muscles must be arranged first, and then covered with appropriate flesh and skin in such a way that it is not difficult to perceive the positions of the muscles. As Nature clearly and openly reveals all these proportions, so the zealous painter will find great profit from investigating them in Nature for himself. Therefore, studious painters should apply themselves to this task, and understand that the more care and labour they put into studying the proportions of members, the more it helps them to fix in their minds the things they have learned. I would advise one thing, however, that in assessing the proportions of a living creature we should take one member of it by which the rest are measured. The architect Vitruvius reckons the height of a man in feet. I think it more suitable if the rest of the limbs are related to the size of the head, although I have observed it to be well-nigh a common fact in men that the length of the foot is the same as the distance from the chin to the top of the head.

1.1.3
Francesco Squarcione details the drawing regime for his pupils

Francesco Squarcione (c.1395–1468) was a Paduan painter who taught Andrea Mantegna (1430/1–1506) and Marco Zoppo (c.1432–78). We know from his will that he had two so-called 'studii' (literally 'studies' or 'studios') in his house and that these contained paintings and sculptures. This corresponds with reports that he taught his apprentices by getting them to copy ancient Roman and Greek sculpture. In this document, an addendum to an

apprenticeship contract dated 1467, Squarcione agreed to teach his pupil to construct perspectival compositions with accurately scaled figures. It is clear that drawings played an important part in this training. [CEK]

Source: Creighton E. Gilbert (1992), *Italian Art 1400–1500* (Evanston, IL: Northwestern University Press), p. 34. Reprinted by permission of Creighton E. Gilbert, translator, and the publisher, Northwestern University Press.

October 30, 1467, Padua

Be it known and clear to whoever may read this writing that master Guzon, painter, has agreed with master Francesco Squarzon, painter, that the latter is to teach the former's son, Francesco, and namely the principle of a plane with lines drawn according to my method, and to put figures on the said plane, one here and one there, in various places on the said plane, and place objects, namely a chair, bench, or house, and get him to understand these things, and teach him to understand a man's head in foreshortening by isometric rendering, that is, of a perfect square underneath in foreshortening, and teach him the system of a naked body, measured in front and behind, and to put eyes, nose, mouth and ears in a man's head at the right measured places, and teach him all these things item by item as far as I am able and as far as the said Francesco will be able to learn, and as far as my knowledge and basic principles will go, and always keep him with paper in his hand to provide him with a model, one after another, with various figures in lead white, and correct these models for him, and correct his mistakes so far as I can and he is capable, and this is agreed by both sides for four months from now, and he is to give me half a ducat every month as my fee . . . [detailed payment provisions, including food provided] and if he should damage any drawing of mine the said Guzon is required to pay me its full worth, etc. And I Francesco Squarcione wrote this with my own hand.

1.1.4

Gerard Horenbout takes on two apprentices

Gerard Horenbout (c.1465–1541) was a painter and manuscript illuminator in Ghent who joined the Guild of Saint Luke in 1487. In these documents we

find him entering into two slightly different kinds of apprenticeship contracts according to the age of the pupils: one with a young man in 1498; the other with a young boy in 1502. The second 4-year apprenticeship began as soon as the first expired. At this relatively early stage in his career, Horenbout seems to have been in demand as a teacher, but he may well also have found the workshop assistance that an apprentice might offer useful until his own children were old enough to train as artists. His daughter Susanna was the illuminator from whom Dürer purchased a manuscript illumination of Christ as Saviour in Antwerp in 1521. (See Dürer's travel diaries below, document 1.1.7.) The Horenbouts rose to some eminence: Gerard was made painter to Margaret of Austria, Regent of the Netherlands in 1515, while Susanna, her brother Lucas, and briefly Gerard too served the court of Henry VIII in England. [CEK/MWF]

Source: V. van der Haeghen (1914), 'Notes sur l'atelier de Gérard Horenbault vers la fin du XVIème siècle', *Bulletijn der Maatschappij van Geschied en Oudheidkunde te Gent*, I, vol. 22, pp. 29–30. Translated from the Flemish by Rembrandt Duits. Copyright © The Open University 2007.

Hannekin van den Dijcke, the son of Cornelis, through friends of his, acknowledged and confirmed that he is committed to take board and lodging with Gerard Horenbout for a term of four years, to produce such works of painting as Gerard will require of him.

It is understood that Hannekin will not be allowed to produce works to sell or give away for his own profit, unless with the knowledge and consent of Gerard.

Furthermore, should Hannekin choose to marry within the above-mentioned term, which would bring great loss to Gerard, who does not want to forfeit his income and profit from Hannekin for any reason, it is stipulated that Hannekin will ask for master Gerard's permission. He also promises, should the marriage take place within the first two years, to pay master Gerard the sum of six pounds groat Flemish. Should it take place within the third or fourth year, Gerard is willing to relent by accepting four pounds groat Flemish. And should the marriage take place within Hannekin's term, and should Hannekin wish to marry regardless, he will be allowed to avoid [the fine] by completing the term, in accordance with the conditions that apply.

And as a guarantee, it is stipulated that Hannekin pledges and commits himself to pay the sum of six pounds groat Flemish, in case he were to leave

his master before the end of his term, for any reason other than the one stated above.

And Cornelis van den Dijcke, his father, and Pieter de Smet, his grandfather, stand surety for him with equal shares.

Act of the 13th of November of the year '98

[Charter, Annual Records 1498–9, fol. 24v]

Item Gerard Horenbout, painter, through an arrangement he made with Master Otto Tengnagel, pastor of the church of St Nicholas in the city of Utrecht, has accepted to provide board and lodging in his house for a nephew of Master Otto called Heinric Heinricz, born in Mechelen [Malines], and promises to teach him his profession, the art of painting, to the best of his abilities. The agreement is for a term of four years, starting on the feast day of St Bavo [1 October] of the present year 1502. Its various stipulations are explained in full in two handwritten statements drawn up by Master Gerard, the one copied from the other, so that both Gerard and Master Otto can keep a copy each.

Thus, Master Otto has come before the magistrates of the charter in Ghent and has promised Gerard to commit himself to paying the expenses and fees for Heinric, over and above the earnings and profits which Heinric will bring Gerard. He will pay a sum of three pounds groat Flemish, the first third of which is due on the feast of St Bavo 1503, the second third on the feast of St Bavo 1504, and the final third on the feast of St Bavo 1505, in this order.

And in the case that Heinric will leave Gerard before the end of the term, without Gerard's permission or extenuating circumstances, such as illness etc., Master Otto promises to pay Gerard a fine to increase the above-mentioned payments up to the sum of six pounds groat Flemish.

For this amount, and for the stipulated three pounds groat Flemish, Master Otto will stand surety with all his possessions.

Next to Master Otto, a certain Joes Zoetius, son of Abraham, has also agreed to stand surety.

Act of the 21st of September 1502

Charter, Annual Records 1502–3, fol. 12v

1.1.5
A master's duty of care for his apprentices

Gerolamo Romanino (1484/7 to c.1560) was a painter at Brescia in the north of Italy. In this document of 1508 we find him entering, along with his brother Giovanni, into a contract to teach a certain Giovanni Francesco. The witnesses on whom they called included a master of textiles from the Netherlands and a master called Aminadeb (after one of the ancestors of Christ listed at the beginning of the Gospel of Saint Matthew), whose family was from Martinengo, a town on the road between Brescia and Milan. The contract makes clear the duty of care inherent in the agreement over and above their commitment to teach a pupil. [CEK]

Source: Camillo Boselli (1977), *Regesto artistico dei notai roganti in Brescia dal'anno 1500 all'anno 1560*, 2 vols, Brescia, vol. 1, pp. 80–1. Translated from the Latin by Dario Tessicini. Copyright © The Open University 2007.

In the name of Christ, Amen, in the year since His birth the thousandth five-hundredth eighth, the eleventh indiction, Monday the twenty-sixth of June, in Brescia, in the house of the underwritten brothers, Masters Girolamo and Giovanni Iacopo, which is in the quarter *canton de Adam* in a room on the ground floor in the presence of Aminadab son of the late Giovannino di Martinengo, resident in the same quarter, Alessandro son of Francesco de Romani, resident in Uradi, both citizens of Brescia, and Master Johannes di Fiandra, master of figures in textiles, resident in the house of the Magnificent ser Matteo de Advocatis; all witnesses are known and are being called and constituted especially.

Then, the brothers Master Girolamo and Master Giovanni Iacopo, painters, sons of the late Romanino di Romano, citizens and residents of Brescia, acting for themselves and their heirs, on the one part; and Matteo son of the late Lazarino di Parma, client of the Magnificent Count Maffei di Gambara, resident in Brescia in the quarter of Saint Clement and Giovanni Francesco, his son, acting for himself and his heirs, on the other part, unanimously and in agreement with each other entered into the underwritten contract, and pacts are validated with a formal agreement. That is:

First, that the said brothers Girolamo and Giovanni Iacopo, master painters, shall bind [themselves] to and officially promise to lodge in their house the aforesaid Giovanni Francesco for a period of six years to start the first day of next July and to provide the same Giovanni Francesco with food and to treat him well according to how it is appropriate between masters and their apprentices.

Then, that the said brothers shall bind [themselves] to and officially promise that after the first four years of the said six, they shall appropriately dress and furnish with shoes the same Giovanni Francesco, and [meet] the related expenses for the remaining two years of the said six years, with the only exception of the shirts that the same Giovanni Francesco will have to provide for himself.

Then, that during this time the said brothers shall bind to and officially promise to teach and train as they can the said Giovanni Francesco in their art of painting.

On the other side, that the said Matteo and Giovanni Francesco shall bind [themselves] to and officially promise to give and effectively deliver at the house of Girolamo and Giovanni Iacopo sixteen loads of grain in the next four years, that is, the fourth part of it each year within the month of July of every year.

I, Stefano, the underwritten notary, for myself and my heirs, was asked by the aforesaid Matteo and Giovanni Francesco to be their main guarantor for the whole sum of these acts, and to abide by all and each of the aforesaid as they promised with each other, as above. And that the said Giovanni Francesco will have carried on for the entire period of the said six years in the ways as above.

That Matteo and Giovanni Francesco binding each other and themselves for the whole sum in case of renunciation and needs, have promised to me, the said notary and guarantor, to be immune and exempt from the aforesaid guarantee.

Besides, the said Masters Girolamo and Giovanni Iacopo, painters, will have and receive from me, Stefano, the aforesaid guarantor, fourteen pounds in gold and coins as payment for the first four loads of grain as promised for the first year, as above, which fourteen pounds the said Matteo and Giovanni Francesco vowed should be given back at my own request. At the presence of the aforesaid witnesses.

That each and all of the aforesaid and underwritten, singularly and conformingly [. . .]

I, Stefano of the late Bartolomeo di Floris di *Isola Scalarum*, citizen of Brescia and resident in the quarter of *platee novarini*, public notary was present to all and each of the above and being requested I wrote it down officially.

1.1.6
Leonardo da Vinci on drawing

Leonardo da Vinci (1452–1519) was a Florentine painter, sculptor, architect and theoretician who, from the 1490s onwards, drafted elements for a treatise on painting with young artists in mind. Since these writings were compiled over a long period of time and were never ordered or edited for publication, they sometimes contradict one another, and it is unclear which versions of his advice he would have eventually preferred. In these texts, Leonardo recommended a range of drawing activities. In his own practice he used drawing in every aspect of his work, from studies taken from nature and figure drawings to mechanical and technical innovations, extending the application of drawings in every way. [CEK]

Source: Leonardo da Vinci (1954), *The Notebooks of Leonardo da Vinci*, ed. and trans. E. MacCurdy, 2 vols. (London: The Reprint Society), vol. 2, pp. 218, 221, 222, 240, 241, 260. Reprinted by permission of Mr Alec McCurdy [sic].

The painter ought first to exercise his hand by copying drawings by good masters; and having acquired facility in this under the advice of his instructor, he ought to set himself to copy good reliefs, following the rules given below.

Of Drawing from Relief

He who draws from relief ought to take his position so that the eye of the figure he is drawing is on a level with his own. And this should be done whenever a head has to be drawn from nature, because generally figures or people whom you meet in the streets all have their eyes at the same level as yours, and if you make them higher or lower you will find that your portrait will not resemble them.

Of the Way to Draw Figures for Histories

The painter ought always to consider, as regards the wall on which he intends to represent a story, the height of the position where he intends to place his

characters, so that when he makes studies from nature for this purpose he should have his eye as much below the thing that he is drawing as the said thing appears in the picture above the eye of the spectator: otherwise the work will be deserving of censure. [. . .]

Figures in relief in the act of movement will in their standing position seem naturally to fall forward.

[ms. 2038 Bib. Nat. 16r]

The youth ought first to learn perspective, then the proportions of everything, then he should learn from the hand of a good master in order to accustom himself to good limbs; then from nature in order to confirm for himself the reasons for what he has learnt; then for a time he should study the works of different masters; then make it a habit to practise and work at his art. [. . .]

Of the Way to Fix in Your Mind the Form of a Face

If you desire to acquire facility in keeping in your mind the expression of a face, first learn by heart the various different kinds of heads, eyes, noses, mouths, chins, throats, and also necks and shoulders. Take as an instance noses: – they are of ten types: straight, bulbous, hollow, prominent either above or below the centre, aquiline, regular, simian, round, and pointed. These divisions hold good as regards profile. Seen from in front, noses are of twelve types: thick in the middle, thin in the middle, with the tip broad, and narrow at the base, and narrow at the tip, and broad at the base, with nostrils broad or narrow, or high or low, and with the openings either visible or hidden by the tip. And similarly you will find variety in the other features; of which things you ought to make studies from nature and so fix them in your mind. Or when you have to draw a face from memory, carry with you a small note-book in which you have noted down such features, and then when you have cast a glance at the face of the person whom you wish to draw you can look privately and see which nose or mouth has a resemblance to it, and make a tiny mark against it in order to recognise it again at home. Of abnormal faces I here say nothing, for they are kept in mind without difficulty.

Of the Proper Time for Studying the Selection of Subjects

The winter evenings should be spent by youthful students in study of the things prepared during the summer; that is, all the drawings from the nude

which you have made in the summer should be brought together, and you should make a choice from among them of the best limbs and bodies, and practise at these and learn them by heart.

Of Attitudes

Afterwards in the ensuing summer you should make choice of some one who has a good presence, and has not been brought up to wear doublets, and whose figure consequently has not lost its natural bearing, and make him go through various graceful and elegant movements. If he fails to show the muscles very clearly within outlines of the limbs, this is of no consequence. It is enough for you merely to obtain good attitudes from the figure, and you can correct the limbs by those which you have studied during the winter. [...]

Of the Order to be Observed in Study

I say that one ought first to learn about the limbs and how they are worked, and after having completed this knowledge one ought to study their actions in the different conditions in which men are placed, and thirdly to devise figure compositions, the studies for these being taken from natural actions made on occasion as opportunities offered; and one should be on the watch in the streets and squares and fields, and there make sketches with rapid strokes to represent features, that is for a head one may make an *o*, and for an arm a straight or curved line, and so in like manner for the legs and trunk, afterwards when back at home working up these notes in a completed form.

My opponent says that in order to gain experience and to learn how to work readily, it is better that the first period of study should be spent in copying various compositions made by different masters either on sheets of paper or on walls, since from these one acquires rapidity in execution and a good method. But to this it may be replied that the ensuing method would be good if it was founded upon works that were excellent in composition and by diligent masters; and since such masters are so rare that few are to be found, it is safer to go direct to the works of nature than to those which have been imitated from her originals with great deterioration and thereby to acquire a bad method, for he who has access to the fountain does not go to the water-pot.

1.1.7

Dürer gives drawings as gifts and uses them to pay day-to-day expenses

Albrecht Dürer (1471–1528) was a painter and printmaker based in Nuremberg. In the diary Albrecht Dürer kept while travelling in the Netherlands in 1521, he mentions making several portrait drawings, some of which he gave as gifts to people who had assisted him, and others that he made as payment for his living expenses. Several of the individuals who received Dürer's drawings were fellow artists to whom his name was evidently well known. His drawings seem to have been valued for their own sake and not just as a preliminary to painting. Dürer also sold and bartered his prints and paintings during his travels. [CEK]

Source: W. M. Conway (1958), *The Writings of Dürer* (London: Peter Owen), pp. 120–1. Reprinted by permission of Peter Owen Ltd, London.

I have received 4 fl. for art-wares. I changed 1 fl. for expenses. I took the portrait of Hans Lieber of Ulm in charcoal; he wanted to pay me 1 fl. but I would not take it. I gave 7 st. for wood and 1 st. for bringing it. I changed 1 fl. for expenses.

14–20 April.

In the third week after Easter (April 21–27) a violent fever seized me, with great weakness, nausea, and headache. And before, when I was in Zeeland, a wondrous sickness overcame me, such as I never heard of from any man, and this sickness remains with me. I paid 6 st. for cases. The monk has bound 2 books for me in return for the art-wares which I gave him. I bought a piece of Arras to make two mantles for my mother-in-law and my wife, for 10 fl. 8 st. I paid the Doctor 8 st. and 3 st. to the apothecary. I also changed 1 fl. for expenses, and spend 3 st. in company. Paid the Doctor 10 st. I again paid the Doctor 6 st. During my illness Rodrigo has sent me many sweetmeats. I gave the lad 4 st. *trinkgeld*.

I have drawn with the metal-point the portrait of Master Joachim and made him besides another likeness with the metal-point.[1] I changed a crown

[1] Bartsch wrongly ascribes to Dürer an engraved likeness of Joachim de Patinir, which however is clearly done after a drawing by Dürer.

for expenses. I again changed 1 fl. for expenses. Paid the Doctor 6 st., also 7 st. at the apothecary's. 1 fl. I changed for expenses. For packing the third bale, which I sent from Antwerp to Nürnberg by a carrier, named Hans Staber, I paid 13 st.; and I paid the carrier 1 fl. for it, and agreed with him to take it from Antwerp to Nürnberg for $1\frac{1}{4}$ fl. the hundredweight. This bale too is to be taken to Hans Imhof the elder. I paid the Doctor, the apothecary, and the barber 14 st. I gave Master Jacob, the surgeon, 4 fl. worth of prints.

I have taken in charcoal the portrait of Thomas Bologna of Rome. My camlet coat came to 21 Brabant ells, which are 3 finger-breadths longer than Nürnberg ells. Also I bought black Spanish skins for it which cost 3 st. each, and there are 34 of them, makes 10 fl. 2 st.; then I paid the skinner 1 fl. for making them up; further there came 2 ells of velvet for trimming – 5 fl.; also for silk, cord, and thread 34 st.; then the tailor's wage 30 st.; the camlet in the coat cost 14 fl. 1 st.; also 5 st. *trinkgeld* for the lad.[2]

Cantate Sunday (the fourth) after Easter – from this I start a fresh account. 28 April. I have again paid the Doctor 6 st. I received 53 st. for art-wares and took them for expenses.

On Sunday after Rogation week Master Joachim, the good landscape 5 May. painter, asked me to his wedding[3] and showed me all honour. And I saw two fine plays there and the first was especially pious and devout. I again paid the Doctor 6 st. I changed 1 fl. for expenses.

On Sunday after our Lord's Ascension-day Master Dietrich, the Antwerp glasspainter, invited me and asked many others to meet me; and amongst them especially Alexander the goldsmith, a rich, stately man, and we had a costly feast and they did me great honour. I made the portrait in charcoal of Master Marx, the goldsmith who lives at Bruges. I bought a broad cap for 36 st. I paid Paul Geiger 1 fl. to take my little box to Nürnberg and 4 st. for the letter. I took the portrait of Ambrosius Hochstetter in charcoal and dined with him. I have also eaten with Tomasin at least six times. I bought some wooden dishes and platters for 3 st. I paid the apothecary 12 st. I gave away two copies of the *Life of our Lady* – the one to the foreign surgeon, the other to Marx's house-servant. I also paid the Doctor 8 st. I paid 4 st. for cleaning an old cap, lost 4 st. at play. I paid 2 fl. for a new cap, and have exchanged the first cap, because it was clumsy, and added 6 st. more for another.

I have painted the portrait of a Duke in oils. I have made a very fine and careful portrait in oils of the Treasurer Lorenz Sterk; it was worth 25 fl. I

[2] The whole cost 37 fl. 2 st.
[3] This was Joachim de Patinir's second marriage. The bride was Johanna Noyts.

presented it to him and in return he gave me 20 fl. and Susanna 1 fl. *trinkgeld*. Likewise painted the portrait of Jobst my host very finely and carefully in oils. He has now given me his for his.[4] And his wife have I done again and made her portrait in oils.

I again changed 1 fl. for expenses. I paid the Doctor 8 st. I have dined twice with Rodrigo. I dined with the rich Canon. I changed 1 fl. for expenses. I had Master Konrad, the Mechlin sculptor, for my guest on Whitsunday. I paid

19 May. 18 st. for Italian prints. Again 6 st. for the Doctor. For Master Joachim have I drawn 4 small S. Christophers[5] on grey paper. On the last day of Whitsuntide

21 May. (Tuesday) I was at the great horse-fair at Antwerp and there I saw a great number of fine stallions ridden, and two stallions in particular were sold for 700 fl. I have been paid 1¾ fl. for prints, the money I used for expenses; paid the Doctor 4 st. I bought two little books for 3 st. 3 times have I dined with Tomasin. I designed 3 sword-hilts for him and he gave me a small alabaster bowl. I took an English nobleman's portrait in charcoal and he gave me 1 fl. which I changed for expenses.

Master Gerhard,[6] the illuminator, has a daughter about 18 years old named Susanna. She has illuminated a *Salvator* on a little sheet, for which I gave her 1 fl. It is very wonderful that a woman can do so much. I lost 6 st.

26 May. at play. I saw the great Procession at Antwerp on Holy Trinity day. Master Konrad gave me a fine pair of knives, so I gave his little old man a Life of our Lady in return. I have made a portrait in charcoal of Master Jan,[7] gold-smith of Brussels, also one of his wife. I have been paid 2 fl. for prints. Master Jan, the Brussels goldsmith, paid me 3 Philips fl. for what I did for him, the drawing for the seal and the two portraits. I gave the *Veronica*, which I painted in oils, and the *Adam and Eve* which Franz did, to Jan the goldsmith in exchange for a jacinth and an agate, on which a Lucretia is engraved. Each of us valued his portion at 14 fl. Further I gave him a whole set of engravings for a ring and 6 stones. Each valued his portion at 7 fl. I bought 2 pairs of shoes for 14 st. and two small boxes for 2 st. I changed 2 Philips fl. for expenses.

4 *Der hat mir für seins nun seins geben.*

5 In 1521 Dürer engraved two S. Christophers (B. 51 and 52), though one of these was done from a drawing of the year 1517 now in the Gigoux Collection. The suggestion that Patinir wanted these figures to set in the foregrounds of such landscapes as he was fond of painting is worthy of consideration.

6 Gerhard Horenbout of Ghent. Charles V's Book of Hours in the Vienna library is his work. He also had a hand in the Grimani Breviary. After 1521 he went to England and entered the service of Henry VIII. His daughter Susanna was likewise in the service of the English King. She married and died in England. [See 1.1.4.]

7 Perhaps Jan van den Perre, afterwards goldsmith to Charles V.

I drew 3 *Leadings-forth*[8] and 2 *Mounts of Olives* on 5 half-sheets. I took 3 portraits in black and white on grey paper. I also sketched in black and white on grey paper two Netherland costumes. I painted for the Englishman his coat of arms and he gave me 1 fl. I have also at one time and another done many drawings and other things to serve different people, and for the more part of my work have received nothing. Andreas of Krakau paid me 1 Philips fl. for a shield and a Child's head. Changed 1 fl. for expenses. I paid 2 fl. for sweeping-brushes. I saw the great Procession at Antwerp on Corpus 30 May. Christi day, it was very splendid. I gave 4 st. as *trinkgeld*. I paid the Doctor 6 st. and 1 st. for a box. I have dined 5 times with Tomasin. I paid 10 st. at the apothecary's and gave his wife 14 st. for the clyster and himself 15 st. for the prescription. I again changed 2 Philips fl. for expenses. Further I paid the Doctor 6 st. I again paid the apothecary's wife 10 st. for the clyster, and 4 st. at the shop. To the monk who confessed my wife I gave 8 st. I bought a whole piece of Harras for 8 fl., and about 14 ells of fine Harras for 8 fl. I again paid the apothecary 32 st. for physic. I paid the messenger 3 st., and the tailor 4 st. I dined once with Hans Fehle and thrice with Tomasin. I gave 10 st. for a birthday present.

On the Wednesday after Corpus Christi in the year 1521, I gave over my 5 June. great bale at Antwerp to a carrier, called by the name Kunz Metz von Schlaudersdorf, to take it to Nürnberg; and I am to pay him for the carrying of it to Nürnberg for every hundredweight 1½ fl. And I paid him 1 fl. on it. And he is to answer for it to Herr Hans Imhof the elder. I drew a portrait in charcoal of young Jakob Rehlinger at Antwerp. I have again dined thrice with Tomasin.

The visit to Lady Margaret at Mechlin (7 and 8 June 1521)

On the eighth day after Corpus Christi I went with my people to Lady 7 June. Margaret at Mechlin. Took 5 st. with me for expenses. My wife changed 1 fl. for expenses. At Mechlin I lodged with Master Heinrich, the painter, at the sign of the Golden Head.[9] And the painters and sculptors bade me as guest at my inn and did me great honour in their gathering. I went also to Poppenreuter[10] the gunmaker's house, and found wonderful things there. And

[8] That is to say drawings representing *Christ bearing his Cross. Mount of Olives* means the *Agony in the Garden.*

[9] The inn-keeper of the *Golden Head* is known to have been a painter. His name was Heinrich Keldermann.

[10] Though born at Köln, he was called Hans von Nürnberg. He was cannon-founder and gun-maker to Charles V.

I went to Lady Margaret's and showed her my *Emperor*,[11] and would have presented it to her, but she so disliked it that I took it away with me.

And on Friday Lady Margaret showed me all her beautiful things; amongst them I saw about 40 small oil pictures, the like of which for precision and excellence I have never beheld. There also I saw more good works by Jan (de Mabuse) and Jacob Walch.[12] I asked my Lady for Jacob's little book, but she said she had already promised it to her painter.[13] Then I saw many other costly things and a precious library.[14] Master Hans Poppenreuter asked me as his guest. I have had Master Konrad twice and his wife once as my guests. Paid 27 st. and 2 st. for fare. I have also drawn with the [metal-point] portraits of Stephan, the chamberlain, and Master Konrad the figure-carver, and on Saturday I came again from Mechlin to Antwerp.

8 June.

1.1.8
Dürer lists the qualities required to be a painter

Albrecht Dürer (1471–1528) planned to publish an encyclopaedic work on art incorporating practical advice and theoretical background, but it was left incomplete at his death. In these sentences from the 'Introduction' and the 'Third of the Books of Human Proportions' from the section 'About Painting' he lists some of the qualities he believed necessary for 'he that would be a painter'. [CEK]

Source: W. M. Conway (1958), *The Writings of Dürer* (London: Peter Owen), p. 181. Reprinted by permission of Peter Owen Ltd, London.

He that would be a painter must have a natural turn thereto.

Love and delight therein are better teachers of the Art of Painting than compulsion is.

[11] Doubtless Dürer's portrait of Maximilian, now in the Gallery at Vienna, dated 1519.
[12] Jacopo de' Barbari.
[13] Bernard van Orley.
[14] The Catalogue of this library exists in the Inventory of the Archduchess' possessions.

If a man is to become a really great Painter he must be educated thereto from his very earliest years.

He must copy much of the work of good artists until he attain a free hand.

To paint is to be able to portray upon a flat surface any visible thing whatsoever that may be chosen.

It is well for anyone first to learn how to divide and reduce to measure the human figure, before learning anything else.

1.1.9
Joachim Camerarius praises Dürer's drawings

Joachim Camerarius (1500–74) was the Professor of Greek at the University of Nuremberg from 1526 and was a prestigious admirer of Dürer's work. Camerarius paid Dürer the tribute of translating his *Vier Bücher von menschlicher Proportion* (*Four Books on Human Proportions*, 1528) into Latin in 1532. In the introductory letter to the reader prefacing that translation, Camerarius provided a detailed 'pen portrait' in Latin of the artist. This was the lengthiest tribute to be paid by a scholar to an artist by that date in the western European tradition, and it was one of the earliest to display interest in draughtsmanship. In this extract from the preface, Camerarius emphasizes that drawing was at the root of the artist's skill. In describing Dürer's activities as a treatise writer Camerarius also stresses Dürer's credentials, not just as a craftsman but also as an intellectual. [CEK]

Source: W. M. Conway (1958), *The Writings of Dürer* (London: Peter Owen), pp. 136–9. Reprinted by permission of Peter Owen Ltd, London.

It is not my present purpose to talk about art. My purpose was to speak somewhat, as needs must be, of the artificer, the author of this book. He, I trust, has become known by his virtue and his deserts, not only to his own country but to foreign nations also. Full well I know that his praises need not our trumpetings to the world, since by his excellent works he is exalted and honoured with undying glory. Yet, as we were publishing his writings, and an

opportunity arose of committing to print the life and habits of a remarkable man and a very dear friend of ours, we have judged it expedient to put together some few scraps of information, learnt partly from the conversations of others and partly from our own intercourse with him. This will give some indication of his singular skill and genius as artist and man, and cannot fail of affording pleasure to the reader. We have heard that our Albrecht was of Hungarian extraction, but that his forefathers emigrated to Germany. We can therefore have but little to say of his origin and birth. Though they were honourable, there can be no question but that they gained more glory from him than he from them.

Nature bestowed on him a body remarkable in build and stature and not unworthy of the noble mind it contained; that in this too Nature's Justice, extolled by Hippocrates, might not be forgotten – that Justice, which, while it assigns a grotesque form to the ape's grotesque soul, is wont also to clothe noble minds in bodies worthy of them. His head was intelligent,[1] his eyes flashing, his nose nobly-formed and, as the Greeks say, τετράγωνου [square]. His neck was rather long, his chest broad, his body not too stout, his thighs muscular, his legs firm and steady. But his fingers – you would vow you had never seen anything more elegant.

His conversation was marked by so much sweetness and wit, that nothing displeased his hearers so much as the end of it. Letters, it is true, he had not cultivated, but the great sciences of Physics and Mathematics, which are perpetuated by letters, he had almost entirely mastered. He not only understood principles and knew how to apply them in practice, but he was able to set them forth in words. This is proved by his Geometrical treatises, wherein I see nothing omitted, except what he judged to be beyond the scope of his work. An ardent zeal impelled him towards the attainment of all virtue in conduct and life, the display of which caused him to be deservedly held a most excellent man. Yet he was not of a melancholy severity nor of a repulsive gravity; nay, whatever conduced to pleasantness and cheerfulness, and was not inconsistent with honour and rectitude, he cultivated all his life and approved even in his old age. The works he has left on Gymnastic and Music are of such character.

But Nature had specially designed him for a painter, and therefore he embraced the study of that art with all his energies, and was ever desirous of

[1] '*Caput argutum.*' The phrase is from Virgil's description of the thorough-bred horse (*Georg.* iii.). The above passage is introduced (with modifications) into Melchior Adam's *Vitæ Germ. Philos.* (p. 66) where this sentence runs: 'the deep-thinking, serene-souled artist was seen unmistakably in his *arched and lofty brow* and in the fiery glance of his eye.'

observing the works and principles of the famous painters of every land, and of imitating whatever he approved in them. Moreover, with respect to those studies, he experienced the generosity and won the favour of the greatest kings and princes, and even of Maximilian himself and his grandson the Emperor Charles; and he was rewarded by them with no contemptible salary. But after his hand had, so to speak, attained its maturity, his sublime and virtue-loving genius became best discoverable in his works, for his subjects were fine and his treatment of them noble. You may judge the truth of these statements from his extant prints in honour of Maximilian and his memorable astronomical diagrams, not to mention other works, not one of which but a painter of any nation or day would be proud to call his own. The nature of a man is never more certainly and definitely shown than in the works he produces as the fruit of his art...... What single painter has there ever been who did not reveal his character in his works? Instead of instances from ancient history I shall content myself with examples from our own time. No one can fail to see that many painters have sought a vulgar celebrity by immodest pictures. It is not credible that those artists can be virtuous, whose minds and fingers composed such works. We have also seen pictures minutely finished and fairly well coloured, wherein, it is true, the master showed a certain talent and industry; but art was wanting. Albrecht, therefore, shall we most justly admire as an earnest guardian of piety and modesty, and as one who showed, by the magnitude of his pictures, that he was conscious of his own powers, although none even of his lesser works is to be despised. You will not find in them a single line carelessly or wrongly drawn, not a single superfluous dot.

What shall I say of the steadiness and exactitude of his hand? You might swear that rule, square, or compasses had been employed to draw lines, which he, in fact, drew with the brush, or very often with pencil or pen, unaided by artificial means, to the great marvel of those who watched him. Why should I tell how his hand so closely followed the ideas of his mind that, in a moment, he often dashed upon paper, or, as painters say, composed, sketches of every kind of thing with pencil or pen? I see I shall not be believed by my readers when I relate, that sometimes he would draw separately, not only the different parts of a composition, but even the different parts of bodies, which, when joined together, agreed with one another so well that nothing could have fitted better. In fact this consummate artist's mind, endowed with all knowledge and understanding of the truth and of the agreement of the parts one with another, governed and guided his hand and bade it trust to itself without any other aids. With like accuracy he held the brush, wherewith he drew the smallest things on canvas or wood without sketching them in beforehand, so

that, far from giving ground for blame, they always won the highest praise. And this was a subject of greatest wonder to most distinguished painters, who, from their own great experience, could understand the difficulty of the thing.

I cannot forbear to tell, in this place, the story of what happened between him and Giovanni Bellini. Bellini had the highest reputation as a painter at Venice and indeed throughout all Italy. When Albrecht was there he easily became intimate with him, and both artists naturally began to show one another specimens of their skill. Albrecht frankly admired and made much of all Bellini's works. Bellini also candidly expressed his admiration of various features of Albrecht's skill and particularly the fineness and delicacy with which he drew hairs. It chanced one day that they were talking about art, and when their conversation was done Bellini said: 'Will you be so kind, Albrecht, as to gratify a friend in a small matter?' 'You shall soon see,' says Albrecht, 'if you will ask of me anything I can do for you.' Then says Bellini: 'I want you to make me a present of one of the brushes with which you draw hairs.' Dürer at once produced several, just like other brushes, and, in fact, of the kind Bellini himself used, and told him to choose those he liked best, or to take them all if he would. But Bellini, thinking he was misunderstood, said: 'No, I don't mean these but the ones with which you draw several hairs with one stroke; they must be rather spread out and more divided, otherwise in a long sweep such regularity of curvature and distance could not be preserved.' 'I use no other than these' says Albrecht, 'and to prove it, you may watch me.' Then, taking up one of the same brushes, he drew some very long wavy tresses, such as women generally wear, in the most regular order and symmetry. Bellini looked on wondering, and afterwards confessed to many that no human being could have convinced him by report of the truth of that which he had seen with his own eyes.

A similar tribute was given him, with conspicuous candour, by Andrea Mantegna, who became famous at Mantua by reducing painting to some severity of law – a fame which he was the first to merit, by digging up broken and scattered statues, and setting them up as examples of art. It is true all his work is hard and stiff, inasmuch as his hand was not trained to follow the perception and nimbleness of his mind; still it is held that there is nothing better or more perfect in art. While Andrea was lying ill at Mantua he heard that Albrecht was in Italy and had him summoned to his side at once, in order that he might fortify his (Albrecht's) facility and certainty of hand with scientific knowledge and principles. For Andrea often lamented in conversation with his friends that Albrecht's facility in drawing had not been granted to him nor his learning to Albrecht. On receiving the message Albrecht, leaving

all other engagements, prepared for the journey without delay. But before he could reach Mantua Andrea was dead, and Dürer used to say that this was the saddest event in all his life; for high as Albrecht stood, his great and lofty mind was ever striving after something yet above him.

Almost with awe have we gazed upon the bearded face of the man, drawn by himself, in the manner we have described, with the brush on the canvas and without any previous sketch. The locks of the beard are almost a cubit long, and so exquisitely and cleverly drawn, at such regular distances and in so exact a manner that the better anyone understands art the more he would admire it and the more certain would he deem it that in fashioning these locks the hand had employed artificial aid.

Further, there is nothing foul, nothing disgraceful in his work. The thoughts of his most pure mind shunned all such things. O artist worthy of success! How like too are his portraits! how unerring! how true!

All these perfections he attained by reducing mere practice to art and method, in a way new at least to German painters. With Albrecht all was ready, certain, and at hand, because he had brought painting into the fixed track of rule and recalled it to scientific principles; without which, as Cicero said, though some things may be well done by help of nature, yet they cannot always be ready to hand, because they are done by chance. He first worked his principles out for his own use; afterwards with his generous and open nature he attempted to explain them in books, written to the illustrious and most learned Wilibald Pirkheimer. And he dedicated them to him in a most elegant letter which we have not translated, because we felt it to be beyond our power to render it into Latin without, so to speak, disfiguring its natural countenance. But before he could complete and publish the books, as he had hoped, he was carried off by death – a death, calm indeed and enviable, but in our view premature. If there was anything at all in that man which could seem like a fault, it was his excessive industry, which often made unfair demands upon him.

Linear Perspective

Cennino Cennini's method for depicting buildings in a painting

Cennino Cennini (c.1370–1440) was a painter, a pupil of Agnolo Gaddi (active 1369–96), and a writer, based in Florence. None of his paintings have been identified, and Cennini is best known for his handbook on artists' techniques, especially drawing and painting. The treatise is usually dated around 1400, and the earliest surviving manuscript is inscribed 1437, 'from the debtors' prison in Florence'. The treatise does not describe recent artistic innovations but is usually taken as a record of standard practice up to the fifteenth century. In this context Cennini describes how to portray architecture in pictorial space by exploiting the empirical observation that lines of depth which recede from the viewer look as though they slant upwards or downwards. [CMR]

Source: Cennino Cennini (1960), *The Craftsman's Handbook: The Italian 'Il libro dell'arte'*, trans. D. V. Thompson Jr (New York: Dover Publications), pp. 56–7. Reprinted by permission of Dover Publications, Inc.

How Buildings are to be Painted, in Fresco and in Secco

If you want to do buildings, get them into your drawing in the scale you wish; and snap the lines. Then lay them in with verdaccio, and with terre-verte, quite thin in fresco or in secco. And you may do some with violet, some with ash gray, some with green, some with greenish gray, and likewise with any color you wish. Then make a long ruler, straight and fine; and have it chamfered on one edge, so that it will not touch the wall, so that if you rub on it, or run along it with the brush and color, it will not smudge things for you; and you will execute those little moldings with great pleasure and delight; and in the same way bases, columns, capitals, façades, fleurons, canopies, and the whole range of the mason's craft, for it is a fine branch of our profession, and should be executed with great delight. And bear in mind that they must follow the same system of lights and darks that you have in the figures. And put in the buildings by this uniform system: that the moldings which you make at the top of the building should slant downward from the edge next

to the roof; the molding in the middle of the building, halfway up the face, must be quite level and even; the molding at the base of the building underneath must slant upward, in the opposite sense to the upper molding, which slants downward.

1.2.2
Alberti and the earliest written description of single-point perspective

Leon Battista Alberti (1404–72) was a patrician, scholar and cleric, as well as an architect and amateur painter and sculptor. *On Painting* was written in Florence first in Latin in 1435 and then in Italian in 1436. It includes, among other things, the earliest description of a systematic perspective construction and practical guidelines for artists to follow. *On Painting* was not published in printed form until 1540. In the following extracts from books 1 and 2 of *On Painting*, Alberti describes the action of the eye in terms of visual rays which artists can use to make perspectival constructions. He defines a painting as an intersection in the visual pyramid or a window between the eye and the object depicted. He then goes on to give two methods which will both help artists construct convincing spatial settings and allow them to position objects and figures in proportion to one another. [CMR]

Source: Leon Battista Alberti (1991), *On Painting*, trans C. Grayson, intro. and notes M. Kemp (Harmondsworth: Penguin), pp. 37, 39–44, 46–9, 53–4, 58–9, 64–7.

In writing about painting in these short books, we will, to make our discourse clearer, first take from mathematicians those things which seem relevant to the subject. When we have learned these, we will go on, to the best of our ability, to explain the art of painting from the basic principles of nature. But in everything we shall say I earnestly wish it to be borne in mind that I speak in these matters not as a mathematician but as a painter. Mathematicians measure the shapes and forms of things in the mind alone and divorced entirely from matter. We, on the other hand, who wish to talk of things that are visible, will express ourselves in cruder terms. And we shall believe we have achieved our purpose if in this difficult subject, which as far as I can see has not before been treated by anyone else, our readers have been able to

follow our meaning. I therefore ask that my work be accepted as the product not of a pure mathematician but only of a painter. [. . .]

We must first speak of position, then of lighting. And we must investigate how it is that, with change of position, the properties inherent in a surface appear to be altered. These matters are related to the power of vision; for with a change of position surfaces will appear larger, or of a completely different outline from before, or diminished in colour; all of which we judge by sight. Let us inquire why this is so, and start from the opinion of philosophers who say that surfaces are measured by certain rays, ministers of vision as it were, which they therefore call visual rays, since by their agency the images of things are impressed upon the senses. These rays, stretching between the eye and the surface seen, move rapidly with great power and remarkable subtlety, penetrating the air and rare and transparent bodies until they encounter something dense or opaque where their points strike and they instantly stick. Indeed among the ancients there was considerable dispute as to whether these rays emerge from the surface or from the eye. This truly difficult question, which is quite without value for our purposes, may here be set aside. Let us imagine the rays, like extended very fine threads gathered tightly in a bunch at one end, going back together inside the eye where lies the sense of sight. There they are like a trunk of rays from which, like straight shoots, the rays are released and go out towards the surface in front of them. But there is a difference between these rays which I think it essential to understand. They differ in strength and function, for some reach to the outlines of surfaces and measure all their dimensions. Let us call these extrinsic rays, since they fly out to touch the outer parts of the surface. Other rays, whether received by or flowing from the whole extent of the surface, have their particular function within the pyramid of which we shall presently speak, for they are imbued with the same colours and lights with which the surface itself shines. Let us, therefore, call these median rays. Among them there is one which is called the centric ray, on the analogy of the centric line we spoke of above, because it meets the surface in such a way that it makes equal angles on all sides. So we have found three kinds of rays: extrinsic, median and centric.

Let us now investigate what part each of these rays plays in the action of sight; first the extrinsic, then the median, and finally the centric. Quantities are measured by the extrinsic rays. A quantity is the space across the surface between two different points on the outline, which the eye measures with the extrinsic rays rather like a pair of dividers. There are as many quantities in a surface as there are points on the outline that are in some way opposed to one another. We use these extrinsic rays whenever we apprehend by sight the height from top to bottom, or width from left to right, or depth from near to

far, or any other dimensions. This is why it is usually said that sight operates by means of a triangle whose base is the quantity seen, and whose sides are those same rays which extend to the eye from the extreme points of that quantity. It is perfectly true that no quantity can be seen without such a triangle. The sides of the visual triangle, therefore, are open. In this triangle two of the angles are at the two ends of the quantity; the third is the one which lies within the eye and opposite the base. *This is not the place to argue whether sight rests at the juncture of the inner nerve of the eye, or whether images are represented on the surface of the eye, as it were in an animate mirror. I do not think it necessary here to speak of all the functions of the eye in relation to vision. It will be enough in these books to describe briefly those things that are essential to the present purpose.* As, then, the visual angle resides in the eye, the following rule has been drawn: the more acute the angle within the eye, the less will appear the quantity. From this it can be clearly understood why it is that at a great distance a quantity seems to be reduced to a point. None the less it does happen with some surfaces that the nearer the eye of the observer is to it, the less it sees, and the further away it is, the greater the part of the surface it sees. This is seen to be the case with a spherical surface. Quantities, therefore, sometimes seem to the observer greater or lesser according to their distance. Anyone who has properly understood the theory behind this, will plainly see that some median rays sometimes become extrinsic, and extrinsic ones median, when the distance is changed; and he will appreciate that where the median have become extrinsic, the quantity will appear less, and conversely, when the extrinsic rays fall inside the outline, the further they are from it, the greater the quantity appears.

I usually give my friends the following rule: the more rays are employed in seeing, the greater the quantity seen will appear, and the fewer the rays, the smaller the quantity. Furthermore, the extrinsic rays, which hold on like teeth to the whole of the outline, form an enclosure around the entire surface like a cage. This is why they say that vision takes place by means of a pyramid of rays. We must, therefore, explain what a pyramid is, and how it is made up of rays. Let us describe it in our own rough terms. A pyramid is a form of oblong body from whose base all straight lines, prolonged upwards, meet at one and the same point. The base of the pyramid is the surface seen, and the sides are the visual rays we said are called extrinsic. The vertex of the pyramid resides within the eye, where the angles of the quantities in the various triangles meet together. Up to now we have dealt with the extrinsic rays of which the pyramid is composed; from all of which it is evident that it is of considerable importance what distance lies between the surface and the eye. We must now speak of the median rays. These are the mass of rays which is contained

within the pyramid and enclosed by the extrinsic rays. These rays do what they say the chameleon and other like beasts are wont to do when struck with fear, who assume the colours of nearby objects so as not to be easily discovered by hunters. These median rays behave likewise; for, from their contact with the surface to the vertex of the pyramid, they are so tinged with the varied colours and lights they find there, that at whatever point they were interrupted, they would show the same light they had absorbed and the same colour. We know for a fact about these median rays that over a long distance they weaken and lose their sharpness. The reason why this occurs has been discovered: as they pass through the air, these and all the other visual rays are laden and imbued with lights and colours; but the air too is also endowed with a certain density, and in consequence the rays get tired and lose a good part of their burden as they penetrate the atmosphere. So it is rightly said that the greater the distance, the more obscure and dimmed the surface appears.

It remains for us to speak of the centric ray. We call the centric ray the one which alone strikes the quantity in such a way that the adjacent angles on all sides are equal. As for the properties of the centric ray, it is of all the rays undoubtedly the most keen and vigorous. It is also true that a quantity will never appear larger than when the centric ray rests upon it. A great deal could be said about the power and function of this ray. One thing should not go unsaid: this ray alone is supported in their midst, like a united assembly, by all the others, so that it must rightly be called the leader and prince of rays. *Further comment would be more appropriate to a show of learning than to the things we set out to treat, and may therefore be omitted here. Besides, much will be said about rays more suitably in their proper place. Let it suffice here, as the brevity of these books requires, to have stated those things that will leave no one doubting the truth of what I believe* I have adequately shown, *namely,* if the distance and position of the centric ray are changed, the surface appears to be altered. For it will appear either smaller or larger or changed according to the relative disposition of the lines and angles. So the position of the centric ray and distance play a large part in the determination of sight. There is also a third condition in which surfaces present themselves to the observer as different or of diverse form. This is the reception of light. One can observe in a spherical or concave body, if there is only one source of light present, that the surface is rather dark in one part and lighter in another, whilst at the same distance and with no change of the original centric position, if the same surface lies in a different light from before, you will see as dark the parts which were bright before under the other light, and as light those parts that earlier were in the shadow. Then, if there are several lights around, various

patches of brightness and darkness will alternate here and there according to the number and strength of the lights. [...]

I have spoken about surfaces and about rays. I have explained how, in seeing, a pyramid is made up of triangles. We have shown how extremely important it is that the distance, the position of the centric ray, and the reception of light should be determined. But as at one glance we see not merely one but several surfaces together, now that we have dealt in some detail with single surfaces, we must enquire in what way surfaces that are connected together present themselves. As we have said, individual surfaces enjoy their own pyramid charged with its particular colours and lights. Since bodies are covered in surfaces, all the observed quantities of bodies will make up a single pyramid containing as many small pyramids as there are surfaces embraced by the rays from that point of vision. Even so, someone may ask what practical advantage all this inquiry brings to the painter. It is this: he must understand that he will become an excellent artist only if he knows well the borderlines of surfaces and their proportions, which very few do; for if they are asked what they are attempting to do on the surface they are painting, they can answer more correctly about everything else than about what in this sense they are doing. So I beg studious painters to listen to me. It was never shameful to learn from any teacher things that are useful to know. They should understand that, when they draw lines around a surface, and fill the parts they have drawn with colours, their sole object is the representation on this one surface of many different forms of surfaces, just as though this surface which they colour were so transparent and like glass, that the visual pyramid passed right through it from a certain distance and with a certain position of the centric ray and of the light, established at appropriate points nearby in space. Painters prove this when they move away from what they are painting and stand further back, seeking to find by the light of nature the vertex of the pyramid from which they know everything can be more correctly viewed. But as it is only a single surface of a panel or a wall, on which the painter strives to represent many surfaces contained within a single pyramid, it will be necessary for his visual pyramid to be cut at some point, so that the painter by drawing and colouring can express whatever outlines and colours that intersection presents. Consequently the viewers of a painted surface appear to be looking at a particular intersection of the pyramid. Therefore, a painting will be the intersection of a visual pyramid at a given distance, with a fixed centre and certain position of lights, represented by art with lines and colours on a given surface.

Having said that painting represents the intersection of a pyramid, we must now examine all those things that enable us to understand that intersection.

We must, therefore, say something further about the surfaces from which, as we have shown, the pyramids to be intersected in the painting arise. Some surfaces lie horizontally before one, like the floors of buildings and other surfaces equidistant from the floor. Others stand perpendicularly, such as walls and other surfaces collinear with them. Surfaces are said to be equidistant from one another when the distance between them is the same at every point. Collinear surfaces are those which a continuous straight line touches equally in every part, like the surfaces of square columns standing in regular succession in an arcade. These remarks should be added to what we said above about surfaces. And to what we said about extrinsic, median and centric rays, about the visual pyramid, should be added the mathematical proposition that if a straight line intersects two sides of a triangle, and this intersecting line, which forms a new triangle, is equidistant from one of the sides of the first triangle, then the greater triangle will be proportional to the lesser. This is what mathematicians affirm. [...]

There is in comparison a power which enables us to recognize the presence of more or less or just the same. So we call large what is bigger than this small thing, and very large what is bigger than the large, and bright what is lighter than this dark object, and very bright what is brighter than the light. Comparison is made with things most immediately known. As man is the best known of all things to man, perhaps Protagoras, in saying that man is the scale and the measure of all things, meant that accidents in all things are duly compared to and known by the accidents in man. All of which should persuade us that, however small you paint the objects in painting, they will seem large or small according to the size of any man in the picture. Of all the ancients, the painter Timanthes always seems to me to have observed this force of comparison best. They say that he represented on a small panel a Cyclops asleep, and put in next to him some satyrs embracing his thumb, so that the sleeping figure appeared very large indeed in proportion to the satyrs.

Up to now we have explained everything related to the power of sight and the understanding of the intersection. But as it is relevant to know, not simply what the intersection is and what it consists in, but also how it can be constructed, we must now explain the art of expressing the intersection in painting. Let me tell you what I do when I am painting. First of all, on the surface on which I am going to paint, I draw a rectangle of whatever size I want, which I regard as an open window through which the subject to be painted is seen; and I decide how large I wish the human figures in the painting to be. I divide the height of this man into three parts, which will be proportional to the measure commonly called a 'braccio'; for, as may be seen from the relation-

ship of his limbs, three 'braccia' is just about the average height of a man's body. With this measure I divide the bottom line of my rectangle into as many parts as it will hold; and this bottom line of the rectangle is for me proportional to the nearest transverse equidistant quantity seen on the pavement. Then I establish a point in the rectangle wherever I wish; and as it occupies the place where the centric ray strikes, I shall call this the centric point. The suitable position for this centric point is no higher from the base line than the height of the man to be represented in the painting, for in this way both the viewers and the objects in the painting will seem to be on the same plane. Having placed the centric point, I draw straight lines from it to each of the divisions on the base line. These lines show me how successive transverse quantities visually change to an almost infinite distance. At this stage some would draw a line across the rectangle equidistant from the divided line, and then divide the space between these two lines into three parts. Then, to that second equidistant line they would add another above, following the rule that the space which is divided into three parts between the first divided (base) line and the second equidistant one, shall exceed by one of its parts the space between the second and third lines; and they would go on to add other lines in such a way that each succeeding space between them would always be to the one preceding it in the relationship, in mathematical terminology, of 'superbipartiens'. That would be their way of proceeding, and although people say they are following an excellent method of painting, I believe they are not a little mistaken, because, having placed the first equidistant line at random, even though the other equidistant lines follow with some system and reason, none the less they do not know where the fixed position of the vertex of the pyramid is for correct viewing. For this reason quite serious mistakes occur in painting. What is more, the method of such people would be completely faulty, where the centric point were higher or lower than the height of a man in the picture. Besides, no learned person will deny that no objects in a painting can appear like real objects, unless they stand to each other in a determined relationship. We will explain the theory behind this if ever we write about the demonstrations of painting, which our friends marvelled at when we did them, and called them 'miracles of painting'; for the things I have said are extremely relevant to this aspect of the subject. Let us return, therefore, to what we were saying.

With regard to the question outlined above, I discovered the following excellent method. I follow in all other respects the same procedure I mentioned above about placing the centre point, dividing the base line and drawing lines from that point to each of the divisions of the base line. But as regards the successive transverse quantities I observe the following method. I have a

drawing surface on which I describe a single straight line, and this I divide into parts like those into which the base line of the rectangle is divided. Then I place a point above this line, directly over one end of it, at the same height as the centric point is from the base line of the rectangle, and from this point I draw lines to each of the divisions of the line. Then I determine the distance I want between the eye of the spectator and the painting, and, having established the position of the intersection at this distance, I effect the intersection with what mathematicians call a perpendicular. A perpendicular is a line which at the intersection with another straight line makes right angles on all sides. This perpendicular will give me, at the places it cuts the other lines, the measure of what the distance should be in each case between the transverse equidistant lines of the pavement. In this way I have all the parallels of the pavement drawn. A parallel is the space between two equidistant lines, of which we spoke at some length above. A proof of whether they are correctly drawn will be if a single straight line forms the diagonal of connected quadrangles in the pavement. The diagonal of a quadrangle for mathematicians is the straight line drawn from one angle to the angle opposite it, which divides the quadrangle into two parts so as to create two triangles from it. When I have carefully done these things, I draw a line across, equidistant from the other lines below, which cuts the two upright sides of the large rectangle and passes through the centric point. This line is for me a limit or boundary, which no quantity exceeds that is not higher than the eye of the spectator. As it passes through the centric point, this line may be called the centric line. This is why men depicted standing in the parallel furthest away are a great deal smaller than those in the nearer ones – a phenomenon which is clearly demonstrated by nature herself, for in churches we see the heads of men walking about, moving at more or less the same height, while the feet of those further away may correspond to the knee-level of those in front.

This method of dividing up the pavement pertains especially to that part of painting which, when we come to it, we shall call composition; and it is such that I fear it may be little understood by readers on account of the novelty of the subject and the brevity of our description. As we can easily judge from the works of former ages, this matter probably remained completely unknown to our ancestors because of its obscurity and difficulty. You will hardly find any 'historia' of the ancients properly composed either in painting or modelling or sculpture.

I have set out the foregoing briefly and, I believe, in a not altogether obscure fashion, but I realize the content is such that, while I can claim no praise for eloquence in exposition, the reader who does not understand at first acquaintance, will probably never grasp it however hard he tries. To intelligent minds that are

well disposed to painting, those things are simple and splendid, however presented, which are disagreeable to gross intellects little disposed to these noble arts, even if expounded by the most eloquent writers. As they have been explained by me briefly and without eloquence, they will probably not be read without some distaste. Yet I crave indulgence if, in my desire above all to be understood, I saw to it that my exposition should be clear rather than elegant and ornate. What follows will, I hope, be less disagreeable to the reader.

I have set out whatever seemed necessary to say about triangles, the pyramid and the intersection. I used to demonstrate these things at greater length to my friends with some geometrical explanation. I considered it best to omit this from these books for reasons of brevity. I have outlined here, as a painter speaking to painters, only the first rudiments of the art of painting. And I have called them rudiments, because they lay the first foundations of the art for unlearned painters. They are such that whoever has grasped them properly will see they are of considerable benefit, not only to his own talent and to understanding the definition of painting, but also to the appreciation of what we are going to say later on. Let no one doubt that the man who does not perfectly understand what he is attempting to do when painting, will never be a good painter. It is useless to draw the bow, unless you have a target to aim the arrow at. I want us to be convinced that he alone will be an excellent painter who has learned thoroughly to understand the outlines and all the properties of surfaces. On the other hand, I believe that he who has not diligently mastered all we have said, will never be a good artist. [. . .]

This art, then, brings pleasure while you practise it, and praise, riches and endless fame when you have cultivated it well. Therefore, as painting is the finest and most ancient ornament of things, worthy of free men and pleasing to learned and unlearned alike, I earnestly beseech young students to devote themselves to painting as much as they can. Next, I would advise those who are devoted to painting to go on to master with every effort and care this perfect art of painting. You who strive to excel in painting, should cultivate above all the fame and reputation which you see the ancients attained, and in so doing it will be a good thing to remember that avarice was always the enemy of renown and virtue. A mind intent on gain will rarely obtain the reward of fame with posterity. I have seen many in the very flower, as it were, of learning, descend to gain and thereafter obtain neither riches nor distinction, who if they had improved their talent with application, would easily have risen to fame and there received both wealth and the satisfaction of renown. But we have said enough on these matters. Let us return to our purpose.

We divide painting into three parts, and this division we learn from Nature herself. As painting aims to represent things seen, let us note how in fact

things are seen. In the first place, when we look at a thing, we see it as an object which occupies a space. The painter will draw around this space, and he will call this process of setting down the outline, appropriately, circumscription. Then, as we look, we discern how the several surfaces of the object seen are fitted together; the artist, when drawing these combinations of surfaces in their correct relationship, will properly call this composition. Finally, in looking we observe more clearly the colours of surfaces; the representation in painting of this aspect, since it receives all its variations from light, will aptly here be termed the reception of light.

Therefore, circumscription, composition and reception of light make up painting; and with these we must now deal as briefly as possible. First circumscription. Circumscription is the process of delineating the external outlines on the painting. They say that Parrhasius the painter, with whom Socrates speaks in Xenophon, was very expert in this and studied these lines very closely. I believe one should take care that circumscription is done with the finest possible, almost invisible lines, like those they say the painter Apelles used to practise and vie with Protogenes at drawing. Circumscription is simple the recording of the outlines, and if it is done with a very visible line, they will look in the painting, not like the margins of surfaces, but like cracks. I want only the external outlines to be set down in circumscription; and this should be practised assiduously. No composition and no reception of light will be praised without the presence of circumscription. But circumscription by itself is very often most pleasing. So attention should be devoted to circumscription; and to do this well, I believe nothing more convenient can be found than the veil, which among my friends I call the intersection, and whose usage I was the first to discover. It is like this: a veil loosely woven of fine thread, dyed whatever colour you please, divided up by thicker threads into as many parallel square sections as you like, and stretched on a frame. I set this up between the eye and the object to be represented, so that the visual pyramid passes through the loose weave of the veil. This intersection of the veil has many advantages, first of all because it always represents the same surfaces unchanged, for once you have fixed the position of the outlines, you can immediately find the apex of the pyramid you started with, which is extremely difficult to do without the intersection. You know how impossible it is to paint something which does not continually present the same aspect. This is why people can copy paintings more easily than sculptures, as they always look the same. You also know that, if the distance and the position of the centric ray are changed, the thing seen appears to be altered. So the veil will give you the not inconsiderable advantage I have indicated, namely that the object seen will always keep the same appearance. A further advantage is

that the position of the outlines and the boundaries of the surfaces can easily be established accurately on the painting panel; for just as you see the forehead in one parallel, the nose in the next, the cheeks in another, the chin in one below, and everything else in its particular place, so you can situate precisely all the features on the panel or wall which you have similarly divided into appropriate parallels. Lastly, this veil affords the greatest assistance in executing your picture, since you can see any object that is round and in relief, represented on the flat surface of the veil. From all of which we may appreciate by reflection and experience how useful the veil is for painting easily and correctly.

I will not listen to those who say it is no good for a painter to get into the habit of using these things, because, though they offer him the greatest help in painting, they make the artist unable to do anything by himself without them. If I am not mistaken, we do not ask for infinite labour from the painter, but we do expect a painting that appears markedly in relief and similar to the objects presented. I do not understand how anyone could ever even moderately achieve this without the help of the veil. So those who are anxious to advance in the art of painting, should use this intersection or veil, as I have explained.

1.2.3
Lorenzo Ghiberti lists the sources for perspective

Lorenzo Ghiberti (1378–1455) began writing his semi-autobiographical *Commentaries* in 1447. They remained unfinished on his death. The third of the three chapters is by far the longest and reads like an unedited anthology of Ghiberti's notes and references on the scientists and philosophers who informed the fifteenth-century conception of vision and optics. The following is a brief section from the third book where Ghiberti credits the Greek, Roman and Islamic sources from which single-point perspective was developed. [CMR]

Source: Lorenzo Ghiberti (1967), *I Commentari*, ed. O. Morisani (Naples: Riccardo Ricciardi, Editore), pp. 58–9. Translated from the Italian by Rahel Nigussie and Carol M. Richardson. Copyright © The Open University 2007.

No one doubts the things which follow, and therefore consider the composition of the eye, and that without this it is not possible to know anything of how one sees; but certain authors say more, some less, and in some things there are differences between them, but those authors who write on perspective[1] all deal with the composition of the eye. They take for granted the ancient natural philosophers and authors of medicine, such as Thales,[2] Democritus,[3] Anaxagoras,[4] Xenophanes,[5] and the other scientists who have written on the things of nature, of how Socrates [469–399 BCE], Plato [427–327 BCE], Aristotle [384–322 BCE], Zeno [of Sidon, c.150–70 BCE], Epicurus [341–270 BCE] and the other philosophers were determined to promote the life of men. Hippocrates,[6] Galen[7] and Avicenna [Ibn Sina][8] demonstrated that this is a difficult matter, and they demonstrated it more fully and more extensively because you will not understand it unless you go back to nature; and because it is necessary to say some things that cannot be found examining perspective alone, although so much is manageable to want to certify these things, I want to clarify them. But I am not going to deal with the principles and all the different opinions in a superficial way. I will discuss the composition of the eye especially following three authors: Avicenna in his books, Alhazen[9] in his first book of perspective, and Constantine [the African][10] in his first book on

[1] The term Ghiberti uses here is *prospettiva*. This implies proportion as well as perspective (as 'looking through').

[2] Thales (c.624–547 BCE) lived and worked in Miletus in Asia Minor (now Turkey). He worked as an engineer but wrote treatises on mathematics and philosophy. Although there are no extant works by him he was credited with having introduced the Greeks to geometry.

[3] Democritus (c.460–370 BCE) was a physicist and philosopher from Abdera, Thrace, in Greece who travelled widely.

[4] Anaxagoras (499–428 BCE) is credited with bringing philosophy with him from Asia Minor and introducing it to the Athenians.

[5] Xenophanes (c.575–478 BCE) was a Greek philosopher and poet who travelled from Asia Minor and settled in the south of Italy.

[6] Hippocrates of Chios (470–410 BCE) was a geometer who taught in Athens.

[7] Galen (c.130–200 CE) was a physician and philosopher.

[8] Avicenna, or Ibn Sina (980–1037 CE), was a doctor who wrote on everything, from logic, music and astronomy, in the context of medicine and healing. He died in Persia (modern Iran).

[9] Abu Ali al-Hasan Ibn al-Haitham is often referred to by his Latin name, Alhazen. He was born in Babylon (modern Iraq) c.965 CE and travelled to Egypt and Spain. He is credited with the earliest use of the camera obscura, which he used to demonstrate that light comes from objects to the eye, and is not sent out from the eye to objects. His writings formed the basis of the fifteenth-century understanding of sight. He died in 1039.

[10] From Tunisia, Constantine the African (1020–7 CE) travelled to Salerno in Italy, where he translated the major Arabic texts into Latin.

the eye, because these authors establish the basics and deal with the things that we want to deal with. That said, although we can follow the words of each, sometimes they contradict one another because of bad translations.

1.2.4
Filarete's method for making drawings of buildings

Giorgio Vasari suggests that Filarete (Antonio di Pietro Averlino c.1400–69) was trained in the workshop of Lorenzo Ghiberti. His *Treatise on Architecture* (1461–4), written while he was working for Francesco Sforza (1401–66), Duke of Milan, was the first treatise on architecture to be written in the Italian vernacular. It takes the form of a dialogue between the architect and his patron. In addition to his history of the origins of architecture and his distillation of Vitruvius' classical orders into three types (Doric, Ionic and Corinthian), he provides practical instructions for making accurate architectural plans and drawings. In the following passage Filarete gives a useful explanation of single-point perspective and its complexities, using Brunelleschi's earlier experiments with mirrors to test the veracity of the results. [CMR]

Source: Filarete (1965), *Treatise on Architecture*, trans. and ed. J. R. Spencer (New Haven and London: Yale University Press), vol. 1, pp. 302–4. Reprinted by permission of the publisher, Yale University Press.

'You have been able to understand the principles of drawing from the preceding book. Now in this one I should like to show you how these lines are extended to make a building or any other thing located in its place with its rule on a plane [surface], whether figures or animals. Now you should pay attention and open the eyes of your intellect, for what I have to say is subtle and difficult to understand. When you wish to build a building, it is necessary to prepare the things needed for its construction. When they are prepared, the foundations are dug, and then arrangements are made for walling it up. We will do the same with this. As it is necessary to have a site in order to build and to dig the foundations, so we too will first make the site in which we wish to make our drawing. First of all our site must be a plane that is made by rule. Then the things drawn here will also be according to a rule and measure. As I have said, be attentive.

'First, in order to make this plane it is necessary to have the two aforementioned instruments. Without them nothing can be done. They are, as I have said, the compasses and the square as well as a ruler. With the compasses you measure every surface and with the square or rather with the ruler you will rule everything that you have measured with the ruler.'

'Tell me why is this called a compass (sesto)?'

'Because it goes six times around a circle made by itself without closing or opening its legs. The square [is so called] because a square is made with it by turning it four times on a linear drawing on any other thing that you want to make square. Everything that man wishes to do must be done with a certain principle and [in a certain] form. The thing begun [must be] continued with the order it deserves. Therefore, we first pretend to stand at a certain window through which we see everything that we wish to describe and draw on our plane.

'With a pair of compasses, make four equidistant points. Join them together with straight lines and make a square. You can do it with a square and make it whatever size you please. When this is done, you decide for yourself how large you want the figures to be. As you have learned before, and it is also a maxim of the philosophers, man is the measure of all things.[1] Take a third part from the figure you want to make; this will be common braccio, for almost all men conform to a rule. When you have done this, take one of these parts, that is one of these braccio, with your compasses and divide the base line of your window. Then along the perpendicular lay out three [of these measures] from the bottom line. At this height draw a very fine line. Then make a point either above, below, or exactly on this line, either in the middle or at the side. If you want the things to appear head-on, place your point in

[1] Man the measure of all things: Alberti (*On Painting*, p. 55), who in turn derived it from Diogenes Laertius, *Lives* 9–51.

The following discussion of the perspective construction is derived from Alberti (*On Painting*, pp. 56–58), although it is much clearer. The reference to the painting as a window, the modular division of the base line into orthogonals, and the establishment of the recession of the transversals on the three braccia measurement of man is strictly Albertian. Alberti does not state so baldly the height of the horizon line as does Filarete; he only suggests that the centric (or vanishing) point and hence the horizon is properly placed when it is as high as the men painted in the picture. Nor does Alberti locate the centric point with any degree of clarity. In general this point did fall on the middle of the centric (or horizon) line, but not necessarily in the center of the picture. There are also numerous examples of the off-center vanishing point, particularly in the notebooks of Jacopo Bellini.

The mode of establishing the recession of the transversals clarifies and proves the method deduced from Alberti's rather vague discussion (see *On Painting*, Book I n. 48). [See 1.2.2.]

the middle of this line. As I have said, they will be more full-face and more pleasant. However, put it wherever you wish.

'Now you must consider how far away you wish to stand to see your work. You should know that the closer you stand the larger the things will appear, and the farther you stand the smaller they will be. Do not stand too far away or too close. In the place where you stand make a perpendicular line, that is, a line that falls from your head to your feet. On this, place a mark three of these [proportional] braccia above the ground and see that this line does not pass the bottom line of your square, that is, the imagined window. Then with a thread, or rather a ruler, [draw a line] from this given term of three braccia to each one of the three braccia marked on the window, that is, the [base] line of your window. Whether you use a string or a ruler make a point wherever it cuts the perpendicular line of your window. Do as I have said until you come to the other side of the square. Each time make the same mark where your thread cuts it. When you have marked all these parts, carry them to the opposite side of the window with your compasses. Even though one of these will seem wide to you and another narrow, pay no attention to it, because this is the way it should be. Then with your ruler draw a straight line from each of these points to the other you have marked.

'Then place a string or ruler from the point that you have put on this [centric] line, whether it is above or anywhere else, to the lines at the bottom of the square. Draw a line to each of these from this point, for these are an analogy to sight. These lines are the rays of your eyes, that is the aforementioned visual rays. You will see this plane all full of parallels, that is, little squares of one braccio each. Even though some seem smaller to you than others and although they do not seem to be square, nevertheless they are all equal and all squares of the same kind, as you will presently see. I think you have understood up to here how a plane is made.'

'I have understood it, but I should like to see you make one. Tell me why these squares do not come out as squares.'

'It is because you see these things on a plane. If you saw them directly, they would appear to be squares to you. To prove that this is so, look at the pavement where square pieces of wood have been spread out, or better look at a ceiling from below. All the beams are equidistant from each other. To the sight, they seem to be more and less. The closer they are to you the more equal they seem to be, and the farther away from you the more they seem to be so close together that one is on top of the other and they all seem to be one.

If you wish to consider this more closely, take a mirror and look at them in it. You will clearly see that this is so. If they are exactly opposite your eye, they will only appear equal. I think that Pippo di Ser Brunellesco, the

Florentine, discovered the method of making this plane in this way.[2] It was certainly a subtle and beautiful thing to discover [how to do it] by rule from what the mirror shows you. Even so, if you consider it carefully, you can see by your eye this change and diminution.

'Then measure whatever you put in this square with the same braccia on the line, where they are located, whether they be figures, animals, buildings, columns, or whatever you wish to do. Some will be smaller than others for the above-named reason. If you look at a group of columns in a line, it will seem to you that the last ones are behind each other and one will seem smaller than the other. This happens for the reason stated above.

'I think you have understood, even though this is very difficult to understand. Nevertheless, you need to practice these things so they will not seem so. The first time the wolf saw the lion he seemed very terrible to him. Then as he drew a little nearer he did not seem to be so terrible. The closer he got the less terrible he appeared. Read Aesop in Greek. Thus it is with everything. The beginnings seem very difficult and then the more a man becomes accustomed to them the easier they seem.

'You have understood how this plane is done with the rule of drawing. It is true that it can be done in other places but, in order not to tire you too much, this way will be enough for the present.

'Whenever you wish to place figures on this plane, as for example men on a piazza, one or more buildings, or whatever you wish to put there, do it in this manner so they will seem correct. See first on what line or parallel you wish to locate this figure. Take your compasses and open them to the same extent as one of these horizontal braccia. With this you then measure your figure, for you know that it is three of these braccia. It will be larger or smaller according to the parallel where you place it. Do it with your compasses in the manner you see drawn here.[3]

[2] For the most recent discussion of Brunelleschi and the origins of the perspective construction see R. Wittkower, 'Brunelleschi and Proportion in Perspective,' *Journal of the Warburg and Courtauld Institutes, 16* (1953), 275–91; and John White, *The Birth and Rebirth of Pictorial Space* (London and New York, 1958), pp. 114–21. Richard Krautheimer (*Lorenzo Ghiberti*, Princeton, 1956, pp. 234–48) presents the most credible solution of Brunelleschi's experiment. Decio Gioseffi (*Perspectiva Artificialis*, Università di Trieste, 1957, pp. 73–83) takes the other facet of the invention mentioned by Filarete and bases the whole experiment on the use of a mirror-like surface. See also A. Parronchi, *Studi sulla dolce prospettiva* (Milan, 1964).

[3] The means of placing figures or buildings within the perspective construction is derived from Alberti (*On Painting*, pp. 70–71). The erection of circular and polygonal structures is assumed in Alberti's construction, but for a closer parallel with Filarete see Piero della Francesca, *De Prospectiva Pingendi*, ed. G. Nicco Fasola (Florence, 1952), *1*, 79–84, and *2*, figs. xvi–xx.

'If you wish to erect a building, do it in the same way with your compasses. Determine how high and how wide you want to make it. With the compasses opened as wide as one of these squares, make a perpendicular mark on one of the corners of the building and another in the same way on the other corner as wide as you wish the facade to be. For the side facade, see how much it will be at the nearer corner. Draw a perpendicular line from this parallel and stop your line. Erect another line at the farther corner. Then see how many [proportional] braccia there are in its height. This second [perpendicular] line will be as high as the first two lines even though it seems lower and shorter to you. This is because these braccia are smaller to the sight than the ones in front; in truth they are all the same size. It is the same with the lines of the building. Draw a line from the top as you have done on the bottom and join these lines together. These will be drawn with a string from the centric point, which has been mentioned before; thus you will see all the parts measured [out].

1.2.5
Piero della Francesca's perspective for painters

Piero della Francesca (c.1415–92) created some of the most complex paintings in the fifteenth century which employ single-point perspective. His prowess in mathematics is usually hidden in the deceptive clarity of the geometrical compositions that sustain his paintings. In fact, he seems to have been as well known as a mathematician as he was as a painter in the fifteenth century. Three mathematical treatises are known to have been written by him, but he may have written several more. In the introduction to *De Prospectiva Pingendi [On Perspective for Painting]*, written in Italian, Piero provides a concise explanation of the significance of the action of the eye on objects so that artists might make accurate drawings of correctly proportioned buildings and objects in the space of the picture plane. The treatise continues after this introduction as a series of complex geometrical and algebraic demonstrations. [CMR]

Source: Piero della Francesca (1984), *De Prospectiva Pingendi*, ed. G. Nicco-Fasola (Florence: Casa Editrice), pp. 63–6. Translated from the Italian by Rahel Nigussie and Carol M. Richardson.

The picture contains in itself three principal parts, which we call drawing, measure and colour. Drawing consists of the profiles and contours which define a thing. Measure consists of the same profiles and outlines and is their position in relationship to one another. By colour we mean to give colours to how things are shown, and lightness and darkness depending on the light source. Of these three parts I intend to discuss only measure, which we will call proportion, combining only some parts of drawing, because in this work I cannot demonstrate proportion without them; colour we leave alone, and we discuss those parts which with lines, angles and proportions can be demonstrated: namely points, lines, surfaces and solid bodies. There are five parts to the process: the first is the seeing, by which I mean the eye; the second is the form of the things in the process of being seen; the third is the distance from the eye to the things seen; the fourth are the lines which leave the form of the thing seen and come to the eye; the fifth is the end of the process by which the thing seen is given its location within the eye.

I will not deal with the eye at length beyond that which is necessary for painting. The eye is the first part because all things present themselves to it under diverse angles; by this I mean that when the things seen are of equal distance from the eye, the larger thing presents itself at a larger angle than the smaller, and in the same way, when things are of equal size and not at equal distance from the eyes, the nearer presents itself at a larger angle than the one farther away, for the difference between them varies, and this is called diminution in distance. The second is the form of things without which the intellect cannot judge nor the eye understand the object. The third is the distance from the eye to the thing, because, if the distance were not there, the object would become contingent, by which I mean contiguous, and if the thing were to be bigger than the eye one would not have the capacity to receive it. The fourth are the lines [visual rays] which present themselves from the edges of the object and terminate in the eye, as a result of which the object is received and discerned by the eye. The fifth is the end of the process in which the eye understands things in proportion to one another as a result of their rays and can therefore judge their measurement: if it were not possible to identify the edges of the object it would neither be possible to understand how things get smaller nor represent them. This is necessary so that you can draw a particular form on the plan in the position in which you want it to appear.

1.2.6
Manetti's descriptions of Brunelleschi's experiments

Antonio Manetti (1423–97) was a Florentine writer who knew Brunelleschi. He may also have been a practising architect. No works are securely attributed to him, but he was consulted on the completion of some of Brunelleschi's projects after the architect's death, including the dome of Florence cathedral. Manetti wrote his life of Brunelleschi (1377–1446) in the 1480s. The biography includes a description of Brunelleschi's experiments with perspective, probably undertaken in the first decade of the fifteenth century. These experiments are usually taken by scholars as the starting point for the systematization of single-point perspective, put into practice and developed by artists such as Donatello and Masaccio, and writers such as Alberti. [CMR]

Source: Antonio di Tuccio Manetti (1970), *Life of Brunelleschi*, ed. H. Saalman, trans. C. Enggass (University Park and London: Pennsylvania State University Press), pp. 42–6. © 1970 by The Pennsylvania State University. Reproduced by permission of the publisher.

During the same period he propounded and realized what painters today call perspective, since it forms part of that science which, in effect, consists of setting down properly and rationally the reductions and enlargements of near and distant objects as perceived by the eye of man: buildings, plains, mountains, places of every sort and location, with figures and objects in correct proportion to the distance in which they are shown. He originated the rule that is essential to whatever has been accomplished since his time in that area. We do not know whether centuries ago the ancient painters – who in that period of fine sculptors are believed to have been good masters – knew about perspective or employed it rationally. If indeed they employed it by rule (I did not previously call it a science without reason) as he did later, whoever could have imparted it to him had been dead for centuries and no written records about it have been discovered, or if they have been, have not been comprehended. Through industry and intelligence he either rediscovered or invented it.

Although he was pre-eminent over many others in many things and consequently refined his own and the following century, he was never known to

boast or praise himself or vaunt or laud himself by a single word. Instead he proved himself by his deeds with the opportunities that came along. Unless greatly provoked by insulting or disrespectful acts, he never became angry and was amiable to his friends. It gave him pleasure to commend those who merited it. He willingly instructed those he thought wished to be instructed and who were capable of instruction. He was very skillful and discerning in that as he was in other things.

He first demonstrated his system of perspective on a small panel about half a *braccio* square. He made a representation of the exterior of San Giovanni in Florence, encompassing as much of that temple as can be seen at a glance from the outside. In order to paint it it seems that he stationed himself some three *braccia* inside the central portal of Santa Maria del Fiore. He painted it with such care and delicacy and with such great precision in the black and white colors of the marble that no miniaturist could have done it better. In the foreground he painted that part of the piazza encompassed by the eye, that is to say, from the side facing the Misericordia up to the arch and corner of the sheep [market], and from the side with the column of the miracle of St Zenobius up to the corner of the straw [market], and all that is seen in that area for some distance. And he placed burnished silver where the sky had to be represented, that is to say, where the buildings of the painting were free in the air, so that the real air and atmosphere were reflected in it, and thus the clouds seen in the silver are carried along by the wind as it blows. Since in such a painting it is necessary that the painter postulate beforehand a single point from which his painting must be viewed, taking into account the length and width of the sides as well as the distance, in order that no error would be made in looking at it (since any point outside of that single point would change the shapes to the eye), he made a hole in the painted panel at that point in the temple of San Giovanni which is directly opposite the eye of anyone stationed inside the central portal of Santa Maria del Fiore, for the purpose of painting it. The hole was as tiny as a lentil bean on the painted side and it widened conically like a woman's straw hat to about the circumference of a ducat, or a bit more, on the reverse side. He required that whoever wanted to look at it place his eye on the reverse side where the hole was large, and while bringing the hole up to his eye with one hand, to hold a flat mirror with the other hand in such a way that the painting would be reflected in it. The mirror was extended by the other hand a distance that more or less approximated in small *braccia* the distance in regular *braccia* from the place he appears to have been when he painted it up to the church of San Giovanni. With the aforementioned elements of the burnished silver, the piazza, the viewpoint, etc., the spectator felt he saw the actual scene when he looked at

the painting. I have had it in my hands and seen it many times in my days and can testify to it.

He made a perspective of the piazza of the Palazzo dei Signori in Florence together with all that is in front of it and around it that is encompassed by the eye when one stands outside the piazza, or better, along the front of the church of San Romolo beyond the Canto di Callimala Francesca, which opens into that piazza a few feet toward Orto San Michele. From that position two entire façades – the west and the north – of the Palazzo dei Signori can be seen. It is marvelous to see, with all the objects the eye absorbs in that place, what appears. Paolo Uccello and other painters came along later and wanted to copy and imitate it. I have seen more than one of these efforts and none was done as well as his.

One might ask at this point why, since it was a perspective, he did not make that aperture for the eye in this painting as he did in the small panel of the Duomo of San Giovanni? The reason that he did not was because the panel for such a large piazza had to be large enough to set down all those many diverse objects, thus it could not be held up with one hand while holding a mirror in the other hand like the San Giovanni panel: no matter how far it is extended a man's arm is not sufficiently long or sufficiently strong to hold the mirror opposite the point with its distance. He left it up to the spectator's judgment, as is done in paintings by other artists, even though at times this is not discerning. And where in the San Giovanni panel he had placed burnished silver, here he cut away the panel in the area above the buildings represented, and took it to a spot in which he could observe it with the natural atmosphere above the buildings.

1.2.7
Leonardo da Vinci on single-point and aerial perpective

Leonardo da Vinci (1452–1519) wrote many notes and filled numerous notebooks with his observations, reflections and experiments, probably with the intention of eventually compiling them into a larger work, *On Painting*. His various writings on perspective include, among other things, the actions of the eye and the various visual effects of distance, colour and light. Rather than simply record his observations, Leonardo includes his reflections on the problems for painters in reproducing these visual effects in their works. [CMR]

Source: Leonardo da Vinci (1938), *The Notebooks of Leonardo da Vinci*, ed. and trans. E. MacCurdy, 2 vols (London: Jonathan Cape), vol. 2, pp. 343, 345–6, 352–3. Reprinted by permission of Mr Alec McCurdy. [sic]

Perspective

It is asked of you, O painter, why the figures which you draw on a minute scale as a demonstration of perspective do not appear – notwithstanding the demonstration of distance – as large as real ones, which are of the same height as those painted upon the wall.

And why [representations of] things, seen a short distance away, notwithstanding the distance, seem larger than the reality.

Tr. 66 a

Wall of Glass

Perspective is nothing else than the seeing of an object behind a sheet of glass, smooth and quite transparent, on the surface of which all the things may be marked that are behind this glass; these things approach the point of the eye in pyramids, and these pyramids are cut by the said glass.

A 1 v.

Citation of the things that I ask to have admitted in the proofs of this my perspective: – I ask that it may be permitted me to affirm that every ray which passes through air of uniform density proceeds in a direct line from its cause to its object or the place at which it strikes.

Of the Diminution of Objects at Various Distances

A second object as far removed from the first as the first is from the eye will appear half the size of the first, although they are of the same size.

A small object near at hand and a large one at a distance, when seen between equal angles will appear the same size. [...]

The farther distant from the eye is the spherical body, the more it is seen.

A 10 v.

As soon as ever the air is illuminated it is filled with an infinite number of images, caused by the various substances and colours collected together within it, and of these images the eye is the target and the magnet.

A 27 r.

Principle of Perspective

All things transmit their image to the eye by means of pyramids; the nearer to the eye these are intersected the smaller the image of their cause will appear.

A 36 v.

If you should ask how you can demonstrate these points to me from experience, I should tell you, as regards the vanishing point which moves with you, to notice as you go along by lands ploughed in straight furrows, the ends of which start from the path where you are walking, you will see that continually each pair of furrows seem to approach each other and to join at their ends.

As regards the point that comes to the eye, it may be comprehended with greater ease; for if you look in the eye of anyone you will see your own image there; consequently if you suppose two lines to start from your ears and proceed to the ears of the image which you see of yourself in the eye of the other person, you will clearly recognise that these lines contract so much that when they have continued only a little way beyond your image as mirrored in the said eye they will touch one another in a point.

A 37 r. and v.

The thing that is nearer to the eye always appears larger than another of the same size which is more remote.

A 38 r.

Perspective is of such a nature that it makes what is flat appear in relief, and what is in relief appear flat.

A 38 v.

The perspective by means of which a thing is represented will be better understood when it is seen from the view-point at which it was drawn.

If you wish to represent a thing near, which should produce the effect of natural things, it is impossible for your perspective not to appear false, by reason of all the illusory appearances and errors in proportion of which the existence may be assumed in a mediocre work, unless whoever is looking at this perspective finds himself surveying it from the exact distance, elevation, angle of vision or point at which you were situated to make this perspective. Therefore it would be necessary to make a window of the size of your face or in truth a hole through which you would look at the said work. And if you should do this, then without any doubt your work will produce the effect of nature if the light and shade are correctly rendered, and you will hardly be able to convince yourself that these things are painted. Otherwise do not trouble yourself about representing anything, unless you take your view-point at a distance of at least twenty times the maximum width and height of the thing that you represent; and this will satisfy every beholder who places himself in front of the work at any angle whatever.

If you wish to see a proof of this quickly, take a piece of a staff like a small column eight times as high as its width without plinth or capital, then measure off on a flat wall forty equal spaces which are in conformity with the spaces; they will make between them forty columns similar to your small column. Then let there be set up in front of the middle of these spaces, at a distance of four braccia from the wall, a thin band of iron, in the centre of which there is a small round hole of the size of a large pearl; place a light beside this hole so as to touch it, then go and place your column above each mark on the wall and draw the outline of the shadow, then shade it and observe it through the hole in the iron.

A 40 v.

In Vitolone there are eight hundred and five conclusions about perspective.

B 58 r.

Perspective

No visible body can be comprehended and well judged by human eyes, except by the difference of the background where the extremities of this body terminate and are bounded, and so far as its contour lines are concerned no object will seem to be separated from this background. The moon, although far distant from the body of the sun, when by reason of eclipses it finds itself

between our eyes and the sun, having the sun for its background will seem to human eyes to be joined and attached to it.

<div align="right">c 23 r.</div>

[...]
A dark object seen against a light background will seem smaller than it is.

A light object will appear greater in size when it is seen against a background that is darker in colour.

<div align="right">i 18 r.</div>

If the eye be in the middle of a course with two horses running to their goal along parallel tracks, it will seem to it that they are running to meet one another.

This that has been stated occurs because the images of the horses which impress themselves upon the eye are moving towards the centre of the surface of the pupil of the eye.

<div align="right">k 120 [40] v.</div>

Painting

Foreshorten, on the summits and sides of the hills, the outlines of the estates and their divisions; and, as regards the things turned towards you, make them in their true shape.

<div align="right">L 21 r.</div>

Among things of equal velocity, that will appear of slower movement which is more remote from the eye.

Therefore that will appear swifter which is nearer to the eye.

<div align="right">B.M. 134 v.</div>

[*Aerial perspective*]
In the morning the mist is thicker up above than in the lower parts because the sun draws it upwards; so with high buildings the summit will be invisible although it is at the same distance as the base. And this is why the sky seems darker up above and towards the horizon, and does not approximate to blue but is all the colour of smoke and dust.

The atmosphere when impregnated with mist is altogether devoid of blueness and merely seems to be the colour of the clouds, which turn white when

it is fine weather. And the more you turn to the west the darker you will find it to be, and the brighter and clearer towards the east. And the verdure of the countryside will assume a bluish hue in the half-mist but will turn black when the mist is thicker.

Buildings which face the west only show their illuminated side, the rest the mist hides.

When the sun rises and drives away the mists, and the hills begin to grow distinct on the side from which the mists are departing, they become blue and seem to put forth smoke in the direction of the mists that are flying away, and the buildings reveal their lights and shadows; and where the mist is less dense they show only their lights, and where it is more dense nothing at all. Then it is that the movement of the mist causes it to pass horizontally and so its edges are scarcely perceptible against the blue of the atmosphere, and against the ground it will seem almost like dust rising.

In proportion as the atmosphere is more dense the buildings in a city and the tress in landscapes will seem more infrequent, for only the most prominent and the largest will be visible.

And the mountains will seem few in number, for only those will be seen which are farthest apart from each other, since at such distances the increase in the density creates a brightness so pervading that the darkness of the hills is divided, and quite disappears towards their summits. In the small adjacent hills it cannot find such foothold, and therefore they are less visible and least of all at their bases.

Darkness steeps everything with its hue, and the more an object is divided from darkness the more it shows its true and natural colour.

B.M. 169 r.

Equal things equally distant from the eye will be judged to be of equal size by this eye.

Of Perspective

The shaded and the illuminated parts of opaque bodies will be in the same proportion of brightness and darkness as are those of their objects [that is of the body or bodies which project upon them].

Forster II 5 r.

Of Perspective

Of things of equal size that which is farther away from the eye will appear of less bulk.

Forster II 15 v.

Sculpture

1.3.1

Posthumous inventory of Tournai sculptor Colart le Cat[1]

Colart le Cat was primarily a so-called 'graveur de lames', that is, a sculptor who produced incised stone grave slabs, a Tournai speciality, but the inventory made on his death also refers to several carved chimney pieces, some in the distinctive black limestone dubbed Tournai 'marble' for which the city was renowned. Colart lived on the 'quai Taille Pierres' ('the quay [where] stones are carved'), on the bank of the river Escaut, where stone was unloaded from the quarries further south and where many sculptors lived and worked. Some of the sculptures, for which payment was outstanding, had perhaps been subcontracted. Sculptor Riflart Lanier was owed money for making a funerary slab in memory of Colart le Cat – an indication of his status – for the pavement of St Catherine's, Tournai. Some of Colart's contacts, such as the sculptor Pierre Tuscap,[2] occur in other Tournai documents or works. Ernoul Prindale might conceivably have been a relative of Jan van Prindale, who worked with Claus Sluter for Duke Philip the Bold of Burgundy at the Chartreuse de Champmol.[3] [KWW]

Source: E. J. Soil de Moriamé (1912), *Les anciennes industries d'art tournaisiennes à l'exposition de 1911* (Tournai), pp. 24–6. Translated from the French by Isabelle Dolezalek. Copyright © The Open University 2007.

Inventory:

Several *ostieux* (tools)

7 alabaster stones, 2 sous.

One stone from Dinant (?), 2 s.

Material for a crucifix for Jehan Hacart the lame (intended for the church of Saint Piat).

[1] See also L. Nys (1993), *La Pierre de Tournai: son exploitation et son usage aux XIIIe, XIVe et XVe siècles* (Tournai), pp. 257–8.

[2] See Nys 1993, doc. 48, p. 400.

[3] For Prindale, see K. Morand (1991), *Claus Sluter, Artist at the Court of Burgundy* (London), ch. 2.

One stone, 9 feet long and 5 feet wide. 100 s.

One stone, 8 feet long and 4 feet wide. 60 s.

One small stone . . . 10 s.

Several bits of *noghes* (gutter), *becqueteaux* [pickaxes] and paving stone.

26 white stones, small and large.

Two alabaster stones, 8 livres.

One stone to complete an upright tombstone, 12 lb.

One fireplace in its present state unfinished, of black stone, with three *vousseaux* (arches and keystones?) and three niches, 3 lb.

One other smaller fireplace, black. 25 s.

– several stonemason tools – several chisels and burins.

Debts:

Item that the deceased, when still alive, had conceded to Pierart de Harlebeque to make a relief, which was still in the said workshop . . .

To Master Simon, stonemason and master craftsman at the church of Saint Martin in Courtrai, for 170 square feet of white stones, which he bought . . . 29 lb. 19 s.

(Payment of salaries): to Henry Espinnaich, stonecarver; to Rogier de Calonne for merchandise . . .

To Willeme Tahon, engraver and tombstone sculptor, for a day's work in his above mentioned profession. . . . 3 s. 5 d.

To Jehan de Rosteleu (for a journey to Anor and another one to Lille).

To Jehan Durant the younger, sculptor . . .

To Piéret Tuscap, for having worked four days in the city of Mons in Hainaut. 18 s. 10 d.

To the same Piéret for having completed a relief, which was for Jaspar from the mill of Chièvre . . . 66 s. 10 d.

To Riflart Lanier for having sculpted and engraved the tomb slab of the said deceased, laid down in the church of Saint Catherine 4 lb. 8 s. 2 d.

To Ernoul Prindale, 24 s. 8 d.

To Eloy le Monnier, 8 s. 9 d.

To the stonemason's guild of the said city in which the said deceased had (been) received during his lifetime, to the said guild 4 lb.

To Alardin du Moret for the money he had lent to the deceased 14 s.

To Henri Lecocq as a salary for having completed a relief, which Piérart de Harlebeque had commissioned from the said deceased, 11 lb. 7 d.

(Money received): from Piètre Fauquiel, resident in Bruges, for three tomb slabs, which the deceased (Colart Lecat) had sold to him while still alive. 10 lb 11 s. 9 d.

From the monks of the church and abbey of Saint Martin of Tournay, for a stone slab sold to them for Dom Robert du Busquiel, formerly elected abbot of the said church. 4 lb. 12 s. 2 d.

From Jehan du Gardin for a tomb slab which was already partly engraved. 9 lb 17 s.

From Jehan Maire, resident in Ghent, for a small stone sold to him. 24 s. 1 d.

From Willaume Danelaere, treasurer of the city of Tournai, for the commencement of a fireplace in two styles, which belongs to the said city, which was in the workshop of the said deceased. 50 s.

1.3.2
Michelozzo and Donatello are contracted to make the Prato Pulpit

On 14 July 1428 a contract was drawn up between Michelozzo (1396–1472) and Donatello (c.1386–1466) and representatives of the committee of works for the chapel of the Sacred Girdle within Prato Cathedral. By tradition, the girdle of the Virgin Mary was thrown down to the doubting apostle St Thomas as proof of her miraculous ascension into heaven, an event he had not witnessed personally. A high-status commission was placed by the commune of the city of Prato, of which the three officials from the committee of works named in the contract were representatives, for an external pulpit for Prato Cathedral, designed for the public display of a relic reputed to be this girdle. Donatello and Michelozzo were evidently working in partnership, and had already made a model of the projected pulpit for the benefit of their patrons. Although the initial contract mentioned only Donatello and Michelozzo, in practice they were liberally assisted by Pagno di Lapo Portigniani and other workshop members. The contractual plan to decorate the pulpit itself with six panels of angels bearing the arms of Prato was later modified and became seven panels of dancing putti set against a gold mosaic background along the lines of the 'cantoria', or singing gallery, for Florence Cathedral, which Dontatello was also working on in the 1430s. Likewise a bronze capital, only half of which was ever cast, was substituted for two little angels specified in the contract to be placed on the cornice to give the illusion that they were holding up the pulpit. [KWW]

Source: D. S. Chambers (1970), *Patrons and Artists in the Italian Renaissance* (London: Macmillan), pp. 63–5. Reprinted by permission of Palgrave Macmillan.

In the name of god, amen 14 July 1428[1]

Be it manifest to whoever shall read the present writing that on the said day the wise and prudent men Ser Lapo, son of Messer Guido de' Migliorati, Niccolò di Piero Benuzzi and Paolo di Donato, all of Prato and *operaii* on behalf of the commune of Prato of the Chapel of the Glorious Virgin Mary in the principal church of Prato, in the absence of their fellow Leonardo di Tato, and together with [names of representatives of the several quarters of Prato], deputed by the praiseworthy office of the Eight Defenders of the *Popolo* and Standardbearers of Justice, taking council with a good number of men of Prato, ordained and commissioned all the below-written matters, as appears publicly written in the book of decrees of the said Signoria of the Eight by the hand of Ser Iacopo da Colle, chancellor of the commune, under the twelfth of the said month.

All have agreed to commission on behalf and in the name of the said Opera and the commune of Prato the making and erection of the pulpit on the wall at the side of the church at Prato, where the precious girdle of the Glorious Virgin Mary is displayed. They commission both the industrious masters Donato di Niccolò di Betto [Donatello] of the parish of S. Cristofano del Corso and Michele di Bartolomeo di Gherardo [Michelozzo] of the parish of San Marco, Florence, masters of sculpture, but especially the said Michele, in his own presence acting also on behalf of the said Donato, according to the following agreements:

First, that they must alter the rectangular pilaster on the new façade into a fluted pilaster, in such a way that it is a suitable base for the pulpit.

Further, they must make the pulpit according to the form of the model they have left in the sacristy of the chapel, all in white Carrara marble and of the measurements mentioned below:

The pulpit should start $5^1/_4$ *braccia* above the ground, upon a cornice on which there are two little angels instead of brackets, each 2 *braccia* tall, and adorned with foliage as shown on the model. And above them a heavy cornice with carved dentils, and above this cornice a projecting ledge carved with

[1] See also R. W. Lightbown (1980), *Donatello & Michelozzo: An Artistic Partnership and its Patrons in the Early Renaissance* (London: Miller), 1980, vol. 1, pp. 23–55.

leaves and profiles. And the base of the pulpit is to rest on this. And on this ledge there may be foliage or whatever the commissioners *operaii* please. And above this base shall be the rounded parapet of the pulpit, as the said model shows, divided into six spaces in which little angels are to be carved, holding between them the arms of the commune of Prato, or something else as the commissioners *operaii* of the work may please. This parapet shall be 5.2/3 *braccia* round the base. The diameter [floor] on the outside shall be adorned with columns and cornices for sills as the model shows.

And the said masters are obliged to give the form and manner to be followed for the work on the front of the church, above the base of the pulpit and provide the master craftsmen of their choice, all at the expense of the said Opera;[2] similarly chalk, ironwork and anything else needed for the work on the wall is to be at no cost to them, and whatever quantity of marble at present in the possession of the Opera . . . which they want.

And the said Michele promises on their joint behalf that the work will be accomplished by 1 September 1429, well and diligently done all at their own expense and according to the judgement of a good master. And as their reward and payment they ought to have of the goods of the Opera whatever sum in florins and *denari* as shall be named at the discretion and judgement of the famous Doctor of Medicine, Maestro Lorenzo d'Agniolo Sassi of Prato, Florentine citizen, to whom the said parties mutually agree . . . to commit the decision. And should he be unable to do so in the given time, or die . . . it will be remitted to the prudent ser Lionardo di ser Stefano di Macteo di Francho, notary and Florentine citizen.

And so that a start can be made, the said masters must be paid 350 florins, at the rate of 4 *lire* to the florin, in instalments as follows: 50 florins on 30 August next, and for each of the months of October and January next 50 florins, for the following April 100 florins, for July 1429 50 florins, and for the whole of September 1429, 50 florins . . . ,

[2] This appears to mean that the authorities should be forewarned of modifications to the façade that the installation of the pulpit would entail. Lightbown translates the passage: 'And as for that which may need to be done to the façade from the floor of the said pulpit to above, the said masters shall be held and obliged to give the form and the method of carrying it out and putting it in and to employ on it those masters that shall seem proper to them at the expense of the said Opera . . .' (Lightbown 1980: 223).

1.3.3

Report on Donatello's progress on the Prato pulpit

On 19 June 1434, the musical instrument maker, Matteo degli Organi, wrote to the committee of works in Prato reporting on Donatello's progress in producing the carved reliefs for the pulpit.

Despite the deadline of 14 months specified in the initial contract, the first delivery of any components of the pulpit was not until December 1429. Donatello's endless prevarications prompted the drawing up of a new contract for the pulpit reliefs in May 1434. The completion of the first of these shortly afterwards deeply impressed Prato representative Matteo degli Organi, and he clearly saw Donatello's abilities as something out of the ordinary. The pulpit was completed only in September 1438, however, and in desperation the Prato authorities resorted to employing other craftsmen to complete and install the pulpit framework. [KWW]

Source: D. S. Chambers (1970), *Patrons and Artists in the Italian Renaissance* (London: Macmillan), p. 66. Reprinted by permission of Palgrave Macmillan.

To the worthy Operaii of the Chapel of Our Lady in Prato

Most dear Sirs
The cause of this letter is that Donatello has finished that story in marble, and I promise you that I know all the experts in this town are saying with the same breath that never has such a story been seen. And it seems to me that he has a good mind to serve you well, he wants us to know it now he is so well disposed; indeed, one does not come across these masters every day. He begs me to write to you for God's sake not to omit to send him some money to spend during this [St John's] holiday, and I charge you to do so; moreover, he is the kind of man for whom enough is as good as a feast, and he is content with anything. So that if the Opera must quieten him by usury, he wants the money to keep himself true to the purpose as he has begun, and no wrong will be done to us.

> In Florence, 19 June 1434
> Mactheo degli Orghani

1.3.4

The Brussels painters' guild claims exclusive rights to market painted works of art

This edict is about certain individuals who were not members of the painters' guild, whether craftsmen or perhaps even dealers, marketing and undertaking contracts for painted works of art in defiance of guild regulations and artistic standards. It shows that art was already being sold ready-made at this early date, whether at local markets or further afield at seasonal fairs. However, it was the fraudulent contracts, perhaps won from potential patrons attending the markets, that really enraged the guild, suggesting that at this date commissioned work remained more important. In this struggle for the sole right to market painted goods, the painters were fulfilling important functions of a guild: ensuring quality control, safeguarding the reputation of the guild, and protecting the rights of a craftsman against unlawful competition. But in gaining control over the contracting and marketing of polychromed sculpture, they encroached on the privileges of the sculptors' guild. The equal right of both painters and sculptors to accept contracts for polychromed sculpture was quickly reasserted, but sculptors were granted the right to get their work polychromed for sale only if it remained unsold for more than a month. An edict of 1454 and a second in 1455 also introduced a system of inspection of works of art by the guilds, and craftsmen's hallmarks were applied as guarantees of quality. [KWW]

Source: H. Nieuwdorp (1981), 'De oorspronkelijke betekenis en interpretatie van de keurmerken op Brabantse retabels en beeldsnijwerk', in *Archivum Artis Lovaniense, Bijdragen tot de Geschiedenis van de Kunst der Nederlanden. Opgedragen aan Prof. E. Dr K. J. Steppe* (Leuven: Uitgeverij Peeters), p. 93. Translated from the Dutch by Rembrandt Duits. Copyright © The Open University 2007. Reprinted by permission of Uitgeverij Peeters.

Brussels, 20 June 1453

... Item it has occurred recently, in Brussels and its surroundings, that various people, who do not belong to the guild, who were never trained in

the craft and do not understand it, and who are not able to distinguish between a good job and a bad illegal one, have ventured to accept commissions[1] for the production of altarpieces and other works by demand of churches in the city and its surroundings regardless. They also do[2] other jobs pertaining to the guild, and present their work on the market as if they were masters of the craft. And at this they are so daring and cunning that they often con good but naive people with slick talk into believing that they can produce work of any size and quality required. They then accept commissions, and produce the works[3] on bad wood that is not durable, so that the churches and the good people who commissioned these works are badly deceived. The guild, which has hitherto enjoyed a favourable reputation at home and abroad, on the markets and elsewhere, is thus brought into serious disrepute, and the innocent members of the guild frequently suffer damage, embarrassment and harm in their good and rightful enterprise. Therefore, now that this scam has become detrimental for the guild, and in particular to protect and warn all those who are customers of the craft, both the sworn elders and good apprentices[4] of the guild have been given the following rights. Namely, that no citizen or inhabitant of the city who does not belong to the guild will be allowed to accept commissions for any work pertaining to the guild for sale or for presentation on the market like the masters of the guild, on penalty of confiscation and a fine, for each offence that is truthfully established, of 20 shillings old style, confiscation to be pursued in all appropriate cases and fines to be imposed as described above. With the exception that everybody is free to buy and sell card games, drawings, coloured woodcuts and other small items as they have done before, without suspicion.

[Brussels, City Archive, Register 1447, fol. L.]

[1] The use of the word 'comenscapen' here might also have connotations of dealing.
[2] or 'have done'.
[3] or 'have these works made'.
[4] or journeymen ('knapen').

1.3.5

Extracts from *De Statua* by Leon Battista Alberti

Alberti (1404–72) wrote to the scholarly Giovanni Andrea de' Bussi, Bishop of Aleria (1417–75), asking his opinion of *De Statua* (*On Sculpture*). This suggests that the treatise was complete some time between 1466, when de' Bussi became bishop, and Alberti's own death in 1472, but some suggest it was in fact written much earlier in the 1440s.[1] Alberti's main aim seems to have been to suggest rational rules and methods for the making of sculpture, and to this end he devised instruments for taking accurate measurements and recording precisely the pose of a figure, whether live or from an existing sculpture. He also included a long list of ideal measurements for the human body, designed to inculcate 'correct' proportions. [KWW]

Source: Leon Battista Alberti (1972), *On Painting and Sculpture: The Latin Texts of 'De Pictura' and 'De Statua'*, ed. and trans. C. Grayson (London: Phaidon), pp. 122–5, 129. © 1972 by Phaidon Press Limited.

I ask you: shall carpenters have set-square, plumb-line, level and circle, with whose direction and guidance they can easily make the angles, and straight and even lines and surfaces, that define and finish their work with complete accuracy, while on the other hand the sculptor is expected to execute his excellent and admirable works by rule of thumb rather than with the constant and reliable guide of rational principle? For my part I believe that every art and discipline contains by nature certain principles and procedures, and whoever applies himself to recognizing and learning them may perfectly accomplish whatever he sets out to do. For just as in a tree-trunk or clod of earth Nature's suggestions made men feel it possible to create something similar to her products, so in Nature herself there lies to hand something which provides you with a method and certain, exact means whereby you may with application achieve the highest excellence in this art. I will now explain what the convenient and

[1] See, for example, G. Wolf (2000), 'The Body and Antiquity in Alberti's Art Theoretical Writings', in A. Payne, A. Kuttner and R. Smick (2000), *Antiquity and its Interpreters* (Cambridge: Cambridge University Press), p. 174.

necessary means are that Nature offers to sculptors to execute their work perfectly.

Since sculptors pursue likenesses, I must start by discussing likeness. Here I might enquire into the nature of similitude and ask how it is that Nature, as we see, is accustomed to observe in any creature that each is like the rest of its kind; and yet, on the other hand, they say, no voice or nose or similar part resembles any other among all the rest of the people. At the same time, the faces of those we have seen as boys we later recognized as adolescents, and those seen as young men you recognize even now they are old, although with age their features have changed a good deal. So that we can say that there are certain things in the forms of bodies which vary with time, while there is something else deeply embedded and inborn which remains always constant and unchangeable in relation to the species. It would take us a long time and probably far out of our way to pursue these matters here; so we will leave other considerations on one side and attend briefly only to what is relevant to the exposition we began.

If I am not mistaken, the sculptors' art of achieving likeness is directed to two ends: one is that the image he makes should resemble this particular creature, say a man. They are not concerned to represent the portrait of Socrates or Plato or some known person, believing they have done enough if they have succeeded in making their work like a man, albeit a completely unknown one. The other end is the one pursued by those who strive to represent and imitate not simply a man, but the face and entire appearance of the body of one particular man, say Caesar or Cato in this attitude and this dress, either seated or speaking in court, or some other known person. To these two ends, to put the matter briefly, there are two things that correspond: *dimensio* and *finitio*. I must therefore speak of these, explain what they are and how they may be used to complete one's work; but first I will set out the advantages they offer, for they have amazing and almost unbelievable powers. The man who possesses them can so record the outlines and the position and arrangement of the parts of any given body in accurate and absolutely reliable written forms that not merely a day later, but even after a whole cycle of the heavens, he can again at will situate and arrange that same body in that very same place in such a way that no part of it, not even the smallest, is not placed exactly in space where it originally stood. For example, if you are pointing with your finger at the rising planet Mercury or at the new moon just appearing, and you wish to record the position of the ring on your finger or the angle of your elbow or such like, you could do it with our instruments so that there would not be the slightest error nor any doubt that this is the way things are. And supposing I covered a statue by Phidias with clay or wax so that it became

a thick column, you would then be able to say, with the help and guidance of the means I speak of, that if you drill at such and such a height you will there arrive without damage at the pupil of the eye, and at another point the navel or the knee, and so on for all the parts; such will be your complete certainty about the lines and angles and the distances and relations between them. Furthermore, from any given example you will be able to record, not only by drawing but also in words and figures, the direction of the lines, the extent of the surfaces and position of the parts, so that you will have no doubt of your ability to make something like it of the same size or smaller or a hundred cubits large, or even, I would say, as big as Mount Caucasus, provided the material we use were sufficient for such an enormous undertaking. What is more amazing is that, if you liked, you could hew out and make half the statue on the island of Paros and the other half in the Lunigiana, in such a way that the joints and connecting points of all the parts will fit together to make the complete figure and correspond to the models used. You will find the knowledge of these things and the method of using them so easy, clear, accurate and convenient, that it would be difficult for anyone to go wrong, unless they deliberately refused to follow them. Yet I would not go so far as to say it is possible for us by this method to imitate or master completely all the similarities and dissimilarities of bodies. I would say it is not within the power of our art or abilities to explain in detail how you might represent the exact likeness of the face of Hercules in combat with Antaeus, or in what ways it differs from the face of Hercules at rest and smiling at Deianira. But as in all bodies different forms result from changes in the bending and stretching of limbs and the position of the parts, and the lines of the body vary in a man if he is standing, sitting, lying down or leaning over, we must treat of the means which enable us to portray these things with constant method; and, as I have said, these are two: *dimensio and finitio.* [. . .]

Dimensio is the accurate and constant recording of measurements, whereby the state and correspondence of the parts is observed and numerically represented, one in relation to another and each to the whole length of the body [. . .]

Finitio is the means whereby we record with sure and accurate method the extensions and curves of lines, and the size and shape and position of all angles, protuberances and recesses. It is called *finitio* because it registers and describes the length and extremities of all lines produced from a perpendicular dropped through a fixed centre to the outermost parts of the body.

1.3.6
1470 regulations of the Antwerp Guild of St Luke

Unlike Brussels, where sculptors and painters belonged to separate guilds, in Antwerp painters and wood carvers were all members of the Guild of St Luke, though stone carvers belonged to the mason's guild. Although dating back to the end of the fourteenth century, the Guild of St Luke increased in importance in the second half of the fifteenth century with the meteoric rise of Antwerp as a commercial and financial centre, and with the foundation in 1460 of the so-called Antwerp 'Pand', a specialist art market functioning during the twice-yearly fairs. The 1470 regulations testify to the burgeoning production of carved and polychromed altarpieces, specifying the type, quality and thickness of wood used, and the procedure for polychromy and gilding. Two hallmarks were introduced: an incised hand certifying the quality of the carving, and the Antwerp castle certifying the quality of the polychromy. While the Brussels guild attempted to safeguard reputations and standards through regulating sales, in Antwerp it was the regulation of production methods that was targeted. [KWW]

Source: J. B. van der Straelen (1855), *Jaerbock der vermaerde en Kunstryke Gilde van Sint Lucas binnen de Stad Antwerpen* (Antwerp), pp. 13–16. Translated from the Dutch by Ria de Boodt, Kim W. Woods and Rembrandt Duits. Copyright © The Open University 2007. Reprinted by permission of Uitgeverij Peeters.

1. That is to say that from now on everyone who wants to enter the guild mentioned above will have to pay an entrance fee of 5 golden Rhenish guilders. Of this Our Lady's church mentioned above will get one Rhenish guilder, as declared in the old act mentioned above. And the guild mentioned above will get the other 4 Rhenish guilders for the benefit of her expenses.

2. Also each journeyman who works with a master has to pay 9 gr. *Brabants* [9 stivers or pennies, called *Brabants*] candle money every year. And all other items in the previous old document are still to be applied, as has been declared and understood.

3. Also what has been decided concerning the altarpieces and other smaller or lesser works mentioned above are described in the statutes and articles hereafter.

4. First that all altarpiece cases of less than 8 feet have to be made of dry wainscot[1] or oak wood without faults or deficiencies.[2] Also the boards of the back of the case have to measure a third of an inch at the thickest side where the rabbet is to be found. At the thinnest side they should be half as thick and the rabbet filled with the same wood. Also the panels of the shutters should be a third of an inch thick.

5. Also for an altarpiece above 8 feet the back has to be half an inch at the rabbet side. Also at the thinnest side a thickness of half that much. Also the panels of the shutters a thickness of a third of an inch.

6. Also every wood that will be used in the altarpiece has to be wainscot oak or walnut without faults or deficiencies, and of healthy wood.[3]

7. Also to all images and tabernacles the ordinances described below have to be applied, that is to say all works made to be sold, unless the customers[4] want it otherwise.

8. Also moreover the painter will not paint images or altarpieces unless the wood has dried sufficiently and has been appraised by the guild officials. Unless someone wants to complete a work in haste, then he is allowed to do so, but the guild officials must first judge whether it is sound.

9. Also no painter will polychrome an altarpiece when there is frost, that is to say when it freezes, unless he has a heated room where the frost does not harm and informs the officials about it. And also no plaster or [chalk] ground to be made unless it is properly ground with a stone as it ought to be.

10. Also one shall not incorporate partial gold [false gold or copper] with fine gold.

11. Also one shall not incorporate silver with fine burnished gold or gold that will be varnished or glazed with colour.[5]

[1] Wainscot here signifies high quality oak boards usually imported from the Baltic; wainscot does not mean panelling at this date and in this context.

[2] The word *fri* is not found in old Dutch dictionaries so may be a transcription error, perhaps for *fu* (*fi*), which may be translated shame or blame; the sense of the passage is clear, however – that the wood should be without fault.

[3] The sense is clear but the precise meaning of the original is obscure: 'dat nyet en slaept ende den rooden ollem nyet en heeft'.

[4] 'Goede liede', literally good people.

[5] Original Dutch 'van wermen', possibly 'verwen' mistranscribed? The statute seems to concern gilding glazed with colour for sgraffito work; there is no other obvious reason to glaze or varnish gold.

12. Also one shall not incorporate [tin] foil or leaf with fine gold, unless it is stamped, in-filled with cement and covered with gold colour or priming coat.[6]

13. Also all [tin]foil or leaf will be gilded with fine gold except for white foil.

14. Also one shall not gild with matte gold unless the ground is primed and on top of that the gold colour is applied and then gilded.[7]

15. Also in order to paint the faces, the hands and everything that is included with them, a priming coat[8] must first be applied.

16. Also one shall not frame[9] altarpieces or tabernacles except with wainscot painted with colours or gilded.

17. Also every ornament on altarpieces or tabernacles that is made of tin or lead shall be gilded or painted with gold colour.

18. Also every work that is worth more than one pound *Brabants* has to follow the prescribed rules unless the customers want it otherwise.

19. Also we next have consented and ordained that the masters of the aforementioned guild will have the described pieces appraised, that is to say altarpieces each of 9 gr. *Brabants* in value. And those inspectors will first apply a hallmark, a hand, on the work when it is still bare wood, and when it has been painted, the city arms, that is to say the castle, so that the merchant may know that both have been appraised.

20. And that everyone of the aforementioned *nation* [corporation, corporate body] shall abide by those statutes and ordonnances and maintain them. And if one of them does something to the contrary, for each item on which he is found negligent, as a punishment he forfeits one golden Rhenish guilder, as much and as many times as it happens, the third part for the Lord, the third part for the city and the third part for the aforementioned guild, but for altarpieces the fine and confiscation is increased to 2 golden Rhenish guilders to be spent as above.

[6] 'Pourmuersel'. This statute is particularly difficult to translate but appears to deal with the practice of creating brocade effects using embossed tin, infilled to maintain the pattern and then gilded (called press brocade).

[7] Another difficult statute to translate, this appears to deal with oil gilding; the two-stage gilding process described here remains difficult to understand, however.

[8] 'Gedootverwet' – the so-called 'deadcolour' used to underpaint flesh tones.

[9] The meaning of 'voederen' is obscure; since the more common meaning of 'to line' makes little sense in this context it is possible that here it signifies 'to frame'.

1.3.7

Utrecht sculptor Adriaen van Wesel makes a carved altarpiece for the Confraternity of Our Lady, 's-Hertogenbosch

The existing altarpiece of the Confraternity of Our Lady, 's-Hertogenbosch, had been damaged by fire in 1463, and the process of acquiring a new one is unusually well documented in the account book of the confraternity. Initially a replacement was sought in Antwerp, which together with Brussels was already a famous centre for the production of carved altarpieces, but it was the Utrecht sculptor Adriaen van Wesel (active from 1447, d. 1489) who was finally approached for the job. No contract survives, but the details of the design and how the altarpiece should be made were evidently decided upon during a discussion in an inn between the carver and members of the confraternity. These included the painter Anthonis, father of Hieronymus Bosch, who was presumably one of the sons mentioned as also present. Two small carved subsidiary shutters survive to this day along with several fragments. It seems that the altarpiece had two sets of shutters, one carved, and the outer set, supplied in 1488–9, painted. Bosch painted two Old Testament scenes on the outer shutters at an unknown date, perhaps as a gift, for no payment for them is recorded in the accounts. The altarpiece was not polychromed until 1508. [KWW]

Source: W. Halsema-Kubes, G. Lemmens and G. de Werd (1980), *Adriaen van Wesel, een Utrechtse beeldhouwer uit de late middeleeuwen* (The Hague: Staatsuitgeverij (exhibition catalogue)), pp. 57–9. Translated from the Dutch by Rembrandt Duits. Copyright © The Open University 2007. Reprinted by permission of Rijksmuseum, Amsterdam.

Accounts of the Brotherhood of Our Lady, 's-Hertogenbosch (1475–6)

[*Preparations for the commission of a new altarpiece for the chapel of the Brotherhood.*]

f.207v Item a panel was inspected in Antwerp, to decide whether we wanted to have a similar one made; the man was treated to a drink 1 shilling 8.5 pence

f.208 Item Gerrit van Kamyck visited Master Adriaen van Wesel, the sculptor, in Utrecht, to invite him to come to 's-Hertogenbosch to negotiate about the new altarpiece of Our Lady; for his labour he was given 7 shillings

[*The Elders of the Brotherhood sign a contract with Adriaen van Wesel and discuss the plans for the altarpiece with him.*]

Item the Elders, some members of the Brotherhood, Anthonis the painter, his sons, and Master Adriaen the sculptor convened at the inn of Jan Maess to discuss and arrange the design and execution of the altarpiece;
for their consumptions at that time 25 shillings 11 pence

Item the above-mentioned Elders, the same master, and some members of the Brotherhood, after having established the design, stayed together at Jan Maess, and consumed 4 quarters of wine at 24 pence a quarter, which, with an additional 1.5 shillings for Master Adriaen's meal the other day, adds up to 13 shillings 8.5 pence

f.208v Item Melis van Boechem and the Elder, Marten van Elmpt, travelled to Master Adriaen van Wesel in Utrecht with the design for the altarpiece, to discuss the altarpiece and sign the contract for it, and they brought back with them a number of candles they ordered in Gorcum, Utrecht, Amersfoort, and Amsterdam; they spent, including the cost of the candles
 3 Rhine guilders 7 shillings 3 pence

The same Master Adriaen has accepted the commission for the altarpiece, to be delivered on the feast day of St Bavo [1 October] in the year 1477, for 350 Rhine guilders; Marten and Melis, at the time of their visit, have given him an advance of 50 Rhine guilders on this sum, which these Elders took from the money in the treasury of Our Lady;
so these 50 Rhine guilders are not accounted for here

Accounts of the Brotherhood of Our Lady, 's-Hertogenbosh (1476–7)

[*The Elders of the Brotherhood go to Utrecht to enquire about the progress of the work.*]

f.259 Item the above-mentioned Elders, together with Master Gerrit Simonsz and Melis van Boechem, travelled to Utrecht to inspect the progress of the new altarpiece on which the master was hard at work, to see whether he was doing a good job or not. And from there they went on to The Hague 8 Rhine guilders 1.5 shillings

Item the servants [or journeymen][1] of master Adriaen, the craftsman of our altarpiece in Utrecht, were given money for consumptions 24 shillings

Accounts of the Brotherhood of Our Lady, 's-Hertogenbosch (1477–8)

[*A servant of Adriaen van Wesel's comes from Utrecht with the message that the altarpiece has been completed.*]

f.265v Item master Adriaen's journeyman[2] was sent to 's-Hertogenbosch with a letter to the Elders saying that the altarpiece has been completed and they should come and collect it; for his expenses 10 shillings

[*The Elders of the Brotherhood rent a ship and go to Utrecht to collect the altarpiece.*]

f.265 Item a ship with a covered hold was rented to collect the new altarpiece completed in accordance with contractual conditions in Utrecht;
for the sum of 2 Rhine guilders 10 shillings

f.265v Item the above-mentioned Elders travelled to Utrecht to collect the above-mentioned altarpiece and had to wait in the ship at Utrecht for three days for lack of wind, and they also had travel expenses going there and coming back 2 Rhine guilders 16 shillings

Item 7 or 8 men carried the altarpiece from the master's house to the ship

Item Master Adriaen's journeymen, his daughter, and the maids were given a tip of 1 guilder of Aerdenhout[?] and 1 guilder of Bavaria[?] 27 shillings

f.267 Item a ticket and a pass for passing the toll when they went to collect the altarpiece of Our Lady in Utrecht cost 2 shillings

[*The altarpiece is lifted from the ship with a crane in 's-Hertogenbosch and brought to the chapel, where preparations for its installation had been made.*]

f.265v Item the altarpiece was hoisted up by crane in 's-Hertogenbosch; Mattheus inden Beer was given a crane-operating fee of 12 shillings

[1] The Dutch word 'knecht' was one of the terms used to describe journeymen during the fifteenth century.

[2] The Dutch term 'cnapen' or 'knapen' is one of the fifteenth-century terms for journeymen.

Item 12 labourers carried the altarpiece from the crane to the church and had to wait for a while; the beer they drank, together with their pay, amounted to 18 shillings 9 pence

Item Jan van der Aa the carpenter, together with his assistants, raised the altarpiece onto the altar and installed it 12 shillings

Item two grave diggers from the [chapel] workshop also helped to raise the altarpiece 6 shillings 2 pence

Item Gillis the craftsman from the [chapel] workshop has toiled in our choir for all of 4 days to remove the irons from the wall

f.266 behind the altarpiece, to point the wall, and to do other jobs for the sake of setting up the altarpiece; he has been given as pay 12 shillings

[*Master Adriaen van Wesel, his wife and his assistants, are received by the Elders. His payment is discussed and the sculptor is awarded an extra sum as the altarpiece is larger or better executed than contractually agreed.*]

f.257 Item at Melis van Boechem's place, Master Adriaen van Wesel, who made our altarpiece, some members of his company, and some members of the Brotherhood who were also present were served with 11 quarters of wine at 23 pence a quarter, which adds up to 18 shillings 10 pence

f.257v Item in the house of Marten van Elmpt, Master Adriaen van Wesel, the master of the altarpiece, and some members of the brotherhood who were present to speak with him, were served with 4 quarters of the same wine, adding up to 6 shillings 11 pence

f.265v Item the Elders had a meal prepared by Wouter van Beerze to convene there with Master Adriaen, his wife, and his assistants, the Elders and some members of the Brotherhood; the Elders paid for food and drink, which amounted to 1 Rhine guilder 15 shillings

f.266 Item the above-mentioned Elders convened at the house of master Aert, the Elder, with some members of the Brotherhood, Master Adriaen, and his wife, to reach a settlement with the master on the surcharge he demanded for his work on the altarpiece on top of [the previously established price of] 350 Rhine guilders, for greatly improving the altarpiece compared to the first plans that were agreed upon; for food and wine

1 Rhine guilder 10 shillings

f.267 Item Master Adriaen van Wesel had agreed to make our altarpiece for 350 Rhine guilders, but having improved the work compared to the first plans that were agreed upon, his payment had to be augmented; Marten van Elmpt paid him 50 Rhine guilders of the initial sum some time last year, and the Elders paid Master Adriaen the remaining 300 Rhine guilders and another 36 Rhine guilders, which was an augmentation of his pay by permission of the Brotherhood and also a compensation for his expenses; these 386 Rhine guilders were taken from ready cash in the treasury of Our Lady;
they are therefore not accounted for here

[The Brotherhood sells the remnants of the preceding altarpiece, which was damaged by fire, to the convent of the nuns of St Gertrud in the Orthensestraat at 's-Hertogenbosch. Adriaen van Wesel gives advice.]

f.238 The Elders, on the suggestion of some members of the Brotherhood, and with the help and consent of Master Adriaen van Wesel, who made our new altarpiece etc., have sold some pieces and statues, which were part of the old altarpiece of Our Lady that was burnt, but had survived intact, and served no purpose for our Brotherhood, to the convent of the nuns of St Gertrud in the Orthensestraat, for the sum of 40 Rhine guilders. Of this sum, the elders have received one half; the other half will be paid next Christmas. The first half thus amounts to 20 Rhine guilders

Accounts of the Brotherhood of Our Lady, 's-Hertogenbosch (1478–9)

[A later account concerning expenses made on the delivery of the altarpiece.]

f.308 Item master Adriaen van Wesel, the master of our altarpiece, was served with wine on the feast day of the Holy Spirit last year 7 shillings

Architecture

1.4.1
Filarete's system of architecture

Antonio di Pietro Averlino (Filarete, c.1400–69) was a Florentine sculptor who established a career in Rome (creating the bronze doors for old St Peters) and then in Milan, where he served (1461–4) in the court of Francesco Sforza to whom he dedicated the first version of his manuscript treatise on architecture (1464). The form of Filarete's treatise was determined by the court culture of the time. In this piece, written as an ingratiating – but also flirtatious and occasionally disciplinarian – dialogue between architect and patron, Filarete placed himself in the role of educator as well as architect. The narrative of the treatise relates to the founding of a new city in imitation of an antique prototype. Filarete used the narrative to explain how architecture can signify different levels of value, both spiritual and material, through the appropriate use of proportion and decorative detail. Cicero and Renaissance humanists such as his friend, the scholar Francesco da Tolentino who called himself Filelfo, were important sources for Filarete's discussion of architectural detail. This in turn was linked with the idea of decorum – that a thing should be appropriate to its use, an appropriate discourse in a court where it was important to demonstrate difference of class and status in order to show off the ruler's power. Most significantly, Filarete adopted from Vitruvius the idea of architectural proportion based on human proportions, using the human head as the basis of all measurement. [TJB]

Source: Filarete (1965), *Treatise on Architecture*, trans. and ed. J. R. Spencer (New Haven and London: Yale University Press), vol. 1, pp. 6, 7, 94–5, 96, 97, 99, 102. Reprinted by permission of the publisher, Yale University Press.

As everyone knows, man was created by God; the body, the soul, the intellect, the mind, and everything was produced in perfection by Him. The body [was] organized and measured and all its members proportioned according to their qualities and measure. [. . .]

Since man is made with the measure stated above, he decided to take the measures, members, proportions, and qualities from himself and to adapt them to this method of building. In order that you can understand every part and its source, I will relate to you first of all the measures, members, and proportions of man. [. . .]

Since the large, small, and medium are universal in their proportions, from them we shall take the measure. I believe the ancients took it from them. We shall also take this rule as the best way and explain it part by part in such a way that I believe everyone will be able to understand it. Because we first have this measure from the Greeks – as they had it from Egypt and from others – we shall use their terms. Vitruvius also named them thus, so we shall follow their order, naming these measures, proportions, and qualities Doric, Ionic, and Corinthian, and explaining them as much as we can. Therefore, our first measures will be these – proportion and quality. For the present, we will leave the principal measures of man for another place.

I [will] speak of the three qualities. Their measures are these. The first, which we call Doric, that is, large, they measure with the head. It is nine heads. This quality is called Doric, that is, large. The small one is called Ionic and it is seven heads. The third is called common, or medium, that is, Corinthian, and is eight heads. The two other qualities we will let stand for the reason mentioned above. The origins of these measures [which explain] why the Greeks called them Doric, Ionic, and Corinthian, will be treated in another place. We have begun with the largest as is fitting. First of all, we will begin with the largest. Because it seems fitting that the large things should precede the smaller, we will begin with these. It is to be believed that the inventors of these things must have taken these measures, that is, quality, from the best-formed large men. It is probable that this quality was taken from the body of Adam, because it cannot be doubted that he was handsome and better proportioned than any other [man] who has ever lived, since God formed him. […]

'My lord, the origin of columns [is from the time] when the first habitations were made.[1] Necessity taught [man], when he first made a hut or arbor or whatever it was, to cut off a piece of wood that had two branches growing opposite each other. He trimmed off all the others and the two left made a fork. When four were made in this form and driven into the earth, he put

[1] Filarete's opinion on the origins of the column would seem to be his own, although his deductions could have been suggested by Vitruvius (4.2), where the wooden origins of Greek architecture are discussed.

His references to Callimachus as the inventor of a fluted column is probably due to a misreading of Vitruvius, who states that the Ionic order imitates the 'folds of matronly robes' (4.1.7). Since this is immediately followed by the Callimachus story, the confusion is understandable. The invention of the Corinthian capital derives from Vitruvius (4.1.8–10). The second variant for the origin of the Corinthian capital may be an oral tradition, as Filarete states, for I have not found a source for it.

four other pieces of wood across them [. . .] In this way the column began. This is my own opinion on the origin of the column. As time went on they became more polished and perfected. Measure, form, proportion, name, and derivations were given to these supports.

'In the first [book] we said that the building is derived and formed from man; so it is with the column. I will tell you first about its derivation and measure from the human form. As for the derivation that it takes from man, according to Vitruvius, the polished columns and [those] without other ornament are like a nude man. Those that are fluted were derived [from a woman] by Callimachus, the Athenian, according to the above-mentioned author. [This Callimachus] saw a young woman with a folded and pleated dress. She [was] very beautiful and pleasing to him. In a simile to her he folded a column, that is, he made it fluted. After him they continued to be made in this form.

'The form of the capital, that is the simile for the ornament, was discovered by this same Callimachus. The simile, according to the report of the above-named author, is this. When this young girl died, she was so loved by her nurse that the nurse brought food to her grave every day. One time she brought it and left it in a basket. It stayed there I do not know how many days. When Callimachus passed by he looked at it and saw that some sort of leaves and herbs were growing under this basket and attaching themselves up its sides. It seemed to him that this thing could be made into the form of a capital and placed on top of a column. Thus, they say, this form of ornament was invented. [. . .]

'You have understood the origins of all these parts of the column. Now you have to understand its measures, qualities, and forms. As I said before, the building is derived from man; as man has members so the edifice, too, has members. The column is not only a member of the building but is also a part of its nature, for many buildings cannot be constructed without the column. [. . .]

'The polished columns, according to Vitruvius, were derived from the nude man and the fluted from that well-dressed young woman, as we have said. Both are derived from the form of man. Since this is so, they take their qualities, form, and measure from man. The qualities, or better Ionic, Doric, and Corinthian, are three, that is, large, medium, and small forms. They should be formed, proportioned, and measured according to their quality. Since man is the measure of all, the column should be measured and proportioned according to his form. About quality and form: as has been said, there are three qualities and forms of men; so it is with columns, that is [they are] large,

small, and medium. The small should be like a man of seven heads. The columns are then seven capitals. The capital should be as tall as the diameter of the column. The diameter of the thickness: you should know how large the circumference of the column is; one-third of its circumference will be its diameter. Whether you want it thick or thin, this is its measure. [Now] understand clearly the medium kind. These, too, are like men of eight heads; according to this simile one can make the column eight capitals. The other quality is nine heads. These are of the largest quality, that is, these columns are nine capitals [tall].[2] Anyone who thinks about it will [see] it is exactly as I said. It is like lords who also need three kinds of persons in order to be lords, that is the upper, middle, and lower classes. You now know the quality and form of the column and how these types come from man. Now I want you to see the measures that are derived from man.

'The measure that the column should have: as man is measured by his head, so the column should be measured by its capital. You understood what I said [about] the diameter of the column, its measure and its capital. The capital is the head of the column. Vitruvius calls it epistyle; he uses these ancient words. I do not want to use them, because they are difficult and no longer current. I will tell you rather the names that are in use today.'[3] [. . .]

'As I have said, they are like the many qualities of men, for example gentlemen who remain with a lord as support and ornament. The middle [class] are also useful and an adornment, but they are not so decorative as the gentlemen. The lowest [order] are for the utility and requirements of the lord and are in his service, but they do not have the beautiful appearance of the other two superior [ones]. I will explain the others as they occur. Columns have within

[2] The column proportions listed here and above are not in agreement with the ones accepted by tradition. The meaning is further complicated by Filarete's apparent reference to the Ionic as 'large' or nine capitals tall here and as small or seven capitals above. The remaining orders participate in the confusion. One must assume that Filarete's knowledge was either quite limited in this area or that he was not particularly careful in the composition of this passage. A comparison of proportions between Filarete, Alberti, and Vitruvius can be arranged in tabular form.

	Filarete	*Alberti*, IX.7	*Vitruvius*, 4.1
Doric	9	7	7
Ionic	7	8	9 (but originally 8)
Corinthian	8	9	–

[3] Although Filarete misread Vitruvius (3.5.8) and assumes that *epistylium* is synonymous with *capitulum*, he is quite modern in his refusal to follow blindly the Vitruvian terminology. Cf. *De Re Aed.*, VI.1.

themselves the simile that was stated above. There are Ionic, Doric, and Corinthian columns. The Doric are the greatest in size, the Corinthian medium, and the Ionic the smallest of them all, that is, of seven heads. This [latter order] is like the lowest [class], that is, for bearing weight. It is used in the building in places where the greatest weight is to be supported. Those of eight heads are also placed where the members of the building need to be supported and held up.' [. . .]

'I think you have understood that each one of these parallels or little squares is ten braccia [on a side]. They are for measuring everything to scale. They should be divided into ten parts, but because they are so small the lines would be on top of each other if we tried to divide them. You will thus understand the squares for the above-named braccia. Each one of these lines can be considered one braccio.

[. . .] is one type and laid out in this manner. There are eleven arches in the front portico, or loggia. Its arches are 12 braccia and the columns are two braccia thick. There are thirteen columns 18 braccia high. The arch will be six [braccia high]. In all, this comes to 24 braccia in height. This makes a proportion of one to two. It will be two braccia above ground level and there will be six steps. [. . .]

'I freely praise anyone who follows the antique practice and style. I bless the soul of Filippo di ser Brunellesco, a Florentine citizen, a famous and most worthy architect, a most subtle follower of Dedalus, who revived in our city of Florence the antique way of building. As a result no other manner but the antique is used today for churches and for public and private buildings. To prove that this is true, it can be seen that private citizens who have either a church or a house built all turn to this usage, as for example the remodeled house in the Via Contrada that is called Via della Vigna. The entire facade [is] composed of dressed stone and all built in the antique style. This is encouraging to anyone who investigates and searches out antique customs and modes of construction in architecture. If it were not the most beautiful and useful [fashion], it would not be used in Florence, as I said above. [. . .]

'I beg everyone to abandon modern usage. Do not let yourself be advised by masters who hold to such bad practice. Cursed be he who discovered it! I think that only barbaric people could have brought it into Italy. I will give you an example. [There is the same comparison] between ancient and modern architecture [as there is] in literature. That is [there is the same difference] between the speech of Cicero or Virgil and that used thirty or forty years ago.

Today it has been brought back to better usage than had prevailed in past times – during at least several hundred years – for today one speaks in prose with ornate language. This has happened solely because they followed the antique manner of Virgil and other worthy men. I give you architecture in the same comparison, for whoever follows antique practice participates precisely in the above comparison, that is, the one on Ciceronian and Virgilian letters. I do not wish to say more, but I beg of your lordship that he at least not use [modern forms] in what he has built. I am quite certain that when you understand drawing a little better you will see that what I say is true.'

1.4.2
Brunelleschi's practice of architecture

The motives of Antonio Manetti (1423–97) for writing a biography of Brunelleschi are unclear. Twenty years after Brunelleschi's death, Manetti served on the public works committee of the Innocenti Foundling hospital and later on the jury for the competition for the façade of the cathedral, and this contact with Brunelleschi's work may have stimulated his curiosity. Another possible explanation is that Manetti found in Brunelleschi a model of an inventive, robust, no-nonsense kind of man from the high-point of Florentine civic pride. When he was writing the biography, in the 1480s, much of this confident self-reliance had evaporated, as Florence came increasingly under the influence of a Medicean court. Manetti attributes to Brunelleschi many characteristics that were in vogue in the 1480s but which would have been more unusual in the first decades of the century. For example, the knowledge of Vitruvius' text and a good visual knowledge of antique Roman architecture had been boosted by manuscript transcriptions and albums of drawings of Roman ruins. Manetti has Brunelleschi go to Rome with Donatello after his failure in the competition to design the Baptistery doors, and attributes to him detailed archaeological investigations, concluding that he used Ionic, Doric, Tuscan, Corinthian and Attic styles in his buildings. In fact, Brunelleschi employed almost exclusively the Corinthian order and then a variant which owes little to precise Roman examples. Manetti is particularly interesting about Brunelleschi's relationships with clients and building committees. He was almost certainly able to pick up a rich tradition of anecdotes circulating on the building sites on which Brunelleschi had worked. In particular, Manetti attributes two characteristics to Brunelleschi that help us

understand Renaissance practice: his reluctance to explain too much about his ideas to others and his reliance on an overall model or plan, coupled with oral instructions to the workmen. [TJB]

Source: Antonio di Tuccio Manetti (1970), *Life of Brunelleschi*, ed. H. Saalman, trans. C. Enggass (University Park and London: Pennsylvania State University Press), pp. 34, 36, 50, 52, 54, 94–8, 120–6. © 1970 by The Pennsylvania State University. Reproduced by permission of the publisher.

Girolamo, you wish to know who that Filippo was who played the practical joke you admire so much on il Grasso, the true account of which I related to you. [...]

Filippo di Ser Brunellesco, architect, was of our city and in my time I knew him and spoke to him. [...]

Thus left out, Filippo seemed to say: my knowledge was not sufficient for them to entrust me with the whole undertaking [of the Baptistery doors]; it would be a good thing to go where there is fine sculpture to observe. So he went to Rome where at that time one could see beautiful works in public places. Some of those works are still there, although not many; some have been removed, carried off, and shipped out by various popes and cardinals from Rome and other nations. In studying the sculpture as one with a good eye, intelligent and alert in all things, would do, he observed the method and the symmetry of the ancients' way of building. He seemed to recognize very clearly a certain arrangement of members and structure just as if God had enlightened him about great matters. Since this appeared very different from the method in use at that time, it impressed him greatly. And he decided that while he looked at the sculpture of the ancients to give no less time to that order and method which is in the abutments and thrusts of buildings, [their] masses, lines, and *invenzioni* according to and in relation with their function, and to do the same for the decorations. Thereby he observed many marvels and beautiful things, since for the most part they were built in diverse epochs by very fine masters, who became so through practical experience and through the opportunity to study afforded by the large compensation of the princes and because they were not ordinary men. He decided to rediscover the fine and highly skilled method of building and the harmonious proportions of the ancients and how they might, without defects, be employed with convenience and economy. Noting the great and complex elements making up these matters – which had nevertheless been

resolved – did not make him change his mind about understanding the methods and means they used. [. . .]

The sculptor Donatello was with him almost all the time during this stay in Rome. They originally went there in agreement about strictly sculptural matters, and they applied themselves constantly to these. Donatello had no interest in architecture. Filippo told him nothing of his ideas, either because he did not find Donatello apt or because he was not confident of prevailing, seeing more every minute the difficulties confronting him.

However, together they made rough drawings of almost all the buildings in Rome and in many places beyond the walls, with measurements of the widths and heights as far as they were able to ascertain [the latter] by estimation, and also the lengths, etc. In many places they had excavations made in order to see the junctures of the membering of the buildings and their type – whether square, polygonal, completely round, oval, or whatever. When possible they estimated the heights [by measuring] from base to base for the height and similarly [they estimated the heights of] the entablatures and roofs from the foundations. They drew the elevations on strips of parchment graphs with numbers and symbols which Filippo alone understood. [. . .]

Returning to the excavations of Filippo and Donato: they were generally called 'the treasure hunters' as it was believed that they spent and looked for treasure. They said: The treasure hunters search here today and there tomorrow. Actually they sometimes, although rarely, found some silver or gold medals, carved stones, chalcedony, carnelians, cameos, and like objects. From that in large measure arose the belief that they were searching for treasure.

Filippo spent many years at this work. He found a number of differences among the beautiful and rich elements of the buildings – in the masonry, as well as in the types of columns, bases, capitals, architraves, friezes, cornices, and pediments, and differences between the masses of the temples and the diameters of the columns; by means of close observation he clearly recognized the characteristics of each type: Ionic, Doric, Tuscan, Corinthian, and Attic. As may still be seen in his buildings today, he used most of them at the time and place he considered best. [. . .]

Among others (I will begin with the early Florentine ones), he was asked by the Guild and University of Porta Santa Maria, the patron who had the responsibility, to construct the portico of the Ospedale degli Innocenti. A plan alone without a wooden model sufficed for that portico. And so he did. Inasmuch as he was asked about the space over the portico and one space only at either side of the portico between two fluted pilasters of *macigno* [sandstone], he

presented a drawing precisely scaled in small *braccia*. That plan in its original form is still in the Udienza de' Consoli of the aforementioned Guild. In it are many various and fine considerations and the reasons are understood by few. He explained it orally to the master builders, the stonecutters, certain citizens, the leaders of the Guild, and to the workers assigned to the undertaking, since he had to be absent for a time. On his return from that place the loggia was built the way it is today, which gave Filippo much displeasure, since they had diverged from his plans in many things. They had built it that way because of the arrogance of one of the *operai*, who did not want to appear to have less authority than Filippo. They did it thinking that Filippo would praise it, and that in the event he did not, of being able to defend what they had done. Since Filippo placed the blame on one of them in particular, the one who had erred the most prepared to defend himself. There are many prominent, very evident defects at variance with the plan Filippo left, which can be noted by anyone who looks for them. One is in the frieze over the loggia arcade; another is in the architrave; another in the two windows and in the small pilasters that were to rise from the [lower] cornice that functions as the sill for the windows up to the [upper] cornice; this [upper] cornice should be where the eaves of the roof are now. There is also a variation from Filippo's proportions in an addition – besides the error of the addition itself – built on the south side, and appearing on the outside façade of the loggia. Then there is an architrave that turns [a corner] downward and continues to the dado of the building. These lapses are, in short, nothing less than the presumption of the person who had it built in that manner on his own authority. The aforementioned person when defending himself was convinced of everything by Filippo. He did not know what to say and for the sake of courtesy I will not give his name. However, to spoil the works of such men [as Filippo] and to take things from them is very presumptuous. Experience proved in the end that nothing was subtracted from Filippo's work without removing beauty, increasing the cost, and in large measure weakening the buildings and damaging their usefulness. [. . .]

About this same time one of the Masters of Sacred Theology of Santo Spirito, a monk named Master Francesco Zoppo, was preaching the Lenten sermons, and as he (as far as is known) accorded his life with his words and appeared to do so throughout his life, he attracted a great concourse of citizens especially from the Quarter. [. . .]

Thus, about the year 1428 five prominent citizens, all from the Quarter, decided at their first meeting that for the time being a *provveditore* should be appointed and together with him the organization of the Ufficio, the Notary, the location, and then the whole building should be studied. And they agreed

easily (since the principal chapel of the old church belonged to the Frescobaldi and Stoldo was a capable and valiant man with affection for the church) that because of the many advantages he should be their *provveditore*. And they nominated him and he accepted willingly. And before any provision was made for expenditures Stoldo saw to everything, hoping to recover his outlay when the money was provided. In meeting and discussing the new office, since Filippo was famous – as was stated above – the citizens had all their hopes in him because of his many experiments pertaining to similar things, and so they appointed him to bring them some good ideas, offering him advantage and honor in compensation, saying clearly to him: We might not be able to pay even if you make something similar to what we are hoping for. So Filippo made a plan with only the foundations of the building and with this explained to them orally what the elevation would look like. Being pleased with it they commissioned him to make, or have made, a scale model in wood and ordered the *provveditore* that he be paid whatever he said. [. . .]

So they laid the [plan out with] cords and came to a part of the foundations toward the Via del Fondaccio outside the [old] church, which did not impede the use of the old church for the time being. Having begun it, because of the misfortunes of the city, they had to wait for a few years. When Filippo had made the model and founded a part of [the church], he said at some point that, insofar as the composition of the edifice was concerned, it seemed to him that he had begun a church in accordance with his intentions. Certainly he did not depart from his model. He began it and founded some chapels and erected a part of it in his day in accordance with this intention. It was a beautiful thing which, with the projection of the material toward the exterior [i.e., the externally projecting semicircular chapels], had no peer in Christendom, not even with the errors made and consented to by others.

Panel Painting

1.5.1

Cennino Cennini's instructions on how to paint drapery in a fresco painting

Cennino Cennini (c.1370–1440) was a Florentine painter who went to Padua in 1388, where he found work in the service of the city's ruler, Francesco da Carrara. He described himself as a pupil of the Florentine painter Agnolo Gaddi (active 1369–96), who was taught by his father, Taddeo Gaddi (active 1332–66). Taddeo Gaddi, in turn, was a pupil of the famous Florentine artist Giotto (c.1270–1337). Cennino's importance is due to his work *Il libro dell'arte* (*The Craftsman's Handbook*), which contains invaluable information on the traditional techniques and artistic practices used in fourteenth-century Italian workshops, many of which continued to be used during the fifteenth century. In this extract, Cennino provides advice on how to paint drapery in a fresco painting, specifying, in particular, how a painter using the egg tempera technique must prepare and mix each colour before applying it to the surface of the painting. [DN]

Source: Cennino Cennini (1960), *The Craftsman's Handbook: The Italian 'Il libro dell'arte'*, trans. D. V. Thompson (New York: Dover Publications), pp. 49–50. Reprinted by permission of Dover Publications, Inc.

Now let us get right back to our fresco-painting. And, on the wall, if you wish to paint a drapery, any color you please, you should first draw it carefully with your verdaccio;[1] and do not have your drawing show too much, but moderately. Then, whether you want a white drapery or a red one, or yellow, or green, or whatever you want, get three little dishes. Take one of them, and put into it whatever color you choose, we will say red: take some cinabrese[2] and a little lime white; and let this be one color, well diluted with water. Make one of the other two colors light, putting a great deal of lime white into it. Now take some out of the first dish, and some of this light, and make an intermediate color; and you will have three of them. Now take some of the

[1] A dark, greenish paint used by painters for outlining and shading.
[2] A red paint, often used by painters for the flesh tones of figures.

first one, that is, the dark one; and with a rather large and fairly pointed bristle brush go over the folds of your figure in the darkest areas; and do not go past the middle of the thickness of your figure. Then take the intermediate color; lay it in from one dark strip to the next one, and work them in together, and blend your folds into the accents of the darks. Then, just using these intermediate colors, shape up the dark parts where the relief of the figure is to come, but always following out the shape of the nude. Then take the third, lightest color, and just exactly as you have shaped up and laid in the course of the folds in the dark, so you do now in the relief, adjusting the folds ably, with good draftsmanship and judgment. When you have laid in two or three times with each color, never abandoning the sequence of the colors by yielding or invading the location of one color for another, except where they come into conjunction, blend them and work them well in together. Then in another dish take still another color, lighter than the lightest of these three; and shape up the tops of the folds, and put on lights. Then take some pure white in another dish, and shape up definitively all the areas of relief. Then go over the dark parts, and around some of the outlines, with straight cinabrese; and you will have your drapery, systematically carried out. But you will learn far better by seeing it done than by reading. When you have finished your figure or scene, let it dry until the mortar[3] and the colors have dried out well all over. And if you still have any drapery to do in secco,[4] you will follow this method.

1.5.2

Cennino Cennini's instructions on how to acquire the skills to paint on panel

Here Cennino Cennini describes how a young apprentice painter should thoroughly familiarize himself with all the preparatory processes that preceded the actual application of paint on panel or wall paintings. [DN]

[3] Here Cennino is describing the *buon fresco* technique, where the paint was applied to wet plaster, which then had to dry, bonding the colour of the paint to it in the process.
[4] A reference to applying the paint after the plaster had dried and therefore onto a dry, non-porous surface.

Source: Cennino Cennini (1960), *The Craftsman's Handbook: The Italian 'Il libro dell'arte'*, trans. D. V. Thompson (New York: Dover Publications), pp. 64–5. Reprinted by permission of Dover Publications, Inc.

Know that there ought not to be less time spent in learning than this: to begin as a shopboy studying for one year, to get practice in drawing on the little panel; next, to serve in a shop under some master to learn how to work at all the branches which pertain to our profession; and to stay and begin the working up of colors; and to learn to boil the sizes, and grind the gessos; and to get experience in gessoing anconas [panel paintings], and modeling and scraping them; gilding and stamping; for the space of a good six years. Then to get experience in painting, embellishing with mordants,[1] making cloths of gold,[2] getting practice in working on the wall, for six more years; drawing all the time, never leaving off, either on holidays or on workdays. And in this way your talent, through much practice, will develop into real ability. Otherwise, if you follow other systems, you need never hope that they will reach any high degree of perfection. For there are many who say that they have mastered the profession without having served under masters. Do not believe it, for I give you the example of this book: even if you study it by day and by night, if you do not see some practice under some master you will never amount to anything, nor will you ever be able to hold your head up in the company of masters.

Beginning to work on panel, in the name of the Most Holy Trinity: always invoking that name and that of the Glorious Virgin Mary.

[1] The technique of applying gold leaf on a bed of adhesive varnish.

[2] In order to represent elaborately patterned materials, such as cloth of gold or brocade, painters used the *sgraffito* technique, whereby paint would be laid on gold leaf and then carefully scraped away, in specific areas, so as to form an intricate pattern of gold leaf and coloured pigment.

1.5.3
Cennino Cennini's instructions on how to prepare and size a panel

An account of the first stages in the elaborate process of preparing a panel painting. [DN]

Source: Cennino Cennini (1960), *The Craftsman's Handbook: The Italian 'Il libro dell'arte'*, trans. D. V. Thompson (New York: Dover Publications), pp. 69–70. Reprinted by permission of Dover Publications, Inc.

Now we come to the business of working on anconas or on panel. To begin with, the ancona[1] should be made of a wood which is known as whitewood or poplar, of good quality, or of linden, or willow. And first take the body of the ancona, that is, the flats, and see whether there are any rotten knots; or, if the board is greasy at all, have the board planed down until the greasiness disappears; for I could never give you any other cure.

See that the wood is thoroughly dry; and if it were wooden figures, or leaves, so that you could boil them with clear water in kettles, that wood would never give you any trouble with cracks.

Let us just go back to the knots or nodes, or other defects which the flat of the panel may display. Take some strong leaf glue; heat up as much as a goblet or glass of water; and boil two leaves of glue, in a pipkin free from grease. Then have some sawdust wet down with this glue in a porringer. Fill the flaws of the nodes with it, and smooth down with a wooden slice, and let it stand. Then scrape with a knife point until it is even with the surrounding level. Look it over again; if there is a bud, or nail, or nail end, sticking through the surface, beat it well down into the board. Then take small pieces of tin foil, like little coins, and some glue, and cover over carefully wherever any iron comes; and this is done so that the rust from the iron may never come to the surface of the gessos. And the flat of the ancona must never be too much smoothed down. First take a size made of clippings of sheep parchments,

[1] When Cennino refers to an *ancona* (rather than a *tavola*), he appears to be describing a large or small panel with the frame and its mouldings already attached. An *ancona* might be a complex structure, like a polyptych, or merely a simple, framed panel.

boiled until one part remains out of three. Test it with the palms of your hands; and when you find that one palm sticks to the other, it will be right. Strain it two or three times. Then take a casserole half full of this size, and the third part water, and get it boiling hot. Then apply this size to your ancona, over foliage ornaments, canopies, little columns, or any sort of work which you have to gesso, using a large soft bristle brush. Then let it dry. Next take some of your original strong size, and put two coats over this work with your brush; and always let it dry between one coat and the next; and it will come out perfectly sized. And do you know what the first size, with water, accomplishes? Not being so strong, it is just as if you were fasting, and ate a handful of sweetmeats, and drank a glass of good wine, which is an inducement for you to eat your dinner. So it is with this size: it is a means of giving the wood a taste for receiving the coats of size and gesso.

1.5.4
Cennino Cennini's instructions on how to paint on panel

Cennino's advice on how to proceed with the actual application of paint on a panel painting, after it has been fully prepared with layers of glue size, linen, gesso and gold leaf. [DN]

Source: Cennino Cennini (1960), *The Craftsman's Handbook: The Italian 'Il libro dell'arte'*, trans. D. V. Thompson (New York: Dover Publications), pp. 91–3. Reprinted by permission of Dover Publications, Inc.

I believe that by yourself you will have enough understanding, with your experience, to train yourself, by following this method, to understand working neatly with various kinds of cloth. And by the grace of God it is time for us to come to painting on panel. And let me tell you that doing a panel is really a gentleman's job, for you may do anything you want to with velvets on your back.[1] And it is true that the painting of the panel is carried out just as I taught you to work in fresco, except that you vary it in three respects. The first, that

[1] Velvet was still a rarity in late fourteenth-century Italy and, therefore, wearing velvet was a mark of a cultured and elegant life style.

you always want to work on draperies and buildings before faces. The second is that you must always temper your colors with yolk of egg, and get them tempered thoroughly – always as much yolk as the color which you are tempering. The third is that the colors want to be more choice, and well worked up, like water. And for your great pleasure, always start by doing draperies with lac[2] by the same system which I showed you for fresco; that is, leave the first value in its own color; and take the two parts of lac color, the third of white lead; and when this is tempered, step up three values from it, which vary slightly from each other: tempered well, as I have told you, and always made lighter with white lead well worked up. Then set your ancona up in front of you; and mind you always keep it covered with a sheet, for the sake of the gold and the gessos, so that they may not be injured by dust, and that your jobs may quit your hands very clean. Then take a rather blunt minever brush, and start to apply the dark color, shaping up the folds where the dark part of the figure is to come. And in the usual way take the middle color and lay in the backs and the reliefs[3] of the dark folds, and begin with this color to shape up the folds of the relief, and around toward the light part of the figure. And shape it up once more in this way. Then take the light color, and lay in the reliefs and the backs of the light part of the figure. And in this way go back once again to the first dark folds of the figure with the dark color. And carry on as you began, with these colors, over and over again, first one and then the other, laying them in afresh and blending them skilfully, softening delicately. And with this[4] you have enough time so that you can get up from your work and rest yourself for a while, and reflect upon this work of yours. Work on panel wants to be done with much enjoyment.

When you have got it well laid in and these three colors blended, make another lighter one out of the lightest, always washing the brush between one color and the next; and out of this lighter one make another lighter still; and have the variations among them very slight. Then touch in with pure white lead, tempered as has been said; and touch in with it over the strongest reliefs. And make the darks, gradually, in the same way, until you finally touch in the strongest darks with pure lac. And bear this in mind: just as you prepared your colors value by value, so you put them into your little dishes value by value, so as not to take one of them for another by mistake.

[2] Red pigment made from dark red gum, *lac*.
[3] Cennino works according to a tripartite system of dark, mid ('backs') and light ('reliefs') areas of paint.
[4] As opposed to fresco.

And use this same system, likewise, for any color which you want to paint, whether reds, or whites, or yellows, or greens. But if you want to make a lovely violet color, take good choice lac, and good choice fine ultramarine blue; and with this mixture and white lead make up your colors, value by value, always tempering them. If you wish to do a drapery with blue with lights on it, make it lighter in this way with white lead; and execute it in the way described above.

1.5.5

Contract for Sassetta's *Madonna della Neve* altarpiece

Ludovica Bertini (d. 1433) was a member of the noble Sienese family of the Bertini and widow of a wealthy merchant, Turino di Matteo. Here, on 25 March 1430, she orders a painting of the Madonna della Neve (Our Lady of the Snow) from the Sienese painter, Stefano di Giovanni, known as Sassetta (c.1400–50) for an altar in the chapel of St Boniface in Siena Cathedral. The documentation for this commission is unusually full and offers an insight into the issues surrounding the making of an altarpiece, as this and the next three documents show. [DN]

Source: M. H. Laurent (1935), 'Documenti Vaticani intorno alla "Madonna della Neve" del Sassetta', *Bullettino senese di storia patria*, XLII, pp. 260–1. Translated from the Latin by Dario Tessicini. Copyright © The Open University 2007.

In the name of God, Amen. In the thousandth four-hundredth and thirtieth year since the Redeemer's incarnation, the eighth indiction, the twenty-fifth of March, according to the practice and tradition of the notaries of the city of Siena, in the time of the pontificate of the most holy Father in Christ and Lord, Martin, by divine providence Pope, the Fifth,[1] in the reign of His Highness, Sigismund, king and Roman Emperor,[2] according to the formulae of the said city, be it publicly known that the revered lady Ludovica, daughter of the

[1] Martin V, who was pope 1417–31.
[2] The German king, Sigismund (1368–1437), who was crowned Holy Roman Emperor in Rome in 1433, but had already laid claim to this title in 1432.

late Francesco Vanni Bertini of Siena, and wife of the late honourable knight Turino di Matteo, late clerk of works [*operarius*] at the holy cathedral of Siena,[3] and tertiary [*clamidata*] of the Franciscan order in Siena,[4] by her own free will, choice and knowledge, and not by mistake, gave and contracted to the wise master Stefano di Giovanni Consoli of Siena [Sassetta], painter, here present and acting for himself, the painting of an altarpiece for the chapel of Saint Boniface,[5] which is near the door of the said cathedral called and named the *Porta del Perdono*, with five full-size figures, that is: the Virgin Mary with her son Jesus Christ in her arms, a seraphic Saint Francis, Saint Peter, Saint Paul and Saint John the Baptist with the Salvator above the Virgin Mary; and a predella with five stories of *Saint Mary of the Snow* with that quantity of gold and those colours appropriate to the said panel, predella and figures. The said master Stefano promised to lady Ludovica, here present and stipulating for herself, her heirs and successors, that he shall paint this panel with the said figures and the predella with the said stories, properly and ornately, according to the judgement of two foreign masters, expert in the said art, one of which, once the panel is done and finished, shall be chosen by the said lady Ludovica and the other one shall be similarly chosen by the said master Stefano, the aforesaid painter, as aforementioned. And the said master Stefano promised to the said lady Ludovica, here present and stipulating as above, that he will execute and complete the said panel, as above, and predella, and the aforesaid work within one year from now, and meanwhile he may not undertake any other work which may delay the said work, the panel and the predella as well; and the said lady Ludovica promised to the said master Stefano, here present and stipulating for himself and his heirs, to hand over and pay what shall be stated by the said masters appointed as above. As for the sum of florins and pennies to be stated in this way, the same lady Ludovica makes and constitutes herself principal debtor and payer of the said master Stefano, here present and stipulating as above, and she promised that she will pay that sum at the complete discretion, will, and simple request of master

[3] Apart from being a wealthy Sienese merchant, Turino di Matteo (d. 20 Aug. 1423) also held a number of important government offices. In 1420 he became the *operaio* or superintendent of the Opera del Duomo, the civic organization that oversaw the administration of Siena Cathedral.

[4] Like her husband, Ludovica was a Franciscan tertiary. She was thus a member of the third order of Saint Francis, made up of lay people, as distinct from the first order, made up of Franciscan friars, and the second order, made up of Clarissan nuns.

[5] In 1430, the altar by the Porta del Perdono was apparently dedicated to Saint Boniface. After the installation of the *Madonna della Neve* altarpiece in 1433, the altar's dedication was changed to that of Our Lady of the Snow.

Stefano and his heirs and successors in Siena, Pisa, Florence, Rome, and in every other place, even if one place is farther than the other, and where the said master Stefano will find, request and have requested, and wanted to meet the said lady Ludovica, with no exceptions by law or fact.

That each and everything of the above and below, the said parties, among themselves and reciprocally, by formal undertaking, promised to conform, comply with, and not to oppose or contravene for any reason, law, cause of law, or action under penalty and for the penalty of two hundred florins, that the party not respecting the previous formal undertaking will hand over and pay to the party respecting the agreement, as many times the aforesaid and each of them shall have been breached and infringed; and when the penalty has been given and paid, whether committed or not, nevertheless each and everything of the aforesaid shall continue be binding and valid for its entire duration. Next, the said parties bound themselves, reciprocally and among themselves, their heirs and successors and all their goods, movable and non-movable, present and future as well, under right of security and mortgage, to return each and all losses, expenses and interests on litigation and assessment caused by observing, keeping the pledges and fulfilling each and all of what is stated above and below, the said parties, reciprocally and among them-selves, renouncing the exceptions of fraud, malicious action in facts and in content, by undue objection, objection without cause or unjust cause done through fear, by right of the court, if the matter is not performed in the same way, and with all support, right and consent of the codes and laws. Moreover, the aforesaid parties swore on the Holy Gospels, physically touching the Scriptures, that each and everything of the above is true and they shall imple-ment and observe it, and they shall not oppose or contravene for any reason, cause of law or fact.

Lady Ludovica and master Stefano, the parties as mentioned above and here present, desiring and agreeing voluntarily to each and everything of the aforesaid, I, Luca, the undersigned judge ordinary, admonished, according to the form of the Sienese constitution, that they shall observe everything and each of the above, among themselves and reciprocally, as is entered above and is written comprehensively.

Drawn up in Siena, in the house of the aforesaid lady di Ludovica, in the presence of Agabito di Ambrogio di Antonio, banker, and Pietro Angelo di Pietro, banker of Siena,[6] who were present and called as witnesses.

[6] It is significant that the two witnesses to the contract are identified as bankers. Much of Siena's economic prosperity was based on international banking.

1.5.6
Valuation of Sassetta's *Madonna della Neve* altarpiece

It was not unusual for the price of an altarpiece to be fixed only on comple-
tion, when it might be evaluated by representatives chosen by the patron and
the artist. Here, on 23 October 1432, Ludovica Bertini selects the Pisan
painter, Gualtieri di Giovanni, as her assessor, and Sassetta, the Veronese
painter Cecchino di Francesco, as his assessor, in order to determine the price
of the *Madonna della Neve*. [DN]

Source: M. H. Laurent (1935), 'Documenti Vaticani intorno alla "Madonna della Neve"
del Sassetta', *Bullettino senese di storia patria*, XLII, pp. 262–3. Translated from the Latin
by Dario Tessicini. Copyright © The Open University 2007.

In the name of God, Amen. In the thousandth four-hundredth and thirty-
second year since the Redeemer's incarnation, the eleventh indiction, the
twenty-third of October, according to the practice and tradition of the nota-
ries of the city of Siena, in the time of the pontificate of the most holy Father
in Christ and Lord, Eugenius, by divine providence Pope, the Fourth,[1] in the
reign of His Highness, Sigismund, king and Roman Emperor, according to
the formulae of the said city, be it publicly known that the aforesaid lady
Ludovica, on the one side, and the aforesaid master Stefano [Sassetta], on the
other, having both agreed that the said panel is complete and it is now time
to choose the said foreign masters[2] who shall assess the said remuneration
and payment for the said panel, as it is recorded above in my own hand,
the undersigned notary, that is: the said lady Ludovica appointed master
Gualtiero di Giovanni of Pisa,[3] painter, and the said master Stefano [appointed]
master Cecchino di Francesco of Verona,[4] painter, to assess in this way
the said remuneration and payment, as above, to be due to the same
master Stefano for the aforesaid painting, both giving the power, choice and

[1] Eugenius IV, who was pope 1431–47.
[2] Following the agreement made in the contract of 25 March 1430, both painter-assessors
had to be non-Sienese.
[3] Gualtieri di Giovanni (active 1389–1445) was a painter from nearby Pisa who had worked
on a number of commissions for fresco paintings in Siena Cathedral between 1411 and 1415.
[4] Cecchino di Francesco (born c.1406, d. before 1480) was a painter from Verona, whose
style of painting was close to that of Pisanello (active c.1415–55), who had also worked
extensively in Verona.

authority to the aforesaid, in this way appointed, to declare, determine, decide and pronounce as it will come from their will and discretion, promising reciprocally and among themselves, by formal undertaking, to implement and observe each and all of the aforesaid and not to oppose or contravene for any reason, law, cause of law, or action, under the penalty and for the penalty included in the said arrangement.

Which penalty, by formal undertaking, the party not respecting the aforesaid promised to hand over and pay to the party respecting the aforesaid, as many times the aforesaid and each of them shall have been breached and infringed; and when the penalty has been given and paid, whether committed or not, nevertheless each and everything of the aforesaid shall continue be binding and valid for its entire duration. Next, the said parties, among themselves and reciprocally, bind themselves, their heirs and successors and all their goods, movable and non-movable, present and future as well, under right of security and mortgage, to return each and all losses, expenses and interests on litigation and assessment caused by observing the aforesaid reciprocally and among themselves, renouncing the exceptions of fraud, malicious action in facts and in content, by undue objection, objection without cause or unjust cause done through fear, by right of the court, if the matter is not performed in the same way, and with all support, right and consent of the codes and laws. Moreover, the aforesaid parties swore on the Holy Gospels, physically touching the Scriptures, that everything and each of the above is true and they shall implement and observe it, and they shall not oppose or contravene for any reason, by cause of law or fact.

The parties here present, desiring and agreeing voluntarily to everything and each of the aforesaid, I, Luca, the undersigned [judge] ordinary, admonished, according to the forms of the Sienese constitution, that they shall observe everything and each of the above, among themselves and reciprocally, as is entered above and is written comprehensively.

1.5.7
A fee is fixed for Sassetta's *Madonna della Neve* altarpiece

The painters Gualtieri di Giovanni and Cecchino di Francesco agree in their valuation of 29 October 1432 that Ludovica Bertini should pay Sassetta 180 gold florins for his work on the *Madonna della Neve* altarpiece. [DN]

Source: M. H. Laurent (1935), 'Documenti Vaticani intorno alla "Madonna della Neve" del Sassetta', *Bullettino senese di storia patria*, XLII, pp. 263–4. Translated from the Latin by Dario Tessicini. Copyright © The Open University 2007.

In the name of God, Amen. We, the aforesaid Gualtiero, assessor appointed as above by the aforesaid lady Ludovica, and Cecchino, aforesaid assessor appointed as above by the aforesaid master Stefano to assess the remuneration and payment of the aforesaid panel painted by the said master Stefano, whose appointment is recorded above in my own hand, Luca, the undersigned notary, are willing to state the remuneration and payment for the said panel to master Stefano, having seen the said panel, figures, stories, the workmanship and what ornament has been made to the said panel, having taken notice and considered those grounds that had to be noticed and considered, having invoked the names of Christ and of his glorious mother the Virgin Mary, we give and declare this arbitration, verdict, decision and ruling among the said parties, in this way and in this writing, that is: that we give, rule, arbitrate and declare that the said lady Ludovica shall receive the said painted panel and ornament of the said chapel, and shall give and pay to the said master Stefano, for his work, skill, gold and colours, one hundred and eighty gold florins at the rate of four pounds and two shillings in Sienese pennies for each florin.[1] And each and all of the above we say, declare and arbitrate, decide and judge in every best respect, way, right, cause and form that we possibly can and will, according to the law and according to the form of our assignment.

Presented, released and finally published in this writing the said arbitration, verdict, decision and ruling by the said master Gualtiero and master Cecchino, the aforesaid assessors, sitting in council in the house of the judges and notaries of the city of Siena[2], in the presence of Antonio di ser Bartolomeo Guidi and Francesco di Pietro di Francesco Panvilini of Siena, here present and called as witnesses, in the year, indiction, pontificate and reign as said [i.e., in doc. 1.5.6], the twenty-ninth of the said month [i.e., October].

In the same year, indiction, day, pontificate and reign as in the aforesaid, be it publicly known that the aforesaid master Stefano, having known of the said arbitration, voluntarily consented, approved and ratified to each and all that it entails, I, the aforesaid notary, Luca, here present as public officer, presiding and stipulating on behalf of and in the name of the said lady

[1] As is customary in documents of this type, the value of the gold florin is carefully stipulated in terms of the local currency, i.e. one florin equals the value of 4 pounds and 2 shillings in Sienese pennies.

[2] The document was drawn up in the headquarters of the Guild of the Judges and Notaries of Siena.

Ludovica and her heirs, on behalf of and in the name of her successors, promising each and all of the above and below, in the presence of the said notary and stipulating as above, to implement and observe and not to contravene in any way, under the penalty entailed in the said arrangement.

Which penalty, by formal undertaking, the same master Stefano promised to the said notary here present and stipulating as above, to hand over and pay as many times the aforesaid and each of them shall have been breached and infringed; and when the penalty has been given and paid, committed or not, nevertheless each and everything of the aforesaid shall continue be binding and valid for its entire duration. Next, the said master Stefano will pledge to the said notary, here present and stipulating, as above, his heirs and successors and all his goods, movable and non-movable, present and future as well, under right of security and mortgage, to return each and all losses, expenses and interests on litigation and assessment caused by observing the aforesaid, renouncing the exceptions of fraud, malicious action in facts and in the content, undue objection, objection without cause or by unjust cause done through fear, by right of the court, if the matter is not performed in the same way, and with all support, right and consent of the codes and laws. Moreover, lord master Stefano swore on the Holy Gospels, physically touching the Scriptures, that everything and each of the above is true and he shall implement and observe it, and he shall not oppose or contravene for any reason, law, cause of law or fact. To which master Stefano, here present, desiring and agreeing voluntarily to everything and each of the aforesaid, I, Luca, the undersigned judge ordinary, admonished according to the form of the Sienese constitution, that he shall observe each and everything of the above, as is entered above and is written comprehensively.

Drawn up in Siena, in the said house in front of the aforesaid Antonio and Francesco, here present and called as witnesses.

I, Luca, son of Nanni di Pietro di Gianni of Siena, public notary by imperial authorization and judge ordinary, was present at each and all of the foregoing and in good faith and as witness of all the aforesaid, I put my usual signature.

1.5.8
Final valuation of Sassetta's *Madonna della Neve* altarpiece

Ludovica challenged the evaluation of Gualtieri di Giovanni and Cecchino di Francesco at the Curia dei Pupilli, a Sienese court responsible for women and

dependants. The result was that the painter Martino di Bartolomeo (representing Ludovica Bertini), the painter Sano di Pietro (representing Sassetta), and Giacomo di Meio di Nanni (as a neutral third party) made the following declaration, dated 30 December 1432, that the price fixed by Gualtieri di Giovanni and Cecchino di Francesco for the painting of the *Madonna della Neve* was a fair price. [DN]

Source: M. H. Laurent (1935) 'Documenti Vaticani intorno alla "Madonna della Neve" del Sassetta', *Bullettino senese di storia patria*, XLII, pp. 265–6. Translated from the Latin by Dario Tessicini. Copyright © The Open University 2007.

In the name of God, Amen. The following is an arbitration given by the undersigned arbiters and arbitrators between the undersigned parties and in the same tenor of words as below, that is as such:

[The text changes here from Latin to Italian.] In the name of God, Amen. We, master Martino di Bartolomeo,[1] painter, arbiter appointed on behalf of lady Ludovica, wife of the late *messer* Turino, late clerk of works [*operarius*] of the Cathedral, and master Sano di Pietro,[2] painter, on behalf of master Stefano di Giovanni, the other side, and I, Jacomo di Meio di Nanni, third party appointed by common agreement of the aforesaid parties, having seen the negotiation among ourselves, having seen the aforesaid panel and considered the value of the aforesaid panel, we judge and rule, decide and declare the said panel to be of the value of one hundred and eighty florins at the rate of four pounds and two shillings to the florin, so that we declare and judge that the arbitration between the parties decided by master Gualtieri of Pisa and Cecchino of Verona is just, right and correct, we confirm the said arbitration, having included in the said evaluation the painting of the chapel and the walls, and therefore we order the said lady Ludovica, that is, the said Guido, her procurator,[3] to give and pay to the said master Stefano the said sum, included in the said sum the monies that the said Stefano may have had from the said lady Ludovica. And we judge and rule that the said master Stefano having received the said sum shall give and hand over to the aforesaid lady Ludovica the said panel; and when the said lady Ludovica will or will

[1] Martino di Bartolommeo, a Sienese painter (active 1389, d. 1434/5), who worked on a number of important civic commissions in Siena cathedral and the town hall.
[2] Sano di Pietro (1405–81), a Sienese painter, who had a long and extremely active career as a painter in Siena and in the surrounding towns and villages.
[3] As a woman, Ludovica Bertini had to be represented by a male procurator or agent at a public event of this kind.

have installed the said panel, he shall attend to and work for it in person as is the custom; and we condemn the loser to pay the expenses to the winner. And the aforesaid we pronounce, rule and decide in the best respect, way, right and form that we possibly can and must and according to the forms and the statutes of the commune of Siena, whose expenses shall be debited to the *Giudice dei Pupilli*.[4]

I, Sano di Pietro, painter of Siena, am content with the aforesaid.

[Latin resumes.] The aforesaid arbitration given and presented by Sano and Iacopo, two of the arbiters and arbitrators mentioned above, sitting in council at Siena in the Curia of the Pupilli, who pronounced, arbitrated and judged as and how it is stated above, also in the presence of the said master Martino, one from the said arbiters and for his part disagreeing with the aforesaid arbitration, in the thousandth four-hundredth thirty-second, year of the Lord's incarnation, the eleventh indiction, according to the practice of the Sienese notaries, in the reign of His Highness, lord Sigismund, king and Roman Emperor by divine will, the thirtieth day of December late after dusk, at the usual time for the court cases in the presence of the said master Stefano, understanding, agreeing and accepting the said arbitration and what is entailed.

Drawn up in Siena at the said tribunal in front of ser Nicolao di Cecco Mattei, notary, Bartolomeo di Giorgio Spinelli and Ludovico di Luca, painter of Siena,[5] here present and called as witnesses.

And I, Giovanni of the late Nicola Guidoni of Siena, public notary by imperial authority and judge ordinary, was present for the aforesaid as requested, have written these things and published with my own hand.

1.5.9

Contract for Enguerrand Quarton's *Coronation of the Virgin* altarpiece

The French painter Enguerrand Quarton (active in Provence 1444–66) and the priest Jean de Montagnac agree on the subject matter for the *Coronation*

[4]　The Tribunal of the Giudice dei Pupilli was a court that took care of the legal interests of women and children.

[5]　Lodovico di Luca (active 1416–49), a painter who is documented as working in Sassetta's workshop on minor projects (such as the painting of banners).

of the Virgin. Written jointly, this document, dated 25 April 1453, provides a rare case of the patron specifying, in great detail, to the painter what the subject matter of the painting is to be and how it is to be organized. It therefore provides evidence of how well-versed in theology Jean de Montagnac was and also how much latitude was give to Enguerrand Quarton in terms of how particular details would be painted. The painting was for an altar in the Carthusian church of the Chartreuse du Val de Bénédictione in Villeneuve-les-Avignon in south-eastern France, where it remained until 1835. It was then transferred to the monastery hospice, which is now a museum. Comparison between this text and the painting reveals that Enguerrand Quarton made a number of changes in order to simplify and clarify the complex figurative composition stipulated in the present contract. [DN]

Source: E. Gilmore Holt, ed. (1957), *A Documentary History of Art*, vol. 1: *The Middle Ages and the Renaissance*, 2 vols (New York: Doubleday), pp. 298–302. © 1981 Princeton University Press. Reprinted by permission of Princeton University Press.

On the 25th day of April [1453], Master Enguerrand Quarton, of the diocese of Laon, painter, resident in Avignon, made a contract and agreement with the said Dominus Jean de Montagnac[1] – both contracting parties being present – for painting an altarpiece according to the manner, form, and prescription contained and set forth article by article on a sheet of paper, which they passed over to me,[2] written in French, whose tenor follows and is such:

Here follows the list of items of the altarpiece that Messer Jean de Montagnac has commissioned from Master Enguerrand, painter, to be placed in the church of the Carthusians,[3] Villeneuve-les-Avignon, on the altar of the Holy City.

First: There should be the form of Paradise, and in that Paradise should be the Holy Trinity, and there should not be any difference between the

[1] The title 'Dominus' ('Lord' in medieval Latin) signals the high social status of Jean de Montagnac.

[2] A reference to the notary, who would register the document in order to make it a legally binding document.

[3] The Carthusians were a strict, contemplative religious order, founded by Saint Bruno in 1084. They wore a distinctive white habit and it has been suggested that the figure in the white habit kneeling beside the tomb of the Virgin in the right-hand foreground of the *Coronation of the Virgin* is a portrait of the patron of the altarpiece, Jean de Montagnac.

Father and the Son; and the Holy Ghost in the form of a dove; and Our Lady in front as it will seem best to Master Enguerrand; the Holy Trinity will place the crown on the head of Our Lady.

Item: The vestments should be very rich; those of Our Lady should be white-figured damask according to the judgement of the said Master Enguerrand; and surrounding the Holy Trinity should be cherubim and seraphim.

Item: At the side of Our Lady should be the Angel Gabriel with a certain number of angels, and on the other side, Saint Michael, also with a certain number of angels, as it will seem best to Master Enguerrand.

Item: On the other side, Saint John the Baptist with other patriarchs and prophets according to the judgement of Master Enguerrand.

Item: On the right side[4] should be Saint Peter and Saint Paul with a certain number of other apostles.

Item: Beside Saint Peter should be a martyr pope over whose head an angel holds a tiara,[5] together with Saint Stephen and Saint Lawrence in the habits of cardinal deacons, also with other martyr saints as arranged by the said Master.

Item: At the side of Saint John the Baptist will be the Confessors. Saint Gregory is to be recognized in the form of a pope as above and two cardinals, one old and one young, and Saint Agricol and Saint Hugh Bishop (Saint Hugh in the habit of a Carthusian),[6] and other saints according to the judgement of the said Master Enguerrand.

Item: On the side of Saint Peter should be Saint Catherine with certain other virgins according to the judgement of Master Enguerrand.

Item: On the side of Saint John the Baptist, the Magdalene, and the two Marys, and Salome, each of which holds in her hands that which they should hold,[7] together with other widows according to the judgement of the said Master Enguerrand.

Item: In paradise below should be all the estates of the world arranged by the said Master Enguerrand.

Item: Below the said paradise, there should be the heavens in which will be the sun and the moon according to the judgement of the said Master Enguerrand.

[4] To the right of the viewer, not to the right of the holy figures.
[5] In the painting there is no angel holding a tiara over this figure.
[6] Saint Hugh (c.1052–1132) was Bishop of Grenoble who welcomed Saint Bruno and his Carthusian monks to his diocese and granted them their first monastery of the Grande Chartreuse (1084).
[7] A reference to the saint's 'attribute' – the distinctive object which identified her or him as a particular saint (e.g. the Magdalen's jar of precious ointment).

Item: After the heavens, the world in which should be shown a part of the city of Rome.

Item: On the side of the setting sun should be the form of the church of Saint Peter of Rome, and, before the said church at an exit, one cone of pine in copper,[8] and from that one descends a large stairway to a large square leading to the bridge of Sant' Angelo.

Item: At the left side of the above-mentioned, a part of the walls of Rome, and on the other side are houses and shops of all types; at the end of the said square is the castle Sant' Angelo and a bridge over the Tiber which goes into the city of Rome.

Item: In said city are many churches, among these is the church of the Holy Cross of Jerusalem where Saint Gregory celebrated mass and there appeared to him Our Lord in the form of Pitie;[9] in which church will be painted the story according to the arrangement of the said Master Enguerrand; in that story will be Saint Hugh, the Carthusian, assisting said Saint Gregory with other prelates according to the judgement of the said Master Enguerrand.

Item: Outside Rome, the Tiber will be shown entering the sea, and on the sea will be a certain number of galleys and ships.

Item: On the other side of the sea, will be a part of Jerusalem; first, the Mount of Olives where will be the cross of Our Lord, and at the foot of that will be a praying Carthusian, and at a little distance will be the tomb of My Lord and an angel below saying: *He has risen: He is not here: Behold the place where they have laid Him.*[10]

Item: At the foot of the said tomb will be two praying figures; on the right side, the valley of Jehoshaphet between the mountains, in that valley, a church where the tomb of Our Lady is, and an angel saying: *Mary has been taken up to a heavenly chamber, in which the King of Kings sits on a star-studded throne*; and at the foot of that tomb a person praying.

Item: On the left side will be a valley in which will be three persons all of one age,[11] from all three will come rays of sun, and there will be Abraham

[8] A monumental pine cone that stood then in the forecourt or 'Paradise' of Saint Peter's in Rome and was considered one of the wonders of the city. It is now in the Giardino della Pigna in the Vatican.

[9] A reference to the miracle of the Mass of Saint Gregory, when Christ, exhibiting the wounds he received at the Crucifixion, appeared to Saint Gregory the Great (c.540–604). 'Our Lord in the form of Pitie' refers to another name for this particular way of representing Christ, that of 'Our Man of Sorrows'.

[10] A quotation taken from the New Testament account of Christ's resurrection in Mark 16:6.

[11] The whole item is omitted in this text.

coming forth from his tabernacle and adoring the said three persons saying: *Lord, if I have found favor in thine eyes, pass not thy servant by: Sit, I shall fetch a little water, and your feet will be washed.*[12]

Item: On the second mountain will be Moses with his sheep and a young boy carrying a bag; and there appears to said Moses, Our Lord in the form of fire in the middle of a bush and Our Lord will say: *Moses, Moses*, and Moses will reply: *Here am I.*

Item: On the right part will be Purgatory where the angels lead those joyous on seeing that they will go to Paradise from those the devils lead in great sadness.

Item: On the left side will be Hell, and between Purgatory and Hell will be a mountain, and from the part of Purgatory below the mountain will be an angel comforting the souls of Purgatory; and from the part of Hell will be a very disfigured devil turning his back to the angel and throwing certain souls into Hell, given him by other devils.

Item: In Purgatory and Hell will be all the estates according to the judgement of the said Master Enguerrand.

Item: The said altarpiece shall be made in fine oil colors[13] and the blue should be fine blue of Acre,[14] except that which will be put on the frame, that should be fine German blue, and the gold that will be used on the frame as well as around the altarpiece should be fine gold and burnished.

Item: The said Master Enguerrand will show all his knowledge and skill in the Holy Trinity and in the Blessed Virgin Mary, and will be governed by his conscience.

Item: On the back of the altarpiece will be painted a cloth of cream damask figures with fleur-de-lis.[15]

A promise was given, I declare, by the same Master Enguerrand to execute these things faithfully and according to the foregoing description, from the next [feast of] St. Michael,[16] for the next one continuous year, for the price of one hundred and twenty florins, each at the value of XXIIII *sous* of the currency at Avignon. Towards the reduction of which sum of florins the said

[12] This quotation is shortened in this text.

[13] Modern conservation reports suggest that the painting was executed primarily in egg tempera. Oil glazes may also have been used – but these are impossible to identify today.

[14] Costly blue ultramarine pigment, made from lapis lazuli, and originating from the eastern city of Saint John d'Acre.

[15] There is no trace today of paint on the back of the painting. This instruction might refer to the decoration of a now lost wooden canopy fixed to the top of the altarpiece.

painter has acknowledged that he has had from the said Dominus Jean forty florins current, concerning which the same painter has expressed his satisfaction, and made the said Dominus Jean quit of them. . . . The remaining sum the said Dominus Jean has promised to pay to the same Master Enguerrand as follows, viz.: twenty florins when the same painter shall have done a half of the said work; likewise, forty florins according to the work he does and in proportion to the work itself [i.e., the whole work]; and the remaining twenty florins immediately when the said work shall have been completed and placed in the said Carthusian church; and the said Jean has promised that he will arrange with the prior and community of the Carthusians that they will be liable to the said Master Enguerrand for the said remainder in the case of a failure on the part of Jean himself. . . .

Done in the spice shop in the dwelling of Jean de Bria, spice merchant,[17] citizen of Avignon, in the presence of . . .

[16] Probably a reference to 8 May, which was the feast day of the apparition of Saint Michael Archangel on Monte Gargano, southern Italy, rather than the feast day of Saint Michael and all angels on 29 September.

[17] It is significant that the contract was drawn up in a spice shop, since spice merchants were the principal sellers of artists' pigments at that time.

Prints and Printmaking

1.6.1
An ordinance from the Stadsarchief, Leuven, concerning the printmaker Jan van den Berghe

This is one of the earliest surviving documents (13 December 1452) regarding printmaking in the Netherlands. Jan van den Berghe is described in this document as a 'printsnydere' or print-cutter, who cut both letters and 'beelden', a word that here, evidently, denotes pictures or figures rather than its more common meaning of statues. Since he is almost certainly to be identified as a woodblock-cutter, this description may indicate that van den Berghe was engaged in the production of block books, each page of which involved both pictures and letters cut from a single block. Allan Stevenson's suggestion that it might have been van den Berghe who was responsible for a block book of the Apocalypse printed in Leuven at this time is a fascinating possibility, but unproven.[1] The successful insistence of the guild of wheelmakers, joiners, wood turners and coopers that van den Berghe should join their ranks was partly based on precedent, but largely on the usual guild criteria of common materials – in this case wood – and tools, even if the craftsmen used them for radically different purposes, as van den Berghe did here, in practising what he described as his 'singular' art. [KWW]

Source: Jan van der Stock (1998), *Printing Images in Antwerp: The Introduction of Printmaking in a City, Fifteenth Century to 1585* (Rotterdam: Sound & Vision Interactive), doc. 3, pp. 305–6. Translated from the Dutch by Ria de Boodt and Rembrandt Duits. Copyright © The Open University 2007.

Item that Andries van Voshem, Peeter van Bladen, Aernd de Muntere and Peeter van Ynden, members of the guild of wheel makers, cabinet makers, wood turners and barrel makers in Leuven on the one hand, and Jan van Berghe, carver of woodcuts, on the other hand, have appeared before the council of this town today. The representatives of the guild requested and demanded that Jan should join the guild of the cabinet makers and comply with its regulations, as is proper and as others with the same profession who were named and discussed [by the representatives] have done in the past. Jan

[1] A. Stevenson (1991), 'The Problem of the Blockbook', *Blockbücher des Mittelalters* (Gutenberg Museum, Mainz: Verlag Philipp van Zabern), pp. 240–1.

answered them and said that he believed others who cut letters and images for printing had not been required by law to join the guild, unless they had argued their cases poorly; and he hoped not to be ordered to join because his work was a special art unlike any other practised within the guild and was partly more like a liberal art[2] than [the crafts represented by] the guild. The representatives of the guild then responded and said that the persons [they had named] who had joined the guild also carved letters and images for printing (for which, on the request of the council, they presented certain evidence), and even if this had not been the case, a printmaker would still be obliged to join the guild as he used the plane and other tools to work the wood of the print blocks and related items; and nobody could give such a narrow definition[3] as to exclude that the work of this manufacturer of woodcuts, through carving and in other ways, had an overlap with [the activities of] the guild, and he could not seek to excuse himself from and try to argue his way out of this by claiming the freedom of a practitioner of the liberal arts. These and other arguments by both parties having been heard at length, Jan submitted to and complied with the ruling of the council, pleading for leniency and mercy regarding any duties to be paid. The town council then considered and deliberated the matter and decided and pronounced as their ruling and verdict that Jan should join the guild and comply with the guild regulations and what they license and dictate. And as he had submitted himself of his own free will and pleaded for mercy, the guild, on the demand and request of the council, granted Jan a certain relief regarding its fees and duties. Decreed in the presence of Lyemingen and Wynghe, burgomasters, and other members of the council. 13 December 1452.

1.6.2
The hard business of printing

German printers introduced the technology of printing books to Italy. Conrad Sweynheym (d. 1477) and Arnold Pannartz (d. 1476) established a press in

[2] The original Dutch reads: 'ginghe eensdeels meer der clerckgien aen'. The term 'clerckgien' or 'clercgien' referred to either the clergy or, by derivation, the community of scholars, i.e. practitioners of the liberal arts, who did not have to be members of a guild.

[3] The original Dutch reads: 'ende soe nauwe en conste he[m] nymant'. I believe this phrase may have been wrongly transcribed and/or interpreted during transcription. It should read: 'ende soe nauwe[n] conste he[t] nyemant', translating as 'and nobody could narrow it down so much'.

1464 at the Benedictine monastery of Santa Scholastica at Subiaco, about 30 miles south of Rome. There they produced what are thought to be the first printed books in Italy, about 10 years after those in Mainz. (The first press was set up in Venice in 1469 by John of Speyer, a German resident, and in Florence in 1471.) In 1467, an associate at Subiaco, Ulrich Han, printed the first illustrated printed book in Italy, Juan de Torquemada's *Meditationes*, a 34-leaf book incorporating text and images derived from a fresco cycle at the cloister of Santa Maria sopra Minerva in Rome. In the same year Sweynheym and Pannartz moved to Rome, where they were given accommodation by the influential Massimo family. They were able to print 300 sheets per press per day. Their request for benefices and salaried ecclesiastical positions, and the 1472 petition to Pope Sixtus IV (1471–84), written by their editor Giovanni Andrea de'Bussi, the Bishop of Aleria (see 1.3.5), and appended to one of their books, makes it clear that success was not automatic even in the scholarly circles of the papal court. In a short time the market had clearly become overloaded. As clerics they were looking for ecclesiastical benefices to tide them over. That said, the Sweynheym and Pannartz firm survived the 1472 crisis for another year after Sixtus IV agreed to support them. [CMR]

Source: (a) Victor Scholderer (1966), 'The Petition of Sweynheym and Pannarz to Sixtus IV', in D. E. Rhodes (ed.), *Fifty Essays in Fifteenth- and Sixteenth-Century Bibliography* (Amsterdam: Menno Hertzberger, pp. 72–3; (b) Massimo Miglio, ed. (1978), *Giovanni Andrea Bussi. Prefazioni alle edizioni di Sweynheym e Pannartz. Prototipografi Romani* (Milan: Edizioni di Polifilo), pp. 82–4. (List of books with dates from Edwin Hall (1991), *Sweynheym and Pannartz and the Origins of Printing in Italy: German Technology and Italian Humanism in Renaissance Rome* (Oregon: Bird and Bull Press for Phillip J. Pirages), pp. 16–17.) Translated from the Latin by Dario Tessicini. Copyright © The Open University 2007.

a) The Petition of Sweynheym and Pannartz to Sixtus IV

Your devoted petitioners Conrad Sweynheym and Arnold Pannartz, clerics of the dioceses of Mainz and Cologne, book printers at the house of the Massimo family, beg Your Holiness to concede them two canonries in two cathedrals, metropolitan or collegiate churches, keeping an equal number of prebends attached to them, even though there may be major and administrative positions attached to the function or office of the curator and electors of others in the same church; moreover, one or two ecclesiastical benefices, even if one of the two is an administrative position requiring the care of souls, a deanery, or a rural archpresbytery, or whichever canonry and administrative position

attached to the function or office of the curator and electors in the same church has been or will be vacant [and] due together or separately for the collection etc. by each and all collectors, both secular and regular, through the production of letters giving them freedom of choice as to the places and by way of authority, etc. You should agree to provide [these letters] to the said Conrad and Arnold by special grace including all exceptions and appropriate clauses.

And [they should be dated] the first of January of the first year of your pontificate; and [they should include] both payments and all benefices; and [they should be valid for] the deanery and the benefice in a cathedral or in metropolitan churches; and their positions and prebends in the same churches as above, and with the statutory exception as regards the choice; and the absolutions [should be] granted to the same petitioners in writing and with a clause of absolution from censorship, etc, even if in effect, etc.

And the above Apostolic letters should be valid everywhere without added costs, even those payable to the abbreviators.[1]

b) Letter of the Bishop of Aleria, Joannes Andreae, Librarian to Our Holy Pontiff, to Pope Sixtus IV

It was once a common and repeated opinion among the pagans, Holy Father and Pope Sixtus IV, that twelve selected princes among those reputed to be the best had to be always prepared for some necessity, and among all authorities their office was exercised through an absolute power. In this respect, Your mercy and wisdom can show that the same can be properly said of the Christians, too. The servants of Your Holiness, Conrad Sweynheym and Arnold Pannartz, our book printers and the first artisans of this beneficial and creative art in Italy, who work mainly in this city and are at Your most holy feet kissing the same ground where Your foot has rested, implore that you have mercy on them, and have asked me to write their letters. I wrote this in their name, in the first instance to [Your] predecessor [Paul II] and secondly to Your divine authority. Holy Father, the book printers [are] struggling and, if Your generosity will not assist, fading under the heavy weight of the books. These are their words:

'We [were] first among the Germans to bring this useful art to the Roman Curia at the time of Your predecessor, with great effort and costs. With our example we have encouraged others in the book industry to try the same. Having been almost left stranded by the amount of expenses involved by this entire enterprise, we resisted with great difficulty and doubled our efforts and

[1] An official of the papal court.

lifted our spirits. Now, we are finally at the end of our tether and implore Your divine intervention. If you read the list of the works we printed, O Father, you will be surprised by how the paper for such a number of books could suffice for an outline of such prominence and apostolic zeal. And should You be able to read it in its entirety, being so occupied as You are with pontifical offices, this letter won't require anything else. In fact, having seen the names of the authors, You will not be able to go any further, if we know Your compassion well enough, as You will soon come to our rescue without distraction from any other business or worry. Holy Father, the books printed in our workshop are catalogued by subject here below:

Donatus, *Pro puerulis*	300 [copies]
Lactantius, *Institutiones contra gentiles* and the other opuscula of this author	825 [1465, 1468, 1470]
Cicero, *Epistolae ad familiares*	550 [1467, 1469]
Cicero, *Epistolae ad Atticum*	275 [1470]
Rodrigo Sánchez di Arévalo, *Speculum humanae vitae*	300 [1468]
Augustine, *De civitate Dei*	825 [1467, 1468, 1470]
Jerome, *Epistolae*	1100 [1468, 1470]
Cicero, *De oratore* and other works	550 [1465?, 1469]
Cicero, *Complete philosophical works*	550 [1469, 1471]
Apuleius, *The Platonist with Alcinous*	275 [1469]
Aulus Gellius, *Attic nights*	275 [1469]
Julius Caesar, *Commentarii*	275 [1469]
Bessarion, *Defensio divi Platonis*	300 [1469]
Vergil, *Opera omnia*	550 [1469, 1471]
Livy, *Historiae romanae decades*	275 [1469]
Strabo, *Geographia*	275 [1469]
Lucan, *Pharsalia*	275 [1469]
Pliny, *Historia naturalis*	300 [1470]
Svetonius, *De duodecim caesaribus*	275 [1470]
Leo I, *Sermones*	75 [1470]
Quintilian, *Institutiones oratoriae*	275 [1470]
Thomas Aquinas, *Catena aurea*	550 [1470]
Cyprian, *Epistolae*	275 [1471]
Bible, with the opusculum of Aristeas	550 [1471]
Silius Italicus with Calpurnius and Hesiod	275 [1471]
Cicero, *Orationes*	275 [1471]
Ovid, *Opera*	550 [1471]
Nicholas of Lyra, *Postilla*	1100 [1471–2]

The sum of all these volumes, as you can see, O Blessed Father, amounts to 12,475 (if we are not mistaken), definitely an enormous amount to bear for your printers, whose position remains untenable. And this is why we initially considered the need of a letter. In fact, the relevant sum necessary for our subsistence cannot do more for us, now that the number of buyers have fallen. And the lack of customers cannot be better shown than by the quires that fill our houses, which, in turn, are empty of commodities. Thus, our hope lies in You, Good Father, who are most wise and learned. To You is given the opportunity to find a remedy for our need so that we do not succumb. Give us help from the highness of Your throne: we are ready for the generosity of Your decision, that is, to give You those of our goods, meaning the quires that we printed, and as many as You wish to have. Let Your extraordinary goodwill support us with some favour on which we and our families can live. The expenses for the volumes of Nicolas of Lyra alone are so considerable that nothing is left for us to survive. If we were to sell our works, not only would we seek nothing from Your generosity, but we would offer them of our own accord and at the precise moment when we know that you need many things, and we will do so with a serene countenance whenever our fortune seems to have made use of your support. Meanwhile, Holy Father, let Your compassion rescue us, since we are left in great poverty. Be always safe and happy, most Blessed Father.'

Rome, 20 March 1472, the first year of Your generous pontificate.

1.6.3
A printer tries to protect his creative rights

In March 1503 in Venice, Aldus Manutius (c.1450–1515) printed a broadsheet in which he accused printers of Lyon of forging books in his name. Aldus had received privileges both from the Venetian government (1501) and from the papacy (1502 and 1503) to protect not an edition of a book, as was usual, but a typeface which was to evolve into the modern italic. Its attractiveness and usefulness meant that it was soon copied in Fano, Florence and Lyon. Aldus had already received a similar privilege in Venice in 1496 for the first of the four Greek typefaces he had designed. The Lyon copyists paid little attention to Aldus's public letter and, to add insult to injury, used the list of mistakes

he included with his books to correct their copies.[1] This example shows that while privileges were an increasingly common recourse for printers keen to protect their rights and exclude others from stealing their designs, whether images or entire editions, they effectively had little impact across national borders in what was a truly international market. Dürer experienced a similar problem (see document 1.6.4). [CMR]

Source: A. A. Renouard (1803), *Annales de l'Imprimerie des Aldus*, Paris, vol. 2, pp. 207–11. Translated from the Latin by Dario Tessicini. Copyright © The Open University 2007.

Aldus Manutius, Roman, to his reader

When I first started to provide scholars with high-quality books, I thought that my trade was only to make sure that the best Greek and Latin works were published by our New Academy, and that they were so perfectly edited through our work and care that they could promote good letters and arts. In truth, something very different happened, so difficult was it to establish the Latin language.[2] Besides the wars, which started, for reasons I do not know, at the time I first came to this harsh country, and which still last today (so that the letters have fought hard with the armies for seven years already), my employees and contractors have already conspired against me four times – Avarice leads to all sorts of evil. With the help of God, they have all been so shattered as to regret their meanness. Now in addition, my books have been badly printed and published under my name in the city of Lyon. They do not bear the name of the publisher, or the place where they were printed, but in order to trick imprudent buyers, their deceit lies in similar fonts and the shape of the book, [which suggest] that these books were produced by us in Venice. For this reason, that is, so that this circumstance will not damage the scholars as well as myself, I want to warn everybody through this letter (and the following) not to be fooled.

To my knowledge [the following authors] have been printed in Lyon with fonts similar to ours: Vergil, Horace, Juvenal with Persius, Martial, Lucan, Catullus with Tibullus, Propertius and Terence. None of them has the printer's name, place, or year of publication. All our books, instead, read 'In

[1] Lisa Pon (2004), *Raphael, Dürer and Marcantonio Raimondi: Copying and the Italian Renaissance Print* (New Haven and London: Yale University Press), p. 45.

[2] Manutius is steeped in Latin literature: this line cleverly adapts Virgil's description of Aeneas' struggle to found Rome – 'so difficult was it to establish the Roman nation', *Aeneid* 1.33.

Venice, in the house of Aldus Manutius, Roman', in this or that year. Secondly, the others do not have any device. Ours have a dolphin coiled around an anchor [. . .]. Moreover, their paper is not of good quality, and it stinks of I don't know what and, at a closer look, there is something French about the fonts (as I will demonstrate). The small capitals are completely mis-shaped and also the vowels and consonants are not connected but detached. In our books these are mostly connected to one another, and it is worthwhile to have a look at these imitations. It is easy to recognize that these are not mine, with all those evident mistakes in them. For instance, in Vergil's edition published in Lyon, at the end of our letter preceding Tityrus's *Bucolics*, it is wrongly printed 'optimos quousque autores' instead of 'optimos quosque'. And at the end of the *Aeneid*, in the first half-page of our letter to the reader, in the last line, it has been incorrectly printed 'maria omnie cirtm', instead of 'maria omnia circum'. Also, there are no accents on the words, while I wrote my letter for the purpose of showing how we should use the accents. And this is what is printed in the edition of Horace, in the second line of my letter: 'Imprissis vergilianis operibus', instead of 'Impressis'. Thirdly, 'Flaccum aggrssi', instead of 'aggressi'. Moreover, the small capitals before the first *Ode*, in the first and second verse, are dreadfully finished with printing ink above and below, as a sort of line. My letter in Juvenal's edition, in the third verse, has 'pubilcamus', instead of 'publicamus'. In the tenth verse 'Ungues quae suos', instead of 'ungues que suos'. Next, in the first half-page 'Semper et assiduo ruptae rectore', instead of 'lectore'. In the same, 'Si vacat, et placidi rationem admittis, eadem', instead of 'edam'. And shortly after, 'Cum tenet uxorem', instead of 'tener'. And later on, 'Eigat aprum', instead of 'figat'. In Martial's edition, right at the beginning of the first half-page, it has been printed in capital letters 'ΑΜΡΗΙΤΕΑΤRUM' instead of 'ΑΜΡΗΙΤΗΕΑΤRUM'. The same has 'Quae tam se posita', instead of 'seposita'. And in the second book to Severus, the Greek εκατοκωλικόυ is missing. [. . .] In Lucan's edition the preliminary epistle is missing, while there is one in mine. At the end of Catullus's edition, they have omitted the letter that is in mine. And these are also indications of whether the books are printed by me in Venice, or in Lyon. And although I have never published an edition of Terence, one has been published anonymously among others in Lyon. This has been done to deceive customers, who might think that it was mine because of the small size of the book and the similar fonts. In fact, they knew that we were planning to reinstate the original text, even keeping the ancient prosody. Therefore, having great expectations, they rushed their publication, hoping that it could be put on sale before I could publish mine. But when the corrected edition has come out, it will be possible to know that right at the beginning of the other it is printed EPITAPHIUM TEREMTII,

instead of 'Terentii'. Moreover, 'Bellica praedia fui', instead of 'praeda' and 'Haec quunque leget', instead of 'quicunque'. At the beginning of the second leaf 'Acta Ludis Megaliensibus, M. Fulvio aedilibus, et M. Glabrione, Q. Minutio Valerio curulibus', instead of 'M. Glabrione, Qu. Minutio Valerio aedilibus curulibus'. Also, thinking that it was the content, they printed 'ARGUMENTUM ANDRIAE'. Before 'Sororem falso', there is 'TERENTII ARGUMENTUM', since these are the contents of Terence's comedies. Yet, it is not by Terence but it was written by Sulpitius Apollinaris, as it is found in the oldest manuscripts 'C. Sulpitii Apollinaris periocha'. The prosody is also very chaotic. The verses of the first scene, which are all trimeters, are separated one from the other, and have to be restored in their place. [. . .]

Those who understand these things should consider how much of my work I put into the editing. We work attentively day and night. We have decided to publish this letter, so that those who will buy these printed textbooks will not be deceived. In fact, it is easy to recognise whether they were published in our house in Venice, or in Lyon.

With regards. Venice, 16 March 1503

1.6.4
Dürer's letter to Jakob Heller

Albrecht Dürer (1471–1528) was both a painter and a printmaker. This letter of 26 August 1509 was written to his patron Jakob Heller on the completion of a painted altarpiece of the Assumption of the Virgin, now destroyed, for the Dominican church in Frankfurt. The fee for the painting was a bone of contention between the two men, and here Dürer points out that he could get 300 florins for such a work in his home city of Nuremberg, and that he had been offered a similar commission for 400 florins, while Heller's 200 florin fee had originally been even lower at 130 florins. One reason for the expense was Dürer's unstinting use of the blue pigment ultramarine, which was fabulously expensive. The artist's famous final outburst that he would have been 1,000 florins better off had he stuck to printmaking was no doubt caused partly by exasperation, but nonetheless it indicates that printmaking was a profitable business at the turn of the sixteenth century, perhaps even more so than painting. The letter also provides valuable insight into some of the more mundane concerns of altarpiece production, including the provision of a frame and satisfactory varnishing. [KWW]

Source: H. Rupprich (1956), *Dürer Schriftlicher Nachlass*, vol. 1 (Berlin: Deutsche Verein für Kunstwissenschaft), pp. 72–3. Translated from the German by Susanne Meurer. Copyright © The Open University 2007.

Albrecht Dürer in Nuremberg to Jacob Heller in Frankfurt am Main, 26 August 1509

First of all rest assured that I am your humble servant, my dear Jacob Heller!

In response to your most recent letter I am sending you the panel well wrapped and with all necessary care taken. I have entrusted it to Hans Imhoff, who has given me another one hundred florin. And believe me, upon my loyalty, that I am still forfeiting my own money in this [venture], without having wasted any time I spent on it. I was also offered 300 florins for it here in Nuremberg. Indeed, these 100 florins would have done me some good, if I had not sent [the picture] to you as a favour and service, since I value the continuation of our friendship higher than 100 florins. I had also rather this painting was in Frankfurt than in any other place in all Germany. And if you assume that I did you an injustice by not letting you set the payment freely and according to your wishes, this happened because you had informed me through Hans Imhoff that I might keep the panel for as long as I wished. Otherwise I would have gladly left it up to you, even though I would have suffered still greater damage. I, however, came to you in the hope that if I had promised to make you something for 10 florin, which then cost me 20 florins, you would not want me to suffer the damage. I therefore ask you to be content that I am taking 100 florins less from you than I could have had for [the painting]. And I am telling you that people wanted to take it from me almost by force, for I painted it with great diligence, as you will see. It is also made with the best colours that I could get hold of. Good ultramarine was used around five or six times for the ground, the upper layers and the final touches to the painting. And after I had already finished it, I again painted over it twice so that it should last for a long time. I know that if you keep it clean, it will remain clean and fresh for 500 years, as it is not made as paintings are usually made. Therefore ensure that it is kept clean, that it will not be touched or have holy water sprinkled on it. I know that it will not be defiled unless so as to harm me. And I thus think that it will please you much. No one shall be able to convince me to make another painting with such efforts. Georg Thurzo himself has offered me a commission for a Virgin in a landscape of the same measure, meticulousness and size, for which he wanted to give me 400 florins. I have refused

this outright, as it would turn me into a beggar. I may choose to make a heap of common paintings in a year bigger than anybody would think possible for one man to accomplish, since on those one can make a profit. This diligent and painstaking work, however, will not continue. Therefore I want to turn my attention to engraving and if I had done so hitherto, I would now be 1,000 florins richer. You should also know that I had a new frame made at my own expense for the centre panel, which cost me more than 6 florin. I have removed the old one because the joiner had made it coarsely. I have, however, not had it fitted with hinges, as you did not want this. It would be good if you had the painting screwed to the frame so that the panel won't split. And when you want to mount the panel, have it installed with two or three fingers' width overhang so that it can be viewed without obstruction from glare. And when I come to see you sometime in the next one, two or three years, the panel will have to be taken down [to check] if it has dried out. In this case, I will once again cover it with a special varnish, which no one else can make, so that it will last for another 100 years longer than [I said] before. Do not, however, let it be varnished by anybody else, as all other varnishes have a yellow tint, which would spoil your painting. I myself would be sorry to see something ruined on which I have worked far more than one year. And be there in person when it is installed so that it shall not be damaged. Treat it carefully, for you will find out from your painters and from strangers how [well] it is made. Please greet your painter Martin Heß from me. My wife kindly asks you for the tip you owe her. I myself ask nothing more of you and hereby recommend myself to you. Please read this letter for its gist, I have written it in haste.

Nuremberg, the Sunday after St Bartholomew 1509
Albrecht Dürer

1.6.5

A letter from block-cutter Jost de Negker to Maximilian I

The Emperor Maximilian I of Austria initiated several woodcut projects in Augsburg, served by the printer Johann Schönsperger (d. 1520) and managed by the court advisor and secretary of Augsburg Conrad Peutinger (1465–1547). The illustrated book or project for which Jost de Negker's woodblocks

were destined is not specified in this letter. Parshall and Landau[1] suggest that it might have been the *Theuerdanck*, an illustrated, semi-biographical romantic account of Maximilian's youth and betrothal, for which Hans Schäufelein, the artist named in the letter, designed some of the woodcuts. The Netherlandish block-cutter Jost de Negker (d. c.1544) entered the Emperor's service some time after 1508. This letter of 27 October 1512 shows that the superior status often accorded to artists as opposed to craftsmen today did not necessarily apply in the Renaissance period. It was the block-cutters who were the salaried, official court employees, on sufficiently good terms with the Emperor to write to him personally. The letter suggests the relatively generous level of salary a skilled block-cutter could command as compared with the designer, and the rate at which he was expected to work (about two blocks a month, assuming de Negker did not already have additional cutters in his service). Hans Schäufelein (c.1482–1539/40) was apparently more of a jobbing designer, paid per design and then only inconsistently. The 1512 portrait of Hans Paumgärtner that Jost de Negker mentions as having been cut from three blocks was the earliest chiaroscuro woodcut to be made using tone blocks alone and was designed by Hans Burgkmair (1473–1531).[2] [KWW]

Source: A. Biff (1892), 'Rechnungsauszüge, Urkunden und Urkundenregesten aus dem Augsburger Stadtarchive, I, 1442–1519', *Jahrbuch der Kunsthistorischen Sammlungen des Allerhöchsten Kaiserhauses*, vol. 13, part 2, pp. xvii–xviii. Translated from the German by Susanne Meurer. Copyright © The Open University 2007.

I have been informed that Your Imperial Majesty desires and requests that the task and individual pieces, which I am in the process of making, should make better and more beneficial progress, and that You have written to Doctor Peutinger on account of this and arranged for him to send me another two or three block-cutters.

This is fine by me, Your most gracious Highness.

I happen to know two block-cutters, who are competent and who would like to work with me in Your Imperial Majesty's service, so that they should learn my new art of cutting, an invention which I, more than anybody else, am capable of, skilled in and knowledgeable about. Even though Schönsperger may have boasted in front of Your Imperial Majesty about his new printing [technique], he learnt it from no one but myself and did it in the same way.

[1] D. Landau and P. Parshall (1994), *The Renaissance Print 1470–1550* (New Haven and London: Yale University Press), pp. 200, 207–8.
[2] Ibid., p. 200.

Hence, if Your Imperial Majesty should be inclined and disposed to accept these two block-cutters, would Your Imperial Majesty have them summoned to me and arrange with Paumgärtner that each should received 100 florins per year so that I can sustain them and they can make a living. I, in the meantime, will take care to arrange and prepare everything for these two block-cutters and finally complete and add the finishing touches in my own hand so that the entire work and all individual blocks will in the end all have similar carving and appear to have been made by one cutter, without anyone being able to distinguish more than one workman.

Once I thus have these other two with me (as I rest assured that Your Imperial Majesty will grant rather than deny [my request] in order to advance the project), I can offer Your Imperial Majesty the preparation and completion of six or seven good pieces or figures of equal and masterful cut per month.

Once my outlined request has been granted, Schönsperger, or whoever else receives orders, will presently commence with the printing. I will also employ all my diligence in what I know and am more capable of than anybody else, as I pointed out above, so that this project shall progress and be completed to Your Majesty's contentment. Therefore would Your Imperial Majesty instruct Hans Paumgärtner to the effect that I will be able to give each month to the two block-cutters what is due to them of their hundred florins so that they can buy food. Most gracious Sir, I have been approached and beseeched by the draughtsman and painter Hans Schäufelein to write to Your Imperial Majesty on account of the fact that after he had designed and drawn figures at Schönsperger's behest and when he should have earned and received a fee from him for what he had worked on and prepared, he could not get any payment out of Schönsperger. [Schäufelein asks] if Your Imperial Majesty could be so kind as to arrange for Doctor Peutinger, Paumgärtner, myself or someone else to ensure that he should be certain to receive his pay. He would much like to receive it from me as someone who understands these matters and as a result he would also be more diligent. For, when Schönsperger pays him, he does so as he pleases, giving him two florins for three figures, etc. I have also been informed that it was brought before Your Imperial Majesty that I was making blocks other than those for Your Imperial Majesty. This shall never happen again, for I have only made one exception when Dietrich Steiner commissioned me to make the portrait of Hans Paumgärtner from three blocks of the size of one sheet, as Your Imperial Majesty will see once they have been printed. Otherwise I have done nothing for anybody. If Your Majesty gives us orders as outlined above, could Your Imperial Majesty arrange for lodgings for us three block-cutters so that we shall have a household to ourselves and shall not be distracted [from our work] by others. For the project demands above

all other things that we should be alone. I graciously plead for your Imperial Majesty to take care of the above and request a reply.

On the eve of St Simon and Jude the apostle, in the year 1512.

1.6.6
The purchase of the contents of an Antwerp printer's workshop

Adriaen van der Eycke's second-hand printing materials had been purchased by Antwerp painter Jan van Dornicke from the dead printer's widow. In addition to a printing press and woodblocks made of pear wood, the inventory also mentions colours and paint brushes. This and the name of the original owner, Adriaan (or Aert) the Illuminator ('verlichtere'), suggest that as well as making prints, Adriaen hand painted them, a reminder that many fifteenth-century prints were, in fact, coloured. According to Jan van der Stock (see the source below, pp. 98, 104, 107), he may have been concerned primarily with the production of decorative printed paper used for wrapping and domestic decoration, but he could have produced figurative prints too. Little else is known about Adriaen van der Eycke. [KWW]

Source: Jan van der Stock (1998), *Printing Images in Antwerp: The Introduction of Printmaking in a City, Fifteenth Century to 1585* (Rotterdam: Sound & Vision Interactive), doc, 13, p. 319. Translated from the Dutch by Ria de Boodt and Rembrandt Duits. Copyright © The Open University 2007.

Adriaen van der Eijcke, printer of images, son of the late Jan, [and Margriet Schalix Jansdochter, his late wife – struck from the record] owes Jan van Doornick, painter, son of Marten, or whoever he appoints in his place [literally 'aut latori': 'or the bearer'], the sum of 345 Rhein guilders and 14 stuivers. Out of this sum, 200 Rhein guilders are for print making equipment, such as woodblocks,[1] (some cut and others new) brushes, pots of paint (some prepared for use and others not), and a press with all its accessories, including all the pear wood required for it, which Jan bought recently from the widow

[1] The Dutch word used here is 'patronen', a general term meaning designs, but the following clause suggests that here it means woodblocks.

of the late Aert, illustrator. The remaining 145 Rhein guilders and 14 stuivers are for prints on fine paper, some of them coloured and others not, which he [Jan] also supplied and provided him [Adriaen] with. The first 200 guilders are due next Christmas, the remaining 145 Rhein guilders and 14 stuivers by Christmas a year later, or by mid March the following year at the latest, for which he [Adriaen] commits himself with everything he possesses. And should anything go wrong with the payment, or with Adriaen [and his wife – struck from the record], or with his possessions, it is determined that Wouter Embrechts, cabinet maker, and Hyllegond van der Eycke, Adriaen's sister; together with her guardian, will come and settle the matter, pledging themselves and what they own. With this surety for Adriaen himself and his possessions, 18 November [1512].

1.6.7
Erasmus's eulogy on Dürer

Desiderius Erasmus of Rotterdam (c.1466–1536) was perhaps the most renowned humanist of the turn of the sixteenth century, whom Dürer had met and sketched during his trip to the Low Countries in 1520. It was perhaps partly a result of receiving the engraved portrait Dürer eventually made from this sketch in 1526 that prompted Erasmus to include a eulogy on Dürer in his dialogues on the proper pronunciation of Latin and Greek written in 1528, the year of Dürer's death. Significantly, Erasmus focuses not on Dürer the painter but on Dürer the printmaker, whose achievements were all the more remarkable for his eschewing the use of colour. The paradox is that many fifteenth- and sixteenth-century prints were hand coloured, including some by Dürer. The Roman writer Pliny the Elder (23–79 CE), to whom Erasmus refers, recounted Apelles' rivalry with another artist in drawing fine lines, stressed his drawing skills and admired the skill of Apelles and others for successfully restricting their palette to four colours, stating: 'Everything was better when there were fewer means. The reason for this is . . . that now we only appreciate the richness of the material and not that of the mind.'[1] Erasmus's eulogy is very much in the same spirit of praising skill and should probably not be understood as a negative aesthetic judgement on coloured

[1] J. Isager (1991), *Pliny on Art and Society: The Elder Pliny's Chapters on the History of Art* (London and New York: Routledge), p. 125.

prints.[2] He was clearly also familiar with Dürer's theoretical treatises, which he publicized here. [KWW]

Source: Erasmus Desiderius (1985), *Collected Works*, ed. J. K. Sowards, vol. 26 (*Literary and Educational Writings* 4: *De recta pronuntiatione*), trans. Maurice Pope (Toronto: University of Toronto Press), pp. 398–9, and p. 597 for notes. Reprinted by permission of the University of Toronto Press.

Lion That would seem just about to cover the subject of writing.

Bear I must add one thing more. All this must be done in such a manner that the boy believes himself to be playing, not learning. Writing is sometimes taught with such savagery that boys learn to hate their letters before they can recognize them.[3] Another thing that will help is for a boy to be occasionally encouraged to do some painting. In fact most boys will want to of their own accord. They love trying to copy the world around them and to identify what others have copied. Just as those who are good at music enunciate better than others, even when they are not singing, so people whose fingers are practised in drawing all sorts of lines write the letters of the alphabet with greater flexibility and grace. You will find a more thorough and detailed treatment of the whole topic in a book by Albrecht Dürer.[4] It is written in German, but is nevertheless full of learning. Dürer is in the tradition of the ancient masters in the field, like Pamphilus of Macedonia and Apelles. Pamphilus was highly learned, as much in literature generally as in geometry and arithmetic, and claimed that these subjects were indispensable to him; Apelles wrote for his pupil Perseus a book on painting in which he says that many of the secrets of his art are derived from mathematics and discusses in some detail the shapes of the letters and the strokes and the proportions to be used in drawing them.

Lion Dürer's name[5] is one I have long been familiar with as a leading painter. He has even been called the modern Apelles.

[2] See S. Dackerman (2003), *Painted Prints: The Revelation of Colour in Northern Renaissance and Baroque Engravings and Woodcuts* (Pennsylvania State University Press/ Baltimore Museum of Art) (exhibition catalogue).

[3] learn to hate . . . recognize them] Erasmus makes the same point in *De pueris instituendis* (CWE 26 324) and *Institutio christiani matrimonii* (LB V 712D).

[4] Dürer's treatise on measurement: *Underweisung der Messung* (Nürnberg 1525); facsimile edition by Alvin Jäggli (Zuring 1966). The third book (of the four into which the treatise is divided) contains detailed prescriptions for forming Roman capital letters on geometric principles.

[5] Dürer's name] In a letter to Pirckheimer (Allen Ep 1991) Erasmus says that this passage was intended as an epitaph for his friend Dürer.

Bear In my view Apelles,[6] who was a man with a generous and noble heart, would if he were now alive willingly stand down to our own Albrecht and allow him first place.

Lion How can you suppose that?

Bear I admit that Apelles was a prince of painting and that his rival artists could find no fault with him except that he did not know when to stop, a criticism which is a sort of compliment in itself. But Apelles used colour. His colours were admittedly restricted in number and the reverse of flamboyant, but they were colours none the less. Dürer, however, apart from his all-round excellence as a painter, could express absolutely anything in monochrome, that is with black lines only – shadows, light, reflections, emerging and receding forms, and even the different aspects of a single thing as they strike the eye of the spectator. His harmony and proportions are always correct. Above all, he can draw the things that are impossible to draw: fire, beams of light, thunderbolts, flashes and sheets of lightning, and the so-called clouds on the wall,[7] feelings, attitudes, the mind revealed by the carriage of the body, almost the voice itself. All this he can do just with lines in the right place, and those lines all black! And so alive is it to the eye that if you were to add colour you would spoil the effect. It is surely much cleverer to be able to dispense with the meretricious aid of colour that Apelles required and still achieve the same results as he did.

Lion I never realized that painting required so much skill. Nowadays it scarcely brings in enough to feed the artist.

Bear There is nothing new in supreme artists being poor men. However painting was once one of the liberal arts.[8] At first only noblemen were permitted to learn it. Subsequently it was allowed to[9] gentlemen of free birth. But teaching it to slaves was forbidden.

[6] Apelles] Erasmus' account of Apelles comes from Pliny *Naturalis historia* 35.79–97, including his magnanimity towards his fellow artists (80, 87), his restricted palette (four colours, 92), and his ability to 'draw things which are impossible to draw' (96). On this last see *Adagia* ii iii 38. 'Not knowing where to stop' is also in the *Adagia* (i iii 19, 'Manum de tabula' literally 'Hands off the picture'). Strangely, Erasmus tells the story the wrong way round. In Pliny 35.80, and also in Cicero *Orator* 73 it is Apelles who accused Protogenes of this fault.

[7] so-called clouds on the wall] *Adagia* ii iv 38.

[8] painting . . . liberal arts] Pliny 35.77 tells us that painting first entered into the syllabus of school education through the influence of Apelles' master, Pamphilos. Erasmus sets painting, along with sculpture and medicine, in a median position between liberal and mechanical arts in his in *Institutio christiani matrimonii* (lb v 661e).

[9] it was allowed to] Added in 1529.

In any case the fact that their rewards are too low is not a disgrace to the artists but to the princes, their patrons.

Lion It is clearly very important to begin with first-class instruction in any skill one is trying to acquire.

1.6.8

Robert Peril's agreement regarding the manufacture of playing cards in Antwerp

Engraving or drypoint were used to print packs of playing cards as early as the second quarter of the fifteenth century, most famously by the so-called Master of the Playing Cards. This document provides important evidence, albeit much later in date, about the making of cheaper woodcut playing cards. Robert Peril produced woodcuts in Antwerp from at least 1522, and is known for two important and large-scale projects: the 24-piece woodcut of the triumphal entry of Charles V on his coronation as emperor, commissioned by Margaret of Austria, Regent of the Netherlands (1530), and the 20-sheet genealogical tree of the house of Habsburg (1540).[1] He belonged not to the artists' Guild of St Luke but to the traders' guild. According to the document here, he had evidently lent woodblocks to Jehan Pamier for the manufacture of cards, suggesting he was also something of an entrepreneur.[2] The quantities of materials and products mentioned in this document are enormous: 500 reams of paper, or 250,000 sheets, and 31 dozen and subsequently 40 gross, or 5,760, packs of cards. The printing of woodcut playing cards was evidently a thriving enterprise, a reminder of the importance of the lower end of the print market, however poor the survival rates of the actual objects might be. An uncut section of playing cards re-used as printed ceiling decoration and recently uncovered in a sixteenth-century house in Antwerp offers an indication of what some of these playing cards might have looked like.[3] [KWW]

[1] D. Eichberger (ed.) (2005), *Women of Distinction: Margaret of York and Margaret of Austria* (Turnhout: Brepols) (published to coincide with exhibition at Mechelen, Belgium), pp. 80–1, 133.

[2] Van der Stock, 1998, p. 38.

[3] Ibid., p. 175, fig. 102.

Source: Jan van der Stock (1998), *Printing Images in Antwerp: The Introduction of Print-making in a City, Fifteenth Century to 1585* (Rotterdam: Sound & Vision Interactive), doc. 17, pp. 328–9. Translated from the French by Isabelle Dolezalek. Copyright © The Open University 2007.

[these words were deleted]

Namely, that today have appeared before us in person Robert Peril, resident in the city of Antwerp on the one hand, and Jehan Pamier of Rouen on the other hand. And they admitted and confessed to the debate and dispute existing between them because of the sum of 77 florins and 5 'patars' that the said Robert Peril owed the said Jehan Pamier for a contract and agreement of playing cards that this Pamier had to deliver to the said Peril. These two parties have come to an agreement as to the above mentioned debate and all that relates to it in the following way. Firstly, that the said Robert Peril, as a payment of the said sum of 77 florins and 5 'patars', yields and transfers to the said Jehan Pamier first of all a debt of 65 guilders and a half, which Jehan Bessart has received from the said Robert. Item also a debt of 33 florins, which Anne Dams, paper maker, resident at the Pont au Tour owes him because of an agreement for 500 reams of paper which the said Anne had to deliver and for which she had received the said 33 florins. And also the entire share and portion that belongs to Robert in the wood of Buys de la Drynoise, which he had bought from the lord of Saint Amadocq, knight and viscount of Quyngnan in Brittany.[4] For the said debts, the said Jehan Pamier may profit by and make use of the said wood, he may receive and do with it and dispose of it as of his own goods, by him suitably acquired, and the said Robert cannot claim any further rights or power over it in any way. By means of this above said concession and transfer, the said Robert will be and remain for ever cleared and acquitted of the said 77 florins and 5 'patars' as they have been entirely paid by him by means of the said concession and transfer, and the said Jehan Pamier will forever be and remain absolved and acquitted before the said Robert, of the said contract and agreement for the playing cards, which the same Pamier had to deliver him, except that the same Pamier will be held to hand over promptly and deliver to the said Robert 31 dozens of fine playing cards, which the said Pamier has already made and accomplished. Moreover, it has been agreed between these two parties that the said Pamier will be allowed to complete 40 gross of cards with the name and stamp of the

[4] Van der Stock identifies this individual with Jean of Saint-Amadour, viscount of Guignen in Brittany.

said Peril, all between now and next All Saints day and he can also sell them until the following 2nd of February, but they need to be the same as those that he had previously made. And the said Pamier will be held to restore and return to the said Robert his blocks and stamps by next Christmas. And thus the different parties will be and remain in agreement regarding the issues and differences mentioned above. And thus these parties have promised and are promising thereafter henceforth by their word of honour and oath to fully and firmly sustain and uphold this said contract and agreement and each one of its clauses, without doing or asking to do or tolerating to be done anything in opposition to this agreement, either by themselves or by any other, directly or indirectly [a note in the margin adds, 'on pain of forfeiting 100 florins for the benefit of the poor to be paid by him who acts to the contrary']. Renouncing all rights and benefits that could help and assist them against the above said, and equally renouncing the maxim 'a remuneration is not valid' etc.

1.6.9
Vasari's life of Marcantonio Raimondi

Vasari's *Life of Marcantonio and Other Engravers of Prints* was an addition to the second (1568) edition of the *Lives of the Artists*. In the 1550 *Lives*, Marcantonio appears as part of Raphael's 'Life'. The *Life of Marcantonio* is unusual because, instead of focusing on a single artist, Vasari used it to sketch a history of printmaking, the first of its kind. As usual, Vasari makes his subject suit his own purpose: for example, he excludes the origins of the technology among German printers and engravers who travelled to Italy, and supplants them instead in Italy with the Tuscan, Maso Fineguerra. However, in his history, Vasari includes a wide range of skills, from engravers to publishers, all of whom he sees as integral to the art. It was only after the publication of his *Lives* that printmaking and its practitioners gradually fell in status in relation to painting. In Vasari's view, Marcantonio's primary importance lay in providing printed reproductions of Raphael's work. Vasari's account is full of contradictions, and he has Marcantonio both collaborating with and stealing Dürer's designs. In suggesting that Dürer should have been born a Tuscan and in omitting the German origins of printmaking, Vasari reveals his bias towards Italian art. Vasari's additions and embellishments nevertheless make the 'Life' a telling source for the early history of printmaking and its reception in Italy. Its inclusion in the *Lives* is in itself a sign of his

recognition of the significance of printmakers – even if he found them hard to reconcile with his larger project.[1] [CMR]

Source: Giorgio Vasari (1996), *Lives of the Painters, Sculptors and Architects*, trans. G. du C. de Vere, intro. and notes D. Ekserdjian, 2 vols (London: David Campbell (Everyman's Library); this edition first published 1927 by Dent), vol. 2, pp. 78–9, 81–2, 84–5.

Marc' Antonio Bolognese and Other Engravers of Prints

While Francesco Francia was working at his painting in Bologna, there was among his many disciples a young man called Marc' Antonio, who, being more gifted than the others, was much brought forward by him, and, from having been many years with Francia and greatly beloved by him, acquired the surname of De' Franci. This Marc' Antonio, who was more able in design than his master, handled the burin with facility and grace, and executed in niello girdles and many other things much in favour at that time, which were very beautiful, for the reason that he was indeed most excellent in that profession. Having then been seized, as happens to many, with a desire to go about the world and see new things and the methods of other craftsmen, with the gracious leave of Francia he went off to Venice, where he was well received by the craftsmen of that city. About the same time there arrived in Venice some Flemings with many copper-plate engravings and woodcuts by Albrecht Dürer, which were seen by Marc' Antonio on the Piazza di S. Marco; and he was so amazed at the manner and method of the work of Albrecht, that he spent on those sheets almost all the money that he had brought from Bologna. Among other things, he bought the Passion of Jesus Christ, which had been engraved on thirty-six wood-blocks and printed not long before on sheets of quarter-folio by the same Albrecht. This work began with the Sin of Adam and the scene of the Angel expelling him from Paradise, and continued down to the Descent of the Holy Spirit.

Marc' Antonio, having considered what honour and profit might be acquired by one who should apply himself to that art in Italy, formed the determination to give his attention to it with all possible assiduity and diligence. He thus began to copy those engravings by Albrecht Dürer, studying the manner of each stroke and every other detail of the prints that he had bought, which were held in such estimation on account of their novelty and

[1] See Lisa Pon, *Raphael, Dürer and Marcantonio Raimondi: Copying and the Italian Renaissance Print* (New Haven: Yale University Press, 2004).

their beauty, that everyone sought to have some. Having then counterfeited on copper, with engraving as strong as that of the woodcuts that Albrecht had executed, the whole of the said Life and Passion of Christ in thirty-six parts, he added to these the signature that Albrecht used for all his works, which was 'A.D.,' and they proved to be so similar in manner, that, no one knowing that they had been executed by Marc' Antonio, they were ascribed to Albrecht, and were bought and sold as works by his hand. News of this was sent in writing to Albrecht, who was in Flanders, together with one of the counterfeit Passions executed by Marc' Antonio; at which he flew into such a rage that he left Flanders and went to Venice, where he appeared before the Signoria and laid a complaint against Marc' Antonio. But he could obtain no other satisfaction but this, that Marc' Antonio should no longer use the name or the above-mentioned signature of Albrecht on his works.

After this affair, Marc' Antonio went off to Rome, where he gave his whole attention to design [. . .]

But returning to Marc' Antonio: having arrived in Rome, he engraved on copper a most lovely drawing by Raffaello da Urbino, wherein was the Roman Lucretia killing herself, which he executed with such diligence and in so beautiful a manner, that Raffaello, to whom it was straightway carried by some friends, began to think of publishing in engravings some designs of works by his hand, and then a drawing that he had formerly made of the Judgment of Paris, wherein, to please himself, he had drawn the Chariot of the Sun, the nymphs of the woods, those of the fountains, and those of the rivers, with vases, the helms of ships, and other beautiful things of fancy all around; and when he had made up his mind, these were engraved by Marc' Antonio in such a manner as amazed all Rome. After them was engraved the drawing of the Massacre of the Innocents, with most beautiful nudes, women and children, which was a rare work; and then the Neptune, with little stories of Æneas around it, the beautiful Rape of Helen, also after a drawing by Raffaello, and another design in which may be seen the death of S. Felicita, who is being boiled in oil, while her sons are beheaded. These works acquired such fame for Marc' Antonio, that his engravings were held in much higher estimation, on account of their good design, than those of the Flemings; and the merchants made very large profits out of them. [. . .]

Now, the fame of Marc' Antonio having grown very great, and the art of engraving having come into credit and repute, many disciples had placed themselves under him in order to learn it. And of their number, two who made great proficience were Marco da Ravenna, who signed his plates with

the signature of Raffaello, 'R.S.,' and Agostino Viniziano, who signed his works in the following manner: 'A.V.' These two engraved and printed many designs by Raffaello, such as one of Our Lady with Christ lying dead at full length, and at His feet S. John, the Magdalene, Nicodemus, and the other Maries; and they engraved another plate of greater size, in which is a Madonna, with the arms outstretched and the eyes raised towards Heaven, in an attitude of supreme pity and sorrow, with Christ, in like manner, lying dead at full length. [. . .]

In the end, Agostino and the above-mentioned Marco between them engraved almost all the works that Raffaello ever drew or painted, and made prints of them; and also many of the pictures painted by Giulio Romano, after copies drawn for that purpose. And to the end that there might remain scarcely a single work of Raffaello that had not been engraved by them, they finally made engravings of the scenes that Giulio had painted in the Loggie after the designs of Raffaello.

Treatises, Histories, Artists and Education

1.7.1
Lorenzo Ghiberti on the education required for making sculpture

The Florentine sculptor Lorenzo Ghiberti (1378–1455) wrote his *Commentarii* around 1450 on the (erroneous) precedent that the ancient Greek sculptor Phidias had composed *Commentaries* (Ghiberti called him 'Pytios'). Ghiberti may also have heard of the *Commentaries* of Julius Caesar which had recounted his military exploits. Ghiberti's autobiography and account of recent art in Italy occupies Part II of the *Commentarii* and is, in one sense, an extension of the habit of keeping *Ricordi* or 'family histories', which Florentine patricians wrote during this period. However, it is one of a three-part treatise which seems to have been aimed at a wider public than his family workshop because it begins, in Part I, with a statement on the skills and knowledge required for a sculptor and a short history of ancient Greek art, and ends in Part Three with a dissertation on Arabic optics (see 1.2.3). In his Introduction to book I, Ghiberti borrows heavily from two classical texts: the introduction to Athenaeus' *Peri mechanematon* or *On Engineering* and the introduction to Vitruvius' *Ten Books on Architecture*. Ghiberti therefore adapted statements about architects and engineers to statements about sculptors. [CEK]

Source: Lorenzo Ghiberti (1912), *Denkwürdigkeiten: I Commentarii*, ed. Julius von Schlosser Magnino, 2 vols (Berlin: Julius Bard), vol. 1, pp. 3–8 and vol. 2, p. 99. Translated from the Italian by Dario Tessicini with footnotes translated from the German by Gerald Schmidt. Copyright © The Open University 2007.

As far as it is possible for one writing about sculpture, O Most Honourable, I shall bear in mind the divine Delphic warning, which admonishes to save time while using lavishly all other things necessary in life. Without regard for money or other seemingly valuable things, let us solely attend to the matters which the ancients have left to us in their writings. And this shall not be fruitless, as we deduce new inventions from them, or easily learn from others. We cannot, however, waste time, which is immutably passing, without regard as if it were worthless. For Nature gives us virtue

during the day to always perform what is useful in our present life, and night-time is similarly bestowed on us very generously for exercising the mind. Therefore those who are justly called wise do not allow themselves to sleep through all the time thus given for resting the body. It seems that they take such care so that the mind should not too long be indolent during the night. Those who write, or rather admonish and teach us, do so for our benefit. They do not use superfluous words, nor do they intend to make their treatises long-winded in order to demonstrate their profound skills. In fact, in doing so they would leave their books full of excess and overabundance and against the judgement of the ancient philosophers, who rightly deemed it necessary to know the measure of time, as well as the terms and definitions of philosophy.

Whoever ensures that this principle is diligently put into practice will greatly benefit from the Delphic warning, no less than from Astrone, Hosio, Archytas, Aristotle and others who wrote similar things. Their doctrines are not useless to young students as first elements and principles; but to those wanting to put something into practice they are altogether far and remote from active consideration. Hence it seems not without reason that Kalamo, a Greek philosopher, though Indian by nation, has told them: 'We are similar to those who spend many words on little matters, but on the most important ones we give the briefest precepts so that everyone can easily understand and remember them.' This point can most thoroughly be gathered by anyone through the commentaries of Dionecho and by those that through him followed Alexander [The Great], as did sculptors and painters and those tending to war-machinery used for sieges, on which Phyrrus Macedon has written. However, so as to not give the impression that we pursue wordiness, of which we disapprove, let us return to our point by firstly answering those who want to harshly correct the composition of words. For, it seems to me that those intent on this composition oftentimes fail to achieve their purpose. In an oration written by the orator Isocrates to Philip to advise him on whether to embark on an enterprise notwithstanding that war had been decided upon before he had dispensed his advice, [Isocrates] says the following: 'While I was occupied with this work, you achieved peace before I had finished the oration.' It also seems good to me to obey those who provide the right principles. Thus, the historian Callisthenes says that it is necessary for those who set out to write something according to the quality of the person and of the work to always adapt the words from one topic to the next. I believe that each dis-course about this art should be brief and clear, as sculptors and painters are, and that as a topic it does not fall under the precepts of rhetoric.

The sculptor, as well as the painter, should be trained in all of the following liberal arts:

Grammar	Perspective
Geometry	History
Philosophy	Anatomy
Medicine	Theory of drawing
Astrology	Arithmetic

Sculpture and painting are a science ornately formed of various disciplines and skills, and it is the greatest among all other arts. The work is made with a certain consideration, which is achieved through [the practical matter of] materials and the industrious [theoretical] reasoning of any generation. And it is through the aim of formation and reasoning that things made with a ratio of astuteness and reason can be demonstrated and explained.

Thus, sculptors and painters, who have disputed [their works] without letters and as if they had used their hands [for their argument] could not achieve or finish [their work] as if they had had the authority for their efforts; while those who come to achieve [their works] through reasoning and letters alone have only a shadow, not the thing itself. Yet those who practised both aspects, as if with all arms adorned, reached their aim much more promptly with authority.

Therefore, it follows that in all disciplines, and particularly in sculpture, there are two aspects: one that is taught and one that teaches itself. The subject is taught and the demonstration is explained on the grounds of doctrine. Hence he who declares himself a sculptor should be seen to be trained in both aspects. He should have great skills and masterly discipline, as skill without discipline, or discipline without skill cannot produce a perfect craftsman. Yet equally, he should be literate, have experience in writing and mastered geometry, have sufficient knowledge of history, or have diligently read philosophy. He should have mastered medicine, read astrology and be proficient in perspective. Moreover, he should be a most perfect draughtsman, and this applies to both sculptors and painters, as drawing is the basis and theory of these two arts. Without being much skilled in the said theory, he cannot have knowledge of or be a perfect sculptor, or a perfect painter. A sculptor is as perfect as he is accomplished as a draughtsman, and the same goes for painters, as the said theory is the origin and foundation of any art.

Besides, he should have seen the works of the ancient and noble mathematicians and geometers, as well as the works by the following authors: Aristarchus of Samos, Philolaus, Archytas of Tarentum, Cirineo, Scopinas,

Archimedes of Syracuse, Apollonius, Constantine the African,[1] Aphacon[2] and Ptolemy.[3] Through natural reasons they have explained many gnomic and numerological matters and left them to following generations. For all that it follows that these qualities and such skill are not given to all men, but only a few.

The sculptor should magnanimously concentrate on philosophy. He should not be arrogant, but instead be simple, humble, faithful and without avarice. This is of great importance as no work can be perfect [if executed] without faith or purity. Neither should he be greedy, having his mind occupied by reaping profit. Instead, he should solemnly tend to his dignity, minding his good reputation, as is prescribed by philosophy. Besides, another essential thing to have studied is the nature of things, called in Greek physiology, or, expressly, philosophy since it deals with many different and interesting natural questions. This is evident in the great philosophers and mathematicians, who observe the principles of nature and know all their rules, as can be seen in the texts on the nature of things which Archimedes Anchimus wrote and also in those by Ctesibus and others of this kind. Those who read them will not understand them unless they are trained in philosophy.

The sculptor also needs to have knowledge of the disciplines of medicine and anatomy, so that when he wants to compose a male figure he knows how many bones there are in the human body, as well as all the muscles of the human body and similarly the nerves and ligaments contained therein. He should also be versed in astrological events and in those of the earth and have knowledge of those of the sky, which the Greeks call climates, in relation to the regions of the earth. Moreover, he should understand the celestial movements. Through astrology East and West, North and South are known, their explanation, equinox, solstice, the path of the Sun and the Moon, the planetary motions and those of the stars, the ecliptic and the twelve zodiacal signs.

[1] *Constantino Arabico*, i.e. Constantinus Africanus of Carthage (end of eleventh century), one of the founders of the medical school of Salerno; died monk of Montecassino. His medical writings, mostly translations from Arabic, were printed in 1536 in Basle. Cf. *Steinschneider*, 'Die europäischen Übersetzungen aus dem Arabischen, Sitzungsber. der kais. Akademie der Wissensch'. in *Wien. Phil. Hist.* 1904, CXLIX, 9. Ghiberti also cites this author in his third commentary.

[2] It is difficult to say which author is meant by this apparently corrupted name. *Alhazen* (*Alacen, Alacon* in the manuscript) is a likely candidate.

[3] *Tolomeo*, i.e. Cl. Ptolemy, the famous astronomer and author of the frequently cited work *Optics*, the original of which is lost and only available in a Latin translation from Arabic (by Eugenius Amiratus, 1154). (Ed. Princeps von Govi, Turin 1885; cf. Hirschberg, *Gesch. D. Augenheilkunde*, Leipzig 1879, I, 157ff.)

Who does not know about these matters, will not understand their causes either.

It follows that this discipline is adorned with and completed by various teachings, and I think with some justification that it is impossible to become a proficient sculptor or painter swiftly and to reach the highest temple of Sculpture and Painting, without having passed through similar stages of the discipline from an early age and without having been fully fed on letters.

Perhaps it is marvellous that nature allows learned men to learn such a large number of doctrines and to retain them in their memory. This is why I have thought in my mind that the disciplines are interrelated and that with deliberation, these [learned men] can still be easily managed. So I tell you that discipline is like a body made up of these members. Thus, those come about who train themselves in all the various teachings from a tender age, and who are learned in all the letters and the recommendations of the ancient sculptors. Phytius, who first built the temple of Minerva most nobly, said in his Commentaries that the sculptor should excel in all arts or doctrines. Phidias, an excellent mind, who magnificently built the temple of Pallas in Greece, which was nobly adorned with histories splendidly executed by his own hands, said that he recorded this in his commentaries, as well as many other buildings, which he had erected and designed.[4]

This was accomplished by those that had reached the highest fame applying themselves to all arts and disciplines with skill and exercise. Yet, this is not convenient: The sculptor cannot be, nor should he be a grammarian, as Aristarchus was, but he should be proficient in the theory of his own art, that is drawing, such as Apelles and Myron. And much more indeed than anybody else, for, the more he is dextrous the more perfect he shall be as a sculptor or painter. He does not have to be a physician, such as Hippocrates, Avicenna and Galen,[5] but he needs to have seen their works, and those on anatomy, to know the number of all the bones in the human body, its muscles and all nerves and ligaments that are in the male figure. The remainder of [the discipline] of medicine is not of much use. Neither should he be singularly excellent in astrology and other arts and doctrines, as a person cannot follow all their particulars in such variety and dignity and the reasoning behind them, but he should be taught and know them in his capacity as a sculptor or painter.

[4] *Phidias.* Addition by Ghiberti. No classical commentaries on Phidias' writings on art survive.

[5] *Avicenna et Galieno.* Another addition to Vitruvius by Ghiberti. Avicenna is the famous Arabic doctor and philosopher, one of Ghiberti's sources for the third commentary, where the programme (on anatomy) mentioned here is described.

Therefore neither painter nor sculptor can be perfect in all disciplines, but those whose own private realm are the artistic skills, do not perform [the other disciplines] as though they had to be praised as kings. Then if single artisans, not all but a few, had some possession of single doctrines and pursued nobility a little, how could a sculptor or a painter taught in a greater variety of arts not do the same? It would be a great marvel if he were not in need of some of these things, but furthermore he who will be determined to excel in all these disciplines with the greatest steadfastness and industry will overcome all other artists. Thus, it is clear that on this point Phytius was wrong, since he believed that single arts are not composed of two aspects, the practice and its theory. Practice is proper to those that are practically trained and in creating the work of art; it is a different matter to be like those that are theoretically trained.

And for these things Nature has given memory for the improvement of their astuteness so that they can note and study all the works of the ancient philosophers and mathematicians.

1.7.2
Two Florentine views of art history: (1) Antonio Manetti

The amateur architect and mathematician Antonio Manetti (1423–97) wrote his biography of Brunelleschi in the 1480s. In it he showed that his hero had done for architecture what Giotto and Nicola Pisano (c.1220–c.1284) had done for painting and sculpture. As well as recounting the history of Brunelleschi's buildings, Manetti provided a brief history of the development of architecture which suggests a knowledge of Vitruvius' *Ten Books on Architecture.* [CEK]

Source: Antonio di Tuccio Manetti (1970), *Life of Brunelleschi*, ed. H. Saalman, trans. C. Enggass (University Park and London: Pennsylvania State University Press), pp. 56–62. © 1970 by The Pennsylvania State University. Reproduced by permission of the publisher.

The art of building in the aforementioned style had its beginnings, like all styles, in very humble and crude things, good only for escaping the cold, heat, wind, and rain, since the early tribes had huts and houses of rough wood

covered with boughs and dried grass such as nature provided; or they were made of earth and of dry stone walls or of stones with earth instead of mortar. From these they progressed to bitumen, which was provided by nature in certain lands. Since it was not available everywhere, men gradually sharpened their wits by experimenting over a long period. Thus they discovered lime by means of fire: by mixing it with sand they economized without impairing the quality. Where stones did not exist they discovered bricks, since clay is present in every habitable area. They progressed from stone in the rough excavated state to cutting them somewhat so that those not fitting together would do so. From that they progressed to dressed stones, since one thing leads to another in building. Such dressed stones were a kind of beginning of display. With wealth and principalities came the ceremonial uses: for splendor, for displaying magnificence, to command admiration, and to provide ease and comfort. They then progressed to the construction of enclosures and defenses for kingdoms and treasures. As we see, those uses first appeared where principalities and wealth first appeared, and therefore the most ancient to be found are the Pyramids and the Labyrinth in Egypt. This is not the place to consider whether the Tartars preceded the Egyptians in regard to water or fire, since the Tartars do not have walled habitations and have no fixed abodes in their country. Those practices were transferred to Assyria and diverse Asian kingdoms. After many transmutations they passed into Europe, to the diverse republics and principalities of Greece particularly. There [they] flourished greatly due to the great geniuses and the wisdom of very worthy men, since Greece may be called the source of philosophers and philosophy, which had been defective for a long period. They experimented to discover what was the best of what had been done and kept it. And since Greece flourished in various places and periods, diverse ways of building were sanctioned according to the skill of the men living at that time. For a time they worked on ornaments and on the durability and strengthening of the buildings. Since each locality had men in power who favored their own artists and intellects, and since none of them wanted to appear to be led or inferior to the others, many various and distinct styles gained ground, as can be observed in the different types of columns mentioned in their literature which I noted earlier. From secular public buildings they went on to churches and temples and various tributes to the gods.

Before the arrival of the Greek geniuses and intellects for a long time [*tenpio*] building in Asia was very crude and undefined, lavish and of great extravagance rather than ordered. Hebrew buildings will not be dealt with, since, being people chosen by God, their forms and terms in general and in particular were inspired by the will of God through the prophets

and like means. However, one might say that the first true correctness and order to come into regular use was in the admirable and very rich temple of Diana in Ephesus in Asia, whose architect was Ctesiphon. It is said that he first placed bases under columns and capitals on the top. The progress from disorganized buildings to more refined ones seems to have gone as follows: as they progressed to bitumen and lime and the dressing of stones they simultaneously progressed to walls, pilasters, and columns, but as the orders were not yet employed they could not but appear very disordered. As it happens, that lack of order was more reprehensible in some things than in others. When the most glaring errors were removed and shunned, they turned to the second, third, and fourth gradations. The plumb line, mason's level, T square, and various tools came out of that. In purging the less offensive faults that remained, it seems that certain pleasing elements appeared; and some elements were more pleasing than others. In that way the ratio – that is to say the proportion – appropriate to those things began to be discovered, and that proportion was something of a corrective to what was displeasing. One must take into consideration that the architraves, friezes, cornices, pediments, mouldings, and jambs were at first made of wood, crude, without ornamentation and were bare as nature provided, since in the beginning – as was noted – these things were born of necessity. Thus columns without capitals or bases originated according to the needs from wooden uprights and beams. In the aforementioned Temple of Diana in Ephesus by that most eminent architect the systemization of these elements was begun. The first rules were to avoid discordancies completely and attain the commendable orders and, it is said, they flowered wonderfully in Greece. Many elements were absorbed by that most famous city, the queen of the entire world, in the transition from the dominion of the Greeks to the dominion of the Romans. Architects are attracted to and go where there is wealth and where principalities exist and where [people] are ready to spend money. Thus architecture moved from the Greek realm. Since architects could not find work there, they looked where principalities and wealth existed. As a consequence masters flourished much more wondrously in Rome than in Greece, as Rome's domain and experience increased. It grew to such a state, renown, and great marvel that even its ruins and the fragments of ornaments are stupendous. But it happened, as had happened in other places, that with the decline of the empire, the architecture and the architects declined. Barbarian tribes of Vandals, Goths, Lombards, Huns, and others arrived bringing their architects with them and built in their manner in those lands where for hundreds of years they ruled. And since the genius of those distant nations was ill adapted to such matters, they appropriated from the people nearest to

them, among whom they also had many followers, especially in Germany where there have always been many artisans and active men who, because of proximity (they had common borders on all sides with most of these countries), were drawn after the conquerors. They built in their fashion where those people ruled. All private, secular, and ecclesiastical buildings were built after their manner and they filled the whole of Italy as well as various places beyond the Alps.

When the last of them, the Lombards, were rooted out by Charlemagne, and the whole of Italy – especially the abbeys and their rulers – were cleansed of them, and Charlemagne arrived at an accord with the Roman pontiffs and that part of the Roman Republic they retained, he also attracted architects from the Roman and pontifical regions. Because of their limited experience they were not very skillful. But since they had been born in the midst of those [buildings] and had not seen others, they built that way. Some slight reflection of the splendor of those ancient buildings can be seen in the renewal and embellishment of our city undertaken by Charlemagne through the architects he brought with him, for example in S. Piero Scheraggio and Santo Apostolo, which are and were Charlemagne's buildings. However, his dynasty did not endure for more than a few generations. The Empire then passed into the hands of the Germans, and the style that through Charlemagne had been restored again for the most part disappeared. The German style gained strength and lasted until our century, up to the time of Filippo, to whom, after this long digression, I intend to return.

1.7.3
Two Florentine views of art history: (2) Leonardo da Vinci

Leonardo da Vinci (1452–1519) began gathering ideas for a treatise on painting while he was working at the court of the Sforza in Milan in the 1490s. This treatise was never completed, but drafts for it survived in his manuscripts. The extract here comes from the manuscript entitled the *Codex Atlanticus* (fol. 141 recto). This passage indicates Leonardo's view of art history. It should be stressed that he introduced his comment on the history of art in Italy since the time of the Romans as part of a discussion on the value of observing 'nature', rather than copying from the work of other artists as recommended by Cennino Cennini (see document 1.1.1). [CEK]

Source: Leonardo da Vinci (1954), *The Notebooks of Leonardo da Vinci*, ed. and trans. E. MacCurdy, 2 vols (London: Reprint Society), vol. 2, p. 258. Reprinted by permission of Mr Alec McCurdy [sic].

How from age to age the art of painting continually declines and deteriorates when painters have no other standard than work already done:

The painter will produce pictures of little merit if he takes the works of others as his standard; but if he will apply himself to learn from the objects of nature he will produce good results. This we see was the case with the painters who came after the time of the Romans, for they continually imitated each other, and from age to age their art steadily declined.

After these came Giotto the Florentine, and he – reared in mountain solitudes, inhabited only by goats and such like beasts – turning straight from nature to his art, began to draw on the rocks the movements of the goats which he was tending, and so began to draw the figures of all the animals which were to be found in the country, in such a way that after much study he not only surpassed the masters of his own time but all those of many preceding centuries. After him art again declined, because all were imitating paintings already done; and so for centuries it continued to decline until such time as Tommaso the Florentine, nicknamed Masaccio, showed by the perfection of his work how those who took as their standard anything other than nature, the supreme guide of all the masters, were wearying themselves in vain. Similarly I would say about these mathematical subjects, that those who study only the authorities and not the works of nature are in art the grandsons and not the sons of nature, which is the supreme guide of the good authorities.

Mark the supreme folly of those who censure such as learn from nature, leaving uncensured the authorities who were themselves the disciples of this same nature!

1.7.4
Books known or owned by Leonardo da Vinci

Pompeo Leoni (b. c.1533, d. 1608), the sculptor and collector, assembled a large number of papers left by Leonardo on his death. Known as the *Codex*

Atlanticus, it contains some of Leonardo's most innovative drawings and writings. On one of the sheets (fol. 210 recto) Leonardo wrote down a list of books which he may have owned or at any rate thought significant. The following extract provides the list of those books and the lengthy bibliographical note based on the research of Girolamo d'Adda which Edward MacCurdy summarizes here. [CEK]

Source: Leonardo da Vinci (1954), *The Notebooks of Leonardo da Vinci*, ed. and trans. E. MacCurdy, 2 vols (London: Reprint Society), vol. 2, pp. 507–11. Reprinted by permission of Mr Alec McCurdy [sic].

Book of Arithmetic	Letters of Filelfo
Pliny	The Sphere
Bible	The Jests of Poggio
De Re Militari	Of Chiromancy
First Decade	Formulary of Letters
Third Decade	Fiore di Virtù
Fourth Decade	Lives of the Philosophers
Guido	Lapidary
Piero Crescentio	Letters of Filelfo
Il Quadriregio	On the Preservation of the Health
Donatus	Ciecho d'Ascoli
Justinus	Albertus Magnus
Guido	Rhetorica Nova
Dottrinale	Cibaldone
Morgante	Æsop
John de Mandeville	Psalms
De Onesta Voluttà	On the Immortality of the Soul
Manganello	Burchiello
Cronica Desidero	Il Driadeo
Letters of Ovid	Petrarch

Bibliographical notes

The existence of this list of books on a page of the Codice Atlantico affords fair ground for the supposition that Leonardo was enumerating the books which he possessed.

Marchese Girolamo d'Adda, from whose erudition as displayed in a rare tract – *Leonardo da Vinci e la sua Libreria – note di un Bibliofilo*, Milano 1873

– the notes that follow are mainly derived, has suggested that as Leonardo uses the Italian and not the classical form of the names of classical authors he may be supposed to be referring to Italian translations. I cannot think that this inference necessarily holds, any more than it would in the case of a modern writer who might use the forms Virgil and Horace in a list of books. There were, however, in existence Italian translations of all the classical works mentioned, and any of these may have been in Leonardo's possession. D'Adda's wealth of bibliographical knowledge causes his descriptions of the various works in the list to serve as an 'open sesame' to Leonardo's library. The notes that follow fall by contrast under the censure that Leonardo invoked on those who make epitomes:

BOOK OF ARITHMETIC – Perhaps La nobel opera de arithmetica ne la qual se tracta tutte cosse a mercantia pertinente facta per Piero Borgi da Veniesia. Venice 1484. The name Maestro Piero dal Borgo occurs in Arundel MS. (B.M.) fol. 190 v. (see p. 525). The two notes that follow refer to a book, viz. 'to have my book bound' and 'show the book to Serigatto'.

PLINY – Historia naturale di C. Plinio Secondo tradocta di lingual latina in fiorentina per Christoforo Landino. 1476 Venetiis.

BIBLE – Earliest Italian version: Biblia volgare historiata. Venecia 1471.

DE RE MILITARI – Valturio? Roberti Valturii de re militari libri XII 1472. Bologna 1483.

FIRST, THIRD AND FOURTH DECADES [OF LIVY] – Earliest Italian version: Tito Livio volgarizzato. Roma 1476.

GUIDO – D'Adda suggests Guido da Cauliaco, author of treatise on surgery: – Guidonis de Cauliaco Cyrurgia. Venetiis 1498.

PIERO CRESCENTIO – writer on agriculture: Ruralium commodorum lib. XII. Petri de Crescenciis 1471. Il Libro della Agricultura di Pietro Crescentio. Florentiæ 1478.

QUADRIREGIO – the Four Realms: – Love, Satan, Vices, Virtues – poem composed in imitation of the Divina Commedia by Federico Frezzi of Foligno. Perugia 1481. Firenze, no date.

DONATUS – Ælius Donatus, author of a short Latin syntax, 'De Octo Partibus Orationis'. Many editions in 15th century.

JUSTINUS – a Roman historian who made an epitome of the general history of Trogus Pompeius.

GUIDO – Richter suggests Guido d'Arezzo: – monk – tenth century – inventor of tonic sol-fa musical system. Many Italian libraries possess MS. copies of his Micrologus De Disciplina Artis Musicæ.

DOTTRINALE – perhaps Doctrinal de Sapience by Guy de Roye, Archbishop of Sens. Latin text 1388. French trans. Geneva 1478, and many others.

MORGANTE – Il Morgante Maggiore. Romantic epic by Luigi Pulci. Il Morgante 23 canti. Per Luca Venetiano stampatore 1481. Il Morgante Maggiore 28 canti, Firenze 1482, and many others.

JOHN DE MANDEVILLE – There were many editions of the Travels. Earliest are Le liure appelle Mandeuille 1480, and Tractato delle piu maravigliose cosse e piu notabili, che si trovano in le parte del mondo vedute . . . del cavaler Johanne da Mandavilla . . . Mediolani . . . 1480.

DE ONESTA VOLUTTÀ – Treatise by Il Platina (Bartolomeo Sacchi). Opusculum de obsoniis ac honesta voluptate. Rome about 1473, Venice 1475. Trans. Platyne. De Honesta Voluptate è Valetudine. Friuli 1480, Venice 1487.

MANGANELLO [The Mangle?] – A savage satire against women in imitation of the Sixth Satire of Juvenal. Author a Milanese of the same name. Venice about 1500.

CRONICA DESIDERO – D'Adda suggests Cronica d'Isidoro: Comensa la cronica de sancto Isidoro menore, con alchune additione caciate del texto ed istorie della Bibia e del libro de Paulo Oroso . . . Ascoli 1477, Friuli 1480.

LETTERS OF OVID – Liber Epistolarum. In Monteregali 1473. Le Pistole di Ovidio tradotte in prosa. Napoli, no date. Epistole volgarizzate . . . Bressa 1489. El libro dele Epistole di Ovidio in rime volgare per messere Dominico da Monticelli toschano. Bressa 1491.

LETTERS OF FILELFO – Francesco Filelfo, Italian humanist. Philelphi epistolarum liber primus (libri XVI), about 1472. Epistolarum familiarum (libri XXXVII), Venice 1500.

THE SPHERE – D'Adda suggests a work by Gregorio Dati: Trattato della sfera, degli elementi, e del globo terrestre in ottava rima Cosenza 1478, or Spaera mundi of Joannis de Sacrobusto. Ferrara 1472.

THE JESTS OF POGGIO – Many editions in Latin and Italian from 1470.

OF CHIROMANCY – Brunet mentions: – Ex divina philosophorum academia coltecta: chyromantica scientia naturalis ad dei laudem finit . . . Venetiis, about 1480. Chyromantica scientia naturalis. Padue 1484.

FORMULARY OF LETTERS – Formulario de epistole vulgare missive e responsive e altri flori ed ornati parlamenti al principe Hercule d'Esti duca di Ferrara composto . . . da Bartolomio miniatore suo affectionato e fidelissimo servo. Bologna, no date. Venice 1487.

FIORE DI VIRTÙ (Flowers of Virtue) – A collection of moral tales and fables composed about 1320. Fiore di virtu che tratta di tutti i vitii humani . . . et come si deve acquistare la virtu. Venetia 1474.

LIVES OF THE PHILOSOPHERS – Perhaps El libro de la vita de philosophi ecc. by Diogene Laertio. Venetiis 1480.

LAPIDARY – Perhaps a translation of the Latin poem De Lapidibus of Marbodeus, or of the Mineralium Libri V of Albertus Magnus, 1476.

ON THE PRESERVATION OF THE HEALTH – Perhaps Arnaldus de Villanova Regimen Sanitatis, 1480, or Ugo Benzo di Siena Tractato utilissimo circa la conservatione de la sanitade. Mediolani 1481.

CIECHO D'ASCOLI – Francesco (diminutive ciecho) Stabili, burnt for heresy in 1347 – author of L'Acerba, a speculative philosophical poem. 'In questo poema dice trovansi delineate le origini di molti trovati moderni, ed in particolare della circulazione del sangue.'

ALBERTUS MAGNUS – Perhaps Opus De Animalibus Romæ, 1478, or Liber secretorum de virtutibus herbarum lapidum et animalium, Bononiæ 1478, or Incomenza el libro chiamato della vita ecc. Napoli 1478.

RHETORICA NOVA – Laurencius Guilemus de Saona: – Rhetorica Nova. Cambridge 1478. St Albans 1480.

CIBALDONE – Opera del excellentissimo physico magistro Cibaldone electa fuori de libri autentici di medicina utilissima a conservarsi sano. Towards the end of the fifteenth century (Brunet).

ÆSOP – Fabulae de Esopo historiate. Venice 1481, 1490. Brescia 1487. Æsopi vita et fabulae, latine, cum versione italica et allegoriis Fr. Tuppi. Neapoli 1485.

PSALMS – El Psalterio de David in lingua volgare. Venetiis 1476.

ON THE IMMORTALITY OF THE SOUL – Marsilio Ficino. Theologia platonica, sive de animarum immortalitate. Florentine 1482.

BURCHIELLO – Li Sonetti del Burchiello fiorentino faceto et eloquente in dire cancione e sonetti sfogiati. Bononiæ 1475.

IL DRIADEO – Poem in ottava rima by Luca Pulci, elder brother of Luigi. Il Driadeo composto in rima octava per Lucio Pulcro. Florentiæ 1478. An edition printed in Florence in 1481 has 'Il Driadeo compilato per Luigi Pulci', and the title-page of that of 1489 has 'Il Driadeo di Luigi Pulci'. The edition printed in Venice, 1491, has 'Il Driadeo d'amore di Luca Pulci'. One that was printed in Florence towards the year 1500 has on the last page 'Qui finisce Il Driadeo compilato per Luca Pulci, Al Magnifico'.

PETRARCH – Many editions, commencing with Sonetti, Canzoni et Trionphi. Venetiis 1470.

1.7.5
Courtiers discuss the merits of painting and sculpture

Baldassare Castiglione (1478–1529) was a diplomat, poet, scholar and soldier born in Mantuan territory. He died while serving as papal nuncio at Toledo. *The Book of the Courtier* was published in 1528, but Castiglione began it some 20 years earlier. The text, which purported to recount discussions at the court of the della Rovere at Urbino, circulated in manuscript in the interim. The book gives advice on the dress, behaviour, interests and knowledge which males and females frequenting courts (or ambitious to do so) should exhibit. Among these accomplishments was an understanding of the visual arts. [CEK]

Source: Baldassare Castiglione (1967), *The Book of the Courtier: Baldassare Castiglione*, trans. G. Bull (Harmondsworth: Penguin), pp. 96–101, 350. © 1967 by George Bull. Reproduced by permission of Penguin Books Ltd.

'Before we launch into this subject,' the Count replied, 'I should like us to discuss something else again which, since I consider it highly important, I think our courtier should certainly not neglect: and this is the question of drawing and of the art of painting itself. And do not be surprised that I demand this ability, even if nowadays it may appear mechanical and hardly

suited to a gentleman. For I recall having read that in the ancient world, and in Greece especially, children of gentle birth were required to learn painting at school, as a worthy and necessary accomplishment, and it was ranked among the foremost of the liberal arts; subsequently, a public law was passed forbidding it to be taught to slaves. It was also held in great honour among the Romans, and from it the very noble family of the Fabii took its name, for the first Fabius was called *Pictor.* He was, indeed, an outstanding painter, and so devoted to the art that when he painted the walls of the Temple of Salus he signed his name: this was because (despite his having been born into an illustrious family, honoured by so many consular titles, triumphs and other dignities, and despite the fact that he himself was a man of letters, learned in law and numbered among the orators) Fabius believed that he could enhance his name and reputation by leaving a memorial pointing out that he had also been a painter. And there was no lack of other celebrated painters belonging to other illustrious families. In fact, from painting, which is in itself a most worthy and noble art, many useful skills can be derived, and not least for military purposes: thus a knowledge of the art gives one the facility to sketch towns, rivers, bridges, citadels, fortresses and similar things, which otherwise cannot be shown to others even if, with a great deal of effort, the details are memorized. To be sure, anyone who does not esteem the art of painting seems to me to be quite wrong-headed. For when all is said and done, the very fabric of the universe, which we can contemplate in the vast spaces of heaven, so resplendent with their shining stars, in the earth at its centre, girdled by the seas, varied with mountains, rivers and valleys, and adorned with so many different varieties of trees, lovely flowers and grasses, can be said to be a great and noble painting, composed by Nature and the hand of God. And, in my opinion, whoever can imitate it deserves the highest praise. Nor is such imitation achieved without the knowledge of many things, as anyone who attempts the task well knows. Therefore in the ancient world both painting and painters were held in the greatest respect, and the art itself was brought to the highest pitch of excellence. Of this, a sure proof is to be found in the ancient marble and bronze statues which still survive; for although painting differs from sculpture, both the one and the other derive from the same source, namely from good design. So if the statues which have come down to us are inspired works of art we may readily believe that so, too, were the paintings of the ancient world; indeed, they must have been still more so, because they required greater artistry.'

Then signora Emilia, turning to Giovan Cristoforo Romano, who was seated with the others, asked him:

'What do you think of this opinion? Would you agree that painting allows for greater artistry than sculpture?'

'Madam,' replied Giovan Cristoforo, 'I maintain that sculpture requires more effort and more skill than painting, and possesses greater dignity.'

The Count then remarked:

'Certainly statues are more durable, so perhaps they may be said to prove more dignified; for since they are intended for monuments, they serve the purpose for which they are made better than paintings. But, leaving aside the question of commemoration, both painting and sculpture also serve a decorative purpose, and in this regard painting is far superior. And if it is not, so to say, as enduring as sculpture, all the same it survives a long time, and for as long as it does so it is far more beautiful.'

Then Giovan Cristoforo replied:

'I truly believe that you are not saying what you really think, and this solely for the sake of your Raphael; and perhaps, as well, you feel that the excellence you perceive in his work as a painter is so supreme that it cannot be rivalled by any sculpture in marble. But remember that this is praise for the artist and not for his art.'

Then he continued:

'Indeed, I willingly accept that both painting and sculpture are skilful imitations of Nature; yet I still do not understand how you can maintain that what is real and is Nature's own creation cannot be more faithfully copied in a bronze or marble figure, in which all the members are rounded, fashioned and proportioned just as Nature makes them, than in a picture, consisting of a flat surface and colours that deceive the eye. And don't tell me that being is not nearer the truth than merely seeming to be. Moreover, I maintain that working in stone is far more difficult, because if a mistake is made it cannot be remedied, seeing that repairs are impossible with marble, and the figure must be started again; whereas this is not the case with painting, which can be gone over a thousand times, being improved all the time as parts of the picture are added to or removed.'

Then, with a smile, the Count replied:

'I am not arguing for the sake of Raphael, nor should you think me so ignorant as not to recognize the excellence shown by Michelangelo and yourself and other sculptors. But I am speaking of the art and not the artists. You say truly enough that both painting and sculpture are imitations of Nature; but it is not the case that the one seems to be what it portrays and the other really is so. For although statues are made in the round, like objects in real life, and painting is seen only on the surface, sculpture lacks many things to

be found in painting, and especially light and shade: for example, the natural colouring of the flesh, which appears altogether changed in marble, the painter copies faithfully, using more or less light and shade according to need, which the sculptor cannot do. And even though the painter does not fashion his figures in the round, he does depict the muscles and members of the body rounded and merging into the unseen parts of his figures in such a way as to demonstrate his knowledge and understanding of these as well. The painter requires still greater skill in depicting members that are foreshortened and disappear gradually into the distance, on the principles of perspective. This, by means of proportioned lines, colours, light and shade, simulates foreground and distance on an upright surface, to the degree that the painter wishes. Does it, then, seem of little importance to you that Nature's colours can be reproduced in flesh-tints, in clothing and in all the other objects that are coloured in life? This is something the sculptor cannot do. Still less can he depict the love-light in a person's eyes, with their black or blue colouring; the colour of blond hair; the gleam of weapons; the darkness of night; a tempest at sea; thunder and lightning; a city in conflagration; or the break of rosy dawn with its rays of gold and red. In short, it is beyond his powers to depict sky, sea, land, mountains, woods, meadows, gardens, rivers, cities or houses; but not beyond the powers of the painter.

'So it seems to me that painting is nobler and allows of greater artistry than sculpture, and I believe that in the ancient world it reached the same perfection as other things; and this we can see from a few surviving works, especially in the catacombs in Rome, but far more clearly from the evidence of classical literature, which contains so many admiring references to both painting and painters, and informs us of the high esteem in which they were held by governments and rulers. For example, we read that Alexander was so fond of Apelles of Ephesus that once, after he had had him portray one of his favourite mistresses, and then heard that the worthy painter had fallen desperately in love with her marvellous beauty, without a second thought he gave the woman to him: this was an act of generosity truly worthy of Alexander, to give away not only treasures and states but his own affections and desires; and it showed, too, how deeply fond he was of Apelles, to please whom he cared nothing about the displeasure of the lady whom he loved so much himself, and who, we may well believe, was more than grieved to lose so great a king in exchange for a painter. Many instances are recorded of Alexander's kindness towards Apelles; but the clearest evidence of his esteem for him is seen in the decree he issued that no other painter should dare to do his portrait. Here I could tell you of the contests of so many noble painters, who were

the admiration and wonder of the world; I could tell you of the magnificence with which the ancient emperors adorned their triumphs with pictures, dedicated them in public places, and acquired them as cherished possessions; I could tell you how some painters have been known to give their pictures away, believing that they could not be adequately paid for with gold or silver; and how a painting by Protogenes was so highly regarded that when Demetrius was laying siege to Rhodes and could have entered the city by setting fire to the quarter where he knew the painting was, rather than cause it to be burned he called off the attack, and so failed to take the place; and how Metrodorus, an outstanding painter and philosopher, was sent by the Athenians to Lucius Paulus to teach his children and to decorate the triumph that he had to make.[1] Moreover, many great authors have written about painting, and this is convincing evidence for the high regard in which it was held. But I would not have us carry this discussion any further. So let it be enough simply to state that it is fitting that our courtier should also have a knowledge of painting, since it is a worthy and beneficial art, and was greatly valued in the times when men were greater than now. And even if it had no other useful or pleasurable aspects, painting helps us to judge the merits of ancient and modern statues, of vases, buildings, medallions, cameos, intaglios and similar works, and it reveals the beauty of living bodies, with regard to both the delicacy of the countenance and the proportion of the other parts, in man as in all other creatures. So you see that a knowledge of painting is the source of very profound pleasure. And let those reflect on this who are so carried away when they see a beautiful woman that they think they are in paradise, and yet who cannot paint; for if they did know how to paint they would be all the more content, since they would then more perfectly discern the beauty that they find so agreeable.'

[1] The anecdote about Protogenes and Metrodorus comes from Pliny's *Natural History*.

Demetrius I of Macedon was the son of Antigonus, King of Asia, one of the generals of Alexander the Great. He besieged Rhodes with gigantic machines in 305 B.C., when he won the name of Poliorcetes or Besieger.

Metrodorus is recorded in Pliny as a painter and philosopher.

Lucius Aemilius Paulus was a Roman consul (181 and 168 B.C.) and general.

Part II

Locating Renaissance Art

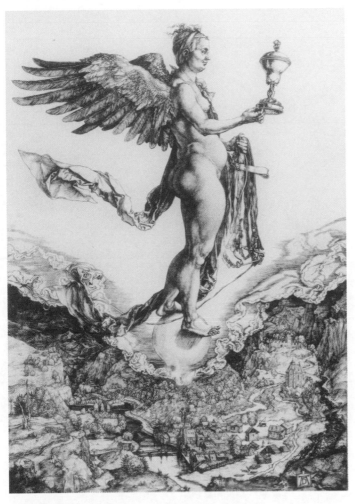

Albrecht Dürer, *Nemesis*, Engraving, British Museum, 1895-9-15-346

Florence and Rome

2.1.1
Domenico Veneziano looks for work in Florence

In April 1438 Domenico Veneziano (active 1438–61), an artist from the north of Italy, wrote to Piero de' Medici, son of Cosimo de' Medici, hoping to work on the decoration of the Dominican convent of San Marco and, in particular, on the high altarpiece for the church if the 'good masters' Filippo Lippi and Fra Angelico were too busy. In fact the commission went to Fra Angelico and resulted in one of his most celebrated altarpieces (now in the Museo di San Marco, Florence). The letter is significant because the artist had clearly identified the patronage of the Medici family as being an important route to finding work in Florence. Although Domenico Veneziano was not able to supplant Fra Angelico in the work for San Marco, by 1439 he was working in Florence on a fresco cycle in the choir of Sant'Egidio, assisted by Piero della Francesca. [CMR]

Source: C. E. Gilbert (1980), *Italian Art, 1400–1500: Sources and Documents* (Englewood Cliffs, NJ and London: Prentice-Hall), pp. 4–5. (Original text in G. Gaye (1839), *Carteggio Inedito d'Artisti*, vol. 1, pp. 136–7.) Reprinted by permission of Creighton E. Gilbert.

To the honorable and generous man Piero di Cosimo de' Medici of Florence, his honored superior, in Ferrara.

Honorable and generous Sir. After the due salutations. I inform you that by God's grace I am well, and I wish to see you well and happy. Many many times I have asked about you, and have never learned anything, except that I asked Manno Donati, who told me you were in Ferrara, and in excellent health. I was greatly relieved, and having first learned where you were, I would have written you for my comfort and duty. Considering that my low condition does not deserve to write to your nobility, only the perfect and good love I have for you and all your people gives me the daring to write, considering how duty-bound I am to do so.

Just now I have heard that Cosimo [de' Medici, Piero's father] has decided to have an altarpiece made, in other words painted, and wants a magnificent work, which pleases me very much. And it would please me more if through

your generosity I could paint it. And if that happens, I am in hopes with God's help to do marvelous things, although there are good masters like Fra Filippo and Fra Giovanni [Angelico] who have much work to do. Fra Filippo in particular has a panel going to Santo Spirito which he won't finish in five years working day and night, it's so big. But however that may be, my great good will to serve you makes me presume to offer myself. And in case I should do less well than anyone at all, I wish to be obligated to any merited punishment, and to provide any test sample needed, doing honor to everyone. And if the work were so large that Cosimo decided to give it to several masters, or else more to one than to another, I beg you as far as a servant may beg a master that you may be pleased to enlist your strength favorably and helpfully to me in arranging that I have some little part of it. For if you knew how I long to do some famous work, and specially for you, you would be favorable to me, I'm certain we won't be wanting in that. I beg you to do anything possible, and I promise you my work will bring you honor.

Nothing else at the moment, except that if I can do anything for you here, command me as your servant, and I hope you won't dislike giving me a reply, and above all inform me of your health, which I desire above all things, and Christ prosper you and fulfill all your desires.

By your most faithful servant Domenico da Venezia painter, commending himself to you, in Perugia, 1438, first of April.

2.1.2
The contract for wall paintings at the Sistine Chapel

This is one of only two surviving documents relating to the commission for the Sistine Chapel, part of the Vatican Palace in Rome and reserved for important papal ceremonies. The chapel, originally built under Pope Nicholas III (reigned 1277–80), was extended under Sixtus IV (reigned 1471–84). Four artists with workshops in Florence – Perugino, Cosimo Rosselli, Domenico Ghirlandaio and Botticelli – collaborated on the project, possibly as early as 1480, and probably as part of Lorenzo de' Medici's attempts to re-establish diplomatic relations with the papacy following the Pazzi Conspiracy of 1478. That said, all of them, apart from Botticelli, had already worked in Rome.

The contract, dated 27 October 1481 and issued by Giovanni de' Dolci, supervisor of papal works, continues the project: the four artists had produced satisfactory work and were to produce another 10 narrative scenes by 15 March 1482. This was a remarkably short period of time for such an extensive project but it was probably set because the pope was 68 years old at the time and eager to make his mark on Rome before his death. The artists were to work closely together, painting the narrative scenes as well as the painted hangings below and the figures of popes above them. [CMR]

Source: D. S. Chambers (1970), *Patrons and Artists in the Italian Renaissance* (London: Macmillan), pp. 20–1. Reproduced with permission of Palgrave Macmillan.

27 Oct 1481. At Rome in the Apostolic Chamber, in the eleventh year of the pontificate of the Most Holy Father in Christ and our Lord Pope Sixtus IV.

At Rome in the Apostolic Palace, the honourable lord Giovanni Pietro de' Dolci of Florence, inhabitant of Rome and supervisor or commissary for the fabric of the Apostolic Palace, acting as he says by mandate and commission of our Most Holy Lord Pope, in the presence of me, public notary, commissioned or contracted the circumspect men Cosimo di Lorenzo Filippo Rosselli, Alessandro Mariani [Botticelli] and Domenico di Tommaso Corradi [Ghirlandaio], of Florence, and Pietro di Cristofano [Perugino] of Città del Pieve in Perugia diocese, painters at present in Rome, to paint the large new chapel within the said Apostolic Palace, from the altar wall downwards, with ten stories of the Old and New Testaments and curtains below. The painting is to be done as diligently and faithfully as each of them and their assistants can make it, as in the work already started. And the said painters have agreed and promised to the said Giovanni de' Dolci, acting in the name of the Pope, to paint the said stories and curtains as above, and to finish them by the fifteenth of next March with payment at the rate as the paintings by the said painters already (begun) in the said chapel will be valued, under penalty of a fine of fifteen gold ducats of the Chamber for any contravention, which penalty they have freely imposed, and which if they contravene the agreement, they are willing should fall upon themselves, and which penalty must be applied by officers for the fabric of the said chapel. And the said painters obliged themselves and all their goods present and future on behalf of the same etc.

2.1.3

The valuation of the first four narratives at the Sistine Chapel

On 17 January 1482 a valuation of the four scenes already completed in the chapel was carried out and the work estimated at 250 ducats per narrative, a high price that reflects the amount Pope Sixtus IV was willing to pay for fast work by esteemed and reliable artists, as much as the artistic value put on the scheme. However the four artists seem to have left the project unfinished later in 1482. Luca Signorelli (c.1450–1523), who probably worked in the chapel as an assistant, helped complete the cycle in 1483. The chapel was consecrated on 15 August 1483, on the patronal festival of the Feast of the Assumption of the Virgin. [CMR].

Source: D. S. Chambers (1970), *Patrons and Artists in the Italian Renaissance* (London: Macmillan), pp. 21–2. Reproduced with permission of Palgrave Macmillan.

17 January 1482

At Rome in the Apostolic Palace in the chamber of the Most Reverend Cardinal of San Clemente [Domenico della Rovere], in the presence of the notary and witnesses below written, by commission and mandate and in the name of Our Most Holy Lord the Pope given by his own word of mouth, and on the other hand, Cosimo Rosselli, Allessandro Mariani, Domenico Corradi (all of Florence) and Pietro di Cristofano of Castel del Pieve of Perugia diocese, the painters under contract to paint the Great Chapel of the Apostolic Palace by mandate of our aforesaid Most Holy Lord the Pope.

They freely agreed with the venerable and honoured lords, Master Antonio of Pinerolo, Master of Divinity, of the Order of Minors, Bartholomeo de Bollis, canon of the Basilica of the Prince of the Apostles in the City, Lauro di San Giovanni of Padua, Giovanni Luigi of Mantua and Ladislas of Padua, both painters, and Master Giovanni Pietro de' Dolci of Florence and inhabitant of Rome, arbiters and judges for the evaluation of the said painting by the said Cosimo, Alessandro, Domenico and Pietro di Cristofano, in the Great Chapel of Our Most Holy Lord the Pope, for the making of the first four stories, furnished with curtains, frames and (portraits of) Popes; the curtains

being finished, they have to be judged by the said arbiters present to view the same.

And the said lords arbiters and judges, elected as above and intent on nothing else, having taken counsel declared and judged the said masters ought to have from Our Most Holy Lord the Pope for the said four stories with the said curtains, frames and Popes, 250 ducats of the Chamber at the rate of 10 *carleni* to the ducat, for each story. And the said painters there present praised, approved and proclaimed the present sentence and declaration etc.

2.1.4
Botticelli pursues outstanding payments for his work in the Sistine Chapel

Although a price had been agreed for the frescoes at the start of 1482 and Botticelli had left Rome for Florence by October, by the end of 1483 he had still not received full payment for his part in the project. In this mandate drawn up for Botticelli by his next-door neighbour on 8 December 1483, he empowered his nephew, who worked at the Salutati bank in Rome, to act as his agent to collect the rest of the money. Even if he was not paid properly by the pope, the reputation Botticelli acquired after working on the Sistine Chapel frescoes established him as one of the best artists of the day in Italy. Sixtus IV died in August 1484: Perugino was eventually paid in 1490, but it is not known if Botticelli ever received what he was owed. [CMR]

Source: D. Corvi (1969), 'Botticelli and Pope Sixtus IV', *Burlington Magazine*, vol. 111, p. 617. Translated from the Latin by Dario Tessicini. Copyright © The Open University 2007. Reprinted by permission of the Burlington Magazine.

1483. The second indiction
Order by Alessandro, painter

Thereafter, in the said year and indiction, the eighth day of December. Recorded in *popolo* [district] Santa Lucia Ognissanti in Florence, in the presence of the witnesses, namely, Iacopo di Domenico Papi, painter from the

popolo San Felice in Piazza of Florence, and Corino di Angelo del Tedesco, from Bologna, painter and at present living in the said *popolo* Santa Lucia Ognissanti in Florence.

Alessandro [Botticelli] of the late Mariano Vanni dei Filipepi, painter of the *popolo* Santa Lucia Ognissanti in Florence, except in case of withdrawal, etc., in all forms, etc., appoints, etc., as his procurator, etc., the kind man Giovanni Benincasa of Mariano Vanni dei Filipepi, his nephew, the brother's son of the said Alessandro, may he be absent or present as well, etc., especially and expressly in order to demand, request, receive, and require that he is given, receives and is delivered, accomplishing, acknowledging and certifying that the said has had and receives in his own name, all together and in all their parts, at the same time and separately, from the most holy Father in Christ and Lord, Sixtus, by divine providence Pope, the Fourth, all and each sum of gold florins, money and/or whatever goods are due to him, howsoever owed or to be owed, for whatever reason, law, way or cause, and in any other way it is possible to name and find, finalizing the receipts and declarations, accomplishing the general and specific terms, receipt, payment in full and release, and without demanding any further agreement, and when, where and how the said procurator, will deem suitable, or likes and will. [. . .]

2.1.5
Filippino Lippi works for Cardinal Carafa in Rome at Lorenzo de' Medici's suggestion

Lorenzo de' Medici and Cardinal Carafa enjoyed a reciprocal relationship whereby one could approach the other for favours. As early as 1471, Carafa had asked for help in getting a political position for an associate. In this letter of 11 September 1488 to Gabriele, Abbot of Montescalari, Carafa declares that he has enjoyed the help of Lorenzo in finding an artist to decorate his chapel in Santa Maria sopra Minerva in Rome, where he was eventually buried. This artist was Filippino Lippi (c.1457–1504), who had already arrived in Rome and had been introduced to the cardinal on 27 August by the Florentine ambassador. Lorenzo's help was part of his campaign to secure a cardinal's hat for his son, something that was eventually achieved in 1492. [CMR]

From: D. S. Chambers (1970), *Patrons and Artists in the Italian Renaissance* (London: Macmillan), p. 23. (Original text in E. Müntz (1889), *Archivio storico dell'arte*, vol. 2, p. 484.) Reproduced with permission of Palgrave Macmillan.

Venerable Abbot

Today at the twentieth hour we gave letters and licence to our Master Philippo [Filippino], with whom we have concluded and contracted the work, as you will understand at his return. Together with the magnificent orator, we read with pleasure your letter of the twenty-sixth of last month, full of doubt lest he should have been supplanted in our favour by his rivals. But wherefore doubt ye, o ye of little faith! Your paternity could well have thought that even had Master Philippo not been as sufficient as he is, having been commended by the Magnificent Lorenzo, we would have placed him above an Apelles, or all Italy. The truth is that on the very day he arrived in Rome, the intrigues began for one who came from your parts. Although we had not yet seen Master Philippo, because of pressing business, we gave no heed. Then, within the brief hour that your Messer Giovanni Antonio brought him to us, we willingly and with joyful mind saw him, and he has been with us ever since, the work was settled with him, and now he is shortly to return with everything ready. From him you will hear everything. We shall only tell you that having been directed on this by the Magnificent Lorenzo, we would not exchange him for all the painters that ever were in ancient Greece. For the rest, we refer you to the letters that the said Master Philippo bears. Fare you well, and do not cease thanking the Magnificent Lorenzo, to whom give a thousand greetings on our behalf.

Rome, 11 September 1488

To the venerable and religious father Lord Gabriel, our beloved Abbot of Monte Scalari, [from] Olivieri, Bishop of Sabina, Cardinal of Naples.

2.1.6

Filippino Lippi explains to Filippo Strozzi why he has gone to Rome

On 2 May 1489 Filippino Lippi wrote to Filippo Strozzi from Cardinal Carafa's palace in Rome to explain why he had apparently abandoned the

Strozzi family chapel at Santa Maria Novella for work in Rome. Lippi had accepted the much more lucrative commission despite his existing obligations, and was hoping that Strozzi could allow him to continue in Rome if he promised to complete the Florence project at the same time. Lippi seems to have managed to complete both commissions: he made regular return visits to Florence to work for the Strozzi during his work for Carafa at Santa Maria sopra Minerva. [CMR]

Source: D. S. Chambers (1970), *Patrons and Artists in the Italian Renaissance* (London: Macmillan), pp. 24–5. Reproduced with permission of Palgrave Macmillan.

In the name of God: 2 May 1489

My most dear and honourable Sir, greetings etc.

I know that you will have wondered at me for leaving you so long without ever having written. It was not because I have not always kept you at heart, and your work, too, which you bestowed on me with so much love; in every way you have done much more for me than I merit. On the contrary, my coming here makes me so much more eager to finish your work, that it seems like a thousand years, but on my return I shall hope to satisfy you well for every delay. And in any case I shall come at the Feast of St John, God willing, and for no other reason than to make a start on the work and attend to nothing else; and I commend myself to you, praying you to pardon all my delay. Truly I am with a good Lord here; he does me so much kindness, and treats me so well, that I would not know a better one to choose for anything. My work satisfies him, and he goes to great expense for it, sparing nothing. I have just been making a marble adornment for the altar, which for my mastery alone amounts to 250 large gold florins. Then comes the decoration, and he wants it all thus. The chapel could not be more ornate, porphyry and serpentine pavement, all most subtly done, on the ground, a most ornate marble parapet, and all most rich in effect. I will say no more; I commend myself to you. Christ guard you always.

 Your servant Filippo di Filippo Lippi, painter with the
 Most Reverend Monsignor of Naples, in Rome

2.1.7

The Duke of Milan's agent reports on Florentine artists

Around 1490, the Duke of Milan's agent in Florence wrote a report for his patron on the best artists then working in the city. The Duke, Ludovico 'Il Moro' Sforza, was looking to employ the most reputable artists at the Carthusian monastery (the Certosa) of Pavia. Sandro Botticelli, Filippino Lippi, Perugino and Domenico Ghirlandaio are singled out for praise. The value judgements made in the report are particularly revealing: some artists are better at panel painting than fresco, some are seen to be better than others, and they had all proved themselves through high-profile commissions that include the Sistine Chapel ('the chapel of Pope Sixtus IV') and the decoration of Lorenzo de' Medici's villa at Spedaletto (destroyed during the Second World War). [CMR]

Source: C. E. Gilbert (1980), *Italian Art, 1400–1500: Sources and Documents* (Englewood Cliffs, NJ and London: Prentice-Hall), p. 139. Reprinted by permission of Creighton E. Gilbert.

Sandro di Botticelli, a most excellent painter in panel and fresco, his things have a manly air and also very good organization and complete balance

Filippino di Fra Filippo, very good, pupil of the above, and son of the most remarkable master of his time, his things have a gentler air, I don't think they have as much skill

Perugino, an outstanding master, especially in fresco, his things have an angelic air, very gentle

Domenico di Ghirlandaio, good master in panel and more in fresco, his things have a good air, and he is very expeditious and does a lot of work

All these above-named painters proved themselves in the Sistine Chapel except Filippino, but all of them at the Ospedaletto of Lord Lorenzo, and the choice is almost even.

2.1.8
Michelangelo's letter to Lorenzo de' Pierfrancesco de' Medici from Rome

On 2 July 1496, Michelangelo wrote to Lorenzo de' Pierfrancesco de' Medici, head of a lesser branch of the family that had retained their position in Florence despite the exile of members of the main branch in 1494. Michelangelo's letter to his Florentine patron has caused some confusion over the artist's original reasons for his trip to Rome in 1496 because it is contradicted by Condivi's *Life of Michelangelo*, which suggests that he went at the invitation of Cardinal Raffaele Riario. Instead, as the letter clearly states, Michelangelo went to Rome with letters of introduction to various members of the Florentine and ecclesiastical community. These included Cardinal Riario, who quickly commissioned a statue of Bacchus from the artist, and Baldassare del Milanese, an agent who had purchased a Cupid carved by Michelangelo in Florence and brought it to Rome to sell. The sculpture was bought for 30 gold ducats from the artist, but the agent managed to sell it for the much higher price of 200 gold ducats on the Roman market, where *al'antica* works were highly prized. Michelangelo was unsuccessful in retrieving the Cupid and it quickly reappeared on the market, ending up in the collection of Isabella d'Este. [CMR]

Source: Michelangelo (1987), *Life, Letters and Poetry* (Oxford: Oxford University Press), p. 77. Reprinted by permission of Oxford University Press.

[in the name of] Jesus. 2 July 1496[1]
Magnificent Lorenzo ... Just to inform you that last Saturday we arrived safe and sound, and we went at once to visit Cardinal San Giorgio and presented him with your letter. He seemed glad to see me and wanted me to go forthwith to look at some statues, and this used up the whole day; so on that day I did not give him your other letters. Then on Sunday the Cardinal went to his new house, where he asked for me; I met him there and he sought my opinion of the things I had seen. I told him my opinion, thinking them without doubt most beautiful. Then the Cardinal asked if I had it in me to undertake some beautiful work myself. I replied that I might not make such

[1] Extant letter not in Michelangelo's hand, addressed to Sandro Botticelli on the outside.

splendid works as he possessed, but he would see what I could do. So we have bought a piece of marble suitable for a life-size figure; and I shall start work on Monday.

Meanwhile last Monday I presented your other letters to Paolo Rucellai, who offered me the money I needed, and likewise the letters for the Cavalcanti. Then I gave Baldassare his letter, and I asked him for the little boy, saying I would give back his money. He answered very sharply, saying that he would sooner smash it into a hundred pieces, that he had bought the boy and it was his, that he had letters showing he had satisfied those who sent it to him, and he had no worry about having to give it back; then he complained a lot about you, alleging that you slandered him. Some of our Florentines are now seeking to make peace between us, but they have achieved nothing.

So now, following the counsel of Baldassare Balducci, I am hoping to succeed through the Cardinal. Nothing more for this letter. I send you my regards. And God keep you out of harm's way.

Michelangelo in Rome.

2.1.9
A dialogue between Florence and Rome against Savonarola

Set in July 1497, Girolamo Porcari's dialogue, *Tuscus and Remus*, takes place at a critical juncture just after Girolamo Savonarola, the Dominican monk, vehement reformer and vocal critic of the excesses of the papacy, had been excommunicated by Alexander VI (pope from 1492 to 1503). Less than a year later, in May 1498, Savonarola was burnt at the stake. This ended the 4-year-long episode that followed the exile of the dominant Medici faction from Florence in 1494, during which Savonarola had led the Florentines to believe that theirs could be the City of God – a New Jerusalem. Porcari's dialogue represents the longer-standing conflict between two political ideologies. Remus, who has the upper hand throughout, represents Rome and the clerical viewpoint, while Tuscus, a follower of Savonarola who is used to represent Florence, is reduced to agreeing that his city has always been dependent on Rome, and the dialogue ends with his subjugation. Girolamo Porcari was a canon of St Peter's basilica in Rome and a member of the papal court, working at the Rota, the tribunal which dealt with ecclesiastical appeals and law suits. From 1495 until his death in 1503 he was bishop of Andria (Puglia). His other works include *A Commentary on the Creation and Coronation of Alexander VI*, printed in Rome in 1493. This and *Tuscus and Remus* may have been designed

to curry favour with the pope so that Porcari would be promoted to the cardinalate.

Source: Girolamo Porcari (1497), *Tuscus et Remus adversus Savonarolam* (Rome). (Latin text in A. Modigliani (1998), 'Roma e Firenze "Tuscus et Remus": Due modelli opposizione?', *Studi Romani*, vol. 46, nos 1–2, pp. 23–8.) Translated from the Latin by Jeremy G. Taylor. Copyright © The Open University 2007.

Two travellers called Tuscus and Remus talk together.

Tuscus	I am rather afraid that I have embarked on a false journey: having put off a better one, I am quite exhausted by walking around and have so far found nowhere to revive myself. How welcome a rest would be for this tired man after a long journey! May this arduous wandering not lead me into further exhaustion! But unless some traveller comes my way misfortune is not far from me.
Remus	Who do I hear is afraid of his own journey?
Tuscus	I do not fear failure: I have already failed.
Remus	I see no one.
Tuscus	Who is this speaking? A traveller?
Remus	A pilgrim from *Tuscia* is wandering from his path.
Tuscus	Greetings traveller!
Remus	And greetings to you I say! But what is the reason for your travel abroad?
Tuscus	A little brother[1] recommended a new path and postponement of an old one and I trusted him.
Remus	You trusted him?
Tuscus	I did, as did the multitude of nations.
Remus	Where are you from?
Tuscus	From Florence, a most illustrious state.
Remus	Most illustrious, certainly, and of great antiquity.
Tuscus	How do you know?
Remus	I listened to my forebears and I read it often.
Tuscus	Which forebears?
Remus	My own.
Tuscus	I wish to know with the utmost interest who your forebears are.
Remus	Rome is my fatherland. Where are your ancestors from?
Tuscus	Rome.
Remus	Rome?

[1] *Fraterculus* – Savonarola.

Tuscus	It is plausible. I have often appreciated that many citizens from my state dwell in Rome.
Remus	They dwell in it and they embellish it.
Tuscus	It is wonderful that they embellish it.
Remus	Ah, why is it wonderful?
Tuscus	Oh, if only you knew of the advantages of Florence!
Remus	Speak also of the disadvantages.
Tuscus	There are disadvantages, but they will not last for a long time.
Remus	As long as the Florentines believe the little brother.
Tuscus	Ah friend!
Remus	Friend, a friend is speaking.
Tuscus	He is a prophet who has proclaimed many things.
Remus	And mad falsehoods.
Tuscus	And the word of God.
Remus	What word of God?
Tuscus	To return to the side of Rome, which was once great.
Remus	It was and is now more honourable.
Tuscus	More honourable now?
Remus	Yes, even now.
Tuscus	I am hearing a new thing and I am ignorant of these honours.
Remus	I believe it. But I am not from Florence where you are from.
Tuscus	I would hear the praises of each state with open ears.
Remus	Whose ears, tell me?
Tuscus	My ears, I say.
Remus	And you would add the ears of your young donkey.
Tuscus	Speak your praises now.
Remus	Of Florence?
Tuscus	Of Florence first and then Rome.
Remus	The state of Florence was founded in the middle of Italy. It is no small settlement that is accustomed to possess the shrewd talents of the Roman Curia, and has taken its apostolic foundation from Linus; and which once wished to be the foremost home of the papacy, and which was not afraid to risk its blood against Henry III, the Corradini and the Manfredi on behalf of the Holy See; which devoutly received Peter coming from Antioch, and the fleeing Eugenius IV;[2] on the banks of the Arno Peter, the Prince of the

[2] In the 1430s Florence had sheltered Pope Eugenius IV when he was unable to return to Rome because of civil unrest, just as the city had also sheltered St Peter when he was en route from Antioch to Rome.

Apostles, established an altar,[3] which Clement later consecrated. From these experiences Florence has always flourished.

Tuscus It flourishes even now.

Remus But it flourished more long ago, because it did not believe the little brother, nor did it neglect the way of truth through the impudence and the chattering voice of that one man or bring upon itself so many afflictions, extreme famine and uncountable expenditure of moveable and immoveable goods, and it was not willing to be second but first among the states in showing total obedience to the Roman papacy.

Tuscus Remus, you have told most wisely not only of human events but divine.

Remus I return to Rome, whose greater power and dignity the Roman teacher Porcari has demonstrated more extensively in his writing.

Tuscus Porcari, who is he?

Remus Auditor of the Rota, Bishop of Andria, and now in charge of the province of Romagna.

Tuscus He whom reputation proclaims?

Remus It proclaims and he has deservedly learned to raise his reputation through deeds.

Tuscus Let us see Rome.

Remus Listen to him speaking as follows. 'I confess that the status and condition of things in the city of Rome in our own age is far, far from that power and imperial grandeur which once it had. But it flourishes, certainly it flourishes still, and although it is spread over a smaller portion of the earth nevertheless the renown of the majesty of the city of Rome rests on more solid foundations. Rome is more worthy under Alexander [VI] than it was under Caesar: one of these was a man, the other a God. Now Rome has significant power in respect of kingdoms and nations which it protects not through arms and iron, nor is mortal blood spilled for its preservation. But rather through a sweet subjugation the greatest part of the world reveres and venerates papal Rome. And whereas once, Rome, you conquered peoples through iron and blood, now power resides in faith alone and the benediction of the pope; kings, not princelings, offer you gifts and bow their heads of their own accord. Begin

[3] Probably San Piero a Grado in Pisa where the Arno once joined the sea and which tradition held was founded by Peter to mark the first place that he set foot in Italy. The present church dates back to the eleventh century.

now, Rome, to rejoice, for you do not have Sulla and Marius as masters, but the divine Alexander as *pontifex* and pastor. You have lost Cicero, Anthony, Crassus and Clodius, but the cardinals, senators of the Church, whom the whole world reveres after the pope, have rendered to you a senate more worthy and holy, embellished not with legions and companies, but with the most renowned men. The taxes of former times are ceasing, but now, Rome, you store up greater tributes while individual states and officials obtain favours from the Roman pontiff. In those days Rome was victorious but through the blood of mortals: it is now decorated by the blood of martyrs. The Roman generals celebrated their triumphs by scattering their wealth extravagantly but today the Roman popes triumph by distributing alms and displaying piety to the peoples. Lucius Sulla, whom, Rome, you are accustomed to calling lucky, sat with immunity watching his crimes from on high. Now our Alexander sits distributing forgiveness and guaranteeing security. You have often seen the head of Commodus and the head of the Colossus of Nero. But now Rome possesses the visible likeness of the Saviour outlined on the linen of the woman Veronica. It possesses the awe-inspiring heads of the apostles Peter and Paul.[4] For these and for a great many other things an uncountable number of men, regions and entire provinces, come to Rome throughout the year, moved by a desire to touch and worship, and they admire and praise Rome as the Lord, mother and mistress of all their peoples. At Rome you will see the Capitol and the theatres of Romans in triumph; at Rome you will find monuments greater than the pyramids and beams and columns of marble and the unbelievable temples of pagans and saints. The human and the heavenly at Rome are joined together.'

Tuscus	I have decided to turn towards both Porcari and Rome.
Remus	You will not be the only one.
Tuscus	I believe it. For I have been disturbed to hear other serious matters.
Remus	But have you now heard the word of the Lord, alas which that little brother . . .
Tuscus	Many times: this in particular, namely that the judgement of the pope is not at all times nor in all ways to be obeyed.

[4] The veil of Veronica and the heads of Peter and Paul are major relics, the former kept at St. Peter's, the latter at St. John Lateran.

Remus	When is it to be obeyed?
Tuscus	Only when it is just.
Remus	The brother violently declared that this is the word of the Lord.
Tuscus	Yes, often.
Remus	This is clearly the opinion of a charlatan, not a preacher.
Tuscus	Alas, what am I hearing?
Remus	But I tell you this is the word of the Lord.
Tuscus	Who declares such things?
Remus	The little brother least of all.
Tuscus	Who then?
Remus	Our Saviour.
Tuscus	Let us bend our knees.
Remus	To the little brother?
Tuscus	Absolutely not. But where does God say these things?
Remus	Where?
Tuscus	I am ignorant of letters.
Remus	You and the little brother.
Tuscus	But I implore you.
Remus	I do not hesitate.
Tuscus	Declare the teachings of the Saviour.
Remus	Are you ignorant that Christ is the Redeemer of all?
Tuscus	God forbid.
Remus	You deny that his instructions must be obeyed.
Tuscus	Do not add another word.
Remus	Speak firmly.
Tuscus	Both firmly and devoutly I know that we must obey the Redeemer with all our strength.
Remus	And you should know that he revealed this most especially to his vicars: 'Who hears you, hears me. Who rejects you, also rejects me' (Luke 10:16). And whoever is chosen as the vicar of Christ on earth will also have been chosen in heaven (Matt 16:19).
Tuscus	Perhaps, if he is chosen justly.
Remus	You fool! Who in the meantime will be a competent judge of this matter? The little brother and whoever strives to obey thepapacy?
Tuscus	What then is to be done?
Remus	We must obey Christ's vicar, the pope; we must serve him lest we die an eternal death.
Tuscus	I am certainly a Christian.
Remus	I hesitate.
Tuscus	Why this hesitation?

Remus	Listen now to the word of God: he is not a Christian who protects himself only in the name of Christ, but denies Christ and does not obey Christ's vicar on earth with humility and obedience and the purest heart.
Tuscus	I will try, assuredly, I will try.
Remus	Thus you will be saved, because if pagans were willing to impose the ultimate punishment on those who were subservient to princes and tyrants, even if they evaded some of their orders, what are we Christians to do?
Tuscus	Much more.
Remus	You understand rightly and thus you will escape the little brother.
Tuscus	May God destroy him.
Remus	He will if he does not go through with his repentance.
Tuscus	Then I would meet him.
Remus	Where, where?
Tuscus	In Florence, so I think.
Remus	And may Florence learn to correct its own errors, so that the vicar of Christ can be the only one with the power to soothe her troubles, the only farmer, the true vine and we are the branches (John 15:1–5), he alone can fish with the hook and cast his net into the deep (Luke 5:4). He alone would draw the net full of men not fish (Eccles 9:12; Matt 13:47), he who reveals heaven, and to whom the keys of heaven have been entrusted.
Tuscus	Now the sun is going down; I would say everything hurriedly.
Remus	In the first place I will reply to the brother as if he were ignorant and you should treat him as a diseased man. Let him show himself to the highest priest. For he is clearly a leper. He needs a doctor who can heal the French disease[5] and who will not hesitate to return the lost little brother by word and deed to the way of obedience not arrogance, purity not decadence, peace not Florentine rebellion, lest he infect the whole people of Florence and the flock of Christ with the same recklessness.

Transacted at Cesena, 2nd July 1497. Alexander VI was pope. Girolamo Porcari, Roman nobleman, Bishop of Andria, Auditor of the Rota, had driven out the rebels and was peacefully governing the Romagna.
Your friend Porcari.
Printed in Rome at Campo dei Fiori.

[5] *morbum gallicum* – syphilis.

2.1.10
A cultural tourist describes some of the sites in Rome

Around 1500 an anonymous 'Milanese draughtsman' (probably Donato Bramante) wrote a poem (translated here as prose) on the sights of Rome, which was circulated as a pamphlet printed on four pages. In addition to the antique statuary on display in the streets and squares – among them the Dioscuri (the 'two great colossi') and the columns of Trajan (here 'Hadrian') and Antoninus Pius referred to here – the writer refers to the collections of sculpture amassed by important cardinals. Elsewhere modern works are praised, including Pollaiuolo's bronze floor tomb for Pope Sixtus IV in St Peter's basilica, completed by 1493. The poet records the kind of expedition popular among artists who were attracted to Rome. Taking a picnic on a visit to study the grotesques at the Golden House of Nero, which was rediscovered in the 1480s near the Colosseum, was particularly popular, despite the difficulties involved in exploring the buried remains of the palace. A vivid picture is recreated of the co-existence of ancient and new works of art and of the excitement of new discoveries. [CMR]

Source: C. E. Gilbert (1980), *Italian Art, 1400–1500: Sources and Documents* (Englewood Cliffs, NJ and London: Prentice-Hall), pp. 102–3. Reprinted by permission of Creighton E. Gilbert.

. . . There are two great colossi, both together, with two men at their feet holding them in check, they are perfect and of the largest size. . . . In the Cardinal of Siena's house may be found three nude graces, and a nymph who seems as if she were drawing a great wind toward her. . . . And in the house of Cardinal Santa Croce, a nude holding a skinned goat, which is much talked of for being good. . . . The city councilors have in bronze a statue of the man that killed the robber Cacus that looks as if it were by him who made Adam. Nearby, within the range of the eye, a gypsy, showing more money lust than the ones Verrocchio made . . . and there are two columns, huge, of stone, which are threatening to fall down, if they fell they would make a great crash, one of Hadrian and one of Antoninus Pius, storied all over with battles, but we prefer the smaller one, it is two hundred feet of big thick carvings. . . .

There is a tomb, of molten material, of the great pope, fourth of his name [Sixtus IV], from Savona, like the one where the enemy of Darius reposed [Alexander the Great]. It is all bronze, and seems to thrust outward, adorned with virtues, muses, and sciences, crowned with praise, reward, and honor. At the top is the pastor himself, in glory like Phoebus' chariot, and he seems natural in its presence. Praxiteles and Scopas and Perseus would not have made it so fine. . . . And Antonio Pollaiuolo made the model, with every nerve and bone in the anatomy, as if Praxiteles had done it. . . . [the trophies of Marius] there are two trophy carvings, a good twenty feet in height, whence I have an unsated desire to draw them, swords, quivers, bows, shields, clubs, helmets, greaves, weapons, breastplates, and cuirasses. . . .

No heart is so hard it would not weep for the vast palaces and broken walls of Rome, triumphant when she ruled, now they are caves, destroyed grottoes with stucco in relief, some in color, by the hands of Cimabue, Apelles, Giotto. At every season they are full of painters, summer more than winter seems to freshen them, just as the name fresco suggests. They go through the earth with belly bands, with bread and ham, fruit and wine, so as to be more bizarre when they are with the grotesques, and our guide Master Pinzino makes us bump our faces and eyes, looking to everybody like a chimney sweep, and makes us think we are seeing toads and frogs, owls, bats, breaking our backs and knees. . . .

Netherlandish Networks

2.2.1
Pero Tafur's impressions of the Netherlands in the 1430s

The Netherlands was just one of the countries that Spanish nobleman Pero Tafur visited during his lengthy travels as a young man in the late 1430s. His admiring description of Bruges confirms the city's commercial and economic importance as the major international trading port in north-western Europe. This judgement was made despite the poor state of the city following its rebellion against Philip the Good in 1436 and the subsequent famine between June and November 1437. Tafur's visit may be dated shortly after this. Although Antwerp's heyday as a port and a market for art really dates from the late fifteenth century, Tafur's account reveals the importance of the famous Antwerp fairs at this much earlier date, not least for the sale of off-the-peg art works. The practice that Tafur describes of monastic and ecclesiastical establishments hosting art markets continued into the second half of the century with the founding of a specialist art market on premises leased from the Church of Our Lady in 1460, which became the only authorized venue for art sales from 1484. [KWW]

Source: M. Letts (ed.) (1926), *Pero Tafur: Travels and Adventures 1435–1439* (London: Routledge), ch. 24, pp. 198–204. Reprinted by permission of Routledge.

This city of Bruges is a large and very wealthy city, and one of the greatest markets of the world. It is said that two cities compete with each other for commercial supremacy, Bruges in Flanders in the West, and Venice in the East. It seems to me, however, and many agree with my opinion, that there is much more commercial activity in Bruges than in Venice. The reason is as follows. In the whole of the West there is no other great mercantile centre except Bruges, although England does some trade, and thither repair all the nations of the world, and they say that at times the number of ships sailing from the harbour of Bruges exceeds seven hundred a day. In Venice, on the contrary, be it never so rich, the only persons engaged in trade are the inhabitants. The city of Bruges is in the territory of the Count of Flanders, and is the chief city. It is well peopled, with fine houses and streets, which are all inhabited by work people, very beautiful churches and monasteries, and excellent

inns. It is very strictly governed, both in respect of justice as in other matters. Goods are brought there from England, Germany, Brabant, Holland, Zeeland, Burgundy, Picardy, and the greater part of France, and it appears to be the port for all these countries, and the market to which they bring their goods in order to sell them to others, as if they had plenty at home.

The inhabitants are extraordinarily industrious, possibly on account of the barrenness of the soil, since very little corn is grown, and no wine, nor is there water fit for drinking, nor any fruit. On this account the products of the whole world are brought here, so that they have everything in abundance, in exchange for the work of their hands. From this place is sent forth the merchandise of the world, woolen cloths and Arras cloths, all kinds of carpets, and many other things necessary to mankind, of which there is here a great abundance. There is a large building above a great tract of water which comes from the sea at Sluys, which is called *la Hala*. Here all goods are unloaded in the following manner. In these parts of the West the sea rises and falls greatly, and between Bruges and Sluys, a distance of two and a half leagues, there is a great canal, as great and as deep as a river, and at different places sluice-gates, as of water mills, are set up, which when opened admit the water, and on being closed the water cannot escape. When the tide rises the ships are laden and travel with their cargoes from Sluys on the tide. When the water has reached its highest point they lock it up, and those ships which have been unloaded and filled with fresh cargoes return with the same water which carried them up-stream, travelling down again with the falling tide. Thus the people by their industry make use of the water, carrying great quantities of goods to and fro, the transport of which, if they had to use beasts, would be exceedingly costly and troublesome.

This city of Bruges has a very large revenue, and the inhabitants are very wealthy. [. . .] anyone who has money, and wishes to spend it, will find in this town alone everything which the whole world produces. I saw there oranges and lemons from Castile, which seemed only just to have been gathered from the trees, fruits and wine from Greece, as abundant as in that country. I saw also confections and spices from Alexandria, and all the Levant, just as if one were there; furs from the Black Sea, as if they had been produced in the district. Here was all Italy with its brocades, silks and armour, and everything which is made there; and, indeed, there is no part of the world whose products are not found here at their best. There was a great famine in the year of my visit.

I departed to see Sluys, which is the seaport of Bruges, and lodged with the captain. [. . .]

I remained there with the captain for two days and saw the place. It numbers more than fifteen hundred burghers, and is strongly fortified with a wall and moat and so crowed with foreigners and their wares that the houses are insufficient to shelter them. I met there many Castilians, and people of other nations known to me. The harbour of this town is said to be very difficult to enter, on account of the sand banks, but, once inside, the ships are very secure and with the tide they can reach the town walls. At low tide many of them lie aground, but on such soft deep sands that they are as well placed as on the water. The harbour looks as if half the world had armed itself to attack the town, so great a fleet of ships of all kinds is always at anchor here: caracks, sloops from Germany, galleys from Italy, barques, whalers, and many other kinds of vessels according to the different countries, and even if the people are enemies among themselves they do not show their enmity either in the harbour or on land, but everyone goes his way and does his business. Anyone acting otherwise is severely punished. One can see there all the nations of the world eating at a common table without disputing. I remained two days at Sluys with the captain, and the returned to Bruges.

I now travelled through Picardy to a city called Arras, which belongs to the Duke of Burgundy. It is a pleasant place, and very rich, especially by reason of its woven cloths and all kinds of tapestries, and although they are also made in other places, yet it well appears that those which are made in Arras have the preference. [. . .]

I [. . .] came to the city of Antwerp, which is in Brabant and belongs to the Duke of Burgundy. It is large, and has about 6000 burghers. There is also an excellent wall with a rampart and a moat. The houses and streets are very fine and it has a good harbour. The ships enter by a river so that the galleys can be fastened to the city walls. The fair which is held here is the largest in the whole world, and anyone desiring to see all Christendom, or the greater part of it, assembled in one place can do so here. The Duke of Burgundy comes always to the fair, which is the reason why so much splendour is to be seen at his court. For here come many and divers people, the Germans, who are near neighbours, likewise the English. The French attend also in great numbers, for they take much away and bring much. Hungarians and Prussians enrich the fair with their horses. The Italians are here also. I saw there ships as well as galleys from Venice, Florence and Genoa. As for the Spaniards they are as numerous, or more numerous, at Antwerp than anywhere else. I met merchants from Burgos who were settled in Bruges, and in the city I found also Juan de Morillo, a servant of our King.

As a market Antwerp is quite unmatched. Here are riches and the best entertainment, and the order which is preserved in matters of traffic is

remarkable. Pictures of all kinds are sold in the monastery of St. Francis; in the church of St. John they sell the cloths of Arras; in a Dominican monastery all kinds of goldsmith's work, and thus the various articles are distributed among the monasteries and churches, and the rest is sold in the streets. Outside the city at one of the gates is a great street with large stables and other buildings on either side of it. Here they sell hackneys, trotters and other horses, a most remarkable sight, and, indeed, there is nothing which one could desire which is not found here in abundance. I do not know how to describe so great a fair as this. I have seen other fairs, at Geneva in Savoy, at Frankfurt in Germany, and at Medina in Castile, but all these together are not to be compared with Antwerp.

2.2.2

Lluís Dalmau is contracted to make an altarpiece for the councillors' chapel in Barcelona

This altarpiece contract, dated 29 October 1443, is important partly because the altarpiece itself survives together with its decorative carved oak inner frame (now in the Museum of Catalan Art, Barcelona), though without the Lamentation specified for the lower register (the 'banco') and the outer part of the frame ('guardapolvos'). The 'model' mentioned in the contract also survives (and is in the Municipal Archive, Barcelona), but it is more of a descriptive diagram than a detailed drawing. Even though this was a wholly Spanish commission, the Flemish oak specified in the contract, the emphasis on portraiture and the jewelled robes stipulated for the Virgin all suggest that this altarpiece was intended to have a Netherlandish appearance. Although a gold background was specified in the contract, the final painting includes angel musicians set against a landscape background and viewed through an architectural arcade. How and why this shift in design occurred is not known, but it is of some interest, as the angel musicians are based on those in Jan van Eyck's famous Ghent altarpiece dated 1432, and Netherlandish landscape painting appears to have been much admired in Europe. The painter Lluís Dalmau (active 1428–60) is known to have spent some time in the Low Countries between 1431 and 1436, where he is assumed to have learned Netherlandish oil-painting techniques. Whether the

appearance of this altarpiece is due to his influence or whether he was selected because he possessed the requisite Netherlandish skills is not known. [KWW]

Source: J. Berg Sobré (1989), *Behind the Altar Table: The Development of the Painted Retable in Spain, 1350–1500* (Columbia, MO: University of Missouri Press), pp. 290–2.

Tuesday 29 October of 1443

In the name of our lord God Jesuchrist, and of his holy virgin mother, and of the virgin Sta. Eulalia sacred heart of Barcelona.

Concerning the retable written about below to be made for the chapel of the House of the Council of the City of Barcelona, the articles written below are made and agreed upon between the honorable sir Johan Lull, sir Ramón Savall, sir Francesc Lobet, sir Anthoni de Vilatorta, and sir Johan the Junyent, Councillors for the present year of the said city as one party, and Mr. Luis Dalmau, painter as the other party.

And firstly the said Luis Dalmau agrees and in his good faith promises to the said honorable Councillors and to their honorable successors on the Council, that from the signing of the present articles until one coming and continually following year from now he will have made, put and set up the said retable within the said chapel with all its necessary finishing, its dimensions, form, measure, and manner according to the interior wall of the said chapel toward the altar, and according to the model already shown to the said honorable Councillors, which retable and the *guardapolvos* he will make and are to be of good wood of Flemish oak, well draped [literally] and gessoed according to the manner of sumptuous retables.

Item the said Mr. Luis Dalmau will paint in proper proportion and measure in the center of the retable the image of our lady Saint Mary seated on a sumptuous throne, with the infant Jesus in her arms, depicted and dressed with a variety of vivid high and well-finished colors, but that her mantle be and has to be colored of acre blue of the finest that can be found, with a solemn border of fine Florentine gold scattered in imitation of pearls and jewels.

And on the right side and right part of the said retable he will paint the image of the virgin St. Eulalia, patron and singular advocate of the said city, having in her hand the *Eucleo* [sic] of her martyrdom. And after in the same right part he will paint three of the said honorable Councillors, that is sir Johan Lull, sir Francesc Lobet, and sir Johan de Junyent kneeling with their

hands together directing their eyes toward the Virgin Mary. And the said Councillors will be depicted according to the proportions and habits of their bodies, with their faces thus their own, lifelike as they actually are, garments formed of robes and cloaks of vermilion color, so beautiful that they appear to be of cochineal, with the *portes* [collars?] and the robe linings appearing to be bordered with beautiful fur.

Item, it is agreed that on the left side of the said retable be painted the image of the blessed apostle Saint Andrew, with his mantle and with the cross of his martyrdom. And after, on the said same left part be painted and depicted the two Councillors, that is sir Ramón Savall and sir Anthoni de Vilatorta, thus proportioned as they are and according to the habits of their bodies, and with their robes and cloaks, and kneeling in and by the form and manner that is mentioned above about the said sir Johan Lull, sir Francesc Lobet, and sir Johan de Junyent.

Item, it is agreed that in the center of the *banco* of the said retable be painted the *Pietat* being in the center of the sepulcher and I. angel who holds the body of Jesuchrist by the shoulders. And at the right side of the said *pietat* he is to paint the image of Saint John the Evangelist. And on the left side Saint Mary Magdalen, of the said *banco* he is to paint the image (of Mary Magdalen) with the alabaster [oil jar] appearing with a sad expression on the occasion of the passion of Jhx. And on each end of the said *banco* is to be painted the arms of the city, accompanied with leaves of appropriate proportion.

Item, it is agreed that all the ground of the said retable, except the places where the said images and other paintings appropriate to the said images are painted, be entirely gilded with good and beautiful gilding of fine gold of Florentine florins.

Similarly it is agreed that at the pinnacle of the *guardapolvos* of the said retable be painted the royal arms of the Crown of Aragon, and at each side of the said *guardapolvos* be painted I. angel holding on each side the royal arms cited above. And on the sides of the said *guardapolvos* are to be diverse gilded leaves.

And for the whole above-mentioned retable, placed and installed within the above-mentioned chapel, according to what is said, the said Luis Dalmau will have, and the said honorable Councillors promise to have to give and pay truly and in fact five thousand Barcelona *sols* by the following payments, that is, for now one thousand and five hundred *sols*. And when the retable is half done, another one thousand and five hundred *sols*. And when the retable will be complete, put installed according to what is said, the remaining two thousand *sols*.

And the said Luis Dalmau will give good and secure guarantees known to the said honorable Councillors to give back and return whatever quantity or quantities that he has had and received of the said five thousand sols, if in the case that for sickness, death or absence, default or whatever other case, he, within the said time of I. year or more time if the honorable Councillors extend it, has not completed, placed, and installed the above-mentioned retable in the above-mentioned chapel in the form mentioned above.

On the day of Tuesday XXIX month of October, year of our lord M°CCCCLX there were signed the above-mentioned articles by the honorable sirs Johan Lull, Ramón Savall, Francesc Lobet, Antoni de Vilatorta, and Johan Junyent, Councillors of this year for the city of Barcelona. And these articles were signed and sworn by the said Luis Dalmau painter to have and to serve as it will be and be had. And the said honorable Councillors obligate the said city, and said Luis all in good faith.

Witnesses the venerable Johan Carreres merchant, Bnus. Montserrat, notary, and subsyndic of Barcelona Pons Cavale, Magistrate of the said honorable Council and Bnus. [*sic*] Rothan Scribe.

2.2.3

Ciriaco d'Ancona's comments on a Deposition triptych by Rogier van der Weyden

This is the earliest recorded comment (1449) by an Italian on a Netherlandish painting. Ciriaco d'Ancona (c.1390–1455) is known primarily as a humanist fascinated by ancient Greek and Roman antiquities, but his sophisticated Renaissance tastes were evidently far from precluding admiration for a work by the Brussels-based painter Rogier van der Weyden (1399/1400–64) in the collection of Lionello d'Este (1407–50) of Milan. Although Rogier's work owed nothing to the antique revival that inspired so many Renaissance Italian artists, Ciriaco was quick to appreciate his excellence in representing nature, whether in terms of convincing human emotion, landscape, or living and dead bodies. Truth to nature was a quality much admired during the fifteenth century in both northern Europe and Italy. Ciriaco went on to mention a Sienese painter whom he describes as a follower of Rogier van der

Weyden, evidence of the artist's impact on Italian art even during Rogier's own lifetime. [KWW]

Source: W. Stechow (1966), *Northern Renaissance Art 1400–1500: Sources and Documents* (Evanston, IL: Northwestern University Press), pp. 8–9. Reprinted by permission of Northwestern University Press.

After that famous man from Bruges, Johannes the glory of painting, Roger in Brussels is considered the outstanding painter of our time. By the hand of this most excellent painter is a magnificently wrought picture which the illustrious prince Lionello of Este showed me in Ferrara on July 8, 1449. In it one sees our first progenitors, and in a most pious image the ordeal of the Deposition of the God-Incarnate, with a large crowd of men and women standing about in deep mourning. All this is admirably depicted with what I would call divine rather than human art. There you could see those faces come alive and breathe which he wanted to show as living, and likewise the deceased as dead, and in particular, many garments, multi-colored soldiers' cloaks, clothes prodigiously enhanced by purple and gold, blooming meadows, flowers, trees, leafy and shady hills, as well as ornate porticoes and halls, gold really resembling gold, pearls, precious stones, and everything else you would think to have been produced not by the artifice of human hands but by all-bearing nature itself.

2.2.4
Bartolomeo Facio's description of the work of Jan van Eyck and Rogier van der Weyden

Among the artists included in the humanist Bartolomeo Facio's *Lives of Famous Men*, written in 1456, were Jan van Eyck and Rogier van der Weyden. Facio had encountered their paintings in Italy, in particular at the court of Alfonso V of Aragon, ruler of Naples, where he was employed. He seems to have been as prepared as Ciriaco d'Ancona to admire the art of these celebrated non-Italians. From Facio we learn that the *Descent from the Cross* owned by Lionello d'Este (1407–50) and described by Ciriaco had a donor

portrait on one of the shutters. There seems to have been a taste for Nether-landish painting among a small, interlinked circle of high-ranking indivi-duals in Italy, for Lionello was the son-in-law of Alfonso; and Ottaviano della Carda, whom Facio mentions owning van Eyck's painting of a woman emerg-ing from her bath, was the nephew of Federigo da Montefeltro, who famously employed the Netherlandish painter Justus of Ghent in the 1470s, and who later owned this picture. The map of the world attributed to van Eyck by Facio has since been shown to have been painted by Guillaume Hobit in 1440.[1] His claim that Alfonso's tapestries were made after designs by Rogier van der Weyden could conceivably be true. [KWW]

Source: M. Baxandall (1964), 'Bartolomaeus Facius on painting', *Journal of the Warburg and Courtauld Institutes*, vol. XXVII, pp. 102, 104–5.

Jan of Gaul

Jan of Gaul has been judged the leading painter of our time. He was not unlettered, particularly in geometry and such arts as contribute to the enrich-ment of painting, and he is thought for this reason to have discovered many things about the properties of colours recorded by the ancients and learned by him from reading of Pliny and other authors. His is a remarkable picture in the private apartments of King Alfonso, in which there is a Virgin Mary notable for its grace and modesty, with an Angel Gabriel, of exceptional beauty and with hair surpassing reality, announcing that the Son of God will be born of her; and a John the Baptist that declares the wonderful sanctity and austerity of his life, and Jerome like a living being in a library done with rare art: for if you move away from it a little it seems that it recedes inwards and that it has complete books laid open in it, while if you go near it is evident that there is only a summary of these. On the outer side of the same picture is painted Battista Lomellini, whose picture it was – you would judge he lacked only a voice – and the woman whom he loved, of outstanding beauty; and she too is portrayed exactly as she was. Between them, as if through a chink in the wall, falls a ray of sun that you would take to be real sun-light.

[1] J. Paviot (1991), 'La mappamonde attribuée à Jan van Eyck par Facio: Une pièce à retirer de son œuvre', *Revue des archéologues et historiens de l'art de Louvain*, vol. 24, pp. 57–62.

His is a circular representation of the world, which he painted for Philip, Prince of the Belgians, and it is thought that no work has been done more perfectly in our time; you may distinguish in it not only places and the lie of continents but also, by measurement, the distances between places. There are also fine paintings of his in the possession of that distinguished man, Ottaviano della Carda: women of uncommon beauty emerging from the bath, the more intimate parts of the body being with excellent modesty veiled in fine linen, and of one of them he has shown only the face and breast but has then represented the hind parts of her body in a mirror painted on the wall opposite, so that you may see her back as well as her breast. In the same picture there is a lantern in the bath chamber, just like one lit, and an old woman seemingly sweating, a puppy lapping up water, and also horses, minute figures of men, mountains, groves, hamlets and castles carried out with such skill you would believe one was fifty miles distant from another. But almost nothing is more wonderful in this work than the mirror painted in the picture, in which you see whatever is represented as in a real mirror. He is said to have done many other works, but of these I have been able to obtain no complete knowledge. [...]

Rogier of Gaul

Rogier of Gaul, a pupil and fellow-countryman of Jan, has produced many matchless monuments of his art. His is a most notable painting in Genoa in which there is a woman sweating in her bath, with a puppy near her and two youths on the other side secretly peering in at her through a chink, remarkable for their grins. His is another painting in the private apartments of the Prince of Ferrara: on one wing Adam and Eve with naked bodies, expelled from the earthly paradise by an angel, and in this there are no deficiencies from the highest beauty; on the other wing, a certain prince as suppliant; and on the centre panel, Christ brought down from the Cross, Mary His Mother, Mary Magdalen and Joseph, their grief and tears so represented, you would not think them other than real. His also are the famous tapestry pictures in the possession of King Alfonso, again the Mother of God, dismayed at hearing of the capture of her son yet, even with flowing tears, maintaining her dignity, a most perfect work; likewise the abuse and pain that Christ Our Lord patiently suffered from the Jews, and in this you may easily distinguish a variety of feelings and passions in keeping with the variety of the action. At Brussels, a city in Gaul, he painted a sacred chapel with the most perfect workmanship.

2.2.5

Marcantonio Michiel records Netherlandish paintings in the homes of collectors in Venice and Padua in the early sixteenth century

The notes on art by Marcantonio Michiel (d. 1552) were discovered in 1800 and not immediately identified as his, hence in older literature the author is referred to as the 'Anonimo'. In his inventories of the art works in collections in the Veneto, Marcantonio's judgements indicate a clear visual discrimination between Italian and Netherlandish painting. He was not sufficiently skilled to be able to distinguish between a genuine Netherlandish painting and the work of an Italian imitator, however, as his account of the *St Jerome* owned by Antonio Pasqualino shows – it is, in fact, the painting attributed to Antonello da Messina now in the National Gallery in London. He gets the subject matter of the diptych owned by Bernardo Bembo wrong: it is John the Baptist and St Veronica, not the Virgin and Child.[1] The Flemish *St Anthony* and the *Virgin and Child in a Church* attributed to Rogier van der Weyden that Marcantonio lists in the Vendramin collection also formed a diptych actually by Jan Gossaert and now in the Doria Pamphili Gallery in Rome.[2] The *Drowning of Pharaoh's Army in the Red Sea* in the Zio collection may well be the one by van Scorel in a private collection in Milan, but this is on panel rather than on canvas, and Marcantonio cannot have seen it in 1512, some 8 years before van Scorel arrived in Italy.[3] These errors show that it is unwise to rely too much on Marcantonio's judgements. If this is so, then it is impossible to be sure that the painting of an otter hunt on cloth in the collection of Leonico Tomeo in Padua was by the celebrated van Eyck, as is sometimes assumed. Michiel's interest in Netherlandish art, however, is not in doubt. [KWW]

[1] L. Campbell (1981), 'Notes on Netherlandish Pictures in the Veneto in the Fifteenth and Sixteenth Centuries', *Burlington Magazine*, CXXIII, pp. 467–73. The diptych is now divided between the Alte Pinakothek, Munich, and the National Gallery of Art, Washington.

[2] Ibid.

[3] M. Faries and M. Wolff (1996), 'Landscape in the Early Paintings of Jan van Scorel', *Burlington Magazine*, CXXXVIII, p. 727.

Source: From T. Frimmel (1896), 'Der Anonimo Morelliano', *Quellenschriften für Kunstgeschichte und Kunsttechnik*, new series, vol. i, pp. 16, 20, 54, 94, 98, 100, 102, 104. Translated from the Italian by Dario Tessicini. Copyright © The Open University 2007.

In the district of San Francesco in the house of Master Leonico Thomeo, the philosopher.
[...] The small picture on canvas of one foot, in which is depicted a landscape with some fishermen, who have caught an otter, with two figures looking on, by the hand of Jan of Bruges [Gianes da Brugia]. [...]

In the house of Master Pietro Bembo.
The diptych of St John the Baptist, dressed [and] with the lamb seated in a landscape on one side, and Our Dear Lady with a small putto in another landscape on the other side, made by the hand of Hans Memling [Zuan Memglino] in the year 1470, if I remember correctly. [...]

In the house of Master Camillo Lampognano, or rather his father Master Nicolò Lampognano.
The picture with half figures of a patron doing accounts with the steward, made by the hand of Jan van Eyck [Zuan Heic] – though I believe Memling [Memelino] – a Fleming, done in the year 1440. [...]

In the house of Master Francesco Zio 1512.
[...] The canvas with the drowning of the Pharaoh, made by the hand of Jan van Scorel of Holland. [...]

In the house of Master Antonio Pasqualino, 1529.
The small panel of St Jerome, reading in his study, wearing the cardinal's garb. Some believe that it was done by the hand of Antonello of Messina. Others believe that the figure was repainted by Jacometto Venitiano, but most people most rightly attribute it to Jan [van Eyck?], or to Memling [Memelin], an old Flemish painter, and like this [painting] exhibits this style, although the face is finished in the Italian [manner], so that it seems to be by the hand of Jacopo. The buildings are in the Flemish [style], the landscape is natural, minute and [highly] finished, and can be seen through a window on the one side, and the door to the study on the other. Here, precisely painted, are a peacock, a partridge and a barber's basin. Attached to the chair is represented a small open letter, which seems to contain the name of the master. However, when viewed more closely and clearly, it does not contain a single letter, but is all an illusion. And in short, the entire work – for its subtlety, colour, drawing, strength and intensity – is perfect.

In the house of Cardinal Grimani, 1521.

The half-length portrait in oil from life of Lady Isabella of Aragon, wife of Duke Philip of Burgundy, done by the hand of Hans Memling [Zuan Memelin], done in the year 1450.

The portrait in oil of the said Hans Memling [Zuan Memellino], and by his hand, done in a mirror, from which it is understood that he was around 65 years of age, rather fat if otherwise of a rosy complexion.

The two portraits, also in oil, of the husband and wife together, in the Flemish manner, are also by the hand of the same.

Many other small panels of saints, all with small shutters in front, also in oil, are by the hand of the same Hans Memling [Zuan Memelino].

The small paintings, also in oil, in which there are small columns and other ornaments, delightfully giving the impression [of being made] of jewels and precious stones, are by the hand of Hieronimo Todeschino.

The many small paintings of landscapes are for the largest part by the hand of Albert of Holland [Alberto de Holanda], of whom I have written on sheet 96.

The large canvas with the tower of Nembrot, with a great variety of things and figures in a landscape, is by the hand of Joachin [?Patenir], . . .

The large canvas containing St Catherine on the wheel in a landscape is by the hand of said Joachin.

The St Jerome in the desert is by his hand.

The canvas of Hell, with a great diversity of monsters is by the hand of Hieronymus Bosch [Hieronimo Bosch]. . . .

The canvas of the dreams is by the hand of the same.

The canvas of Fortuna with the whale that swallows Jonah is by the hand of the same.

Here, there are also works by Barberino Venetiano [Jacopo de' Barbari], who went to Germany and Burgundy, and taking on that manner made many things, which are . . .

Also there are [works] of Albrecht Dürer [Alberto Durer].

Also there are [works] by Girardo de Holanda . . .

The large design of the Conversion of St Paul is by the hand of Raphael, done for one of the tapestries of the [Sistine] chapel.

The famous work, which Master Antonio Siciliano is selling to the cardinal for 500 ducats, was done in miniature by many masters over many years. Here there are miniatures by the hand of Zuan Memelin [Hans Memling], . . . by the hand of Girardo da Guant [Gerard of Ghent - Gerard Horenbout], . . . by Livieno da Anversa [Livino of Antwerp] . . . Amongst these the twelve months are praised in particular, and above the others the month of February, in which a young boy is urinating in the snow, making it yellow, and where the landscape is all snow-covered and frozen.

In the house of Master Giovanni Ram, 1531, in Santo Stefano.
The bust-length portrait of Rugerio da Burselles [Rogier van der Weyden], a celebrated old painter, in oil on a small wood panel, done by the hand of the same Rogier and executed with a mirror in the year 1462. [. . .]

2.2.6
Pietro Summonte describes works by Jan van Eyck and Rogier van der Weyden in Naples

The Neapolitan humanist Pietro Summonte wrote to Marcantonio in 1524, apparently at Marcantonio's request, to instruct him about art in Naples, particularly the work by Netherlandish painters.[1] Much of his letter concerns the Italian painter Colantonio (born c.1420, d. after 1460), who is alleged to have been trained in a Netherlandish style by King René of Anjou, briefly king of Naples 1438–42. Colantonio's imitation of the Netherlandish technique and even, according to the extract here, completion of a Netherlandish painting might be taken as an indication of the prestige that Northern European art enjoyed at the Neapolitan court in the first half of the fifteenth century. Summonte also describes works of art imported to Naples directly from the Netherlands by Alfonso V of Aragon, who replaced René of Anjou as ruler of Naples in 1442. The Flemish painting of St George that Colantonio is reported to have copied is perhaps one by van Eyck acquired by Alfonso in 1445. Like Marcantonio Michiel, Summonte's knowledge of Netherlandish art was faulty: for example, he claims Petrus Christus worked earlier than

[1] J. Fletcher (1981), 'Marcantonio Michiel, "che ha veduto assai"', *Burlington Magazine*, CXXIII, p. 606.

either Jan van Eyck or Rogier van der Weyden. It has also been argued that Colantonio was in fact more indebted to the French art associated with King René's court than to Netherlandish painting.[2] [KWW]

Source: F. Nicolini (1925), *L'Arte Napoletana del Rinascimento* (Naples), pp. 161–3. Translated from the Italian by Dario Tessicini. Copyright © The Open University 2007.

Yet I believe that in our country this art has not been properly celebrated. I am convinced that this is because our rulers have been mainly concerned with the art of war, tournaments, horse harnesses[?], and hunting, and therefore they have loved and favoured only the craftsmen of these arts. King René [of Anjou] was also a skilled painter and was very keen on the study of the discipline, but according to the style of Flanders. He ruled this region for a very short period of time, since he was expelled by King Alfonso I. The other kings of the past, who can be considered as belonging to the Italian nation and were keen to send for painters, sculptors, architects and all sorts of glorious artists, were, I regret to say, ruined and removed from power at a very early stage, so that they could not leave behind any good monument. [. . .]

Since that time, our country has not had a remarkable painter, be they a fellow countryman or a foreigner, until our Master Colantonio, a Neapolitan, and a man so skilled in the art of painting that if it hadn't been for his premature death, he would have been set to do great things. He did not reach perfection in the art of drawing because of the times. Instead this was reached by his disciple Antonello da Messina, who, as I understand, was also known to your people. According to his times, Colantonio's inclination was rather for the style of Flanders and the colouring of that country, to which he was so committed that he had decided to go there. But King René kept him here showing him the style and method of that colouring.

In Naples there are four works by Colantonio.

One is in the church of San Severino, and it is Our Lady with the Son in her arms, on the one side Saint John, Saint Catherine on the other. In the upper part is a Crucifixion and the Annunciation of the Angel to Our Lady. In the Crucifixion, one can see a darkness so marvellous that it scares those who look at it. And in the predella of the image over the altarpiece, which is the best, there are the 12 apostles, painted with faces so admirably alive and diverse. And there is another marvel, ie. that our Lord and Saint James the

[2] J. Wright (1980), 'Antonello da Messina: The Origins of his Style and Technique', *Art History*, vol. iii, no. 1, pp. 45–6.

Less look so much the same that they have not one feature over which one can say that they differ. Yet the expertise of the wise painter is shown by the fact that he gave to the Lord a certain celestial majesty, whereas Saint James, is represented in a less imposing manner as is appropriate: something difficult, almost impossible, to express in a painting.

The second work by Colantonio is in [the Church of] Saint Peter Martyr. It represents Saint Vincent the Confessor, on a ship caught by such stormy, frightful waters and dreadful clouds that frighten to look at. A very skilful work.

The third is in San Lorenzo. The figure of Saint Jerome seated in his studio where there are so many books and so diverse in their shape . . . , with some small sheets of paper attached to the wall with wax, some of them dangling as if they were standing in the air. A very renowned work among our painters, still compared to the works of our own age, though it was made according to the ancient canons.

The fourth is in Santa Maria Nova, in the chapel under the pulpit for the sermons. And this is a panel painted with the full figure of Our Lord. This work came from Flanders, to which Colantonio himself added two angels on both sides, so similar to the original in shape, style, *incarnato*, colours and cloth dressing the figures [draperies], that everybody is compelled to think that it is all by the same hand.

He could copy with great skill everything he wanted; and all he copied were works from Flanders, which at the time were the only ones to be reputed fashionable. Also from Flanders, in this period, came the skilfully painted life portrait of the Duke Charles of Burgundy. Colantonio managed to have it on loan from the dealer who owned it and made one so similar that it was impossible to tell from the other. He then returned the new one he had made, which the dealer took as his own, until Colantonio revealed to him the ingenious trick. Likewise he made a copy of a panel representing Saint George, approximately two and half spans for each side, also coming from Flanders. And this was a renowned work, where one could see the knight leaning and throwing his spear into the mouth of the dragon, piercing through so deep that the skin on the other side was already swollen and stretched outwards. And the fine knight was so bent forward and strained against the dragon that his right leg was seen losing the stirrup and he himself almost unseated. The reflection of the dragon was visible on the left leg of the shiny armour as in a mirror, and the rust on the tree of the saddle stood out against all that metallic splendour. Finally, good Colantonio forged this painting in such a way that it could not be told from its original model but for a tree, an oak that he deliberately wanted to turn into a chestnut. This painting is now in Naples, in the cabinet

of the Most Illustrious Lady Duchess of Milan. The portrait of the Duke of Burgundy is not here, though, despite the claim of Giacomo Sannazzaro that he has seen it.

And since we have made a short digression on the things of Flanders, I shall not fail to mention the three canvasses made in that country by the renowned master Roger [van der Weyden], son-in-law of that other great master, Jan [van Eyck] who at first specialized on the illumination of books, that is miniatures, as it is known nowadays. But Roger only specialized in full-size figures. In those three paintings on cloth there was the entire Passion of Our Lord Jesus Christ in full-size figures, as I said, and among the many admirable features there was that of the figure of Christ, which looked exactly the same, up to the last detail, every time and in each diverse position he was depicted. Such skilfulness was admired by all the onlookers. It was common wisdom that King Alfonso I had bought these three paintings in Flanders for the sum of 5,000 ducats. Now they must be in the possession of that poor lady, Queen Elizabeth, widow of the late King Frederick, in Ferrara.

Nowadays, Sir Sannazzaro has a small painting representing the figure of a Christ in a glory, a notable piece of art by the hand of Petrus Christus, a renowned painter in the Flanders who lived before Jan and Roger.

This is what I could come to know about the things in Flanders. Your Lordship is now in a place where more detailed information can be gathered and listen as much as he wishes to foreign and domestic things, to his complete satisfaction.

Tapestries

2.3.1

Statutes of the Tapestry-Makers' Guild in Brussels

These statutes of 1450–1 provide an insight into two important features of the tapestry industry in Brussels: the generations of craftsmen, with family businesses practising and perfecting the same trade; and the tight control and organization of all aspects of the design and production of tapestries. The restrictions on those allowed to practise as tapestry weavers within Brussels, the limitations on how much work apprentices were allowed to undertake and, above all, the strict quality-control measures of materials and production methods provided the basis for the growth and success of Brussels as an important centre of tapestry production from the mid-fifteenth century onwards. [EC]

Source: A. Wauters (1878), *Les tapisseries bruxelloises. Essai historique sur les tapisseries et les tapissiers de haute et de basse-lice de Bruxelles* (Brussels: Julien Baertsoen), note 1, pp. 35–40. Translated from the Dutch by Ria de Boodt and Elizabeth Cleland. Copyright © The Open University 2007.

Rights granted by the lord and the town to the tapestry weavers' guild.

Recording how the worthy journeymen of the tapestry weavers' guild in Brussels recently applied to the Duke's bailiff (or *Amman*) and aldermen of the town of Brussels, to be separated from the major guild to which they belong, to become an independent guild, for which guild a future will not be envisaged should certain relevant requirements not be honoured. If that proves to be the case, the aforementioned worthy journeymen will not be able to serve within the realm of the lord and the town. Thus, Jan van Edingen, lord of Kestergate, the Duke's bailiff, and the burgher masters, aldermen and councilors have approved, consented, given and granted in their sessions to henceforth supervise the aforementioned worthy journeymen of the tapestry weavers' guild, as is needed, and that they should follow and use the points which follow hereunder, in order that they can be a credit to the lord and the town, if called for, and in order that they run an honourable guild.

1. First, that from now on in the aforementioned guild, no one will become or be accepted as a master unless he is a burgess of Brussels. And if the sworn members (or guild officials), of the aforementioned guild accept someone as a master who is not a burgess, each sworn member will have to pay a fine of one golden rider, the coin of the dukes of Burgundy and Brabant, to be divided half to the merciful lord, the Duke of Burgundy, and the other half to the aforementioned town of Brussels. Even in the case of payment, the master must become a burgess before he will be allowed to enjoy the status of master.

2. Also, that, from now on, anyone wishing to join the aforementioned guild who has not learned the profession in Brussels or in its recognized jurisdiction has to pay the aforementioned guild, at his own cost, 4 golden riders or something of the same value, as well as provide the sworn members with two barrels of Rhenish wine. He must also have learned the aforementioned profession for three years in a free town before his acceptance as a master in the aforementioned guild.

3. Also, that anyone wanting to learn the aforementioned profession of tapestry weaving in the aforementioned town of Brussels or its jurisdiction who is not the child of a free master of the aforementioned guild, has to pay the guild, at his own cost, 2 golden riders or something of the same value, as well as provide the sworn members with one barrel of Rhenish wine, if he stays more than 14 days with the aforementioned guild. And he will have to learn the aforementioned profession for 3 years before consideration for acceptance as a free master. And if afterwards he wants to become a free master in the aforementioned guild, then he will have to pay the guild a further 2 golden riders as well as provide the sworn members with one barrel of Rhenish wine. Exception from payment of these fees is extended to the children of free masters, in light of their established privileges and rights.

4. Also, that any journeyman, having learned the aforementioned profession outside the town of Brussels or its jurisdiction, and intending to practise the profession in this town, must pay the aforementioned guild, at his own cost, half a rider or something of the same value, as well as provide the sworn members with one barrel of Rhenish wine, as long as he has learned the profession for 3 years and practised it in another free town. However, he may work up to 14 days without having to pay the aforementioned half-rider nor any other fine. And if, after fourteen days' work, he does not pay the aforementioned guild in the aforementioned way, and his master does not inform the sworn members, then this master

must pay a fine of half a rider or something of the same value, to be divided one-third to the lord Duke of Burgundy, one-third to the town and one-third to the aforementioned guild. Even in the case of payment of this fine, the journeyman must still also pay the aforementioned guild his half-rider.

5. Also, that all legal children of the masters of the aforementioned guild be permitted 3 extra working days off not allowed to anyone else, and they must all come to register at the guild, otherwise they will be penalized, unless they are burgesses. And they may not become a master, or practise as a master, unless they have learned the profession for a period of 3 years, just as is the requirement for those who are not masters' children.

6. Also, that each master of the aforementioned guild is allowed to teach the aforementioned profession to one of his own legal a children, and moreover is allowed to have one other apprentice and no more, in good faith. All those who break this rule will be fined a half-rider for every time that it happens, to be divided one-third to the lord Duke of Burgundy, one-third to the town and one-third to the aforementioned guild.

7. Also, that no member of the aforementioned guild be allowed to work before the sounding of the Morning Bell nor after the sounding of the Dusk Bell, under penalty of a fine of a half-rider, to be divided in three as above. And that the sworn members are allowed to call before the Duke's bailiff and one town steward any one whom they suspect of breaking this rule, and may make a solemn declaration to justify the complaint before the Duke's bailiff and steward.

8. Also, that, from now on, the masters of the aforementioned guild must have all painted additions undertaken at the *Blauwerie* and nowhere else, to any linens, warp-faced textiles, serge textiles, cushion covers, bench covers or any other work under jurisdiction of the aforementioned guild and which they intend to sell on, under penalty of a fine of one rider, to be divided in three as above. And should the sworn members hold this charge against a member of their guild, then the accused will be called before the Duke's bailiff and one town steward, in order for correct proceedings to be set in motion.

9. Also, that no member of the aforementioned guild may be allowed to sell and support himself from the proceeds of the sale of any new work under jurisdiction of the aforementioned guild in the town of Brussels or its dependencies, unless it has been correctly valued and given seal of approval, under penalty of 3 riders to be divided as above. And that the

aforementioned sworn members may call before the Duke's bailiff and stewards anyone whom they feel is guilty of breaking this rule. Exception is extended to any foreign merchants from outside the town trading on their free market day, as they have a traditional right to enjoy this privilege. And if any tapestry work is brought to the town to be sold that is not considered of high enough workmanship to be given seal of approval, it is allowed to be offered for sale on Fridays at the Wood Market and nowhere else, and there it must be marked as non-guild-valued goods.

10. Also, if any journeyman of the aforementioned guild leaves his master's work untended out of eyeshot, or if he goes gambling or drinking within working hours, against the will or without the consent of his master, then he will have to pay a fine of two old groots, to be divided in three as above, on condition that his master complains to the sworn members within 3 days of the journeyman's gambling or drinking.

11. Also, that no member of the aforementioned guild may deliver or cause to be delivered any work made within the town of Brussels or its jurisdiction, unless it has first been given seal of approval and been valued in accordance with the rules drawn up for this purpose, under penalty of a fine of one and a half riders, to be divided in three as above. And anyone who wants to have any works valued and given seal of approval must take his work to Saint Christopher's in Ruisbroek, where those officials allocated to give the seal will be available three days a week, namely Tuesday, Thursday and Saturday, from Easter to Saint Bavo's Day between 8 and 9 o'clock and, from Saint Bavo's Day until Easter, between 9 and 10 o'clock.

12. Also, that every master must give all tapestry work made for resale a warp count of 24, with each warp composed of 12 threads. Anyone who does otherwise must pay a fine of one rider, to be divided as above.

13. Also, if an apprentice leaves his master during his apprenticeship and does not work for 14 days without any obvious reason, and does not give notice of this to the sworn members of the guild or to his master, then he must pay a fine of 6 old groots, and he may not practise the aforementioned profession until they have been paid. And if this occurs, the master must give notice of it to the sworn members within 3 days after the 14 days of absence have passed, and if he does not do so, then he will also be obliged to pay a fine of 6 old groots, for immediate division as above.

14. Also, that no master of the aforementioned guilds may have more than one apprentice at a time whatever their level, nor be allowed to teach the profession to anyone, unless this be his own child, who is permitted 3

extra working days off in the aforementioned guild, although the child is still obliged to complete 3 years of study before acceptance as a master into the aforementioned guild.

15. Also, that no member of the aforementioned guild may work with cows' hair, nor with goats' hair, nor with the hair of any other animal, nor with any forbidden yarns whatsoever. Nor may they buy or sell any works whatsoever made with materials of this sort, whether or not they were produced within or beyond Brussels, under penalty of a fine of one pound for every groot, to be divided in three as above, and moreover, he will not be allowed to practise his profession for the course of one year.

16. Also, that no merchant or female merchant is allowed to offer for sale together, in his or her display window or his or her house, new works under the jurisdiction of the aforementioned guild made inside Brussels together with works made outside Brussels, unless they are clearly separated from each other, under penalty of two riders, to be divided in three as above. And also, anyone who sells work made outside Brussels claiming it to be work produced within Brussels, must pay the same fine for each instance of this, to be divided as above. And the Duke's bailiff and the steward may each declare a further official settlement should they choose to do so.

17. Also, that no journeyman of this guild will produce, nor offer for sale, nor deliver any work whatsoever coming under the jurisdiction of the aforementioned guild under penalty of a fine of three riders, to be divided as above, unless the action is undertaken in the name of his master or mistress in good faith.

18. Also, that no journeyman of the aforementioned guild is allowed to produce yarn or cloth under the jurisdiction of the aforementioned guild himself, nor to cause this to be done, unless it is for his own personal use, and with the knowledge and consent of his master, under penalty of a fine of one rider, to be divided in three as above, to be paid every time this happens.

19. Also, that no master of the aforementioned guild is allowed to subcontract, to inveigle, to lure away, nor to cause to be lured away, another master's journeyman, nor a journeyman belonging to the guild who he has in his workshop during his working hours, or during the time that he ought to be working for his master, under penalty of a fine of one rider, to be divided in three as above, to be paid every time this happens.

20. Also, if a master of the aforementioned guild is involved in public scandal then he may not enjoy the freedoms of the guild until he has extricated himself from the scandalous situation.

21. Also, that anyone who offends the sworn members or the clerk of the aforementioned guild by anger or any manner of behaviour, in connection with the guild, will be called before the lord and the town, who will investigate the charge according to the circumstance of the situation.

22. Also, that no member of the aforementioned guild may work on Sunday or on holy days which must be celebrated in church, under penalty of a fine of one rider, to be divided as above, to be paid every time this happens.

23. Also, that no master of the tapestry weavers' guild is allowed to employ another master's journeyman. Any master who wishes to employ such a journeyman, must ask the master if his journeyman has any outstanding obligations, in terms of both money and work. And if the journeyman has not completed his obligations, then the other master is not allowed to employ him unless he himself pays and fulfils the outstanding duties, and this must be done before he is allowed to employ the journeyman. And if he does not do so, then he will be obliged to pay a fine of one old schild, to be divided in three as above.

24. Also, that the seal of the aforementioned guild used to stamp tapestry work, must remain continuously within the holy precinct of Saint Christopher's, and may not be removed elsewhere.

25. Also, if anyone is indebted to the guild, whether it be a fine owed or any money due to the guild, them he must pay within the month that the serving sworn members draw his attention to it, on the understanding that the sworn members believe the outstanding fine to be just. And if one who is a member of the aforementioned guild does not pay, then he will be obliged to pay an additional fine of fifteen pounds current money each time that this happens, to be divided in three as above. And the sworn members must collect the outstanding debt and the fine, and pay the lord and the town their part, within 6 weeks after the feast of Saint John the Baptist.

26. Also, that the good journeymen of the aforementioned guild shall take part in all civic processions, in their guild's name, in good faith.

27. Also, that when the sworn members make their rounds to collect the guild's money or fines, or because of any other business pertaining to the guild, that two sworn members will each receive no more than 2 stuivers, as the guild sees fit and for no other cause, always unless the Duke's bailiff and the serving aldermen of the town of Brussels change, correct, extend or limit the points dealt with here, if after due consideration, it seems to them the best course of action to take.

Done on 7th April in the year fifty before Easter

2.3.2

The Signoria of Florence recommends a weaver from Bruges

This letter of recommendation of 1456, written for 'Livino di Giglio', a weaver from Bruges, by the Governing Council (*signoria*) of Florence, provides an intriguing record of the activities of an early itinerant northern weaver and of the response to his work by his southern patrons. The terms used to praise the tapestries which he had created for the *signoria* come from the writings of Pliny the Elder. [EC]

Source: C. Conti (1875), *Ricerche storiche sull'arte degli arazzi in Firenze* (Florence: G. C. Sansoni), appendix doc. 1, pp. 95–6. Translated from the Latin by Dario Tessicini. Copyright © The Open University 2007.

It is preferable that the officers of the arts, etc., and those men to be honoured and favoured for some art and virtue, are especially praised by those among which their works of art made them famous. Levino Gigli of Bruges, above all an honest man and a most excellent craftsman with miraculous skills in the weaving of figures in tapestry has been in our city for some time. And while in the service of Our Republic, he weaved, among other works, one with figures and different colours so exceptionally close to nature that they might seem to lack soul and voice alone and can be taken for real bodies. We make use of this remarkable work as a *spalliera* for public occasions, such as the accession to office of our magistrate or in the most solemn celebrations; and so gleams this artefact that its sight is most welcomed and renowned by the crowd; it brightens the 1,300 square cubits, or so, that it covers of our Palazzo. For this artefact, beside the sum that we paid to him for the excellent service, we also add our praise and recommendation. And since he is about to move elsewhere in order to extend and augment his fame with other similar works of art, and to be known, we invite our friend and allies, and order our subjects and vassals, that when the aforementioned Levino will reach your territory, he shall be welcomed and treated in a friendly way, allowing him the right of free movement within and across borders with his goods and possessions without having to pay toll or taxes, as a special indulgence of our city. And also we entrust him to your extraordinary goodwill and kindness, since the said master is extraordinary. And those practicing an art shall be honoured

with praises and enriched with favours, so that they will be more committed, and others encouraged. In fact, honour nourishes the arts and it inspires the quest for glory.

Given the 2 July 1457

2.3.3
A dispute between the Painters' Guild and the Tapestry-Makers' Guild

This document of 1476 reveals that the Brussels' Magistrate had had to arbitrate in a dispute which broke out between the Painters' Guild and the Tapestry-Makers' Guild in Brussels in connection with the division of labour. In particular, they could not agree whose role it was to design and assemble tapestry cartoons. The ordinance outlines the circumstances and accusation made by the painters, and ends with the magistrate's decision, which draws a neat distinction between the original creation of cartoons and the assemblage and reuse of existing patterns already in the tapestry-makers' possession. [EC]

Source: A. Wauters (1878), *Les tapisseries bruxelloise. Essai historique sur les tapisseries et les tapissiers de haute et de basse-lice de Bruxelles* (Brussels: Julien Baertsoen), note 1, pp. 48–9. Translated from the Dutch by Ria de Boodt and Elizabeth Cleland. Copyright © The Open University 2007.

Between the painters and the tapestry weavers

Because particular disagreements and quarrels have arisen between the sworn-members (or guild officials) and the worthy journeymen of the painters' guild in Brussels, on the one hand, and, on the other, the sworn-members and worthy journeymen of the tapestry weavers' guild in the same town. Because various journeymen, foreign and others, have made particular patterns on paper with charcoal and chalk for some tapestry weavers, which these tapestry weavers have worked from, contrary to the rights of their guild granted them by the lord and legislation of this town. And the aforementioned aldermen have pointed out that as a result of this, particular fines are owed

which they will receive from the aforementioned tapestry weavers, provided that they denounce and call to account the foreign journeymen. Because the aforementioned tapestry weavers, who challenge them with the belief that they have done no wrong, seek that they be able to do this kind of work, or cause it to be done, without having to take the painters into account, because of many reasons to that end, cited by them. And the aforementioned two parties, even before any sentence or arrangement concerning their shared discord could be decided upon or delivered by the jurisdiction, have let it be known to the aforementioned aldermen that they, with the mediation of good men, have come to an agreement over the aforementioned quarrel and settled the matter amicably, and accede to the carried points, which follow hereunder, pressing that they, meeting the needs of both their guilds, be granted by the jurisdiction. And thus, Hendrick van den Eycken, representative magistrate of the duke's bailiff (or *Amman*) in his absence, the burgher masters, aldermen and councillors of the aforementioned town of Brussels, being strongly inclined to preserve and advance unity, accord and peace among the town's inhabitants, after granting both parties prior deliberations, have approved, consented and granted the points which follow hereunder, to be in effect from now on, in perpetuity. This being so, except that the serving duke's bailiff and the aldermen of Brussels may always improve, limit, extend, correct and revoke them, without any dissent from other parties. To wit, that the aforementioned tapestry weavers will always be allowed to make a few things without having to take the painters into account: drapery, trees, foliage and grass, and birds and animals which are represented on verdures and if an area of a pattern is missing, they themselves may correct or lengthen that with charcoal, chalk or pen, exclusively for their own use, and not for resale in any form whatsoever. And should anyone in the tapestry wavers' guild, whether he is a master, a journeyman, or other unknown person, be found to be working other than has been agreed upon with the painters' guild, then he will be fined each time this happens, with the fine demanded by the painters, granted by the lord and town in good faith.

Done and agreed [. . .] 6 June [14]76

Siena

2.4.1
Ghiberti's admiration for early Sienese art

In the second book of his *Commentaries*, Lorenzo Ghiberti comments on the work of a few fourteenth-century Sienese painters. From these comments it is clear that the Florentine sculptor admired the work of these painters, particularly that of the 'learned' Ambrogio Lorenzetti (fl. c.1317, died before 1348). Ghiberti's familiarity with early Sienese art undoubtedly arose from his experience of being consulted in 1416 and 1417 by Siena's Opera del Duomo on the design and execution of the font for the city's Baptistery. Although he did not produce the two reliefs allocated to him until 1427, contemporary documents indicate that Ghiberti visited Siena when he was first consulted about the project. It is likely, therefore, that he made notes about the works of art he saw there, and then later used these notes when writing his 'Commentaries'. [DN]

Source: Lorenzo Ghiberti (1912), 'The Commentaries of Lorenzo Ghiberti', in J. von Schlosser (ed.), *Lorenzo Ghiberti's Denkwürdigkeiten (I Commentarii)*, translated by the staff of the Courtauld Institute of Art, 2 vols (Berlin), pp. 18–19.

In the city of Siena there were excellent and learned masters, among whom was Ambrogio Lorenzetti,[1] a very famous and notable artist who left many works. He was a master of composition, among whose works is one, in the Minorite church (S. Francesco), very large and well executed, which fills the whole wall of a cloister, relating how a youth decides to become a friar. He enters the Order, is vested by the Prior and then with other friars fervently seeks permission to preach the Christian faith to the Saracens in Asia. These friars set out and begin preaching, but are taken prisoner and brought to the Sultan who straight way orders them to be tied to a column and beaten with rods. They are immediately tied up and two men begin beating them: the painting shows how these men are relieved by others and rest themselves, their rods still in their hands, dripping with sweat, their hair damp, weary and uneasy, so that the art of the master seems marvellous; and besides this there are all the people with their eyes fixed on the naked friars, and the

[1] Ambrogio Lorenzetti, active 1317, died, most probably, in 1348. Ghiberti praises him highly, but omits his painter brother, Pietro Lorenzetti (active 1315–45), in his account.

Sultan, seated in the Moorish fashion, all with such varied poses and costumes that one would certainly believe them alive. The Sultan sentences them to be hanged on a tree, and the picture shows one hanged on a tree; it is clear that the people standing watching are listening to the hanged friar who continues to preach. The executioner is ordered to behead them. The execution takes place in the presence of a great crowd, on horseback and on foot: there is the executioner, with many men-at-arms, there are men and women, and, when the friars are beheaded, there is a tempest with hail, lightning, thunder and earthquakes, so that one seems to see painted all the perils of the sky and earth, and it seems that everyone seeks shelter in great trepidation – men and women pull their clothes over their heads, the men-at-arms hold their shields over their heads and the hail beats down on them: it really seems that the hail bounces from the shields as if driven by great winds. Trees are bent to the earth and split, everyone seems to flee, one sees them all fleeing. One sees the executioner fall beneath his horse and get killed, and so many people are baptised. For a painted story it seems to me a marvellous thing.[2]

He was a perfect master, a man of great genius, a very fine draughtsman and deeply learned in the theory of his art. On the facade of the Hospital he painted two histories, which were the first: one shows the Birth of Our Lady, the second her entry into the Temple, very well done.[3] For the Augustinians he painted the Chapterhouse: on the vault are the stories of the Creed, on the main wall three histories. The first represents S. Catherine in a temple, with the tyrant seated on high examining her; it seems to be a feast-day in the temple as there are many people shown inside and outside it with priests sacrificing at the altar: this scene is very elaborate and excellently done. On the other side she disputes with the wise men in the presence of the tyrant and she seems to defeat them – some go into a library to look for books to refute her. In the middle is Christ crucified, with the thieves and with men-at-arms at the foot of the cross.[4] In the Palazzo (Pubblico) of Siena he painted

[2] These frescoes represented the events leading up to the martyrdom of a Sienese Franciscan friar at Tana (near Bombay) in 1321. They were painted on the walls of the cloister at San Francesco, probably in the mid-1330s, and have now been destroyed apart from a few fragments showing the hailstorm described by Ghiberti.

[3] This is a reference to the Hospital of Santa Maria della Scala which, as the city's principal hospital, orphanage and pilgrim hospice, was then one of the city's most important charitable institutions. It is generally believed that Ambrogio's brother Pietro Lorenzetti painted the *Birth of the Virgin* and Ambrogio the *Presentation of the Virgin in the Temple*. A later source gives the date of these façade paintings as 1335.

[4] A fresco of the *Virgin and Christ Child with Saints*, attributed to Ambrogio Lorenzetti by modern scholars, but not mentioned by Ghiberti, survives in the ex-chapterhouse of

Peace and War with his own hand: the allegory of Peace shows merchants going about their business in security, leaving their wares in the woods and returning for them: and the disruptions caused by War are shown perfectly.[5] There is also a Cosmography, that is, the whole of the habitable earth: as Ptolemy's Cosmography was not then known, it is not surprising that his is not perfect. In the Cathedral there are three very perfect works of his.[6] At Massa (Marittima) there is a large panel and a chapel;[7] at Volterra a noble panel by his hand; in Florence the Chapter-house at S. Agostino, and a panel and a chapel in S. Procolo.[8] At the Scala, where the foundlings are received, there is a very admirable Annunciation.[9]

Master Simone was a very fine and very famous painter.[10] The Sienese masters consider him to be their best, but it seems to me that Ambrogio Lorenzetti was much better, and far more learned. To return to Master Simone: by his hand there is a Madonna embracing the Child with many other figures, all marvellously coloured, in the upper hall of the Palazzo Pubblico.[11] A very good panel picture is in the same Palace, and on the facade of the Hospital are two scenes; one of the Betrothal of the Virgin, the other of her Visitation by many women and girls, this being richly ornamented with buildings and figures.[12] In the Cathedral are two panels of his;[13] he also began,

Sant'Agostino, which was the principal church of the Augustinian Hermits in Siena. The other paintings described by Ghiberti are now lost.

[5] These are the well-known frescoes (for which Ambrogio Lorenzetti received payments in 1338 and 1339) on the walls of the room now known as the Sala della Pace on the first floor of the Palazzo Pubblico.

[6] One of these was probably the *Presentation in the Temple*, now in the Uffizi Gallery, Florence. A painted inscription on the painting gives the name of Ambrogio Lorenzetti and the date 1342.

[7] A panel painting by Ambrogio Lorenzetti depicting the Virgin and Christ Child with angels, saints and the three theological virtues is now in the civic museum of Massa Marittima.

[8] Four scenes depicting scenes from the life of Saint Nicholas by Ambrogio Lorenzetti and with a provenance of San Procolo are now in the Uffizi Gallery, Florence.

[9] The Hospital of Santa Maria della Scala.

[10] Simone Martini, active 1315, died 1344.

[11] The *Maestà* (for which Simone Martini received payments in 1315 and 1321) on the east wall of the room, now known as the Sala del Mappamondo on the first floor of the Palazzo Pubblico and next to the Sala della Pace.

[12] See note 3 above. Modern art historians are generally agreed that Ghiberti's attribution of these two scenes, now identified as the *Betrothal of the Virgin* and the *Return of the Virgin to the House of her Parents*, to Simone Martini is probably correct.

[13] One of these was probably the *Virgin of the Annunciation with Saints Ansano and Massima*, now in the Uffizi Gallery, Florence. A painted inscription on the painting gives the names of both Simone Martini and Lippo Memmi and the date 1333.

above the gate which leads to Rome, a very large Coronation, of which I saw the red preparation ('cinabrese'). There is also, above the door of the Opera (del Duomo), a Madonna and Child with a canopy held above them by flying angels and with many Saints around them, all done with great care. He lived when the Papacy was at Avignon and there he did many things. Master Filippo was his collaborator and is said to have been his brother:[14] they were worthy masters who painted a great quantity of panels, diligently wrought and most exquisitely finished.

Sienese masters also worked in Florence; one, called Barna,[15] was more excellent than the others and he painted two chapels for the Augustinians with many scenes; one showing a young man led to execution, who is in great fear of death and who is comforted by a friar; there are many other figures, and, judging from these and other works by this master, he was very skilful. He was very learned and painted many Old Testament scenes at San Gimignano[16] and many other works at Cortona.

Duccio lived in Siena and held to the Greek manner; he was outstanding and the big picture in Siena Cathedral is his work. On the front is shown the Coronation of Our Lady, and on the back New Testament scenes.[17] This picture was excellently and sapiently made: it is a magnificent work by a most noble painter. In the city of Siena there were very many painters and it was filled with noble spirits; in order not to say too much I omit mention of them.

2.4.2
The commissioning of the reconstructed altar and altarpiece for the Cappella dei Signori

In this document of 24 December 1448, the Consistory (a fifteenth-century equivalent of today's Cabinet) presents the Sienese painter Sano di Pietro

[14] Lippo Memmi (active 1317–48), Simone Martini's brother-in-law.
[15] The precise identity of this Sienese painter and his work continue to be the subject of debate among art historians.
[16] These frescoes still survive in the church of the Collegiata at San Gimignano and are by the Sienese painter Bartolo di Fredi (active 1353–1410).
[17] Active 1278–1319. The painting, somewhat inaccurately described here by Ghiberti, is Duccio's famous double-sided altarpiece, known as the *Maestà*, installed on the high altar of Siena Cathedral in 1311.

(1405–81) and the woodworker Giovanni di Magno with a highly detailed description of the reconstruction that the officials wanted for the existing altar and altarpiece in the principal chapel of the Palazzo Pubblico. These written instructions must also once have been accompanied by an equally specific drawing. In creating a new wooden framework for an altarpiece (which was probably a multi-panelled polyptych by the early fourteenth-century painter Simone Martini), the painter is also requested to provide five new predella panels, which are to emulate a series of early fourteenth-century frescoes on the façade of the Hospital of Santa Maria della Scala. This commission thus provides a demonstration of the respect that still existed in fifteenth-century Siena for the art of the previous century. [DN]

Source: M. Eisenberg (1981), 'The First Altar-piece for the "Cappella dei Signori" of the Palazzo Pubblico', *Burlington Magazine*, CXXIII, pp. 135–6. Reprinted by permission of the Burlington Magazine.

The work to be done at the altar of the chapel of the Signori should be as follows; that is, according to the drawing provided.

First, to remake the altar, that is, all the superstructure of it, enclosed and covered with patterns of maple.

And all the plinths made of panels of split maple, with frames and ornament harmonising with the stalls where one kneels in the said chapel.

Also, that the side edges [i.e. pilasters] of the said altar-piece, that go straight up, be patterned with beautiful and fine wood, with all the necessary large and small frames and with all the fields between these frames or arcades, where arcades should be, all worked in beautiful and fine inlays, harmonising with those frames and inlays in the choir, or the door that master Domenico created in the chapel.[1]

Also, returning to the said altar-piece, there should be from one side to the other a frame above and another below ornamented with dentils; that above with fine inlays between one frame and the other; and the canopy with an arcade, all beautiful, according to the said drawing.

And in the same manner the faces of the said pilasters should be inlaid and framed to the full height; said pilasters should be cut obliquely, and not project too far in front of the said altar-piece, so that they do not hide or cast shadows or darkness on the figures of the altar-piece.

[1] This is a reference to the wooden choir stalls that survive in the chapel today. They were executed by the Sienese woodworker Domenico di Niccolò, 'dei Cori' (c.1363–1450), using the Articles of the Creed as the subject matter of the inlay that ornaments the seat backs.

Also there is to be made a predella below the said altar-piece, which should be *tre quarri* [i.e. 43.5 cm] in height surrounded by frames, and frames between, that is between each scene; because there should be made five stories of Our Lady like those that are above the doors of the Scala Hospital,[2] placing in the middle the Assumption and on each side two scenes, which should be painted in a fine manner, and all the surfaces and frames done in fine gold and the figures decorated and worked in a good grade of ultramarine and gold, where suitable or other colours also of fine quality.[3]

And the above mentioned canopy should be covered with a good blue, but not ultramarine, with gold stars.

And all the said work should be done according to the said drawing for which all these things should come to __ florins, at the rate of 4 *lire* for each florin, exactly; and said masters should use the funds provided for the work to the full amount.

The said work is not to go in height beyond the feet of the Saviour who crowns our Lady.[4]

And all the said work should be completed by the said masters and the expenses declared for everything by July next which would be 1449.

2.4.3
Aeneas Silvius Piccolomini and international politics

At this stage of his career, Aeneas Silvius Piccolomini (1405–64) was still only a cardinal and Bishop of Siena, but, as this extract from his *Commentaries*

[2] This is a very specific instruction to the painter, Sano di Pietro, that he should closely follow the subject of the scenes of the early life of the Virgin on the exterior façade of the Hospital, described by Ghiberti in his 'Commentaries'. It appears from these instructions that there was also a painting of the *Assumption of the Virgin* on the façade which is not mentioned by Ghiberti.

[3] The five panels of Sano di Pietro's predella survive, but now dispersed in three different museum collections. They are: *The Birth of the Virgin* (University of Michigan, Ann Arbor); *The Presentation of the Virgin in the Temple* and *The Betrothal of the Virgin* (Pinacoteca Vaticana); *The Return of the Virgin to the House of her Parents* (Staatliches Lindenau Museum, Altenburg).

[4] This is probably a reference to a fresco painting on the altar wall of the *Coronation of the Virgin* by Taddeo di Bartolo (active 1368–1422), which was part of the early fifteenth-century fresco decoration for the chapel. This painting no longer survives.

reveals, he was very active as a diplomat on the international stage. The document also offers an interesting, if highly partial, account of how the Sienese perceived themselves in relation to their close neighbours, Florence, and describes the constituency of various political parties within Siena itself. The actual meeting of the bride and groom in 1452 was later depicted by Pinturicchio (c.1452–1513) in the Piccolomini Library adjacent to the cathedral of Siena commissioned by Aeneas's nephew, Francesco Todeschini Piccolomini, Cardinal and Archbishop of Siena. [DN]

Source: Pius II (1936–7), *The Commentaries of Pius II*, trans. F. Alden Gragg with notes by L. C. Gabel, *Smith College Studies in History* (Northampton, MA), XXII, pp. 51–62. Reprinted with the publisher's permission.

Aeneas [Silvius Piccolomini] meanwhile had gone to his church at Trieste, but in the jubilee year [1450] he was recalled by the Emperor and sent with Gregor Volckenstorf and Michael Pfullendorf to Alfonso, King of Aragon and Sicily, to arrange a marriage between the Emperor and Leonora, sister of the King of Portugal.[1] The Portuguese ambassadors were already gathered at Naples. When after forty days of negotiation the matter was finally concluded, Aeneas, in the presence of the King, the Apostolic Legate, the Cardinal of Amiens, the Dukes of Clèves, Calabria, Suessa, and Silesia, and a great number of prelates and counts, delivered a speech in the senate hall of the Castelnuovo at Naples on the nobility and virtue of the contracting parties. This was afterward committed to writing by many. Going from here to the Pope [Nicholas V] toward the end of the jubilee year, he announced in a public consistory that the marriage had been arranged and that the Emperor would come the next year to be crowned. [...]

The following year was the one when the Empress Leonora was, according to agreement, to sail from Portugal to the harbor of Talamone in Sienese territory and the Emperor Frederick was to enter Italy and be crowned at Rome. He was very eager that they should go to Rome together and together be crowned by the Pope's own hands. Therefore twelve noble matrons and maidens were chosen to receive the royal bride at the harbor and to be her attendants and two barons and two knights were appointed to accompany them. To this number were added Aeneas and the Emperor's secretary, Michael Pfullendorf, who were to discharge the duties of ambassadors. After they had

[1] Frederick III of Austria, Holy Roman Emperor (1440–93) and Leonora (or Eleanora) of Portugal, who was also the niece of Alfonso V of Aragon, King of Sicily and southern Italy.

received the Empress at Talamone they were all to escort her to Siena and there await the Emperor's arrival. Aeneas and Michael were further instructed to inform the communes and princes of Italy, and especially the Pope, that the Emperor, about whose coming they were beginning to have doubts, would certainly arrive at the feast of St. Martin [November 11], to ask safe-conduct for him; to fix fair prices for the supplies he would need. Letters dealing with these matters were sent ahead.

At this news the powerful in Italy were filled with terror, the weak with hope; princes wavered, rumor was rife, and there was fear of uprisings such as had been known of old at the coming of emperors. But the Sienese were more frightened than anyone else, because they thought that Aeneas, a member of a great and noble family, bishop of their city, who had the ear of the Emperor and was highly esteemed by him, desired a revolution in their government. Now Siena is considered next to Florence the chief city of Tuscany; it rules many flourishing towns and possesses a wide territory. At first the nobles were in power, but when they were divided among themselves and voluntarily withdrew, the government passed to the people. Among them also, as usually happens, some were more able than others and as one party after another became powerful, it seized the government. One party was called The Nine, another The Twelve, not because these were their actual numbers but because they appointed that number of Priors to govern together; another, because under its régime it had reformed the city's laws and rebuilt the walls, was called The Reformers. Of these the so-called Twelve (they were actually five hundred), although they are rich merchants, are nevertheless considered insignificant; they have been deprived of any part in the government and live an almost servile existence. The Nine and The Reformers share the functions of government equally with the people and allow the nobles on sufferance, as it were, a certain number of offices. Thus the Sienese thought that Aeneas, being a noble, would at the Emperor's arrival set on foot some scheme to restore his family to their old prestige and power. When therefore he had carried out the Emperor's instructions at Venice, Ferrara, Bologna, and Florence and was on his way to Siena, they were afraid of him, watched to see what he would do, and forbade the people to go to meet him. Some, as is the way of the populace, even hurled abuse at him and the ruling party actually hated him. The way of the world is certainly absurd with nothing about it fixed or stable. During the preceding year no one could look at or praise Aeneas enough, but now when he entered the city, he was hateful to all and not a soul did him the honor of going out to meet him. At his house he was welcomed by only a few; in the public squares he heard many curse him; *it was even rumored that there was a conspiracy against his life.* But he bore

everything calmly and smiled to himself at the change of fortune. When therefore he appeared before the senate, after discharging the Emperor's mission he begged the presiding magistrate not to be suspicious of him, saying that one who had been loaded with so many favors by their government had no reason to wish to oppose it; he, who as bishop was their most honored citizen, desired peace and loathed all dissension; the Piccolomini family, to which he belonged, had like the other nobles always been treated honorably by the party now in power; Gregorio Lolli,[2] a celebrated lawyer and one of the chief magistrates of the city, was his cousin, the son of his father's sister, Bartolommea; his sisters were married to members of the ruling party and their children would be his heirs; in short there was no conceivable reason why he should be hostile to the government. He said furthermore that the Emperor was not coming to be king of Italy but to be crowned; he had with him illustrious princes and powerful nobles, who were all lovers of peace and came as friends not foes; nothing was to be feared from them, as they desired only permission to pass; the Emperor had never loved civil strife, his honor was to be relied on, and he carried out faithfully what he promised. By these words he appeased them somewhat and was enabled to remain among them in safety. [. . .]

But meantime disturbances had arisen in Austria, which put off the Emperor's journey many days, and the Empress was seriously delayed by unfavorable winds and violent storms. Therefore Aeneas had to spend sixty days at Talamone, days which were very dull both for him and for his colleagues. Still he employed the interval in visiting Monte Argentaro and the famous Port' Ercole and Ansedonia, which is worth seeing, for, though its buildings are in ruins, its walls, built of huge, square-hewn stones fitted together with extraordinary precision without mortar, still stand on a hill above the Tuscan Sea looking out toward Carthage.

By a remarkable coincidence, on the very day when the Emperor, who had crossed from Germany into Italy and was proceeding as quickly as possible, entered Florence, the Empress, sped by some breeze from heaven *or by sheer chance*, landed at Leghorn.[3] Aeneas too received on the same day letters from both the Emperor and the Empress bidding him and his colleagues come at once to Pisa. Thereupon, accompanied by his colleagues and the ladies in waiting, he obediently made haste to go thither through Grosseto, Scarlino, and the territory of Volterra. [. . .] They debated a long time at Pisa about sending the bride to the Emperor, till finally, after the other matters had been arranged, the Marquis of Portugal, who had received Leonora from her

2 Gregorio Lolli later became Pius II's confidential secretary.
3 Known today as Livorno. This landing took place on 2 February 1452.

brother and was charged with bringing her to the Emperor, in the presence of the ambassadors, the distinguished nobles of Pisa, and the notaries, took the Empress by the hand and delivered her to Aeneas that he might escort her to the Emperor. [...]

Meantime the Emperor had reached Siena and was awaiting his bride there. When he learned that she was coming with all possible speed, he sent to meet her first the citizens, then his brother Albert, Duke of Austria, then his cousin Ladislas, King of Hungary and Bohemia, and fourth and last the clergy carrying relics of the saints. He himself with the two Apostolic Legates, Pope Nicholas's brother,[4] the Cardinal of Santa Susanna, and the Cardinal of Sant' Angelo, at his side awaited the bride outside the city between the second and third gates. There in a wide open space the royal couple dismounted and embraced.[5] Heinrich Leubing an expert in canon law, spoke for the Emperor and Aeneas for the Empress. Soon after this the Sienese erected there a marble column as a lasting memorial[6] that after-ages might know that an Emperor from the East and an Empress from the West had first met in that place.

Meanwhile the Sienese had banished from the city all those among The Twelve and The Nobles who could bear arms and especially Aeneas's kindred, the Piccolomini. But when they realized the Emperor's mildness and clemency and saw that Aeneas had spoken the truth, they returned to their old admiration for him, proclaimed him their good father and citizen, recalled his family, ceased to suspect them, and appointed him their ambassador to the Pope.

2.4.4
Pius II's canonization of Saint Catherine of Siena

Aeneas Silvius Piccolomini was elected pope in 1458 and took the name Pius II. As a member of one of Siena's noble families, he was highly receptive to

[4] Filippo Calandrini, step-brother to Pope Nicholas V.

[5] This meeting occurred on 24 February 1452 outside the Porta Camollia, the principal northern gate of the city.

[6] This column with the carved coat of arms of Frederick and of Leonora still survives today outside Porta Camollia. It was erected in late April 1452 at the expense of the Sienese government. It also features prominently in Pintoricchio's painting of this event in the Piccolomini Library.

the campaign energetically pursued by the Sienese to secure the canonization of the late fourteenth-century mystic, reformer and writer, Catherine of Siena. The canonization in 1461 by Pius II was also later commemorated in Pintoricchio's paintings for the Piccolomini Library. [DN]

Source: Pius II (1947), *The Commentaries of Pius II*, trans. F. Alden Gragg with notes by L. C. Gabel, *Smith College Studies in History* (Northampton, MA), XXX, p. 391. Reprinted with the publisher's permission.

Meantime the Pope, who had been asked by his fellow citizens to enroll the blessed Catherine of Siena[1] among the holy virgins of Christ, called a council of the bishops then in Rome, to which three cardinals who had investigated her life and miracles reported all that they had learned. When the meeting, on being asked its pleasure, approved with one voice the maiden's canonization, Pius ordered a tribune to be raised in the basilica of St. Peter, from which after celebrating mass he delivered an oration on the merits of the girl. [...] At the end, with the warm approval of the cardinals, bishops, abbots, and other prelates present, he directed that Catherine should be enrolled with the usual ceremonies in the catalog of sainted maidens and ordained an annual commemoration of her. He granted indulgence for seven years to all who visited the tomb[2] which contains her bones and himself dictated the bull of canonization [...].

2.4.5
Pius II's description of his cathedral in Pienza and its interior

In this part of his *Commentaries*, Pius II offers a perceptive account of the cathedral that he had built in Pienza by the Florentine architect Bernardo

[1] Catherine of Siena (1347–80) was one of the most powerful figures in the political and religious life of her day. She lived a life of extreme abstinence in her father's house in Siena. Her activities ranged from serving the poor of her own city to shaping the course of papal politics by visiting Avignon in 1376 to persuade Gregory XI to return to Rome.

[2] Then located in a chapel in the right transept of the Roman church of Santa Maria sopra Minerva. As a direct result of the saint's canonization in 1461, an earlier tomb and effigy of c.1430 was made more elaborate. In the nineteenth century, the saint's tomb was placed under the high altar of the church, where it can still be seen today.

Rossellino (1409–64). In this description of the building, he also briefly refers to the four altarpieces that he commissioned from four of Siena's leading practitioners in painting – Vecchietta, Sano di Pietro and Giovanni di Paolo, and the much younger Matteo di Giovanni. [DN]

Source: Pius II (1951), *The Commentaries of Pius II*, trans. F. Alden Gragg with notes by L. C. Gabel, *Smith College Studies in History* (Northampton, MA), XXXV, pp. 601–3. Reprinted with the publisher's permission.

Next [to the palace] stood the church built in honor of the Blessed Mary Ever a Virgin. Because of the unevenness of the ground it was really two churches, an upper and a lower. When they started to dig for a foundation, they went down fully a hundred and eight feet before they found any and even then it was none too good, since, when they cracked the crumbling stones in their effort to strike a solid base, they kept coming on fissures and sulphurous exhalations. While they were trying to shut out the fumes, the sides of the pit, which were not sufficiently protected, gave way and some of the workmen were killed. Therefore they constructed very broad arches from rock to rock and laid the wall on them without having sufficiently investigated the solidity of the rocks. Though they were very large it was uncertain how firmly they were set in the earth and a crack in the building running from bottom to top gave rise to a suspicion as to the security of the foundation. The architect thought the crack was caused by the settling of the mortar while it was hardening and that they need not fear for the safety of the structure. Time will tell. The walls are very thick and adequate to carry their own weight and that of the two rows of arches above them.

The lower church was reached by a door and thirty-six broad steps. Two columns in the middle supported the entire structure. Three large windows let in ample light for the whole church and the four altars and the beautiful white marble font in one of the chapels. The very aspect of the church rouses emotion and a devout reverence in all who enter.

The upper church is 140 feet long, 60 high, and as many wide, not counting the space taken by the chapels which add to both the length and the width. Of necessity its greatest length, contrary to custom, is from north to south.

The square before the palace was paved with bricks laid on their sides in mortar. Three steps of hard stone ran the width of the church façade. By these you ascended to the church which was entered through an open space fifteen feet wide instead of a vestibule. The façade itself is 72 feet high, made of stone resembling the Tiburtine, white and shining as marble. It was modeled on those of ancient temples and richly decorated with columns and arches and

semicircular niches designed to hold statues. It had three beautifully propor-
tioned doors, the center one larger than the others, and a great eye like that
of the Cyclops. It displayed the arms of the Piccolomini above them the papal
fillet wreathed about the triple crown, and the keys of the Church between.
The façade is of the same breadth all the way from the foundation to the roof.
From there to its top it has the form of a pyramid decorated with charming
cornices. The other walls are of less precious material but the stones are
squared and well polished with projections like ribs interspersed at regular
intervals to strengthen the fabric.

As you enter the middle door the entire church with its chapels and altars
is visible and is remarkable for the clarity of the light and the brilliance of the
whole edifice. There are three naves, as they are called. The middle one is
wider. All are the same height. This was according to the directions of Pius
who had seen the plan among the Germans in Austria. It makes the church
more graceful and lighter. Eight columns, all of the same height and thickness,
support the entire weight of the vaulting. After the bases were in place and the
columns with four semicircular faces had been set upon them and crowned
with capitals, the architect saw that they were not going to be high enough.
He therefore placed above the capitals square columns seven feet high with a
second set of capitals to support the arches of the vaulting. It was a happy
mistake which added charm by its novelty. The side naves are of the same
width as far as the third column; there they begin to narrow and the entire
church ends in a semicircular apse. The further part, like a crowned head is
divided into five small chapels which project from the rest of the structure; it
has the same number of arches, as high as the naves, in which are fastened
gold stars and they are painted the color of the sky to imitate the heavens.
The vaulting in the naves was painted in various colors and the columns,
which we have said were added together with their capitals to correct an
error contributed the colors of porphyry and other precious marbles. The
lower columns were left in the natural white stone. The walls of the church
and all the rest of the building gleam with a wondrous white lustre.

In the central chapel were the episcopal throne and the canons' seats, made
of precious wood decorated with sculpture and designs in the work called
intarsia. In the other four chapels were altars adorned with paintings by
illustrious Sienese artists.[1] In the second to the left of the throne was the

[1] This is a reference to the four surviving altarpieces in Pienza Cathedral which are:
Vecchietta, *The Virgin of the Assumption with Saints Agatha, Pius, Calixtus and Catherine
of Siena*; Sano di Pietro, *Virgin and Christ Child with Saints Mary Magdalene, James, Philip
and Anne*; Giovanni di Paolo, *Virgin and Christ Child with Saints Bernardino, Anthony
Abbot, Francis and Sabina*; Matteo di Giovanni, *Virgin and Christ Child with Saints
Catherine of Alexandria, Matthew, Bartholomew and Lucy*.

repository for the Host, of finely carved white marble. Every chapel has a high and broad window cunningly wrought with little columns and stone flowers and filled with the glass called crystal. At the ends of the naves, were four similar windows, which when the sun shines admit so much light that worshippers in the church think they are not in [a] house of stone but of glass. On the two columns nearest the door are two fonts, the work of no mean genius, from which those who enter sprinkle themselves with holy water. The high altar stands between the last two columns and is ascended by four steps. The priest and his attendants when celebrating mass, have the people behind them and the choir in front next to the pontifical chair. In the body of the church are two other altars to serve the congregation.

To the right of the main church is a sacristy, to the left a bell-tower which was to be 160 feet high. A third of this was still unfinished. From the lower church on the right and left 132 spiral stairs cut in the thickness of the walls led to the upper church and the roof.

In the square before the palace was a deep well of living water, the mouth of which was decorated with very beautiful marble columns supporting an entablature artistically sculptured. There were also chains and buckets for drawing water.

All these buildings except the bell-tower which was still unfinished were completed from foundation to roof in three years.[2] [...]

In order to preserve the dignity and brilliance of the church Pius issued the following bull:

'Pius, Bishop, Servant of the servants of God, for the record of the future. In this church which we have erected and dedicated to the Blessed Virgin Mary, Mother of our Lord and God, no one shall bury a dead body except in the tombs assigned to priests and bishops. No one shall deface the whiteness of the walls and columns. No one shall draw pictures. No one shall hang up tablets. No one shall erect more chapels and altars than there are at present. No one shall change the shape of the church either the upper or the lower. If anyone disobeys he shall be accursed and unless in articulo mortis may be absolved only by the authority of the Pope. Given at Pienza September 16, in the year of the Incarnation of our Lord 1462 and the fifth year of our pontificate.'

[2] Between 1459 and 1462.

The Post-Byzantine Renaissance

2.5.1

The will of the painter Angelos Akotantos

The will of the Cretan painter Angelos Akotantos (active 1436), preserved in the archives of *Duca di Candia* kept in Venice, was written by Angelos himself and registered on 16 November 1457 after his death. Angelos probably died sometime beforehand, possibly in 1450, while the will itself had been made in 1436 as a precaution just before his journey to Constantinople. Angelos lived and worked in Candia (now Herakleion), the capital of Crete, during its Venetian occupation (1211–1669). He was certainly the most influential painter of his time and the springboard of post-Byzantine art – the art produced after the fall of Constantinople in 1453 in centres that were under Latin domination (e.g. Crete, the Ionian islands). [AL]

Source: M. I. Μανούσακας (1960–1), Ἡ Διαθήκη του᾽ Αγγελου Ακοτάντου (1436), ἀγνώστου Κρητικοῦ Ζωγράφου᾽, Δελτιον της Χριστιανικῆς Αρχαιολογικῆς Εταιρείας [M. I. Manousakas, 'The Testament of Angelos Akotantos (1436), an Unknown Cretan Painter', *Deltion tis Christianikis Archaiologikis Etaireias*], vol. 4, ser. 2, pp. 146–9. Translated from the Greek by Dimitra Kotoula. (Greek personal names and names of places are given here in their standard phonetic transcription. In cases where no standard transcription exists, the names have been strictly transliterated.) Latin notes translated by Dario Tessicini. Copyright © The Open University 2007.

[Notary's addition in Latin:] On the 16th December 1457, the underwritten document in Greek, in the hand of master Angelos Akotantos, and presented by master Iohannes Akotantos, painter, is recorded below, word by word, and according to the rule of law, including those marks contained in the document.

Note that after the said document there is this one.

On the 25th April, the thirteenth indiction, in Candia, the aforesaid Sir Angelos, presented to myself, Georgios Vataci, the above document that he said he wrote with his own hand and that he wanted to be his will; he asked that after his death I shall copy it in the form of an official document with the customary additions and clauses. Witnesses were Petrus Sarentino, Micaletus Demilano and Galeacius Crassan.

[Will in Greek]

It was because of the disobedience of our forefather Adam that all of us have surrendered ourselves to death and to decay and there is not a single man who will live and not experience death. For this reason, I, too, Angelos Kotantos [Akotantos], the painter, as a mortal man who is in debt to death and is about to sail to Constantinople, now order and compose this testament of mine concerning my belongings and this is what I wish. First of all, I wish Manouel Marmaras, the goldsmith, my best man, and my wife and my nephew Micheli Prigkipas to be the executors of this testament. Then, I order that, first, 16 *hyperpyra*[1] should be given as charity for the love of God to 8 families of poor good men who now live in poverty and it is my command that two commemorations should take place 40 days after my death; one should be performed by the superior of the monastery of Valsamonero, the holy father Ionas, and the second should take place at the church of Christ Kephalas.[2] And my servant, Loutzia, after my death should feel free to take the clothes I have put aside for her. And if my wife wishes, she could take back the utensils she had brought with her as a dowry each kind in accordance with what she gave to me and whatever she had given to me so far in *denaria*[3] she should take back in *denaria*. Also, I leave all her gifts to her, if she wishes so, however, if she prefers to take them back in *denaria* then I do not leave her the gifts. And if she gives birth to a male child and this child grows up and gets married I leave my house to my son – the house where I live – and he should not have the right to sell it or leave it to anybody, the house should pass from child to child. And my son should be obliged to give for my soul 4 *hyperpyra* each year to 4 poor good men who need them. And if my son dies without leaving a legitimate male child I wish my house to be given to my brother Ioannis and

[1] *Hyperpyra*: Byzantine gold coin of standard weight (4.55 g) introduced by Alexios I in 1092. The term continued in use after the end of the Byzantine period. See Philip Grierson (1982), *Byzantine Coins* (London: Methuen), pp. 215–17. For monetary equivalencies and intrinsic values of the coins that appear in the text of the testament, see Cécile Morrisson and Jean-Claude Cheynet, 'Prices and Wages in the Byzantine World', in A. E. Laiou (ed.) (2002), *The Economic History of Byzantium: From the Seventh through the Fifteenth Century* (Washington: Dumbarton Oaks), vol. 2, pp. 815–78.

[2] The church of Christ Kephalas is one of the most famous churches in Candia, Crete. For more information see M. Manoussakas (1959), 'Recherches sur la vie de Jean Plousiadénos (Joseph de Méthone), (1429–1500)', *Revue des Études Byzantines*, 17, p. 45, ft. 98.

[3] Denarion is a silver coin, in Greek *denarion*, in Latin *denarius*. The earliest specimens are from approximately the start of the second century BC. The average wage of a soldier and of a day labourer was one denarion.

he, Ioannis, should be obliged to give each year for my soul 12 *hyperpyra* to 6 families of good men who now live in poverty. And Ioannis should not have the right to sell the house or leave it to anybody but his child should inherit it and onwards it should pass on from one male child to the next and that child should always give the *psychikon*[4] I decree. However, if my brother Ioannis dies leaving no male descendant the house should be given to St Catherine, the *metochion* [dependency] of Mount Sinai[5] and they should pay, first, the land and house tax to the treasury – the tax is for the upper floor where I live, I also have the use of the small shop downstairs, and for the ground floor that our father gave to my brother Ioannis when he got married – that is, 20 *hyperpyra* and 3 *grossia*,[6] and both of us, Ioannis and myself, are obliged to pay, I the two-thirds and Ioannis the rest, as our father had commanded. And, then (if they inherit the house), the Sinaites should be obliged to give each year for my soul 14 *hyperpyra* to 7 families of good men who now live in poverty and the rest that is left from the rent of the house should be sent to Mount Sinai. And if my wife gives birth to a female child the house should be given to her as a dowry and my child, male or female, who will inherit the house should always give the four *hyperpyra* that I have ordered to be distributed as *psychikon*. And the child, if a female, should not be allowed to marry before she becomes 15 years old and if the female child dies before marriage then the house should be given to my brother Ioannis on the conditions that I have left and prescribed above. And the child who is to be born, if a boy, I wish first to go to school and then to learn the art of how to paint and if he does so I leave him my drawings and all my painting equipment. But if he does not learn the art, how to paint, I mean, I leave my drawings, those I have executed in charcoal, to my brother Ioannis. In addition, I

[4] *Psychikon*: donations or offerings, usually in money, made posthumously for the commemoration of the soul of the deceased. For numerous examples of the use of the term in Byzantine testaments, see John Thomas and Angela Constantinides Hero (eds) (2000), *Byzantine Monastic Foundation Documents: A Complete Translation of the Surviving Founders' Typika and Testaments* (Washington: Dumbarton Oaks), 5 vols, esp. vol. 5, pp. 1893, 1986.

[5] The monastery of St Catherine, Mount Sinai, had strong ties with Crete (and Cyprus), where it possessed daughter-houses, and was (and still is) renowned for its collection of icons. See Yuri Piatnitsky et al. (eds) (2000), *Sinai, Byzantium, Russia: Orthodox Art from the Sixth to the Twentieth Century* (London: Saint Catherine Foundation in association with the State Hermitage Museum, St Petersburg).

[6] *Grossia*: from the Venetian word *grosso*. Heavy silver coins issued first in Genoa in 1172 and then in Venice in 1192. It was the most important medieval trade coin. The *grossi* was also the main coin of Cyprus and was later a Turkish coin.

wish the furniture and the utensils that are to be left over, as well as anything in gold or in silver that will be found, to be sold and the money along with any other *denaria* that may be found should be placed in a safe investment where they will give interest. From this interest my wife, as a widow with child, should keep a certain amount until the child gets married. However, if the child dies before getting married my wife should take 100 *hyperpyra* for the period she will remain a widow and from the remaining amount I leave to my brother Theodoros 50 *hyperpyra* and to Ioannis *hyperpyra* . . . and to my sister the Barbina, the wife of Mr George Barbo, the hairdresser, I leave 10 *hyperpyra* and to my nephew, Micheli Prigkipa, *hyperpyra* . . . and to my grand-mother Apladou who is a widow I leave 5 *hyperpyra* and the money that may be left over should be given to other female children who wish to get married . . . And if my wife wishes to ask for her dowry back she should ask for it in *denaria* for I wish all the utensils she had given to me as a dowry to be sold and given back to her apart from her gifts. And I leave my books to my child, if a boy in order to learn how to read and these should pass from child to child but if the child dies at an early age the books should be sold and the money should be given as charity to good poor men who now live in poverty and to poor widows and to cover the wedding expenses of poor young girls who wish to get married. Also, I wish that the icon of the head of St Catherine, the round one, should be sent after my death to the Sinaites who should display it each year on the feast day of the saint in my memory. Also, I wish that after my death the two icons that hung in my room, the Resurrection of Jesus Christ and the other one depicting the Nativity of Christ, should be sent to Christ Kephalas to be displayed in the middle (of the church) on the stand which I have provided for this purpose – the Resurrection on Easter and the Nativity on Christmas day. And with money from my savings they should perform three liturgies there – one on Easter Sunday, a second one on the next day and on Tuesday a third one – and another one at Christmas, on the twenty-sixth, the day after Christmas, and then (the icons) should be brought back home and the child who is to be born, male or female, should be obliged, as long as they shall live, to take care of all these each year as I have prescribed. However, if the child dies I leave these two icons, the one of the Resurrection and the other one of the Nativity, to Christ Kephalas where I also order as *psychikon* the construction of two wooden cases with leaves made of glass on the front cover in order that the icons may be securely kept inside. The cases should be hung high up and (the icons) should be brought and displayed in the middle of the church, the first on Easter day and the second one on Christmas day, and I leave the stand for the display of the icons to the church. And my brother Ioannis who will inherit my house

should be obliged to perform the three liturgies each year – the three during Easter – and the other one at Christmas and these liturgies should also be carried out by his grandchildren and their descendants. If, however, the house goes to the Sinaites they should be obliged to perform the four liturgies to Christ Kephalas annually at Easter and at Christmas. If the child who is to be born dies, the icon of Christ, the big one, which is hanging outside over the door on the upper part of the frame, I leave it to my brother Ioannis.

[Notary's addition in Latin:] 6 November 1457, the priest Andreas Janizoplo confirmed with his oath that the above writings have been handwritten by the aforesaid Master Angelos Akotantos and he said he knows this, since the witness saw other writings by the said Sir Angelos, that this Sir Angelos gave to the witness during his lifetime and in this way he knew the handwriting of the said Master Angelos.

The eighth day of the aforesaid month, Ignatius Mezolatus, *ieromonachus*, confirmed with his oath that the above writing was handwritten by the afore-said Angelos and said he knows this, since the witness saw many times the writings of the aforesaid Master Angelos.

2.5.2
Ioannes Akotantos sells the drawings of his brother, Angelos Akotantos

Ioannes Akotantos (d. before 1513) was the brother of Angelos Akotantos, the famous Cretan painter whose will survives (see document 2.5.1). Ioannes, too, lived and worked in Candia, the capital of Crete, during the Venetian occupation (1211–1669); he was also a painter. Ioannes, according to Angelos's wishes in his will, inherited his drawings. On 7 August 1477, Ioannes decided to sell 54 of these drawings to another Cretan painter, Andreas Ritzos (active second half of fifteenth century, d. 1503), who was most probably an appren-tice in Angelos's workshop. The sum of 3 gold ducats would have been con-sidered as rather expensive for its time, which indicates the importance that the painters ascribed to these patterns. [AL]

Source: M. Cattapan (1968), 'Nuovi Documenti Riguardanti Pittori Cretesi dal 1300 al 1500', *Πεπραγμένα του Β΄ Διεθνούς Κρητολογικοῦ Συνεδρίου*, τ. Γ (Τμῆμα Μεσαιωνολογικὸν) [Pepragmena of the II Diethnous Kretologikou Synedriou, vol. III, Tmima Mesaionologikon] (Athens), pp. 42–3. Translated from the Latin by Dario Tessicini. Copyright © The Open University 2007.

I, Iohannes Akotantos, painter, and my heirs, make publicly known that I give and sell to you, here present and content, Andreas Ritzos, painter, and your heirs, 54 pieces of samples of different figures of saints, called *sqinasmata* in Greek, that I gave and brought to you so that you could acknowledge you had received them, and as a price and payment for all 54 samples of the aforesaid, as we agreed, you gave and paid 3 Venetian golden ducats and I consign the said drawings trustingly and peacefully, but also declaring this explicit condition: that I sold you the said drawings with the condition that if I recover from the physical infirmity that I presently suffer, and I wish to have the drawings back for my use only and not for selling them to someone else, then you will be bound to give the said drawings back to me, and I will give you and pay 3 gold ducats. Reciprocally, I, the aforesaid.

Note that on the eighth, the notary will give back the document requested by Pandon Sansone and it is in a sheet of paper, together with others.

2.5.3
Contract to teach the art of painting in the workshop of Ioannes Akotantos

In this contract of 1453 the rules are outlined under which the Cretan painter Ioannes Akotantos, a resident of Candia (see document 2.5.2), undertook to teach the art of painting to a young apprentice. [AL]

Source: M. Cattapan (1968), 'Nuovi Documenti Riguardanti Pittori Cretesi dal 1300 al 1500', Πεπραγμένα του Β' Διεθνούς Κρητολογικού Συνεδρίου, τ. Γ (Τμήμα Μεσαιωνολογικὸν) [Pepragmena of the II Diethnous Kretologikou Synedriou, vol. III, Tmima Mesaionologikon], (Athens), pp. 44–5. Translated from the Latin by Dario Tessicini. Copyright © The Open University 2007.

On the same day [30 October 1453]. – I, the aforesaid Bonassida, with my heirs, make publicly known, that I grant you, sir Iohannes Akotantos, painter and citizen of Candia, the custody of my son Antonio, and godchild of the aforesaid priest Vasili, here present and content, for a period of 5 years from now. In this time, you will have to teach him the art of painting honestly and appropriately. In this time you will have to provide him with shoes and I will pay unconditionally for his subsistence, and he will have to assist you in what is necessary for the above art. And I, the aforesaid Iohannes, am satisfied and

content with the above and I promise and maintain that I will teach and train him in the art of painting as much as he can and as long as he can provide for his subsistence; and the said Antonio will assist me in what is necessary for the above art, the aforesaid priest Vasili, his godfather, being content with the above. And if in the next months something will intervene against this [agreement], then the party that did not comply with it will have to compensate the party that did comply. Under the penalty of 25 *yperpera*, the contract being always valid. Signed by the aforesaid, who asked to do so.

2.5.4

Contract to teach the art of painting in the workshop of Andreas Pavias

Andreas Pavias (d. before 1512) was one of the most important Cretan painters active in the second half of the fifteenth century. He was probably trained in the workshop of Angelos Akotantos (see document 2.5.1). His patrons were both Orthodox and Catholic Christians. As this contract informs us, the well-documented and respected painter Angelos Mpitzamanos (1467–1532) was one of his apprentices for 5 years, between 1482 and 1487. Mpitzamanos's father, Nikolaos, acted on his behalf, since Angelos was only 15 years old when the contract was made in 1482. [AL]

Source: M. Cattapan (1972), 'Nuovi elenchi e documenti dei pittori in Creta dal 1300 al 1500', Θησαυρισματα [Thesaurismata], vol. 9, p. 221. Translated from the Latin by Dario Tessicini. Copyright © The Open University 2007.

I, Nikolaos Pitzamanos, citizen of the city of Candia, with my heirs, declare to you, Sir Andreas Pavias, painter, and to your heirs, that my son Angelino, here present and content, will serve you as your apprentice in your aforesaid art and in everything you will tell and instruct him honestly and properly, and he can do and know, for a period of five years from now. In this time you will have to teach him your aforesaid art with all your ability and effort, and to feed him. I, the aforesaid Andreas am content with the aforesaid, etc. I signed the contract under the penalty of 30 *yperpera*.

Witnesses: Manussius. I gave a copy to the aforesaid Angelino.

2.5.5
Andreas Pavias intervenes to secure the return of an icon painted by Angelos Akotantos

This contract offers indirect proof that Andreas Pavias (see document 2.5.4) probably learned the secrets of his art in Angelos Akotantos's workshop: he was obviously considered appropriate to intervene here to secure the return of an icon of the Nativity of Christ painted by Akotantos. We have no further information on the priest Georgios of Gradou, to whom the icon was to be returned. [AL]

Source: M. Cattapan (1977), 'I Pittori Pavia, Rizo, Zafuri da Candia e Papadopoulo dalla Canea', Θησαυρισματα [Thesaurismata], vol. 14, no. 15, p. 215. Translated from the Latin by Dario Tessicini. Copyright © The Open University 2007.

Master Andreas, painter, entrusts [*cometendo*] the priest Georgios of Gradou from Castel Chedri, here present, that in his stead and name he has full power and responsibility over Castel Faro and in any other place where it will be needed, to claim and receive from Calogrea Calathopoula a painting by the late master Angelos [representing] the *Nativity of Our Lord*, given to her in loan by the said master, or to ask for 10 ducats as its price. And he will have to make those arrangements as he were the said master Andreas and he will have to swear, etc. He who was asked to do so.

Witnesses Jacopo Rapan and Nicolo Maçaman.

2.5.6
The commission of the Venetian ruler of Nauplio for a *pala d'altare*

Nikolaos Zafuris (d. by 1501) was one of the best and most famous post-Byzantine Cretan artists. In all probability he was an apprentice in Angelos Akotantos's workshop (see document 2.5.1) and was a contemporary of

other major painters, such as Andreas Ritzos and Andreas Pavias (see documents 2.5.2 and 2.5.5). The document (in three parts) bears testimony that his fame had travelled outside the borders of Crete, since the *pala d'altare* was commissioned by Giovanni Nani, the Venetian ruler in Nauplio (in the Peloponnese). The commission of the now lost work was a collaboration, since it also involved another painter, Georgios Vlastos, whose name is mentioned in documents between the years 1469 and 1507, and a sculptor, Nikolaos Barbarigo. [AL]

Source: M. Cattapan (1972), 'Nuovi elenchi e documenti dei pittori in Creta dal 1300 al 1500', Θησαυρισματα [Thesaurismata], vol. 9, pp. 209–10. Translated from the Latin by Dario Tessicini. Copyright © The Open University 2007.

1

I, Master Nikolaos Barbarigo, sculptor, resident in the city of Candia, bind myself and my heirs to you, revered priests Master Luca de Nigroponte and Master Cristoforo Mauro of the late Master Marco, and my Lord Petro Venerio of the magnificent Master Domenico, here present and content, and your heirs, as procurators of the magnificent Master Giovanni Nani, governor of Nauplio, to agree in all of the below and I bind myself to make and carve an altarpiece with 18 *capitelli* with small and beautiful handworks and carvings made appropriately from my own wood of *flurea* and old cypress, where figures will be painted; the said altarpiece will have to be 8 and half feet tall to the top and 6 feet wide, and I promise to craft and to complete its carving with my work, and to deliver and bring it completed to you by the next Lent and as we agree to remain bound. We also agree that I shall pay the expenses of 11 ducats over my work for each month of delay after the end of the said Lent. And for my work we agree that you shall give me 11 ducats of which 6 in advance and the rest at the completion of the altarpiece. And we, the aforesaid priests Luca and Cristoforo Mauro declare ourselves as guarantors [*plezij*] of the aforesaid Master Nikolaos Barbarigo for the 6 ducats that are given to the aforesaid Master Nikolaos, and that you, Sir Petro Venerio, named as above, can always keep with us.

Besides, we, Georgios Vlastos and Nikolaos Zafuris, painters, declare ourselves as guarantors [*plezji*] of the 6 ducats as above for the party of the aforesaid Master Nikolaos Barbadico [*sic* for Barbarigo]. Signed, etc. Witnesses Nicolaos Longo – Georgios Yeriti.

The fourth day of the same month, in the presence of this notary, Master Nikolaos Barbarigo received the aforesaid 6 ducats from the aforesaid Sir Petro Venerio. I gave a copy.

2

I, Master Nicolaos Zafuris, painter, citizen of the city of Candia, with my heirs, make publicly known to you, the aforesaid procurators, that I promise and bind myself to paint 18 figures and all other figures that need to be done in the altarpiece for Nauplio; and that the figures will be 23 all together and I promise to make them beautiful and gilded as it is appropriate, and also I promise that I will make and deliver them finished and gilded by next May, otherwise 2 ducats will be subtracted from my salary for each month, if I delay from the said term, and for my workmanship we agree that you will give me 13 ducats, of which, 6 you shall give me [in advance] and the rest at the completion of the said paintings.

Priests Master Lucas and Master Cristoforos are the guarantors for the said 6 ducats that are given in advance, and Master Barbadico [Barbarigo], sculptor, and Georgios Vlastos, painter, are both guarantors for the whole sum and each part of it.

Note that on the fourth of the same month the said 6 ducats were given to Nikolaos Zafuris by the said Sir Petro Venerio. I gave a copy.

3

I, Master Georgios Vlastos, painter, citizen of the city of Candia, promise and bind myself with you, the aforesaid procurators, to gild appropriately with my art the entire altarpiece that is crafted for Nauplio and we agree that it will be gilded by the end of next May and for my work we agree that you shall give me 11 *yperpera* for the making of each hundredth of golden leafs that I will put in place, and you shall provide me with the appropriate quantity of gold for the work. And if I am not finished by the said time in May, you shall detract, at my expense, 2 ducats from my salary for each month of delay after the said term the term in May; and you will have to give me in cash 3 golden ducats and the rest at the completion of the said work. The aforesaid priests Master Lucas and Master Cristoforos are guarantors for the said 3 ducats, and Master Nikolaos Zafuris and Master Nikolaos Barbarigo are both guarantors for the whole sum and each part of it of the said 3 ducats. Note that on the

fourth of the same month 3 ducats were given to Georgios Vlastos by sir Petro Venerio. I gave a copy.

2.5.7

On the making of *anthibola* (imprinted cartoons)

Dionysios of Furna (c.1670–c.1744) was an established painter, who resided in Mount Athos from the age of 16. He wrote the *Painter's Manual* (*Hermeneia*) between 1730 and 1734. It is the oldest surviving iconographical guide with instructions on how to paint according to Byzantine practices, and reflects very much earlier practices. [AL]

Source: P. Hetherington (ed. and trans.) (1974), *The 'Painter's Manual' of Dionysius of Fourna* (London: Sagittarius Press), p. 5.

How to Make a Copy

When you want to make a copy, do thus: if the original panel is painted on both sides, smear some paper with uncooked *peziri* and leave it for one day in the shade to soak in. Then rub it well with bran to extract the oil thoroughly so that the colours take where you want them to, and the archetype is not damaged. Having attached the four corners of the original to the paper, make some black colour with a little egg, carefully trace the forms and then put in the shading. After this, prepare some white, whiten the image and put in the highlights with diluted white; in this way it will become like an icon, as the paper is transparent and all the forms of the original show through; only, so that it does not rub off, be careful only to apply the white thinly. If it happens that the other side of the panel is unmarked, put some unoiled paper on it, and having put it in the light of a window or on a sheet of glass or on a frame, the forms will show through clearly; support your hand and trace the forms on to the paper carefully, and put in the highlights with red pigment. If you do this you will have a copy just like the original. However, if the archetype is on oiled paper, do thus: put some black colour into a scallop shell with some garlic juice like that which you used for gilding fine lines, and

mix them; then go over the forms of the whole figure of the saint that you are copying, whether it is on oiled paper, on panel, on a wall or whatever it may be. Then you mix red colour with garlic juice and go over the whites of the face and clothes, if you wish taking a third or fourth colour and forming the highlights; just take care to keep the colours separate. Then wet a sheet of paper the same size as the prototype, and put it between other sheets so that they can absorb some of the water, just ensuring that the paper remains a little moist; then place it on the archetype and press it down carefully with your hand in such a way as not to displace it. Carefully lift up one corner and see if an impression has been left; if it has not, press it a second time more thoroughly. You will thus have made a printed copy in every way identical to the prototype. You must only realise this, that when the archetype is an old painting, either on a wall or on an old panel, you will have to use more garlic juice; but if it is a new wall-painting, a newly-varnished icon, or an oiled paper you will want less garlic juice and more colour. Do a test first on a small bit of paper, drawing one or two brush-strokes, and if it goes well trace the remainder. Undertake nothing without doing a trial piece first, so that you do not work in vain.

2.5.8
How to plaster a wall

Another extract from the *Painter's Manual* of Dionysios of Furna, this time relating to the preparation of a wall for fresco painting (see document 2.5.7). [AL]

Source: P. Hetherington (ed. and trans.) (1974), *The 'Painter's Manual' of Dionysius of Fourna* (London: Sagittarius Press), p. 14.

How to Plaster a Wall

When you wish to paint scenes in a church, it is necessary first to paint the upper parts and then the lower. For this you first get ready a ladder and then take some water in a capacious vessel and splashing with a spoon, wet the wall. If it is a wall of mud bricks, scrape the wall as much as you can with

a pointed trowel (since if the surface is vaulted the plaster will fall off later); wet it again and give it a coat of plaster. If it is a brick wall wet it five or six times and apply plaster thickly to the thickness of two fingers or more so that it will stay damp while you work on it. If it is a stone wall only wet it once or twice and apply less plaster, as the stone is colder and the plaster will not dry so fast. In the winter put on a layer of plaster late in the day and the final layer early the next day; in the summer, do it as you are ready to. When you have applied the final layer evenly and well with the plasterer's trowel leave it to become firm and then draw on it.

Venice

2.6.1
From the *Mariegola* (rule-book) of the Mercers' company in Venice

This chapter of the Mercers' rule-book gives some indication of the range of goods available for sale in fifteenth-century Venice. It also shows how the Venetian guilds were concerned to protect their members' livelihoods in the face of an influx of unregulated foreign traders. One eminent figure who later transgressed such regulations was the painter Albrecht Dürer (see his letter of 2 April 1506, reprinted in document 2.6.13). The rule-book from which the following extracts are taken was adopted in May 1446. [PW]

Source: D. Chambers and B. Pullan with J. Fletcher (eds.) (1992), *Venice: A Documentary History* (Oxford: Blackwell), pp. 281–5. Reprinted by permission of Blackwell Publishing Ltd.

We are aware that for some time now many foreigners from various countries have begun to stock and sell mercery, on the Rialto bridge, on the Piazza San Marco and throughout the city, on stalls, on stands, and on the ground, and from makeshift shops [*botege e postize*], both on holidays and on working days; and because of this our trade of mercery is being destroyed, although mercers pay high rents and heavy imposts, being burdened with large families and bearing the taxes allocated to the city. If no measures are taken, the said mercers, your most loyal citizens, will shortly be ruined.

Item. There has occurred, and continues to occur, the greatest damage to the commonweal because every day these offenders take a substantial amount of mercery from the German exchange house, a little at a time, without paying duty. They may not trade in these wares, because they are foreigners, and are therefore offending against our holy laws. Worse still, we have seen some Germans from the exchange house openly setting up makeshift shops, thus snatching the bread from the mouths of your most loyal citizens. It is necessary and most fitting to make provision against such things. Be it determined that from now on no person, male or female, citizen or foreigner, of any status whatsoever, may sell or cause to be sold any mercery or any item that pertains

to it, in any part of Venice, from stands or from stalls, or from the ground, or from makeshift shops, or from the squares, or from the bridges, or from the balconies of closed shops, either on working-days or on holidays; they may do so only from the proper shops. [...]

Item. There are many tradesmen, such as fustian weavers, apothecaries, goldsmiths, and those in silk and other trades, and fruiterers, and dealers in second-hand clothes throughout the city, who through certain people buy violet silk and have many things made, such as silken and linen thread and cord and fringe and belts of silk and things for the house [*soratilli*], and display them on balconies and sell them retail and wholesale. This they must not do. [...]

Item. For some time now many foreigners have been arriving, Flemings, Frenchmen, Germans, Italians, and men of other nations, and they are still arriving every day. They have settled here, and they make girdles, big bags, woollen and straw hats, wallets, playing-cards, caps, and dyed skins for girdles and bags. For these activities and many others they ought to join our Scuola. That all may be regulated and scandal be avoided, be it understood that all persons, Venetians or outsiders, male or female, of whatsoever status, who produce or cause to be produced, or sell or cause to be sold in their shops, articles which appertain to mercery shall be subject to our rule book and obliged to join the craft, and offenders shall be liable to the said penalty. [...]

Item. Be it understood that all mercers' wares which come into the German exchange house shall be subject to our trade, and that our mercers may freely stock and sell these goods, such as basins and other brassware, iron and tin, locks, mirrors, mirror glass, caps, gloves of wool or hide, cups, bales of cloth [*torselli*]. shears, scissors, jugs, Paternoster beads, hats, spectacles, *pexii da ducatio* [?], razors, axes, belts, combs of horn or wood, cushions, serges, coarse cloth, and every other kind of mercery, even though it be not named: everything shall be regarded as subject to our trade. [...]

Item. It is our wish that all other mercers' wares made in Venice or outside Venice be subject to our craft, i.e. combs of ivory, felt caps of all kinds and felts for making caps, cotton and silk veils, spools, weaver's paste, handkerchiefs (whether worked in silk or not), fans, veils, coifs, vestments, gold from Cologne, pewter which comes with the Flanders galleys or into the German exchange house, cushions made of chequered cloth and of tapestry, and pouches. Be it understood that all the aforesaid items, whether mentioned specifically or not, being articles which mercers have been accustomed to stock, shall all be subject to our rule book. ...

2.6.2
Gentile Bellini undertakes the decoration of the Grand Council chamber

On 21 September 1474, the Venetian Grand Council confirmed the appointment of Gentile Bellini to undertake the redecoration of the Grand Council chamber of the Ducal Palace, the huge hall where the hundreds of patricians eligible met to transact the business of the Republic. The hall had been decorated with a narrative fresco cycle of major events in the city's history between 1415 and 1420 by Gentile da Fabriano (his father's master) and Pisanello, but these paintings had soon deteriorated. Gentile Bellini, a member of the most important workshop in Venice in the fifteenth century, was to replace the decayed frescoes with oil paintings on canvas, which fared better in the city's humid climate. Twenty-two paintings were made of the *Life of Pope Alexander III*. In 1177 the Pope and Emperor Frederick Barbarossa made peace at Venice, with the doge mediating. It was an important event for the Republic which demonstrated its significance on an international stage. Part of Gentile's duties also included painting a portrait of each new doge, which put him at the centre of contemporary politics. With the exception of a brief break from 1479 to 1480, he worked on the paintings until 1493. Gentile's paintings had to be replaced after 1577 following a fire. The '*sansaria*' referred to in the document was a financial brokership attached to the German merchants' guild (the Fondaco dei Tedeschi) that would provide Gentile with an annual income, instead of a salary. [PW]

Source: D. S. Chambers (ed.) (1970), *Patrons and Artists in the Italian Renaissance* (London: Macmillan), pp. 79–80. Reproduced with permission of Palgrave Macmillan.

Our faithful citizen of Venice, Gentile Bellini, the pre-eminent painter, has offered his services for the rest of his life to maintain the paintings in the Hall of the Greater Council, which for the most part have perished. He requires no salary, but for his maintenance he has humbly petitioned that something may be allowed him. And since the said Hall is among the foremost showpieces of our city we have judged it seemly to provide for its restoration and repair. Therefore, the motion is carried that by the authority of this Council

the said Gentile shall be appointed to the work of restoring and renovating the paintings of the said Hall. And he shall be obliged to restore and repair them, when and where the work is needed, as committed to him by the 'Provveditori' of Salt, who must provide him with our expenses for colours and other things necessary to the said work. But in truth since every labourer is worthy of his hire, it may be agreed that in reward for his labours the first *sansaria* [brokership] of the *Fondaco* that falls vacant shall be conferred upon him for life by the authority of this Council.

2.6.3
Gentile Bellini is sent on a mission to Constantinople

In his *Summaries of Venetian History* in the entry for 1 August 1479 Marin Sanudo (1466–1536), a Venetian patrician, recounts the story of the Turkish Sultan's request for an artist, and the prompt dispatch to Constantinople of a diplomatic mission including Gentile Bellini. Gentile took a book of drawings by his father, Jacopo, as a gift to the sultan, Mehmed II. At the court Gentile painted portraits, cityscapes and designed a medal for the sultan. When he returned in early 1481 he resumed work in the Grand Council chamber at the Ducal palace. [PW]

Source: Patricia Fortini Brown (1988), *Venetian Narrative Painting in the Age of Carpaccio* (New Haven and London: Yale University Press), p. 54. Reprinted by permission of the publisher, Yale University Press.

On the first day of August a Jewish orator from the Lord Turk arrived with letters. He wished for the Signoria to send him a good painter, and invited the Doge to go to honor the marriage of his son. [The Signoria] responded, thanking him, and sent Gentile Bellini, an excellent painter, who went with the galleys of Romania; and the Signoria paid his expenses, and he left the third of September.

2.6.4
Giovanni Bellini is contracted to decorate the Grand Council chamber

On 29 August 1479 Giovanni Bellini was appointed by the Grand Council to take over decorating their Grand Council chamber. This was necessary because his brother, Gentile, had recently been appointed to a mission to Constantinople and left the city on 3 September. Giovanni seems to have continued to make the devotional paintings and portraits for which he was sought after while appointed to work at the Ducal palace, relying on his efficient workshop. [PW]

Source: Patricia Fortini Brown (1988). *Venetian Narrative Painting in the Age of Carpaccio* (New Haven and London: Yale University Press), p. 273. Translated from the Latin by Dario Tessicini. Reprinted by permission of the publisher, Yale University Press.

Since our faithful citizen Gentile Bellini, painter, who was restoring the figures and paintings of our Council's Great Chamber, was sent to Constantinople under the order and at the service of our State, and since it is necessary to continue the restoration of the said chamber, which is one of the main ornaments of our city, it is decreed by the authority of this Council that our faithful citizen Giovanni Bellini, eminent painter, shall be appointed to the restoration and renovation of the said work, and he shall be bound to restore and renew where and when it is necessary, and as he will be ordered by our magistrates [*provveditori del sale*]. They will pay the expenses for the colours and for what is necessary for the work. And since each employee deserves his salary, it is understood that as a reward for his work, he shall be appointed by the authority of this Council to the first *sansaria* at the Fondaco that will be vacant, in the same way as it was done for the aforesaid Gentile. And if there is anything against the Council, it shall be suspended this time only. And the office of the *sansaria* shall remain with the aforesaid Gentile, who will be bound to continue the aforesaid work when he will be back in Venice.

2.6.5
Giovanni Bellini is exempted from duties in the painters' guild

In this document of 26 February 1482 Giovanni Bellini's contribution and status as a painter in Venice are recognized with the title 'painter of our state' ('pictor nostri Dominii'). He is exempted from duties within the painters' guild, but not from paying his dues and taxes. The significant point here, however, is that Bellini is not being excused guild duties because of his eminence, nor to enable scope for personal advancement, but because of a need to concentrate his energies on a state commission. [PW]

Source: Patricia Fortini Brown (1988), *Venetian Narrative Painting in the Age of Carpaccio* (New Haven and London: Yale University Press), p. 274. Translated from the Latin by Dario Tessicini. Copyright © The Open University 2007. Reprinted by permission of the publisher, Yale University Press.

Giovanni Bellini, for his excellent skills in the art of painting, is to be called 'painter of our state', and therefore responsible for the renovation of the Council's Great Chamber. And it is to be publicly rewarded by our state, so that with the exception of one duty, he can be free from any other. He is exempted by the aforesaid councillors from all offices and services of the painters' school and guild, however still contributing to all the obligatory duties and commitments of his guild, that is the annual taxes and other duties performed by all others in the school. And this shall be communicated to the magistrates so that they will respect and enforce this decision of ours.

2.6.6
Alvise Vivarini's petition to work on the decoration of the Grand Council chamber

On 28 July 1488 Alvise Vivarini (1442/53–1503/5) petitioned the Greater Council to allow him to join the artists working on the Grand Council

chamber of the Ducal Palace. Like the Bellini brothers, he probably hoped for a lucrative pension, hence his offer to work for his expenses only. He probably also hoped to maintain the position of the Vivarini workshop by working on the prestigious official project alongside the Bellinis and others, which gave them access to the most important members of Venetian society. While his petition was accepted and he was allocated three paintings, only one was completed on his death. [PW]

Source: D. S. Chambers (ed.) (1970), *Patrons and Artists in the Italian Renaissance* (London: Macmillan), pp. 80–1. Reproduced with permission of Palgrave Macmillan.

Most Serene Prince and Excellent Signoria

I, Alvise Vivarini of Murano, being a most faithful servant of Your Serenity and of this most illustrious state, have long been desirous of showing an example of my work in painting, so that your Sublimity may see and know from experience that the continuous study and diligence to which I have applied myself has not been vain in success, but in honour and praise of this famous city. As a devoted son, I offer myself without any reward or payment for my personal labour in making a picture to surpass myself; that is, to paint it in the Hall of the Greater Council in the manner in which the two Bellini brothers are working at present. Nor do I at present demand for the painting of the said work anything more than the canvas and expenses of colours and the expenses of assistants to help me as the Bellini have. When I have truly perfected the work, I will then remit it freely to the judgement and pleasure of your Serenity, that from your benignity you may deign to provide me with some just, honest and suitable reward which in your wisdom you decide the work to merit. I will go ahead with it hoping for the utter satisfaction of Your Serenity and of all this most excellent Lordship, to whose grace I humbly recommend myself.

The Lords Councillors named below have admitted the above petition of the industrious and pre-eminent painter Alvise Vivarini of Murano, and thus order the noble 'Provveditori' of Salt that they should put it into execution, causing the same painting to be prepared in the place where the painting of Pisan[ello] is and providing for the expenses of assistants and colours according to the aforesaid petition.

Councillors Ser Luca Mauro, Ser Marco Bollani, Ser Marco Trevisan, Ser Andrea Quirini, Ser Tommaso Lippomano

2.6.7
Marin Sanudo, from *Praise of the City of Venice*

Marin Sanudo (1466–1536) was a Venetian patrician who, in the 1490s, began to write a diary-cum-chronicle of the city that doubled as a guidebook for visitors: 'De origine, situ et magistratibus urbis venetiae'. Sanudo's text has become a standard point of reference for the understanding of the city during the Renaissance. He offers an account of the city's origins and the 'myth' of Venice, and provides vivid descriptions of the contemporary city and the life of its inhabitants. [PW]

Source: D. Chambers and B. Pullan with J. Fletcher (eds) (1992), *Venice: A Documentary History* (Oxford: Blackwell), pp. 6–7, 9–10, 11, 13. Reprinted by permission of Blackwell Publishing Ltd.

There are two ways of getting about in Venice: by foot, on the dry land, and by boat. Certain boats are made pitch black and beautiful in shape; they are rowed by Saracen negroes or other servants who know how to row them. Mostly they are rowed with one oar, though Venetian patricians and senators and ladies are usually rowed with two oars. In summer the cabins have a high covering to keep off the sun, and a broad one in winter to keep off the rain; the high ones are of satin, and the low sort green or purple. These small boats are dismantled at night because they are finely wrought and each one is tied up at its mooring. There is such an infinite number of them that they cannot be counted; no one knows the total. On the Grand Canal and in the *rii* [small canals] one sees such a continual movement of boats that in a way it is a marvel. There is easily room on them for four people, comfortably seated within. The basic cost of these boats is 15 ducats, but ornaments are always required, either dolphins or other things, so that it is a great expense, costing more than a horse. The servants, if they are not slaves, have to be paid a wage, usually one ducat with expenses, so that, adding it all up, the cost is very high.

And there is no gentleman or citizen who does not have one or two or even more boats in the family, according to household, etc. [...]

There are three classes of inhabitants: gentlemen [nobles] who govern the state and republic [...]; citizens; and artisans or the lower class. The gentlemen are not distinguished from the citizens by their clothes, because they all dress in much the same way, except for the senatorial office-holders, who during their term of office have to wear the coloured robes laid down by law. The others almost always wear long black robes reaching down to the ground, with sleeves open to the elbows, a black cap on the head and a hood of black cloth or velvet. Formerly they wore very large hoods, but these have gone out of fashion. They wear trimmings of four sorts – marten, weasel, fox or even sable – which are worn a lot in winter; also skins and furs of vair [squirrel] and sendal [fine silk]. Soled stockings and clogs are worn in all weathers, silk [under]shirts and hose of black cloth; to conclude, they wear black a lot. [...] The majority are merchants and all go to do business on Rialto, as I shall write below. The women are truly very beautiful; they go about with great pomp, adorned with big jewels and finery. And, when some grand lady comes to see Venice, 130 or more ladies go to meet her, adorned with jewels of enormous value and cost, necklaces worth from 300 up to 1000 ducats, and rings on their fingers set with large rubies [*balassi*], diamonds, rubies, sapphires, emeralds and other jewels of great value. There are very few patrician women (and none, shall I say, so wretched and poor) who do not have 500 ducats worth of rings on their fingers, not counting the enormous pearls, which must be seen to be believed. [...]

Leaving the Piazza, you go towards Rialto by a street called Merceria, with shops on each side. Here is all the merchandise that you can think of, and whatever you ask for is there. And when it is decorated – because all [visiting] lords want to see it – it is one of the finest streets in Venice. Thus you proceed towards the Rialto Bridge, which was first erected in 1458 and completed in May in the form it now has with shops upon it. [...] Near this bridge and overlooking the Grand Canal is the exchange house [*Fondaco*] of the German merchants, where the Germans live and carry on their business. There are brokers appointed for this, and only they can deal with the Germans; and there are three patricians there who draw the money as we shall explain below. They pay 100 gold ducats a month in rent, from which can be understood the prominent position and the size and convenience of the place, being in the middle of Rialto. [...]

San Polo, the fifth sestier, is so called after the name of the church there, which has a very big, wide and beautiful *campo* where on Wednesday mornings a market is held, selling everything you could want. [...] On Saturdays

there is also a market on St Mark's Piazza, which is much finer than this one. In this sestier is the island of Rialto, which I would venture to call the richest place in the whole world. First of all, overlooking the Canal, is the grain warehouse, large and well stocked, with two doorways and many booths; there are two lords appointed to supervise it, as I shall relate below. Then you come to Riva del Ferro, so called because iron is sold there; where it ends at the Rialto Bridge is the public weighhouse, where all the merchandise for sale has to be weighed, and the reckonings are made of customs and excise duty. Here is the Rialto itself, which is a piazzetta, not very large at all, where everyone goes both morning and afternoon. Here business deals are made with a single word 'yes' or 'no'. There are a large number of brokers, who are trustworthy; if not, they are reprimanded. There are four banks: the Pisani and Lippomani, both patricians, and the Garzoni and Augustini, citizens. They hold very great amounts of money, issue credits under different names, and are called authorized bankers [*banchieri creti*]; their decisions are binding. They have charge of the moneys of the Camerlenghi. Furthermore, throughout the said island of Rialto there are storehouses, both on ground level and above, filled with goods of very great value; it would be a marvellous thing were it possible to see everything at once, in spite of the fact that much is being sold all the time. Every year goods come in from both east and west, where galleys are sent on commission from the Signoria; they are put in the charge of whoever wants this [responsibility], provided he is a patrician, by public auction. It should be noted that the Venetians, just as they were merchants in the beginning, continue to trade every year; they send galleys to Flanders, the Barbary Coast, Beirut, Alexandria, the Greek lands and the Aigues-Mortes. All the galley [fleets] have a captain elected by the Great Council, and the Signoria appoints the galley patrons by auction at Rialto. [...]

On Rialto, moreover, are all the skilled crafts; they have their separate streets. [...]

Here, on the Canal, there are embankments where on one side there are barges for timber, and on the other side for wine; they are rented as though they were shops. There is a very large butchery, which is full every day of good meat, and there is another one at St Mark's. The Fishmarket overlooks the Grand Canal; here are the most beautiful fish, high in price and of good quality. The fish are caught in the Adriatic sea by fishermen, for there is a neighbourhood in Venice called San Niccolò where only fishermen live, and they speak an ancient Venetian dialect called *nicoloto*. It is remarkable to see, that they live in Venice and speak the way they do. Also from various other places, such as Murano, Burano, Torcello, and Chioggia too, fishermen come with their fish to sell it here in the Fishmarket. [...] There are also oysters

in very large quantities. They bring as much fish here as can be sold in a day and in the evening none is left, the cause of it being that everyone spends, and every one lives like lords. And in this city nothing grows, yet whatever you want can be found in abundance. And this is because of the great turn-over in merchandise; everything comes here, especially things to eat, from every city and every part of the world, and money is made quickly. This is because everyone is well-off for money. Here at Rialto it is like a vegetable garden, so much green stuff is brought from nearby places, and such varieties of fruits are on sale, and so cheap, that it is marvellous. But I shall just repeat what I heard from somebody else, who said 'where business is good, good stuff can be had.'

2.6.8

From the *Memoirs* of Philippe de Commynes

Philippe de Commynes (c.1447–1511) was a courtier and diplomat who served several monarchs in the late fifteenth century, initially in Burgundy and later in France. He was Charles VIII's ambassador to various Italian city-states in the early 1490s, first to Venice in October 1494, and returning there a year later in 1495. His *Memoirs* were completed in 1498. In histories of Venice, de Commynes is often cited for his observation that 'most of their people are foreigners' (*Memoirs*, p. 493). Actually de Commynes' remark occurs in the context of a discussion of the Venetian political system rather than a descrip-tion of the city's social and cultural diversity. Nevertheless, elsewhere in the *Memoirs* he does discuss the richness of the city. In these extracts he first gives an account of his reception and a journey down the Grand Canal, before writing about the celebrations attending the signing of the Holy League by various Italian states against the French. The extract includes a description of a procession in the Piazza San Marco that vividly complements in words the painting of a similar procession by Gentile Bellini. [PW]

Source: S. Kinser (ed.) (1969), *The Memoirs of Philippe de Commynes*, trans. I. Cazeaux, 2 vols (Columbia, SC: University of South Carolina Press, and New York: Harper Torch-books). Extracts from vol. 2, bk 7, ch. 18, pp. 489–90 and 500–1.

The day that I entered Venice [October 2, 1494] people came to meet me from as far as Fusina, which is five miles from Venice; and there one leaves the boat in which one came from Padua along a river [the Brenta] and gets into neat little barges covered with tapestry, and with beautiful thick rugs inside to sit on. And the sea reaches up to there, and there is no closer land by which one may arrive in Venice; but the sea is very calm there unless there is a storm; and because it is so calm a great number and all kinds of fish are taken there.

And I marveled greatly to see the placement of this city and to see so many church towers and monasteries, and such large buildings, and all in the water; and the people have no other form of locomotion except by these barges, of which I believe thirty thousand might be found; but they are very small. [. . .]

In the place called Fusina twenty-five gentlemen, elegantly and richly dressed with beautiful scarlet silk material, came to meet me; and there they told me that I was welcome, and they led me to a church of Saint Andrew near the city, where I found again as many other gentlemen, and with them the ambassadors of the dukes of Milan and of Ferrara. And there too they made another speech to me and ushered me to some other boats which they call *piatti*, which are much larger than the others. There were two of them, covered with crimson satin, and carpeted with tapestries. There was room for forty people to sit in each one. They had me sit between these two ambassadors (to be seated in the middle is the place of honor in Italy), and they took me along the main street, which they call the Grand Canal, and which is quite wide. Galleys pass along it, and I have seen ships weighing four hundred tons and more near the houses there. I believe that it is the most beautiful street in the whole world and the one with the most beautiful buildings. It goes all the way through the town.

The houses are very large and high, and the old ones are made of fine stone and are all painted. The others have been made in the last hundred years and all have a façade of white marble which comes to them from Istria, one hundred miles from there, and they also have many large slabs of porphyry and serpentine in the front. On the inside most of them have at least two rooms which have gilded ceilings, rich mantlepieces of cut marble, gilded bedsteads, and painted and gilded screens, and very fine furniture inside. It is the most sumptuous city which I have ever seen and the one that treats ambassadors and foreigners with most honor and the one that is governed most wisely and the one in which the service of God is celebrated most solemnly. [. . .]

After dinner all the ambassadors of the league met together on their barges, as is their pleasure in Venice; everyone has some, according to the number of men in his retinue, and at the expense of the Signoria; and there may have been forty barges, all of which had pennants with the arms of their masters. And all this company came and passed in front of my windows, and there were many musicians. [. . .] At night they had a wonderful celebration with fireworks on the steeples; many lanterns were lighted on the houses of these ambassadors and artillery was fired. I went in a closed barge along the streets to see the festival at about ten o'clock at night, and especially in front of the houses of the ambassadors where banquets and fine feasts were taking place.

This was not yet the day of the publication or of the great celebration; for the pope had sent word that he wished it to be postponed for another few days in order to have it done on Palm Sunday, which they call Olive Sunday. [. . .] [I]n Venice they set up a well-made wooden walk above the ground, as they do on the day of Corpus Christi, and it reached from the palace up to the end of the Piazza San Marco. And after Mass, which was sung by the pope's ambassador, who gave absolution from punishment and sin to whomever would be present at the publication, the Signoria and the ambassadors, all well dressed, marched in procession along this walk. Many wore crimson velvet robes which the Signoria had given, at least the Germans [did]; and all their servants had new robes, but they were rather short. At the return of the procession a great number of mystery [plays] and [allegorical] personages were presented: first Italy, and afterwards all the kings and princes, and the queen of Spain. And at the return they had the league proclaimed at a porphyry stone, where such publications are made. And there was an ambassador from the Turk who was present, hidden at a window; he had been dismissed but they wanted him to see this festival. And at night, by the intermediary of a Greek, he came to speak to me and he was at least four hours in my room. And he was very anxious for his master to be our friend.

2.6.9

From Pietro Casola's account of a pilgrimage to Jerusalem

Venice was the most important point of departure for Christian pilgrims travelling to the Holy Land. Father Pietro Casola, a pilgrim from Milan, left

an account of Venice as he saw it before his journey to Jerusalem in 1494. [PW]

Source: P. Fortini Brown (2000), 'Behind the Walls: The Material Culture of Venetian Elites', in J. Martin and D. Romano (eds), *Venice Reconsidered* (Baltimore: Johns Hopkins University Press), pp. 295–338 (passage cited on p. 296). © 2000 by Johns Hopkins University Press. Reprinted with permission of the Johns Hopkins University Press. Fortini Brown's source was M. Margaret Newett (1907), *Canon Pietro Casola's Pilgrimage to Jerusalem in the Year 1494* (Manchester: Manchester University Press), pp. 128–9.

Something may be said about the quantity of merchandise in the said city, although not nearly the whole truth, because it is inestimable. Indeed it seems as if the whole world flocks there, and that human beings have concentrated there all their force for trading. I was taken to see various warehouses, beginning with that of the Germans – which it appears to me would suffice alone to supply all Italy with the goods that come and go – and so many others that it can be said they are innumerable. . . . And who could count the many shops so well furnished that they also seem warehouses, with so many cloths of every make – tapestry, brocades and hangings of every design, carpets of every sort, camlets of every colour and texture, silks of every kind; and so many warehouses full of spices, groceries and drugs, and so much beautiful white wax! These things stupefy the beholder, and cannot be fully described to those who have not seen them.

2.6.10
The Bellini brothers are contracted to work at the Scuola Grande di San Marco

On 15 July 1492 the governing board of the Scuola Grande di San Marco, one of the most important of these peculiarly Venetian institutions, contracted with Gentile and Giovanni Bellini to decorate their *albergo*, or meeting room. Jacopo Bellini (c.1400–1470/1), their father, had provided two paintings of the Passion of Christ for the Scuola in 1466, mentioned in the contract, which were lost in a fire in 1485, the reason why more paintings were required. The Senate contributed to the cost. Because the brothers were

still working on the Grand Council chamber paintings, work was not begun until the early sixteenth century. In 1504 Gentile began the huge painting of *St Mark Preaching in Alexandria* (Milan, Brera) and in 1505 presented a drawing for the Martyrdom of St Mark. The first painting had to be completed by Giovanni in 1507 as Gentile was too ill to continue. He died the same year. [PW]

Source: D. S. Chambers (ed.) (1970), *Patrons and Artists in the Italian Renaissance* (London: Macmillan), pp. 56–7. Reproduced with permission of Palgrave Macmillan.

Moved by divine rather than human inspiration, our dear and most beloved brothers Messer Gentile Bellini (at present our most worthy *Guardiano da matin*) and his peerless brother Messer Giovanni Bellini, in whose name the former also acts, are both desirous and avid to make a start, with their praiseworthy skill and art of painting, on the canvases which are to be done for the Hall of this our blessed Scuola. And this is in devotion and memory of their late father Messer Jacobo Bellini, who worked in the said Hall before the burning of the Scuola. This they offer to do not from desire for gain, but only to the end that it should be for the praise and triumph of omnipotent God, offering themselves according to the conditions written below, viz:

They must start with all the upper façade of the said Hall on a single canvas, on which must be put such stories and works as shall be detailed by the Scuola, though in accordance with the advice and opinion of the said two brothers.

No arrangement is made concerning the fee, nor shall any other arrangement be made, save with reference to their work, their consciences and the discretion of experienced and intelligent persons.

Item, after doing the said work, they are obliged to do as many others in the said Scuola as they shall be ordered, either in excess of the estimate, or by way of making up the difference, for a further 25 ducats each, making 50 ducats, or a total of 100 ducats.

It is resolved that the Scuola bears the expense of everything that is required for the said work, as is just and honest. And in order that the work shall be worthy and deserving of praise, it shall be done with quickness and all possible solemnity. It is also understood that the said work cannot be given to anyone else to do, either in part or in any way at all, provided that the said brothers perform their duty.

2.6.11
Gentile Bellini agrees to continue work at the Scuola Grande di San Marco

On 1 May 1504, the governing board of the Scuola Grande di San Marco decided to continue with the commission to decorate their meeting room after over a decade of delays due to work on the Grand Council chamber of the Ducal Palace. Gentile Bellini here promises to make his painting of *St Mark Preaching in Alexandria* better than his *Procession in the Piazza di San Marco* of 1496 in the *Miracles of the True Cross* series, previously undertaken for the Scuola di San Giovanni Evangelista. [PW]

Source: Patricia Fortini Brown (1988), *Venetian Narrative Painting in the Age of Carpaccio* (New Haven and London: Yale University Press), pp. 392–3. Translated from the Italian by Dario Tessicini. Copyright © The Open University 2007. Reprinted by permission of the publisher, Yale University Press.

Sc. di San Marco:
. . . our brother, Sir Gentile Bellini, at present vicar of the Banca, moved by his affection and generosity towards our school, and eager to leave therein eternal memory of his skills, offered to paint a canvas for the *albergo* of the said school to be placed on the façade over the main door of the said *albergo* [. . .]

Gentile Bellini:
[The painting] will be better executed than the one over the door of the *albergo* of San Giovanni.

2.6.12
Giovanni Bellini is contracted to complete his brother's work

On 4 July 1515 the governing board of the Scuola Grande di San Marco issued a contract to Giovanni Bellini, 23 years after the original commission, to complete the work on the meeting room left unfinished because of his brother's

death in 1507 and the pressure of other work. Giovanni himself died only a little later in 1516, leaving his painting of *The Martyrdom of St Mark*, a companion to his brother's *St Mark Preaching in Alexandria*, unfinished. It was eventually completed by his student Vittore Belliniano (active 1507–29). [PW]

Source: D. S. Chambers (ed.) (1970), *Patrons and Artists in the Italian Renaissance* (London: Macmillan), p. 58. Reproduced with permission of Palgrave Macmillan.

[Messer Bellini is commissioned] to make a painting on canvas in which he must paint a story of Messer San Marco, of how when he was in Alexandria he was dragged along the ground by those infidel Moors. And this painting has to go above the door of the Hostel Hall between the two walls, like the other painting above the bench where the Guardian and companions sit. The said picture is to be done by the said Messer Giovanni Bellini, according to the agreements written below as to time, price and conditions. The first of these is that the said Guardian and companions commission the painting from Messer Giovanni Bellini at the expense of the Scuola.

The said Messer Giovanni shall also be obliged to paint upon the said canvas the story written above, with houses, figures, animals and all other details, wholly at his expense, with colours and everything else rendered to perfection, as is fitting to the place, and as the excellence of the said Messer Giovanni's skill may require, and to better the painting opposite which his brother Messer Gentile did.

The Grand Guardian and companions promise to give to the said Messer Giovanni, as his fee for painting the above canvas, the same price the aforesaid Messer Gentile had on the same conditions.

The said Messer Giovanni is obliged to bring the said painting to perfection within the same time as the aforesaid Messer Gentile gave to the above work on those precise conditions.

The above Guardian and companions are obliged to pay the said Messer Giovanni as security for the above work 10 ducats in cash. They are further-more obliged to pay money to Messer Giovanni from time to time according to the work he does. The said Guardian and companions and Messer Andrea, *provedador*, must from time to time go to view the work and give to the said Messer Giovanni a sum according to the progress of the work. As security for the said Messer Giovanni, so that he has cause to work and so that he may know where he can have what has been promised him from time to time, he is allowed the advantage on the current state loans in the Chamber of State Loans (*Imprestidi*) in the name of Ser Nicolo Aldioni, which have been con-

ceded to the works of the said Scuola, as appears by a motion passed in the general chapter.

I, Vettor Ziliol, Grand Guardian of the Scuola of Messer San Marco, am content as above.

I, Andrea Ruzier, *provedador*, am content as above.

I, Giovanni Bellini, am content as above.

2.6.13
Dürer's correspondence on Venice, and on Venetian art and artists

Dürer first travelled to Venice as a young man in 1495. He was there for a second time just over a decade later in 1506–7. It was at this time that he painted the *Madonna of the Rosegarlands* for the church of the German merchants in Venice, and famously contrasted his treatment in Italy with the status of artists back in Germany. Dürer's correspondence with his friend and mentor, the humanist Willibald Pirckheimer, has been preserved. In it, Dürer talks about his *Rosegarlands* painting, about the difficulties he experienced with Venetian artists and their guild rules, about the continuing eminence of Giovanni Bellini, and about some oriental carpets Pirckheimer had asked him to look out for. In order to preserve the informal flavour of the correspondence, we have retained one of Dürer's salutations to his friend at the beginning of the extracts, but have thereafter merely differentiated them by date. [PW]

Source: the nineteenth-century translation of Dürer's letters by Sir Martin Conway in T. Sturge Moore (1905–11), *Albert Dürer* (London: Duckworth), 1905/11. The extracts are from pp. 80–91.

To the honourable, wise Master Willibald Pirkheimer, Burgher of Nürnberg, my kind Master.

VENICE, *January 6, 1506.*

I wish you and yours many good, happy New Years. My willing service, first of all, to you dear Master Pirkheimer! Know that I am in good health; I

pray God far better things than that for you. As to those pearls and precious stones which you gave me commission to buy, you must know that I can find nothing good or even worth its price. Everything is snapped up by the Germans who hang about the Riva. They always want to get four times the value for anything, for they are the falsest knaves alive. No one need look for an honest service from any of them. Some good fellows have warned me to beware of them, they cheat man and beast. You can buy better things at a lower price at Frankfurt than at Venice.

About the books which I was to order for you, the Imhofs have already seen after them; but if there is anything else you want, let me know and I will attend to it for you with all zeal. Would to God I could do you a right good service! gladly would I accomplish it, seeing, as I do, how much you do for me. And I pray you be patient with my debt, for indeed I think much oftener of it than you do. When God helps me home I will honourably repay you with many thanks; for I have a panel to paint for the Germans for which they are to pay me a hundred and ten Rhenish florins – it will not cost me as much as five. I shall have scraped it and laid on the ground and made it ready within eight days; then I shall at once begin to paint and, if God will, it shall be in its place above the altar a month after Easter.

VENICE, *February 7*, 1506.

How I wish you were here at Venice! There are so many nice men among the Italians who seek my company more and more every day – which is very pleasing to one – men of sense and knowledge, good lute-players and pipers, judges of painting, men of much noble sentiment and honest virtue, and they show me much honour and friendship. On the other hand there are also amongst them some of the most false, lying, thievish rascals; I should never have believed that such were living in the world. If one did not know them, one would think them the nicest men the earth could show. For my own part I cannot help laughing at them whenever they talk to me. They know that their knavery is no secret but they don't mind.

Amongst the Italians I have many good friends who warn me not to eat and drink with their painters. Many of them are my enemies and they copy my work in the churches and wherever they can find it; and then they revile it and say that the style is not *antique* and so not good. But Giovanni Bellini has highly praised me before many nobles. He wanted to have something of mine, and himself came to me and asked me to paint him something and he would pay well for it. And all men tell me what an upright man he is, so that I am really friendly with him. He is very old, but is still the best painter of them all. [. . .]

VENICE, *February* 28, 1506.

I wish you had occasion to come here, I know you would not find time hang on your hands, for there are so many nice men in this country, right good artists. I have such a throng of Italians about me that at times I have to shut myself up. The nobles all wish me well, but few of the painters.

VENICE, *April* 2, 1506.

The painters here, let me tell you, are very unfriendly to me. They have summoned me three times before the magistrates, and I have had to pay four florins to their school. You must also know that I might have gained a great deal of money if I had not undertaken to paint the German picture! There is much work in it and I cannot get it quite finished before Whitsuntide. Yet they only pay me eighty-five ducats for it. Now you know how much it costs to live, a nd then I have bought some things and sent some money away, so that I have not much before me now. But don't misunderstand me, I am firmly purposed not to go away hence till God enables me to repay you with thanks and to have a hundred florins over besides. I should easily earn this if I had not got the German picture to paint, for all men except the painters wish me well.' [. . .]

VENICE, *September* 8, 1506.

Most learned, approved, wise, knower of many languages, sharp to detect all encountered lies and quick to recognise plain truth! Honourable much-regarded Herr Willibald Pirkheimer. Your humble servant Albrecht Dürer wishes you all hail, great and worthy honour *in the devil's name, so much for the twaddle of which you are so fond.* [. . .]

I have taken all manner of trouble about the carpets but cannot find any broad ones; they are all narrow and long. However I still look about every day for them and so does Anton Kolb. [. . .]

My picture, you must know, says it would give a ducat for you to see it, it is well painted and beautifully coloured. I have earned much praise but little profit by it. In the time it took to paint I could easily have earned 220 ducats, and now I have declined much work, in order that I may come home. I have stopped the mouths of all the painters who used to say that I was good at engraving but, as to painting, I did not know how to handle my colours. Now every one says that better colouring they have never seen.

My French mantle greets you and my Italian coat also! It strikes me that there is an odour of gallantry about you; I can scent it out even at this distance; and they tell me here that when you go a-courting you pretend not to be more than twenty-five years old – oh, yes! double that and I'll believe it. [. . .]

The Doge and the Patriarch have also seen my picture. Herewith let me commend myself to you as your servant. I must really go to sleep as it is striking the seventh hour of the night, and I have already written to the Prior of the Augustines, to my father-in-law, to Mistress Dietrich, and to my wife, and they are all downright whole sheets full. So I have had to hurry over this letter, read it according to the sense. [. . .]

VENICE, *September* 23, 1506.

You must know that my picture is finished as well as another *Quadro* the like of which I have never painted before. And as you are so pleased with yourself, let me tell you that there is no better Madonna picture in the land than mine; for all the painters praise it, as the nobles do you. They say that they have never seen a nobler, more charming painting, and so forth.

But in order to come home as soon as possible, I have, since my picture was finished, refused work that would have yielded me more than 2000 ducats. This all men know who live about me here. [. . .]

VENICE, *about October* 13, 1506.

O, dear Herr Pirkheimer, just now while I was writing to you, the alarm of fire was raised and six houses over by Pietro Venier are burnt, and a woollen cloth of mine, for which only yesterday I paid eight ducats, is burnt, so I too am in trouble. There is much excitement here about the fire.

As to your summons to me to come home soon, I shall come as soon as ever I can, but I must first gain money for my expenses. I have paid away about 100 ducats for colours and other things. I have ordered you two carpets for which I shall pay tomorrow, but I could not get them cheap. I will pack them in with my linen.

And as to your threat that, unless I come home soon, you will make love to my wife, don't attempt it – a ponderous fellow like you would be the death of her.

I must tell you that I set to work to learn dancing and went twice to the school, for which I had to pay the master a ducat. No one could get me to go there again. To learn dancing I should have had to pay away all that I have earned, and at the end I should have known nothing about it.

In reply to your question when I shall come home, I tell you, so that my lords may also make their arrangements, that I shall have finished here in ten days; after that I should like to ride to Bologna to learn the secrets of the art of perspective, which a man is willing to teach me. I should stay there eight or ten days and then return to Venice. After that I shall come with the next

messenger. How I shall freeze after this sun! 'Here I am a gentleman, at home only a parasite.'

2.6.14

From Francesco Sansovino, *Dialogue on All the Notable Things which are in Venice*

This is an extract from Francesco Sansovino's (1521–83) first guidebook to the city of Venice and its art (*Dialogo di tutte le cose notabili che sono in Venetia*), originally published in 1556. Sansovino published a second book, *Della Venetia città nobilissima et singolare*, in 13 volumes in 1581. With subsequent additions by sixteenth- and seventeenth-century authors, this became the standard work on Venice on which virtually all subsequent accounts drew. In his imaginary dialogue with a visitor to Venice in this extract, Sansovino singles out the Bellinis for praise from other fifteenth-century artists. He traces their fame especially to their work on the Grand Council chamber and Gentile's commission by the Turkish Sultan. [PW]

Source: D. Chambers and B. Pullan with J. Fletcher (eds) (1992), *Venice: A Documentary History* (Oxford: Blackwell), pp. 391–3. Reprinted by permission of Blackwell Publishing Ltd.

FOREIGNER Certainly, signor, the paintings in this room [the Hall of the Great Council] have given me much food for thought, because the variety of styles and their beauty and gracefulness, one finds most satisfying here.

VENETIAN Do you take pleasure in painting perhaps?

FOREIGNER A little. I also like sculpture and architecture a lot, but I don't know much about them.

VENETIAN Have you seen what is going on in this city in the three professions that you mentioned?

FOREIGNER No, I haven't seen much of what I wanted to see, but I have heard tell of wonders.

VENETIAN Sir, you will also be satisfied on this count, now that I see you are interested in the subject. I will make it all clear to you, but

	I want us to begin with painting, because it was introduced earlier to this city than either sculpture or architecture.
FOREIGNER	As you please.
VENETIAN	We have had painting for a long time, as is proved by the portraits of the Doges which are in the lunettes of the ceiling in the Great Council Hall, and Gian Bellini and Gentile are no less alive in our memories.
FOREIGNER	I have heard tell of them.
VENETIAN	In their time they were much esteemed, so much so that the Great Turk asked our government for one of them, who went and accomplished what the Turk wanted, and returned here much honoured and rewarded. Their style was very careful and almost like miniature painting. . . . Have you noticed that in Venice there are more paintings than in all the rest of Italy?
FOREIGNER	It is right and proper that you, being the richest men in Italy, should also have more beautiful things than the others, because craftsmen go where the money flows and where the people are soft-living and well fed.

Architectural Treatises

2.7.1
Vitruvius' ideas on architecture

Little is known about Vitruvius except that he worked as a Roman engineer and architect between c.40 and c.17 BCE and that he dedicated his treatise *On Architecture* (in 10 books) to the Emperor Augustus. His text, originally illustrated, is a mixture of traditional wisdom culled from lost sources in Greek and Latin and Vitruvius' own practical experience. The text has survived in a number of quite different medieval transcriptions, with frequent gaps and inconsistencies made more baffling by his use of Greek terminology. Vitruvius was influential in the Renaissance for the status he gives to architects as intellectuals as well as practitioners. Equally influential was Vitruvius' association of architectural aesthetics with the theory of numbers and proportion, and with human proportion – that all the parts of a building should be related in a pleasing relationship, in imitation of the parts of the human body. Vitruvius also insisted that beauty should not be separated from structural soundness and usefulness, giving architecture an essential social and moral aspect. Vitruvius was also significant for his descriptions of the details of three of the orders: Doric, Ionic and Corinthian. His accounts of the origins of the orders became part of the repertoire of Renaissance knowledge, and his method of using modules based on a diameter of the shaft of the column was universally copied. Vitruvius' treatise was widely available through manuscript and printed editions. It also inspired a number of related architectural treatises and commentaries, among them Alberti's *De Re Aedificatoria* (see document 2.7.2), which helped develop an accessible architectural vocabulary unlike the practice-based and orally-transmitted masons' secrets that had previously dictated practice. [TJB]

Source: Vitruvius (1999), *Ten Books on Architecture*, trans. I. D. Rowland, with commentary and illustrations by T. Noble Howard and additional commentary by I. D. Rowland (Cambridge: Cambridge University Press), pp. 1, 25, 26, 47, 48, 54, 55. Reprinted by permission of the authors and of Cambridge University Press.

The architect's expertise is enhanced by many disciplines and various sorts of specialized knowledge; all the works executed using these other skills are evaluated by his seasoned judgment. This expertise is born both of

practice and of **reasoning**.[1] **Practice** is the constant, repeated exercise of the hands by which the work is brought to completion in whatever medium is required for the proposed design. **Reasoning**, however, is what can demonstrate and explain the proportions of completed works skillfully and systematically.

Thus architects who strove to obtain practical manual skills but lacked an education have never been able to achieve an influence equal to the quality of their exertions; on the other hand, those who placed their trust entirely in theory and in writings seem to have chased after a shadow, not something real. But those who have fully mastered both skills, armed, if you will, in full panoply, those architects have reached their goal more quickly and influentially. [...]

Symmetry

Just as in the human body there is a harmonious quality of shapeliness expressed in terms of the cubit, foot, palm, digit, and other small units, so it is in completing works of architecture. For instance, in temples, this symmetry derives from the diameter of the columns, or from the triglyph, or from the lower radius of the column; in a ballista, it derives from the hole that the Greeks call *peritrêton*, in boats from the [spacing of the] oarlock, which the Greeks call the *diapegma*; likewise for all the other types of work, the reckoning of symmetries is to be found among their component parts. [...]

All these works should be executed so that they exhibit the principles of **soundness**, **utility**, and **attractiveness**. The principle of **soundness** will be observed if the foundations have been laid firmly, and if, whatever the building materials may be, they have been chosen with care but not with excessive frugality. The principle of utility will be observed if the design allows faultless, unimpeded use through the disposition of the spaces and the allocation of each type of space is properly oriented, appropriate, and comfortable. That of **attractiveness** will be upheld when the appearance of the work is pleasing and elegant, and the proportions of its elements have properly developed principles of symmetry. [...]

The **composition** of a temple is based on **symmetry**, whose principles architects should take the greatest care to master. **Symmetry** derives from **proportion**, which is called *analogia* in Greek. **Proportion** is the mutual calibration of each element of the work and of the whole, from which the proportional system is achieved. No temple can have any compositional system

[1] The boldface labels duplicate the rubrics (headings) found in most manuscripts of Vitruvius.

without symmetry and proportion, unless, as it were, it has an exact system of correspondence to the likeness of a well-formed human being.

For Nature composed the human body in such a way that the face, from the chin to the top of the forehead and the lowermost roots of the hairline should be one-tenth [of the total height of the body]; the palm of the hand from the wrist to the tip of the middle finger should measure likewise; the head from the chin to the crown, one-eighth; from the top of the chest to the hairline including the base of the neck, one-sixth; from the center of the chest to the crown of the head, one-fourth. Of the height of the face itself, one-third goes from the base of the chin to the lowermost part of the nostrils, another third from the base of the nostrils to a point between the eyebrows, and from that point to the hairline, the forehead also measures one-third. The foot should be one-sixth the height, the cubit, one-fourth, the chest also one-fourth. The other limbs, as well, have their own commensurate proportions, which the famous ancient painters and sculptors employed to attain great and unending praise.

Similarly, indeed, the elements of holy temples should have dimensions for each individual part that agree with the full magnitude of the work. So, too, for example, the center and midpoint of the human body is, naturally, the navel. For if a person is imagined lying back with outstretched arms and feet within a circle whose center is at the navel, the fingers and toes will trace the circumference of this circle as they move about. But to whatever extent a circular scheme may be present in the body, a square design may also be discerned there. For if we measure from the soles of the feet to the crown of the head, and this measurement is compared with that of the outstretched hands, one discovers that this breadth equals the height, just as in areas which have been squared off by use of the set square.

And so, if Nature has composed the human body so that in its proportions the separate individual elements answer to the total form, then the ancients seem to have had reason to decide that bringing their creations to full completion likewise required a correspondence between the measure of individual elements and the appearance of the work as a whole. Therefore, when they were handing down proportional sequences for every type of work, they did so especially for the sacred dwellings of the gods, as the successes and failures of those works tend to remain forever.

Perfect Numbers

In the same way, they gathered the principles of measure, which seem to be necessary in any sort of project, from the components of the human body:

the digit, palm, and cubit, for example, and grouped these units of measure into the perfect number which the Greeks call *teleion*. The ancients decided that the number called ten was perfect, because it was discovered from the number of digits on both hands. And if the number of digits on both hands is perfect by nature, it pleased Plato to state that the number was also perfect for this reason, that the decad (10) is achieved by adding together those [four] individual elements which the Greeks call *monades*. As soon as they reach eleven or twelve, because they will have passed beyond ten [and beyond the four of the tetrad] they cannot be perfect until they reach the next decad. In a manner of speaking, the first four integers are the component parts of the perfect number.

However, mathematicians who take the opposing side in this argument have said that the number which is called six is perfect, because that number has six components all of which agree in their ratios with the number six. [...]

They also hold that number perfect because, just as the foot occupies the sixth part of human height, so, too, the number that brings the dimension of the feet to completion, when multiplied by six, delimits the height of the body. Furthermore, the ancients observed that the cubit is composed of six palms and twenty-four digits. [...]

The names of the three types are based on the formation of the columns: Doric, Ionic, and Corinthian, of which the Doric was the first to occur and did so in ancient times. [...]

When they had decided to set up columns in this temple, lacking symmetries for them, and seeking principles by which they might make these columns suitable for bearing loads yet properly attractive to behold, they measured a man's footprint and compared it with his height. When they discovered that for a man, the foot is one-sixth of his height, they applied this ratio to the column, and whatever diameter they selected for the base of the column shaft, they carried its shaft, including the capital, to a height six times that amount. Thus the Doric column came to exhibit the proportion, soundness, and attractiveness of the male body.

After this, the Ionians also built a temple to Diana; seeking a new type of appearance, they applied the same ratio based on footprints to a woman's slenderness, and began making the diameter of the columns measure one-eighth their height, so that their appearance would be more lofty. Instead of a shoe, they put a spira underneath as a base, and for the capital, as if for hair, they draped volutes on either side like curled locks. The front they adorned with moldings and festoons arranged in the place of tresses, and they left flutes down the whole trunk of the column to mimic, in matronly manner, the folds of a stola. Thus they derived the invention of columns from two sets

of criteria: one manly, without ornament, and plain in appearance, the other of womanly slenderness, ornament, and proportion.

Later generations, more advanced in the elegance and subtlety of their aesthetic judgment, who delighted in more attenuated proportions, established that the height of the Doric column should be seven times the measure of its diameter, and the Ionic column should be nine times the width. For that type of column is called Ionic, because it was first made by the Ionians.

Discovery of Corinthian Symmetries

Now the third type, which is called Corinthian, imitates the slenderness of a young girl, because young girls, on account of the tenderness of their age, can be seen to have even more slender limbs and obtain even more charming effects when they adorn themselves. [. . .] It is said that the invention of this type of capital occurred in the following manner. A young Corinthian girl of citizen rank, already of marriageable age, was stuck down by disease and passed away. After her burial, her nurse collected the few little things[2] in which the girl had delighted during her life, and gathering them all in a basket, placed this basket on top of the grave. So that the offering might last there a little longer, she covered the basket with a roof tile.

This basket, supposedly, happened to have been put down on top of an acanthus root. By springtime, therefore, the acanthus root, which had been pressed down in the middle all the while by the weight of the basket, began to send out leaves and tendrils, and its tendrils, as they grew up along the sides of the basket, turned outward; when they met the obstacle of the corners of the roof tile, first they began to curl over at the ends and finally they were induced to create coils at the edges.

Callimachus, who was called "Katatexitechnos" by the Athenians for the elegance and refinement of his work in marble,[3] passed by this monument and noticed the basket and the fresh delicacy of the leaves enveloping it. Delighted by the nature and form of this novelty, he began to fashion columns for the Corinthians on this model, and he set up symmetries, and thus he drew up the principles for completing works of the Corinthian type.

There are, however, types of capitals that are put on the same columns yet called by different names. I am not able to give the special qualities of their

[2] Reading MSS *poculis* as a version of *pauculis* along the lines of *plostrum* for *plaustrum*.
[3] This reading from Pliny, *NH* 34.92; MSS have *Catatechnos* = "thoroughly skilled."

symmetries, nor for that matter to name the types of columns, but it seems to me that their vocabulary has been drawn and modified from Corinthian, Ionic, and Doric, whose symmetries have been adapted to the refinement of new types of carving. [. . .]

1. Nothing should be of greater concern to the architect than that, in the proportions of each individual element, buildings have an exact correspondence among their sets of principles. Thus, once the principle of the symmetries has been established and the dimensions have been developed by reasoning, then it is the special skill of a gifted architect to provide for the nature of the site, or the building's appearance, or its function, and make adjustments by subtractions or additions, should something need to be subtracted from or added to the proportional system, so that it will seem to have been designed correctly with nothing wanting in its appearance.

2.7.2
Alberti improves on Vitruvius

Leon Battista Alberti (1404–72), a junior member of an influential Florentine family, made his career as what we would now call a civil servant in the papal court (1432–64). Increasingly his advice came to be taken on architectural projects, and he has been credited with the design of a number of buildings. According to the diarist Matteo Palmieri, Alberti presented a version of his architectural treatise *De Re Aedificatoria* (*On the Art of Building*) to Pope Nicholas V in 1452. He probably began work on the treatise in the 1430s, shortly after completing his treatise on painting (1435). Written in Latin, it was in part an attempt to make sense of Vitruvius' work and improve on it. Laid out in 10 books (like Vitruvius' text), Alberti's treatise is more methodical and offers useful advice for architects. Books I–V group material on practical issues of building, focusing on the strength and utility aspects of architecture. Book VI marks a break, focusing on aesthetics and architectural design, which is the subject of Books VI–IX. Book X draws together a number of cautionary tales about faults and failures in building. A peculiarity of Alberti's treatise, unlike that of Filarete, is that he often describes buildings as if referring to antiquity. Therefore he usually refers to 'temples' and describes the forms of antique temples, adding only brief remarks on modern church architecture. In describing temples, he praises above all those based on a circular plan, however impractical this might be for church design. His

is therefore essentially an intellectual approach to understanding the rules and practice of antique architecture. This approach, inspired by antique sources, both literary and architectural, was an important part of the fundamental changes that took place in architectural practice in the second half of the fifteenth century. [TJB]

Source: Leon Battista Alberti (1988), *On the Art of Building*, trans. and eds J. Rykwert, N. Leach and R. Tavernor (Cambridge, MA: MIT Press), pp. 154–9, 182, 195, 196–7, 211–12, 230–2, 292–4, 307–8, 309, 317. Reprinted by permission of the publisher, MIT Press.

Here Begins the Sixth Book of Leon Battista Alberti. On Ornament

The lineaments, the materials for construction, and the employment of craftsmen; also anything else that might seem relevant to the construction of buildings, both public and private, sacred and profane; again, anything that would protect them from the assaults of bad weather and make them adaptable to the requirements of place, time, man, or thing – we have dealt with all this in the five preceding books. How thoroughly we have done so you may yourself discover as you examine them. I do not think you would want greater application in dealing with such matters. As heaven is my witness, it was a more demanding task than I could have imagined when I embarked on it. Frequent problems in explaining matters, inventing terms, and handling material discouraged me and often made me want to abandon the whole enterprise. On the other hand, the very reasons that first induced me to embark on it summoned me back to my undertaking and encouraged me to continue. For I grieved that so many works of such brilliant writers had been destroyed by the hostility of time and of man, and that almost the sole survivor from this vast shipwreck is Vitruvius, an author of unquestioned experience, though one whose writings have been so corrupted by time that there are many omissions and many shortcomings. What he handed down was in any case not refined, and his speech such that the Latins might think that he wanted to appear a Greek, while the Greeks would think that he babbled Latin. However, his very text is evidence that he wrote neither Latin nor Greek, so that as far as we are concerned he might just as well not have written at all, rather than write something that we cannot understand.

Examples of ancient temples and theaters have survived that may teach us as much as any professor, but I see – not without sorrow – these very buildings

being despoiled more each day. And anyone who happens to build nowadays draws his inspiration from inept modern nonsense rather than proven and much commended methods. Nobody would deny that as a result of all this a whole section of our life and learning could disappear altogether. [...]

As I vacillated, and hesitated whether to press ahead or to give up, my love of work and enthusiasm for learning prevailed; and where intelligence failed me, enthusiastic study and hard application supplied. No building of the ancients that had attracted praise, wherever it might be, but I immediately examined it carefully, to see what I could learn from it. Therefore I never stopped exploring, considering, and measuring everything, and comparing the information through line drawings, until I had grasped and understood fully what each had to contribute in terms of ingenuity or skill; this is how my passion and delight in learning relieved the labor of writing. [...]

What we have written is (unless I am mistaken) in proper Latin, and in comprehensible form. We shall do our utmost to continue like this in the remainder of the work.

Of the three conditions that apply to every form of construction – that what we construct should be appropriate to its use, lasting in structure, and graceful and pleasing in appearance – the first two have been dealt with, and there remains the third, the noblest and most necessary of all.

Now graceful and pleasant appearance, so it is thought, derives from beauty and ornament alone, since there can be no one, however surly or slow, rough or boorish, who would not be attracted to what is most beautiful, seek the finest ornament at the expense of all else, be offended by what is unsightly, shun all that is inelegant or shabby, and feel that any shortcomings an object may have in its ornament will detract equally from its grace and from its dignity.

Most noble is beauty, therefore, and it must be sought most eagerly by anyone who does not wish what he owns to seem distasteful. What remarkable importance our ancestors, men of great prudence, attached to it is shown by the care they took that their legal, military, and religious institutions – indeed, the whole commonwealth – should be much embellished; and by their letting it be known that if all these institutions, without which man could scarce exist, were to be stripped of their pomp and finery, their business would appear insipid and shabby. When we gaze at the wondrous works of the heavenly gods, we admire the beauty we see, rather than the utility that we recognize. Need I go further? Nature herself, as is everywhere plain to see,

does not desist from basking in a daily orgy of beauty – let the hues of her flowers serve as my one example.

But if this quality is desirable anywhere, surely it cannot be absent from buildings, without offending experienced and inexperienced alike. What would be our reaction to a deformed and ill-considered pile of stones, other than the more to criticize it the greater the expense, and to condemn the wanton greed for piling up stones? To have satisfied necessity is trite and insignificant, to have catered to convenience unrewarding when the inelegance in a work causes offense.

In addition, there is one particular quality that may greatly increase the convenience and even the life of a building. Who would not claim to dwell more comfortably between walls that are ornate, rather than neglected? What other human art might sufficiently protect a building to save it from human attack? Beauty may even influence an enemy, by restraining his anger and so preventing the work from being violated. Thus I might be so bold as to state: No other means is as effective in protecting a work from damage and human injury as is dignity and grace of form. All care, all diligence, all financial consideration must be directed to ensuring that what is built is useful, commodious, yes—but also embellished and wholly graceful, so that anyone seeing it would not feel that the expense might have been invested better elsewhere.

The precise nature of beauty and ornament, and the difference between them, the mind could perhaps visualize more clearly than my words could explain. For the sake of brevity, however, let us define them as follows: Beauty is that reasoned harmony of all the parts within a body, so that nothing may be added, taken away, or altered, but for the worse. It is a great and holy matter; all our resources of skill and ingenuity will be taxed in achieving it; and rarely is it granted, even to Nature herself, to produce anything that is entirely complete and perfect in every respect. "How rare," remarks a character in Cicero, "is a beautiful youth in Athens!" That connoisseur found their forms wanting because they either had too much or too little of something by which they failed to conform to the laws of beauty. In this case, unless I am mistaken, had ornament been applied by painting and masking anything ugly, or by grooming and polishing the attractive, it would have had the effect of making the displeasing less offensive and the pleasing more delightful. If this is conceded, ornament may be defined as a form of auxiliary light and complement to beauty. From this it follows, I believe, that beauty is some inherent property, to be found suffused all through the body of that which may be called beautiful; whereas ornament, rather than being inherent, has the character of something attached or additional.

This granted, I continue: Anyone who builds so as to be praised for it – as anyone with good sense would – must adhere to a consistent theory; for to follow a consistent theory is the mark of true art. Who would deny that only through art can correct and worthy building be achieved? And after all this particular part concerning beauty and ornament, being the most important of all, must depend on some sure and consistent method and art, which it would be most foolish to ignore. Yet some would disagree who maintain that beauty, and indeed every aspect of building, is judged by relative and variable criteria, and that the forms of buildings should vary according to individual taste and must not be bound by any rules of art. A common fault, this, among the ignorant – to deny the existence of anything they do not understand. I have decided to correct this error; not that I shall attempt (since I would need detailed and extended argument for it) to explain the arts from their origins, by what reasoning they developed, and by what experience they were nourished; let me simply repeat what has been said, that the arts were born of Chance and Observation, fostered by Use and Experiment, and matured by Knowledge and Reason.

Thus medicine, they say, was developed by a million people over a thousand years; sailing too, as almost every other art, advanced by minute steps.

Building, so far as we can tell from ancient monuments, enjoyed her first gush of youth, as it were, in Asia, flowered in Greece, and later reached her glorious maturity in Italy. It would seem to me quite likely that the kings of Asia, being men of considerable wealth and leisure, when reflecting on their own standing, their wealth, and the majesty and greatness of their thrones, saw the need for grander roofs and more dignified walls, and began to search out and collect anything that might be of use to this end; then, perhaps, to make their buildings as large and splendid as possible, they used the largest trees available for their roofs and built their walls of a finer stone. Their buildings became impressive as well as graceful.

Then, thinking that it was the huge scale of their works that was admired, and that one of the primary tasks of a king was to build what lay beyond the capacity of the private citizen, these kings became enamored of the immensity of their works, until their rivalry led to the folly of constructing pyramids.

I believe that experience in building gave them an opportunity to discern differences in number, order, arrangement, and exterior appearance in their buildings, and allowed them to compare one to another. In this way they learned to appreciate the graceful and to spurn the ill-considered.

Next came Greece, a country where upright and noble minds flourished, and the desire for embellishing what was theirs was evident, and, above all,

great attention was given to the construction of temples. Therefore they began by examining the works of the Assyrians and the Egyptians, from which they realized that in such matters the artist's skill attracted more praise than the wealth of the king: for vast works need only great wealth; praise belongs to those with whom the experts find no fault. The Greeks therefore decided that it was their part to surpass through ingenuity those whose wealth they could not rival, in whatever work they undertook. As with other arts, so with building, they sought it in, and drew it out from, the very bosom of Nature, and began to discuss and examine it thoroughly, studying and weighing it up with great incisiveness and subtlety.

They inquired into the differences between buildings that were admired and those that were not, overlooking nothing. They performed all manner of experiment, surveying and retracing the steps of Nature. Mixing equal with equal, straight with curved, light with shade, they considered whether a third combination might arise, as from the union of male and female, which would help them to achieve their original aim. They continued to consider each individual part in the minutest detail, how right agreed with left, vertical with horizontal, near with far. They added, took away, and adjusted greater to smaller, like to unlike, first to last, until they had established the different qualities desirable in those buildings intended to endure for ages, and those erected for no reason as much as their good looks. This was their achievement.

As for Italy, their inborn thrift prompted them to be the first who made their buildings very like animals. Take the case of a horse: they realized that where the shape of each member looked suitable for a particular use, so the whole animal itself would work well in that use. Thus they found that grace of form could never be separated or divorced from suitability for use. But once they had gained dominion over the world, they were so obviously eager to embellish their city and property as the Greeks had been, that within thirty years a house that might have been considered the finest in the entire city would not rank in the first hundred. There was such an incredible surfeit of talent in this field that at one time, I read, seven hundred architects were being employed in Rome alone, whose work could scarcely be praised enough. The empire had sufficient resources to supply anything needed to provoke astonishment: they say that a certain Tacius gave the people of Ostia a bath building with a hundred columns of Numidian marble for which he paid with private funds. In spite of all this, they preferred to temper the splendor of their most powerful kings with a traditional frugality, so that parsimony did not detract from utility, nor was utility sacrificed to opulence, but could also incorporate anything that might be devised to enhance comfort or grace.

Their concern and enthusiasm for building continued unbroken, until eventually they probed so thoroughly into the art that there was nothing so recondite, concealed, or abstruse as not to have been explored, traced out, or brought to light; all this with the help of the gods, and little resistance from the art itself. Since the art of building had long been a guest among the Italians, more particularly among the Etruscans, who, besides the miraculous works of their kings, of which we read, such as labyrinths and sepulchers, have inherited from ancient Etruria very old and excellent precepts about the building of temples; because, I say, the art of building had long been a guest in Italy, and because the desire for her was so evident, she seems to have flourished there, so that Italy's dominion over the world, already famous for every other virtue, was by her ornament made still more impressive. She surrendered herself therefore to their understanding and possession, thinking it a disgrace that the leaders of the world, the glory of all nations, should be rivaled in the splendor of their works by peoples surpassed in every other virtue. [. . .]

Through the example of our ancestors, therefore, and through the advice of experts and constant practice on our part, thorough understanding may be gained on how to construct marvelous buildings, and from that understanding well-proven principles may be deduced; rules that should not be ignored by anyone eager – as we all should be – not to appear inept in what he builds. These we must set down, as was our undertaking, and explain to the best of our ability. These principles either direct every aspect of beauty and ornament throughout the building or relate individually to its various parts. The former are derived from philosophy, and are concerned with establishing the direction and limits to this art; the latter come from the experience of which we spoke, but are honed, so to speak, to the rule of philosophy and plot the course of this art. These latter ones have a more technical character, and I shall deal with them first, saving the former more general rules for an epilogue. [. . .]

There are two kinds of false opening. One is part of the wall, so that a certain amount is concealed within and a certain amount stands out of the wall. The other has its columns standing completely free of the wall, like those of a portico. Thus the former is called "engaged," the latter "detached." With the engaged, the columns are either round or quadrangular. The round ones should project no more and no less than their radius; the quadrangular ones, no more than a quarter and no less than a sixth of their width. With the detached, the columns must never stand out by more than one and a quarter

times their entire base, or by less than their column and base combined. With those, however, which stand out one and a quarter times, there must be a corresponding quadrangular one engaged to the wall. With the detached, the beam is not continuous across the whole face of the wall, but is interrupted at right angles, directly above the columns, so that at that point the ends of the lowest beam break out from the wall and extend to meet the capital of each individual column. Similarly, other members of the beam must run around these detached capitals. With the engaged, however, you may, if you so wish, either use a continuous beam and a cornice uninterrupted for the whole length of the building, or follow the layout for the detached columns, with the beam going out and returning.

All temples consist of a portico and, on the inside, a *cella*; but they differ in that some are round, some quadrangular, and some polygonal. It is obvious from all that is fashioned, produced, or created under her influence, that Nature delights primarily in the circle. Need I mention the earth, the stars, the animals, their nests, and so on, all of which she has made circular? We notice that Nature also delights in the hexagon. For bees, hornets, and insects of every kind have learned to build the cells of their hives entirely out of hexagons. [...]

To the temple are added tribunals; sometimes many, sometimes few. With quadrangular temples there is almost invariably one at the further end, opposite the door, where it is immediately obvious to anyone entering. With a quadrangular plan, tribunals along the side look best when they are twice as long as they are wide; on each side there should preferably be only one tribunal, but if more are required, they should be odd in number. With round and, likewise, polygonal plans several tribunals may conveniently be added; depending on the number of sides, either each side should have a tribunal or they should alternate, one side having one, the next one being without. Round plans may conveniently accommodate six or even eight tribunals. With polygonal plans, make sure that the corners are equal in size and shape.

Then the tribunal itself may be rectangular or semicircular. But if there is to be only one tribunal, at the head of the temple, it should be semicircular for preference; a quadrangular one would be the second choice; but where there are to be a number of tribunals, close together, they will look more pleasing if, in plan, they alternate between the quadrangular and the semicircular, with elevations corresponding to each other.

The opening of the tribunal should be set out like this: In a quadrangular plan, where there is to be a single tribunal, divide the width of the temple into

quarters, of which the mouth of the tribunal then takes up two; alternatively, if a more generous space is required, divide the width into sixths, and allow the opening to take up four. This will allow the ornament (such as the columns), the windows, and so on, to fit conveniently into their respective positions. When there are to be several tribunals around the plan, you may, if you so wish, make those along the side as deep as the main one. But, for the sake of dignity, I would prefer to make the main tribunal one twelfth part larger than the others. This also applies to quadrangular plans, in that it is quite permissible for the main tribunal to have equal sides, but if so, the rest must have a breadth, from right to left, twice their depth.

The Dorians made their beam at least as wide as half the diameter at the base of the column. They gave their beam three fascias; below the top one, several short battens were attached; on the underside of each of these were fixed six nails, intended to hold in place the cross-beams, which projected from the wall to the level of the battens: clearly this device was to prevent them from slipping inward. The overall height of the beam was divided into twelve units, from which were derived all the measurements of the elements described below. The lowest fascia was four units high, the middle one, next to it, six, and the top one took up the remaining two units. Of the six units of the middle fascia, one was taken up by the battens, and another by the nails fixed beneath. The battens were twice six units in length. The blank spaces between the ends of the battens were twenty minus two units wide. Over the beam are set the cross-beams, whose ends are cut at right angles, and which stand out half a unit. The width of these cross-beams should equal the thickness of the beam, and their height should be half as much again, or twice nine. Up the face of the cross-beams are incised three straight grooves, cut at right angles, equidistant, set at intervals of one unit. The edges on either side were chamfered to a depth of half a unit. The gaps between the cross-beams in more elegant work are filled with tablets, as broad as they are high. The cross-beams are set vertically above the solid of each column. The faces of the cross-beams stand out half a unit from the tablets; the tablets, meanwhile, are flush with the lowest fascia of the beam below. In these tablets are sculpted calves' skulls, roundels, rosettes, and so on. Each of the cross-beams and tablets has, as a border, a platband two units high.

Above this there is a plank, two units thick, its lineaments those of a channel. In its thickness there extends a pavement – as I might describe it – three units wide, its ornament of small eggs based, unless I am mistaken, on the stones that stand out from the mortar in paving. On this are set mutules, of equal width to the cross-beams and equal thickness to the "pavement," one positioned above each of the cross-beams, projecting out twelve units and

cut perpendicularly to the level. The mutules are bordered by a gullet three quarters of a unit thick. On the underside, between the mutules, were carved rosettes and acanthus.

Above the mutules sits the cornice, four units in height. This consists of a platband with a gullet border. The latter takes up one and a half units. If the work is to have a pediment, every layer of the cornice is to be repeated in it, and within each layer each particular element should be set at the correct angle and be aligned exactly with the others along the plumb. The difference between the pediment and the top of cornice, however, is that at the top of a pediment there is always a border of a wave, four units high in the case of the Doric order, to act as a rainwater drip; but in a cornice it is only included when there is to be no pediment above. But more about pediments later. So much for the Dorians. [. . .]

It is quite clear that the original role of the basilica was to provide a covered assembly room where princes met to pronounce justice. A tribunal was added to give it greater dignity. When the main enclosure proved too small, porticoes, opening inward, were added on either side, in order to increase the space; first simple porticoes, then double. Others added a further aisle transversely to the tribunal: this we shall call the "causidiciary," being the place where the orators and advocates would operate. These two naves joined together to form a shape similar to the letter T. It would appear that later, for the sake of the servants, further porticoes were added to the outside. The basilica, then, is composed of nave and porticoes.

Since the basilica has the character of a temple, it should adopt much of the ornament that is appropriate to it; but in so doing, it should give the impression of seeking to imitate rather than rival the temple. Like the temple, the basilica should be set on a podium, but the height of the podium should be one eighth less, in keeping with its lower religious standing. All its other ornament should lack the gravity of that of a temple. A further difference between a basilica and a temple is that the former, because of its almost rampaging crowd of litigants, and because of the need to read and record documents, should have clear passages and well-lit openings. It would be commendable if the plan of the basilica were to allow anyone arriving in search of a patron or a client to find where they are at first glance. For this reason columns should be wider apart; they should ideally be arched, although the trabeated form is also acceptable.

The basilica, then, may be described as a form of wide, quite open walkway, roofed and surrounded by inward-facing porticoes. For any without porticoes might be considered not so much a basilica as a curia or senate house, a building type that will be dealt with in the appropriate place.

The basilica ought to have a plan with a length twice its width. It should also have a central nave, and a free and unimpeded causidiciary. If it is to have no causidiciary, but only the simple porticoes on either side, it should be laid out as follows: The width of the plan is divided into ninths, five of which are allocated to the central nave and two to each of the porticoes. The length also is divided into ninths, one of which is taken up by the depth of the alcove of the tribunal, and two by the width of the alcove at its mouth. [. . .]

I therefore conclude that anyone who wants to understand correctly the true and correct ornament of building must realize that its principal component and generator is not the outlay of wealth but the wealth of ingenuity. I firmly believe that any person of sense would not want to design his private house very differently from those of others, and would be careful not to incite envy through extravagance or ostentation. On the other hand, no sensible person would wish that anyone else should surpass him in the skill of his workmen, or in praise for his counsel and judgment; as a result the overall division and compartition of lineaments will draw much praise, which is itself the primary and principal form of ornament. To return to the subject.

The royal palace and, in a free city, the house of anyone of senatorial rank, be he praetor or consul, should be the first one that you will want to make the most handsome. We have already discussed how to adorn their public sections appropriately. We shall now set out how to adorn those parts restricted to private use. I would give each house a dignified and splendid vestibule, according to its importance. Beyond this should be a well-lit portico; there should be no shortage of magnificent open spaces. As far as possible, in short, every element that contributes to dignity or splendor should follow the example of public works; yet they should be handled with such restraint as to appear to seek delight rather than any form of pomp. Just as in the previous book, on public buildings, [we said that] the temporal ought to concede to the sacred in dignity as far as is reasonable, so in refinement and quantity of ornament, private buildings should allow themselves to be surpassed easily by public ones. [. . .]

The severest restraint is called for, in the ornament to private buildings, therefore, although a certain license is often possible. For instance, the whole shaft of a column may be over slender, too swollen, or too retracted at its entasis perhaps, compared to what is strictly permissible in public buildings, yet it should not be faulted or condemned, provided the work is not malformed or distorted. Indeed, sometimes it may be more delightful to stray a little from the dignity and calculated rule of lineaments, which would not be

permitted in public works. How charming was the practice of those more fanciful architects of stationing huge statues of slaves at the door jambs of a dining room, so that they support the lintel with their heads; and of making columns, especially for garden porticoes, that resembled tree trunks, their knots removed and their branches tied into bundles, and the shaft scrolled and plaited with palms and carved with leaves, birds, and channels, or, where the work is intended to be very robust, even quadrangular columns, flanked on either side by half-columns; for capitals they would set up baskets laden with hanging bunches of grapes and fruits, or palms sending off new shoots from the tops of their stems, or a mass of snakes tangled in various knots, or eagles clapping their wings, or a gorgon's head full of wrestling snakes, and other such examples that would take too long to describe.

In doing this, the artist must, as far as he is able, guard each part in its noble form by skilfully maintaining the lines and angles, as if he would not wish to cheat the work of the appropriate *concinnitas* of its members, yet seeming to entertain the viewer with a charming trick – or, better still, to please him by the wit of his invention. [. . .]

In establishing dimensions, there are certain natural relationships that cannot be defined as numbers, but that may be obtained through roots and powers. A root is the side of a squared number, whose power equals the *area* of that square. The cube is a projection of the square. The primary cube, whose root is one, is consecrated to the Godhead, because the cube of one remains one; it is, moreover, said to be the one solid that is particularly stable and that rests equally sure and steadfast on any of its sides. However, if one is not an actual number, but the wellspring of number, which both contains and springs from itself, we might perhaps call two the first number. From it as root you produce an *area* of four, which, if extended upward to a height equal to a side, will form a cube of eight. From this cube is derived the rule for outlines. First of all it provides the side of the cube, called the cube root, which generates an *area* of four and the full cube of eight. From this we derive that line running from the one angle of the *area* to the opposite angle, the straight line dividing the square into two equal parts, for which reason it is called the diameter. The numerical value of this is not known, but it is obviously the square root of eight. Next, there is the diameter of the cube, which we know for sure to be the square root of twelve. Lastly, there is the line in the right-angled triangle whose two shorter sides are joined by a right angle, one being the square root of four, the other the square root of twelve. The third and longest line, which is subtended by the right angle, is the square root of sixteen. Such as we have reviewed, therefore, are the natural relation-

ships between numbers and other quantities to be used in defining the diameter. Each should be employed with the shortest line serving as the width of the *area*, the longest as the length, and the intermediate one as the height. But sometimes these may be modified to suit the building.

The shapes and sizes for the setting out of columns, of which the ancients distinguished three kinds according to the variations of the human body, are well worth understanding. When they considered man's body, they decided to make columns after its image. Having taken the measurements of a man, they discovered that the width, from one side to the other, was a sixth of the height, while the depth, from navel to kidneys, was a tenth. The commentators of our sacred writings also noted this and judged that the ark built for the Flood was based on the human figure.

The ancients may have built their columns to such dimensions, making some six times the base, others ten times. But that natural sense, innate in the spirit, which allows us, as we have mentioned, to detect *concinnitas* suggested to them that neither the thickness of the one nor the slenderness of the other was suitable, so that they rejected both. They concluded that what they sought lay between the two extremes. They therefore resorted first to arithmetic, added the two together, and then divided the sum in half; by this they established that the number that lay midway between six and ten was eight. This pleased them, and they made a column eight times the width of the base, and called it Ionic.

The Doric style of column, which suited squatter buildings, they established in the same way as the Ionic. They took the lesser of the two previous terms, which was six, and added the intermediate term of the Ionic, which was eight; the sum of this addition was fourteen. This they divided in half, to produce seven. They used this number for Doric columns, to make the width of the base of the shaft one seventh of the length. And again they determined the still more slender variety, which was called the Corinthian, by adding the intermediate Ionic number to the uppermost extreme and dividing the sum in half: the Ionic number being eight, and the uppermost extreme ten, the two together came to eighteen, half of which was nine. Thus they made the length of the Corinthian column nine times the diameter at the base of the shaft, the Ionic eight times, and the Doric seven. So much for this. [. . .]

Of the arts the ones that are useful, even vital, to the architect are painting and mathematics. I am not concerned whether he is versed in any others. I will not hear those who say that an architect ought to be an expert in law, because he must deal with the rules for containing water, establishing boundaries, and proclaiming the intention to build, and with the many other

legal constraints encountered during the course of building. Nor do I demand that he should have an exact understanding of the stars, simply because it is best to make libraries face Boreas, and baths the setting sun.

Nor do I say that he ought to be a musician, because he must place sounding vases in a theater; nor an orator, to instruct his client on what he proposes to do. Let him have insight, experience, wisdom, and diligence in the matters to be discussed, and he will give an articulate, accurate, and informed account of them, which is the most important thing in oratory.

Yet he should not be inarticulate, nor insensitive to the sound of harmony; and it is enough that he does not build on public land, or on another person's property; that he does not obstruct the light; that he does not transgress the servitudes on rain dripping from the eaves, on watercourses, and on rights of way, except where there is provision; and that he has a sound knowledge of the winds, their direction, and their names; still, I would not criticize him for being better educated. But he should forsake painting and mathematics no more than the poet should ignore tone and meter. Nor do I imagine that a limited knowledge of them is enough.

But I can say this of myself: I have often conceived of projects in the mind that seemed quite commendable at the time; but when I translated them into drawings, I found several errors in the very parts that delighted me most, and quite serious ones; again, when I return to drawings, and measure the dimensions, I recognize and lament my carelessness; finally, when I pass from the drawings to the model, I sometimes notice further mistakes in the individual parts, even over the numbers. For all this I would not expect him to be a Zeuxis in his painting, or a Nichomachus in arithmetic, or an Archimedes in geometry. Let it be enough that he has a grasp of those elements of painting of which we have written; that he has sufficient knowledge of mathematics for the practical and considered application of angles, numbers, and lines, such as that discussed under the topic of weights and the measurements of surfaces and bodies, which some called *podismata* and *embata*. If he combines enthusiasm and diligence with a knowledge of these arts, the architect will achieve favor, wealth, fame for posterity, and glory.

Part III

Viewing Renaissance Art

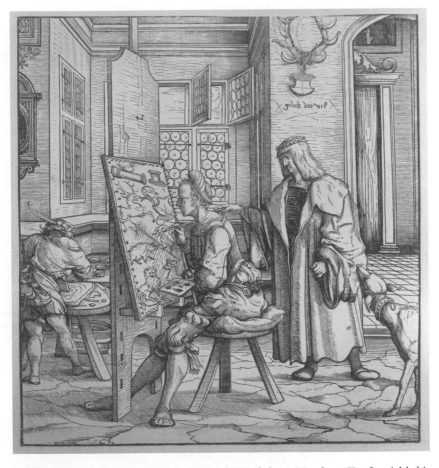

Hans Burgkmair, Weisskunig in a Painter's Workshop, Woodcut, Kupferstichkabinett, Berlin

Art, Class and Wealth

3.1.1
Treasures in the ducal chapel of Charles the Bold, Duke of Burgundy

When Philip the Good, Duke of Burgundy (1396–1467), died and was succeeded by his son Charles the Bold (1433–77), a grand inventory of all ducal possessions was made to determine the exact size of Charles' inheritance. The inventory is so vast that even the abridged version of it published by Léon de Laborde in the middle of the nineteenth century covers more than 200 printed pages. The small selection of extracts presented here is limited to items from the ducal chapel, where a large number of works of art were kept. Sources indicate that the dukes of Burgundy may have treated their chapel treasury as an art collection rather than merely as a group of functional liturgical and devotional objects. At least one foreign ambassador to the ducal court is reported to have been shown the treasures, and this event does not appear to have been exceptional. The extracts give an impression of the great variety of the ducal 'art collection', which included a broad array of different forms of craftsmanship and the spectacle of exclusive materials, with objects ranging from silver-gilt statuettes, gold crosses and reliquaries encrusted with precious stones, to embroidered altarpieces, and countless sets of gold-brocade liturgical vestments and altar cloths (each coherent set, made of the same fabric, known as a *chappelle*). [RD]

Source: Léon de Laborde (1849–52), *Les ducs de Bourgogne. Études sur les lettres, les arts et l'industrie pendant le XVe siècle et plus particulièrement dans les Pays-Bas et le duché de Bourgogne*, 3 vols (Paris: Plon frères), vol. 2. Translated from the French by Isabelle Dolezalek and Rembrandt Duits. Copyright © The Open University 2007. NB: The inventory lists the weight of each object made of precious metal in marks, ounces and sterlings (or esterlins): 1 mark = 20 ounces = 240 esterlins = 244.75 grams.

2020. Item one statuette of Saint George, presented by the people of Bruges, weighing 35 marks, 1 ounce, 10 sterling [c.8.6 kg].

21. And another statuette of Saint Barbara, also given by the people of Bruges, weighing 36 marks, 3 ounces, 15 sterling [c.8.9 kg].

22. Item one golden cross, weighing, including the base, 2 marks, 2 ounces, 5 sterling [c.0.7 kg], encrusted with 5 balas rubies, 20 sapphires, 4 clusters of

pearls, with three pearls per cluster and . . . at each end 3 pearls. And there is a part of the True Cross in the centre and it bears the arms of Monseigneur the Duke and his device of the two C's;[1] for this, 2 marks, 2 ounces, 5 sterling [c.0.7 kg].

23. Item one golden cross adorned with a round crystal in the centre and a tabernacle surrounding it. And on the said crystal in the centre there are two balas rubies and two sapphires, weighing 1 mark, 7 ounces, 2 sterling and a half [c.460 g].

24. Item one figure of Saint Louis made of silver-gilt, on a base supported by[?] three lions, the base decorated all around with the coats of arms of different French noblemen in enamel, with the . . . reliquaries . . . and the key, weighing 14 marks, 2 ounces [c.3.5 kg].

25. Item one Saint Jerome of silver-gilt, with a lion in front of him on one side and on the other a shelf [reuwe?] filled with books, and the base bears the arms of Monseigneur the Duke Jehan (John the Fearless), weighing 14 marks, 5 ounces [c.3.6 kg].

[. . .]

2049. Item one cross of chalcedony, with silver-gilt fittings, a crystal in the centre in which to place the *corpus domini* [the sacred host], made with tabernacles on the sides, which contain a total of 5 figures of male and female saints in white silver, and on the 4 ends of this cross there are 4 white fleurs-de-lys, and it has been mounted on an elongated base decorated all around with the heads of the apostles and figures playing instruments rendered in enamel; the said cross is encrusted with various stones of little value, several of which are missing, weighing all together 38 marks, 6 ounces [c.9.5 kg].

50. Item one large golden cross with the Trinity, which is beautiful, encrusted from top to bottom with a number of pearls, sapphires and balas rubies and none are missing, weighing 13 marks [c.3.2 kg].

51. Another golden cross with a figure of the crucified Christ in white enamel, which has an iron bar inside; the said cross is richly adorned with raised pearls and balas rubies [and] with three diamonds at the hands and feet, weighing 5 marks, 2 ounces [c.1.3 kg].

[1] Two 'Cs': CC, standing for the Comte de Charolois, the title of Charles the Bold before he acceded to the ducal throne.

52. Item one base of silver-gilt, to be used with the said cross, with statuettes of Our Lady and Saint John, weighing 15 marks, 2 ounces, 10 sterling [c.3.7 kg].

53. Item one cross of silver-gilt made as branches [bastons?] . . . adorned . . . which has a crucifix, Our Lady on one side and a [female] Saint . . . mounted on a base bearing the arms of Monseigneur, weighing 10 marks, 4 ounces [c.2.6 kg].

54. Item one large crystal cross which has an image of the crucified Christ in silver-gilt and the said cross is adorned all around with similar decorations in silver-gilt; it rests on a base with a masonry pattern also entirely made of silver-gilt, weighing 50 marks, 1 ounce [c.12.3 kg].

[. . .]

2062. One large cross, of silver-gilt, which has 4 crystals on its 4 arms, 3 of which show 3 figures, while in the fourth, a crystal is placed in which to put the *corpus domini* [the sacred host]; and on the 4 ends of the cross, there are the 4 evangelists; and the image of the crucified Christ is made of white silver and on either side of the cross stand Our Lady and Saint John, and on the base, which is made of double layered [?] copper, is a Veronica and it also carries a small Annunciation in silver, weighing all together 29 marks, 3 ounces [c.7.2 kg].

62a. One golden reliquary adorned with two balas rubies, two sapphires, one emerald, several pearls, none of which is missing, and on top a sapphire, weighing 1 mark, 2 ounces, 15 sterling [c.0.3 kg].

63. One golden panel with four roundels Venetian style. And in the centre the story of the Trinity in white enamel, and on the 2 sides 2 little angels, and the figures are in the round; the said panel is adorned with 6 balas rubies, 6 sapphires and 12 clusters of pearls 3 by 3, and with 3 little diamonds at the hands and feet of the crucified Christ, weighing 9 marks, 7 ounces [c.2.4 kg].

64. One round golden panel in the manner of . . . with the figure of Our Lady in enamel on the front and 3 other figures, and adorned with 6 balas rubies, 6 clusters of pearls, each cluster consisting of 2 pearls, and on the other side a Veronica held up by 2 angels, weighing 7 ounces and a half [c.0.2 kg].

[. . .]

2140. One paten of silver-gilt, with inside a Crucifixion covered with crystal and a panel with a Crucifixion, and on the other side the coronation of Our Lady, weighing all together 1 mark and a half [c.0.35 kg].

141. One embroidered altarpiece in 3 parts, the central part of which shows the story of the 3 Magi bringing their offerings, the other part has the death of Our Lady and the third one the birth of our Lord.

142. Item, another altarpiece, also embroidered and in 3 parts, of which the central part also shows the story of the 3 Magi, the second part the story of King David, sitting on a throne with several figures kneeling before him, and in the third part, the story of Salomon sitting on a throne and the Queen of Sheba kneeling before him; these altarpieces bear the coat of arms of Monseigneur and the CC.

143. One small rectangular reliquary of silver, gilded where it holds the relics, one of the sides carrying a sculpted crucifix, weighing 4 ounces [c.120 g].

144. Another reliquary of silver-gilt, round, Venetian style, which carries the relics under a crystal, and around it are placed 5 pearls, weighing 5 ounces [c.150 g].

145. One other small reliquary in the shape of a panel, decorated in pointillé and with different relics, weighing 3 ounces including all the said relics [c.90 g].

176. Item, a *chappelle* of white cloth of gold, entirely new, including vestments for the priests, deacons and subdeacons and 4 chasubles, the vestments for Monseigneur in velvet with 2 heights of pile, the apparels embroidered, 3 albs and 3 amices, one drap de passet[?], one other cloth to cover the lectern, and one other piece of fabric, which one lays down in front of the prelate when he sits on a throne, and maniples, part of which are lined. Note that the chasubles, [and the vestments of the] priest, deacon and subdeacon, [the] amices, [and] lectern cloths are of black satin and the other pieces are lined with fabric; all are embroidered with the device of the Order of the Golden Fleece and that of the two Cs.

3.1.2
The *camera grande* of Doctor Bartolo di Tura

Life in the wealthy Italian Renaissance household revolved around the *camera grande*, or grand chamber, which combined the functions of a stately bedroom (its centrepiece was usually a sumptuously draped bed), reception room for guests, and exhibition space for luxurious household commodities and works of art. Typically, larger houses had more than one suite of rooms, each one allocated to a family unit of husband, wife and children. Every suite of rooms could have its own chamber, but the *camera grande* in the suite of the head of the household was generally the most prestigious. What follows is an excerpt from the inventory of the household of the Sienese physician Bartolo di Bandino di Tura (1391–1477), which reveals the contents of the grand chamber on the first floor. The inventory shows the state of the household in 1483, following the deaths of Bartolo's son Bandino and his wife Camilla, who left their five children in the care of an aunt. The first-floor chamber is described as having belonged to Bandino, who had been the head of the household from the time of Bartolo's death six years earlier. [RD]

Source: C. Mazzi (1900), 'La casa di Maestro Bartolo di Tura', in *Bulletino Senese di Storia Patria*, 3. Translated from the Italian by Dario Tessicini and Rembrandt Duits. Copyright © The Open University 2007.

The house of Maestro Bartolo di Tura

In the large room upstairs, that used to be Baldino's

A large bed, decorated with painted gold brocade, enclosed by four posts Venetian style
A straw mattress with a red border around it
A feather mattress, measuring 5 braccia, in good condition
Two feather pillows, in good condition
Two used [bed] curtains, with buttons on the side and embroidery; the one made of two pieces of fabric, the other of four, with large fringes at the bottom
A canopy for the bed, in the shape of a baldachin, [mounted] at the head of the bed

A sheet in good condition, made of 4 lengths of fabric, with embroidery, measuring 6 ½ braccia

A sheet in good condition, measuring 6 ½ braccia, made of 3 lengths of fabric, without embroidery

A silk cushion, embroidered, made with stripes, without a cover, good quality

A red cushion, with silk borders, without a cover,

A length of black fabric with various flowers in gold

Several pieces of fabric, pink, maroon [pavonazzo], and other colours, some old some new, i.e. cuts

A pair of veils, for ladies, with decorations and embroidery, each made of three lengths of fabric

A sash [fascia?] for little children

Two large towels with three stripes, used and worn

An old white towel, [da dirannare?]

A towel [da dirannare?], with narrow stripes

A threadbare towel, of coarse cotton

Two old silk veils, to cover [the heads of] ladies, and a linen case

A box painted red, empty

A linen sack, quite large, full of pieces of fabric and sleeves and hoses, old and used, of different colours and types

A brass jug, with handles and a lid, and two basins for washing one's hands

A brass jug, in a modern style

A brass basin, old style, and

A brass chandelier, old style

Four large tin plates, old, and old style

Two small tin plates, old style, and old

A round tin carving board, new, to serve meat at the table

A cup, a bowl and a saucer, made of tin, old style

Another threadbare towel, filled with cotton, used, entirely white

A threadbare towel, with a black stripe, used

A square handkerchief, new, rather coarse

Seven braccia of grey cotton cloth, new, rather coarse

A rectangle made of pieces of wool, filled with straw

A brush with long hairs [rosta di setole longhe?]

Two chests with inlays, resting on feet, attached to the side of the bed

A chest made in the same way, at the foot of the bed

A narrow chest and a box with various inlays, both used for storage at the back of the bed

A large chair, with a coat rack, entirely made of walnut, with beautiful inlays and with a chest underneath, with a lock

A small woollen mattress for the above-mentioned chair, new, filled with cotton

An Our Lady with Child on her arm flanked by little angels, on panel

A small panel with two figures representing Saints Cosmas and Damian

Two beautiful round baskets, made of wicker, with a smaller basket in the middle

A white bed cover, measuring 5 braccia, filled with cotton, used

A white, thin, cotton bed cover for the summer, in good condition, measuring 8 braccia

A new woollen bed cover, filled with cotton, measuring 5 braccia

Another thin bed cover, made of green and red silk, old

A pair of large chests, painted with stories, with covers of green fabric

A large cloth for a canopy [celone?], measuring 7 braccia, old, red

A large tapestry in several colours, striped

A fine cloth for on a bench, with a pile, measuring 3 braccia, used

A large ivory mirror with a garland of figures for a frame

Two new towels, with 3 coloured stripes each, attached to each other

Two pairs of kid gloves, used

A new pair of kid gloves, lined with leather

A new pair of woollen gloves for boys, decorated with needlework

Two caps for women, the one of green velvet, the other of black damask, used

An inkpot made in the shape of a small box, painted in gold, with foliage; a pair of gilt scissors; a silver brooch in the shape of a hand and some *agnusdei* [statuettes of the eucharistic Lamb] crafted in gold, inside the said inkpot

A piece of embroidery from a chasuble, with gold thread, to be put on an altar cloth [?]. A brush, with long hairs, with a decorated handle

Two fine crystal cups, one with figures, the other plain, and with a lid

Two more pairs of kid gloves, used

A wicker basket with a rose of the Virgin Mary inside

Two chords of white and black silk, with a tassel at the end

Another chord of white silk, for children

Two silk purses, old style

A small cradle, with a bundle of several pieces of silk and embroidery in silver and gold thread inside

A bag [cannone?] of crimson silk, for embroidery

A garland [giardinello?], lined with green damask, to wear on one's head

A fan of peacock feathers, with a carved decorated

A beautiful round basket of fine wicker with a smaller basket inside [nel mezzo?]
A pair of cushions, covered with white linen
Another pair of cushions, covered with red crimson taffeta
A majolica plate, beautiful, large
Three large bottles filled with rose water and pink vinegar.
A wooden desk on an elevation [predella]
A feather mattress, [weighing] approximately 6 pounds

3.1.3
Luxury goods in the rooms of Lorenzo the Magnificent

The suite of rooms belonging to Lorenzo the Magnificent in the Medici palace in Florence was richly furnished and littered with luxurious commodities. This series of extracts from the 1492 inventory of the palace, taken after Lorenzo's death, shows some of the items of furniture and clothing as well as the character of Lorenzo's 'art collection'. The inventory also gives an appraisal of the value of most of the objects that are listed. It is unclear whether this appraisal was already included in the original document drafted in 1492 or was added later in 1512, when the Medici returned from a period of living in exile and wished to reclaim their possessions. The prices are in keeping with those known from other sources concerning the art market in fifteenth-century Florence. They give an idea of the relative value of a wide range of different artefacts, including a wooden stool and a set of fire irons, a scarlet woollen gown, panel paintings (both Italian and Flemish), Byzantine minia-ture mosaics (tiny mosaics that served as icons), antique cameos, jewellery, precious-stone vases, and goldsmith's work. [RD]

Source: M. Spallanzani and G. Gaeta Bertelà (eds) (1992), *Libro d'inventario dei beni di Lorenzo il Magnifico* (Florence: Associazione 'Amici del Bargello'). Translated from the Italian by Dario Tessicini and Rembrandt Duits. Copyright © The Open University 2007. NB: Dimensions are given in *braccia*: 1 *braccio* = 58.4 cm. Weights are given in pounds (*libbre*), ounces (*once*), and sometimes *denari* or *grani*: 1 *libbra* = 12 *once* = 288 *denari* = 6,912 *grani* = 339.54 grams. Weights of precious stones are also given in carats (*carati*): 1 *carato* = 4 *grani* = 0.20 grams. Prices are given in gold florins (*fiorini*): 1 *fiorino d'oro* = 20 *soldi* = 240 *denari*.

Inventory of the Possessions of Lorenzo de' Medici

[folio 13v]

[. . .]

In the large room adjacent to the hall, called Lorenzo's room

A wooden panel, carved and gilded, 4 ½ braccia high, 2 ½
braccia wide, to which a marble image of Our Lady has been
attached fl. 25
A wooden bed, measuring 5 braccia, inlaid with scenes in
perspective, decorated with heads and figures in gilt relief, on
an elevated base [predella] fl. 25

[folio 14]

[In the name of] Jesus
Continued. In the same room adjacent to the grand hall

A small day bed [letuccio], measuring 5 ½ braccia, with
decorations as above fl. 25
A chest, measuring 3 ½ braccia, with decorations as above fl. 10
A pair of chests, with gilded decorations, measuring 3 ½
braccia each, on which Petrarch's *Trionfi* have been painted fl. 25
A wall panel [spalliera] for the above-mentioned chests,
painted blue with falcons and coats of arms rendered in gold fl. 10
A chair with arm rests, decorated with spindle wood
ornaments and inlays, measuring 4 ½ braccia fl. 3
A cypress table, decorated with spindle wood ornaments and
inlays fl. 2
A bench with pine wall panels [spalliere] and inlays, measuring
12 braccia fl. 8
A panel, 3 braccia long, on which a view of the Holy Land has
been painted fl. 6
A round birth tray [desco da parto], on which the Triumph of
Fame has been painted fl. 10
A panel, measuring 2 ½ braccia, on which [a view, map, or
personification of] Spain has been painted fl. 8
A cabinet, on which a lady has been painted [and] with two
figures painted on the doors fl. 3

A marble head above the arch of the door to the chamber:
a portrait of Lady Lucrezia [Tornabuoni] fl. 10

A marble head above the exit to the antechamber: a portrait of
Piero di Cosimo [de' Medici]. fl. 12

An alabaster panel with a wooden frame decorated with bone,
worth approximately fl. 4

A tapestry for on the table, measuring 5 braccia, with a pile,
worth approximately fl. 6

Two panels, one small and one big, on which two heads of
Christ have been depicted in mosaic fl. ••

Three panels in mosaic, showing the head of St Peter on the
first, that of St Paul on the second, and that of St Lawrence
on the third fl. ••

A round panel in mosaic, showing a portrait of Giuliano di
Lorenzo [de' Medici] fl. ••

A panel in mosaic, showing a boy's head fl. ••

[folio. 14v]

[In the name of] Jesus
Continued. In Lorenzo's grand chamber

A marble panel, set in a wooden frame, showing a relief of the
Ascension by the hand of Donato [Donatello] fl. 15

A nude figure in marble, standing, holding a staff, sculpted in
the round fl. ••

Another small figure in marble, sculpted in the round,
reclining fl. 13

A canvas from Flanders, 5 ½ braccia long and 4 braccia high,
on which arches, landscapes and figures have been painted fl. 25

A clock of gilt copper, with its accessories, 1 braccio high, circa
5/8 braccia wide, worth approximately fl. 25

Four brass candlesticks decorated with foliage, attached to the
wall fl. 4

A fleur-de-lys of gilt copper, for the banner [palio] of [the feast
of] St John [the Baptist] fl. 5

An ostrich's egg and a mirror ball on a silk cord fl. 1

A chair upholstered with maroon [pavonazzo] leather fl. 3

A set of fire irons, i.e. dogs, tongs, shovel, and fork fl. 3

A satin cloth to cover the chests, 12 braccia long fl. 6

Furnishings of the bed in the chamber

A straw mattress made of burlap	fl. 1
Two mattresses stuffed with wool, one of which is made of cotton	fl. 5
One duvet and two cushions stuffed with down, weighing . . . pounds	fl. 18
A white bed-curtain, with a fringe	fl. 7
A fine white bed cover	
A fine white bed cover (together)	fl. 10
A bed curtain decorated with foliage, and a bed-cloth with figures in the storage compartment of the day bed [letuccio]	fl. 25

[folio 15]

[In the name of] Jesus
Continued. In the chamber, on the day bed [letuccio]

Two small mattresses, stuffed with wool	fl. 1
A white bed-cover, measuring 6 braccia	fl. 2
A tapestry [stored] in the day bed, measuring 6 braccia	fl. 4
Two blue velvet cushions	fl. 1

In the first chest

A long gown of maroon [pavonazzo] cloth from London, lined with fine miniver, worth approximately	fl. 22
A long gown of pink cloth lined with ermine	fl. 25
A long gown of maroon [pavonazzo] cloth, lined with grey fur from the belly [of a squirrel]	fl. 40
A long gown of maroon [pavonazzo] cloth with laces, lined with crimson fur from the belly [of a squirrel]	fl. 60
A long gown of maroon [pavonazzo] satin, lined with white fur from the belly [of a squirrel?]	fl. 40
A long gown of fine cloth from Lucca, lined with green silk	fl. 30
A long gown of maroon fine cloth, lined with crimson taffeta	fl. 14
A long gown of fine deep maroon [pavonazzo] cloth, lined with crimson silk	fl. 15
A long gown of fine black cloth, lined with black taffeta	fl. 10
A long robe of pink cloth, lined with miniver	fl. 15
A long robe of pale maroon [pavonazzo] cloth, lined with marten	fl. 30

A robe of pale maroon [pavonazzo] cloth, lined with miniver	fl. 7
A robe of grey cloth from Flanders, lined with miniver	fl. 8
A robe of brown cloth, lined with fur from the flanks of a marten	fl. 6
A robe of brown cloth, lined with silk	fl. 10
A gown of Moorish cloth, lined with ermine	fl. 40
A robe of maroon [pavonazzo] cloth, lined with crimson taffeta	fl. 20
A robe of maroon [pavonazzo] cloth from Bruges, lined with crimson silk	fl. 50
A robe of grey cloth from London, to wear on the day bed, lined with crimson velvet	fl. 40
A blanket of pink cloth, measuring 5 ½ braccia, lined with miniver	fl. 20
Another grey blanket, measuring 3 ½ braccia by a width of 2 ½ braccia, lined with miniver	fl. 4

[...]

[folio 16v]

[In the name of] Jesus
Continued. In the anteroom of the chamber

A small panel, on which the deposition of Our Lord has been painted, with many saints carrying Him to the sepulchre, by the hand of Fra Giovanni [Fra Angelico]	fl. 15
A marble panel, showing Our Lady with the Child on her arm, by the hand of Donato [Donatello]	fl. 6
A panel of gilt bronze, showing Our Lady with the Christ Child in her arms, set in a frame, by the hand of Donato [Donatello]	fl. 25
A panel with a gilded frame, on which a St Jerome and a St Francis have been painted, by the hand of Pesello [Pesellino] and Fra Filippo [Lippi]	fl. 10
A small panel, on which a Crucifixion has been painted, with three other figures, by the hand of Giotto	fl. 6
A marble panel with many figures in relief and other things rendered in perspective, i.e. [the sermon?] of St John, by the hand of Donato [Donatello]	fl. 30
A small tondo, showing Our Lady, by the hand of Fra Giovanni [Fra Angelico]	fl. 5

A tondo, 2 braccia high, showing the story of the Magi, by the hand of Pesello [Pesellino]	fl. 20
A panel, measuring 1 ½ braccia, on which [a view, map, or personification of] Rome has been painted	fl. 20
A panel, measuring 4 ½ braccia, on which the universe has been painted	fl. 50
A small marble panel above the door to the study with five figures from Antiquity	fl. 10
A small marble panel with figures from Antiquity	fl. 8
A panel, measuring 3 ½ braccia, on which [a view, map, or personification of] Italy has been painted	fl. 25
A panel, measuring 2 ½ braccia, with two portraits, i.e. Francesco Sforza and Gattamelata, by the hand of a Venetian painter	fl. 10
A bench, measuring 10 braccia, with a pine wall panel [spalliera], walnut panels in front and inlays	
A brass candlestick decorated with various types of foliage (together)	fl. 5
A bed of blank wood, measuring 4 ½ braccia, and walking stick	fl. 1

[folio 17]

[. . .]

<div align="center">

[In the name of] Jesus
Continued. In the study [scrittoio]

</div>

A large jasper water basin with two handles, with silver-gilt fittings, weighing 13 ½ pounds [c.4.6 kg], worth	fl. 2000
A medium-size jasper water basin, similar to the one above, without handles, with silver-gilt fittings, weighing 5 pounds [c.1.7 kg], worth	fl. 500
A medium-size jasper water basin, with fittings similar to those of the one above, without handles, weighing 4 ½ pounds [c.1.5 kg], worth	fl. 500
A sardonyx jug, with a handle of the same stone, and a base and spout of silver-gilt, weighing 11 pounds and 3 ounces [c.3.8 kg], worth	fl. 2000
A crystal jug with a handle, a lid, and a spout, with fittings of silver-gilt, weighing 9 pounds [c.3 kg], worth	fl. 800

A sardonyx cup with handles, with fanciful patterns derived
 from the differently coloured layers of the stone, with a base
 of silver-gilt, weighing 2 pounds, 9 ounces [c.0.9 kg] fl. 600

[folio 17v]

[In the name of] Jesus
Continued. In the study [scrittoio]

A large cup of agate and sardonyx, with handles, the foot and
 the lid made of silver-gilt, weighing 5 pounds [c.1.7 kg],
 worth fl. 650
A crystal cup, with a crystal lid with gold fittings, the base
 encrusted with 6 sapphires and 6 balas rubies, and in
 between those 12 large pearls and three gold enamel
 ornaments with a further 3 balas rubies and 3 pearls each,
 and on the lid 7 sapphires, 7 balas rubies, 14 large pearls, 27
 rubies and in between the latter 12 pearls, and on the top a
 diamond, weighing 3 pounds, 4 ounces [c.1.1 kg], worth fl. 800
A crystal cup with three feet, with silver enamel fittings in the
 German style, and a similar lid, weighing 6 pounds [c.2 kg],
 worth fl. 800
A crystal cup with ribs, engraved with foliage, with silver
 fittings, the base and the lid embossed and coloured white,
 weighing 2 ½ pounds [c.0.85 kg], worth fl. 50
A cup of agate and sardonyx, with silver-gilt fittings, weighing
 1 pound, 5 ounces [c.0.5 kg] fl. 50
A cup with a lid, of jasper and amethyst, with gold fittings, the
 base encrusted with 12 rubies and 18 pearls, the lid with 18
 rubies and 18 pearls, weighing 2 pounds, 4 ounces [c.0.8 kg],
 worth fl. 400
A small crystal jug, with a crystal lid with silver-gilt fittings,
 weighing 2 pounds, 5 ½ ounces [c.0.8 kg] fl. 80
A jasper cup with handles and a lid, with all its fittings made
 of silver-gilt, weighing 5 pounds, 4 ounces [c.1.8 kg] fl. 400
A jasper bowl with a base and a rim of silver-gilt weighing 2
 pounds, 8 ounces [c.0.9 kg] fl. 60
A jasper jug with handles and a lid, with silver-gilt fittings,
 weighing 8 pounds [c.2.7 kg] fl. 600
An amethyst dish, weighing 2 pounds [c.0.7 kg] fl. 20

[folio 18]

[In the name of] Jesus
Continued. In the study [scrittoio]

An agate water basin, fitted with a rim, handles, and a base in silver-gilt engraved with ivy leaves, weighing 9 ¹/₂ pounds [c.3.2 kg]	fl. 400
A dish made of jasper, chalcedony and amethyst, with a rim and a base of silver-gilt, weighing 2 pounds, 4 ounces [c.0.8 kg]	fl. 150
A cup made of chalcedony and jasper with patches of yellow, its lid, rim and base fitted with silver and gold and a single pearl at the top of the lid, weighing 2 pounds, 3 ounces [c.0.75 kg]	fl. 200
A jasper water basin, not too large, its base and rim fitted with ribbed silver-gilt, weighing 5 pounds, 10 ounces [c.2 kg], worth	fl. 200
A jasper and amethyst cup with a silver rim and base, weighing 5 pounds, 10 ounces [c.2 kg]	fl. 50
A crystal cup with a lid, with 3 small putti for feet, with silver-gilt fittings, weighing 1 pound, 3 ¹/₂ ounces [c.1.4 kg]	fl. 80
A cup of green jasper and sardonyx, its lid, rim, and base made of embossed silver-gilt, weighing 3 pounds, 8 ounces [c.1.2 kg]	fl. 150
A cup with two handles, made of jasper with patches of white, its rim and base made of silver-gilt, weighing 3 pounds, 10 ounces [c.1.3 kg]	fl. 300
A dish made of sardonyx, chalcedony and agate, on which various figures have been represented, and with a head of Medusa on the outside [NB: the Tazza Farnese], weighing 2 pounds, 6 ounces [c.0.85 kg]	fl. 10000
A horn of a unicorn, 3 braccia long; we value it at	fl. 6000

Miscellaneous cameos

A cameo set in gold with 4 figures and the story of Icarus and Daedalus, the back decorated in pointillé, [with a] diamond, a coat of arms and letters, worth approximately	fl. 400
A cameo set in gold, showing 3 figures coming out of a forest, the back engraved with branches and roses	fl. 100

A cameo set in gold, showing women guiding a child on a lion,
the back decorated in pointillé with a diamond, feathers,
letters fl. 450

[. . .]

[folio 20]

[In the name of] Jesus
Continued. Miscellaneous jewellery in the study [scrittoio]

A cameo set in gold, incised with an image, showing a nude
figure with a tree on his shoulders, a boy in a chariot, a
figure next to him with his arm raised, a demon on the yoke
beam, throwing fire, [the chariot] drawn by two figures,
wearing garments of thin cloth revealing their bodies, red,
incised with branches fl. 1000

A chalcedony [cameo] incised with an image showing a figure
reclining on an altar with a base underneath and his left leg
sticking out, one arm directed backwards with a knife in his
hand, a drapery on his shoulder and the [other] arm raised
with an armed figure in his hand, set in gold, the incision
transparent, without a [metal] back fl. 1500

A large cornelian incised fairly deeply with an image showing
three figures, the one standing and partially in the nude,
holding a lyre in his hand, with a nude figure kneeling at his
feet, the other with the head of an old man, sitting with the
hands behind his back, bound to a tree [Apollo and
Marsyas?], without a back, transparent, set in gold fl. 1000

A cornelian set in gold, incised with an image showing a
chariot with a figure on it, pulled by 4 horses going upwards,
and below two figures, one lying down and the other half
kneeling [Phaeton?], transparent, without a back fl. 1000

A cameo set in gold, incised fairly deeply with an image
showing a nude figure, in a sitting posture, resting on one
foot, leaning against a rock a boy on his left shoulder, his
arm raised, a basket with fruit at his feet on the rock, a
shepherd's crook and a bagpipe, on a black back, decorated
in pointillé, with a diamond and a coat of arms fl. 800

A cameo set in gold, incised in medium relief with an image
showing a Bacchante with a lion's skin, the head on her left

arm, a head and a vine branch in the right hand, the back
decorated in pointillé and with foliage fl. 400
[. . .]

[folio. 21v]

[In the name of] Jesus
Continued. Rings in the study [scrittoio]

A golden staff, encrusted with a cameo incised with an image
 showing a lying figure and another throwing itself upon the
 back of the first one fl. 10
A golden ring, with a hyacinth incised with an image showing
 the head of Antoninus, from the shoulders upwards, with a
 glimpse of his clothing fl. 10
A gilded staff, encrusted with a cornelian incised with an
 image of a head showing six [?] fl. 25
A golden ring, with a cameo incised with an ancient mask in
 profile fl. 10
A golden staff, encrusted with a cameo incised with an image
 of a child sitting on a cloth in water fl. 20
A golden ring, encrusted with a cameo incised with an image
 of a woman shown down to her girdle, with a drapery
 around her shoulders, pouring milk into a vessel [chono] fl. 20
A gold enamel ring, encrusted with a cameo incised with a
 horse's head in relief fl. 10
A golden ring, encrusted with a cameo incised in shallow relief
 with the bald head of an old man, the flesh rendered in red
 and the hair in white fl. 40
A golden ring, encrusted with a cameo engraved with a facial
 mask fl. 20
A brooch, encrusted with a cameo incised fairly deeply with an
 image of a sea monster, ridden by a winged child holding on
 to its head fl. 20
A golden staff, encrusted with a cameo incised in relief with an
 ancient lyre fl. 10
[. . .]

[c.22v]

[In the name of] Jesus
Continued. The inventory

A smooth ruby, in a setting of pure gold	fl. 80
A fine rectangular balas ruby, in a setting of pure gold	fl. 500
A rectangular diamond, in a setting of pure gold	fl. 120
A rectangular ruby set in gold	fl. 40
Another rectangular ruby set in gold	fl. 30
A perfect turquoise set in gold	fl. 200
Another perfect turquoise set in gold	fl. 200
A faceted diamond with eight faces, in a setting of pure gold	fl. 60
A conical diamond, in a setting of pure gold	fl. 100
A pearl, in a setting mounted on a ring with black enamel, circa 5 carats [c.95 g.]	fl. 50
A pearl, set in gold engraved with rosettes inlaid with silver, circa 3 $\frac{1}{2}$ carats [c.0.67 g.]	fl. 18
A rectangular emerald, set in gold	fl. 25
A ruby set in gold, small	fl. 12
Ten loose round pearls, weighing 2 $\frac{1}{2}$ denari [c.3 g.]	fl. 10
Three round pearls, without holes, 12 carats [c.2.3 g.]	fl. 90
A rectangular balas ruby, set in a golden plaquette inlaid with silver	fl. 60
A pair of golden touchstones with 97 pieces [of metal], one half of them silver, the other half gold, weighing 3 ounces, 9 denari each [c.95 g.]	fl. 150
A casket used as a small box for pearls and rubies	fl. 300
A golden reliquary in the shape of a tabernacle with six wings, encrusted with 8 pearls of 3 $\frac{1}{2}$ grana [c.0.17 g.] each and six balas rubies weighing 1 pound, 6 denari [c.0.35 kg.] in total, worth approximately, including its protective case fitted with golden locks, chains, hooks and keys	fl. 1500

[. . .]

[folio. 25v]

[In the name of] Jesus
Continued. The inventory

Another small rectangular panel, showing St John the Baptist in fine mosaic, with a silver-gilt revetment, in relief, with letters, Greek style	fl. 25

Another large panel, with a figure of St John the Baptist, half-
length, with a raised edge [isghuancio?] and a silver
revetment in relief and with Greek letters, and 10 roundels
with half-length figures in mosaic fl. 80
Another large panel, measuring ²/₃ braccia, showing a half-
length figure of St Peter in mosaic, with a silver-gilt
revetment with 10 roundels showing various stories in relief,
made in Greece fl. 30
Another small panel, showing Our Lady standing, in mosaic,
slightly damaged, with a silver-gilt revetment, divided into
compartments by means of filigrain, with 8 rings with half
figures in half relief fl. 20
Another small panel, entirely made of silver and enamel, with
a revetment and roundels, two figures depicted on the
revetment, a St Peter and a St Paul, and a figure of Christ
standing in the middle, in mosaic fl. 30
Another small panel with 2 standing figures in mosaic, a St
Peter and a St Paul, with a silver-gilt revetment decorated
with foliage and roundels in relief fl. 40
Another small panel, measuring ²/₃ braccia, with a figure in
mosaic . . . [dentro uno sanoto?], with a silver-gilt revetment
with miscellaneous foliage and 12 roundels with half figures
of saints in half relief fl. 30
A small soapstone panel, with an image of Our Lady standing
with the Christ Child on her arm carved in the centre, and
a frame of the same stone, in which half figures of the
Twelve Apostles have been carved in half relief, and also a
revetment of silver-gilt with miscellaneous foliage, relief,
and 4 roundels in half relief in the corners, with 4 half
figures of the 4 Evangelists in enamel, and various stories
from the life of Christ in the other roundels on the
revetment fl. 40
[. . .]

[folio 28]

[In the name of] Jesus
Continued. The inventory

A girdle of silver-brocaded damask, with a clasp and a fitting at
the end made of white silver, weighing 1 pound fl. 8

Four dog collars, made of narrow strips of gold brocade with
 silver clasps and fittings, weighing 1 pound 6 ounces
 [c.0.5 kg] fl. 6
Two knives in a protective case, with jasper handles with bands
 of silver-gilt fl. 4
A folding panel constructed like an ivory book, circa ½
 braccia high, carved in relief with various figures, i.e. a
 Crucifixion with the two Maries and apostles and angels on
 one side, and Our Lady enthroned nursing the Christ Child
 on her arm on the other, flanked by St John the Baptist and
 St James and several angels fl. 20
A panel in a small box, showing a painting of Judith with the
 head of Holofernes and a maid, by the hand of Andrea
 Squarcione fl. 25
A small panel from Flanders, showing St Jerome in his study
 with a small cabinet filled with books, rendered in
 perspective, and a lion at his feet; made by Giovanni di
 Bruggia [Jan van Eyck], painted in oil, in a protective case fl. 30
A small panel, showing a portrait of a French lady, painted in
 oil, made by Pietro Cresci [Petrus Christus] from Bruges fl. 40
An ivory chess board with 2 clasps that can be folded like a
 book, measuring ¼ braccia on the one side and 1 braccia
 the other, with various decorations and roundels in various
 types of bone, and roundels with coats of arms, devices, and
 enamels, with pieces, draughts, and dice fl. 30
A small panel in the shape of a small box, containing an
 alabaster panel carved in relief, showing Jupiter in the water
 in the guise of a bull and a woman named Europa on his
 back [the Rape of Europa] fl. 10

Views on Art in Florence

3.2.1
The Florentine merchant Giovanni Rucellai discusses his spending

Giovanni Rucellai (1403–81) was a wealthy Florentine patron, most famous now for his patronage of the architect and humanist Leon Battista Alberti, who was responsible for the innovative classicizing designs of the Rucellai Palace (begun c.1453), Rucellai's burial chapel dedicated to the Holy Sepulchre in the church of San Pancrazio (1467), and the façade of Santa Maria Novella (1470). This extract is from his commonplace book, the *Zibaldone Quaresimale*. This is a compilation of advice for his two sons, and has sections on family management, civil life, family and civic history, and records of miscellaneous objects and buildings that Rucellai believed worthy of memory, including accounts of his artistic and architectural commissions. In this passage, he characterizes his spending on building work as part of more general contributions to the city as a whole through charity and taxation. [JB]

Source: Giovanni Rucellai (1960), *Giovanni Rucellai ed il suo Zibaldone*, ed. A. Perosa, vol. 1: *Il Zibaldone Quaresimale* (London: Warburg Institute), pp. 120–2. Translated from the Italian by Dario Tessicini and Jill Burke. Copyright © The Open University 2007. Reprinted by permission of the Warburg Insitute.

Memoirs of 1473

Memoirs of the causes and reasons why I, Giovanni Rucellai, consider myself as content, or even more content than any other citizen of my neighbourhood of Santa Maria Novella – and, perhaps, in the whole city only a few can surpass me. Among other things, I am very satisfied to know for certain that this [contentment] is not the outcome of my strength of character, or my actions, but it came from God's grace, and I pray that He will give me the grace to understand this, and not to be ungrateful, since, in truth, the grace he has given me is more than I asked for or desired.

Firstly, I have lived a long life, since in the present year, 1473, I am 70 years of age. And, amongst other things, I have been very healthy and, for 40 years now without interruption, I have not been sick or spent one single day in bed.

Through God's grace, I have been very fortunate in the businesses of trading and banking. I was resourceful and competent, and I started working when I was still a lad, actually a young boy. From my work I gained a great reputation and a great deal of trust, and in my heyday I established many banking companies in Florence with several partners and had companies and branches outside Florence in a number of places, such as Venice, Genoa, Naples and Pisa. In Florence I also at several times became involved with seven wool workshops as a business partner with several others. From these trades I have earned large sums, and with the earnings I have supported vast expenditure, above all the taxes of the commune, for which I calculate that I have paid 60,000 florins up to the present day. I have also provided for the dowries of five of my married daughters, and this cost me 10,000 florins. Moreover, I provided for the purchase of several sites for construction [of the Rucellai palace], which cost me a great deal of money, since I had to give 30 soldi for each lira, besides the trouble of convincing the sellers to sell (which was almost impossible). I made one house out of eight. Three were faced onto the Via della Vigna, and five were behind it. In addition, I have spent vastly on this house; on the façade of the church of Santa Maria Novella; on the chapel with the tomb that I had made in the church of San Pancrazio, and later on the vestments of golden brocade for the same church, which cost me more than a thousand ducats; on the loggia opposite my house; and on the house and garden of my holdings in Quaracchi and Poggio a Caiano. All of the above gave me and still give me the greatest satisfaction and pleasure, since in part they serve the honour of God as well as the honour of the city and the commemoration of myself.

It is generally said (and it is true), that earning and spending are among the greatest pleasures given to men in this world, and it is difficult to say which one gives greater pleasure. Since in the last 50 years I have not done anything but earn and spend, which, as I said above, gave me great satisfaction and pleasure, my opinion is that there is more happiness in spending than in earning.

I employ and pay salaries to three farmers on my country estates. There are another three manservants in the household, four or five maidservants (that is, slaves), one tutor to teach the youngsters, and four or five horses, which are all things of great satisfaction.

I have two sons, Pandolfo and Bernardo, who are what they are, two grandsons, the sons of my sons, and four granddaughters. This offspring brings me great consolation and contentment.

I also have good family connections comparable to hardly any other in our city. Since I was a relative of Piero di Cosimo de' Medici, and of his

sons, Lorenzo and Giuliano, I was honoured, revered and respected. I have enjoyed and still enjoy their happiness and fortune, for which I was very satisfied.

Outside Florence I have two grand villas, as I said. One is near the town and the other far away, that is one in Quaracchi and the other in Poggio a Caiano. Both are well stocked with household goods, for which I am very satisfied.

And since our city was at war and in grave debt for 30 years (that is, from 1423 to 1453), and since I wished to be able to witness a long, safe and stable peace in my time, God granted me the grace in my old age that we have been at peace for 20 years, that is, from 1453 to 1473, with the exception of one year, in 1467, when we were at war in Romagna against the Venetians led by Bartolomeo da Bergamo. We quickly exited the war with great honour; I gained great satisfaction from this as it was something I very much desired.

I was and still am most satisfied by a legacy I have made to the Bankers' Guild, for an offertory to be made by the Guild every year, with the body of the guild in the church of San Pancrazio, with a certain amount of sweetmeats and Trebbiano wine; also for the marriage of four girls each year who were born and grew up in the parish of San Piero a Quaracchi, and for two lamps which have to burn day and night in the tomb of the said church. These things give me much pleasure and satisfaction, since they serve the honour of God and the commemoration of myself.

It could be said that I have done all of the above during times of adversity, since I have not been on good terms with the state, but rather under suspicion for 27 years, that is, from 1434 to 1461. Therefore I have had to steer a straight path without committing any mistake, and it is even more amazing that I got where I am today, and having been in adversity gives me more pleasure than if I had always been prosperous. God be praised and thanked for all things. Amen.

They commonly say that in a good life there is a good death, and since I am nearing the end of my life, I wanted to remember all of the above, so that reason will force me to die gladly, and thus so pleases the Lord God to concede me His grace.

[Afterwards, in the year 1474, I suffered a great loss from my company in Pisa, which was managed by Ridolfo Paganelli. He tricked me and stole through deception. The damages he caused amount to 20,000 florins, so that, together with other adversities, after being rich, I became poor. God be praised for everything.]

3.2.2
A coppersmith describes the festivities in Florence for St John the Baptist

There are relatively few extant Renaissance descriptions of paintings and sculptures, especially from a non-elite audience. Accounts of festivals and the temporary art works made for them, however, are more common, and can give us an insight into the way people valued and understood the visual arts in a wider sense. This is an account by a Florentine artisan, the coppersmith Bartolommeo Masi (1480–1531), of the festivities held in June 1514 for Florence's patron saint, John the Baptist. This festival was particularly lavish as it was held just after the return of the Medici family from exile in 1512 and the triumphant election of Giovanni de' Medici as Pope Leo X in 1513. The story of the triumph of Camillus tells of the exiled Roman dictator who returned to the city victorious after expelling the Gauls from Italy. The use of this imagery at the time was contentious because, although it could be interpreted as alluding to the return of the Medici family, many people thought it could refer to a potentially dangerous anti-French policy on the part of the new regime. Notably, this allegory passes Masi by, and he seems more interested in the spectacle of wild beasts tearing each other apart on the Piazza della Signoria. [JB]

Source: Bartolommeo Masi (1906), *Ricordanze di Bartolommeo Masi, Calderaio fiorentino dal 1478 al 1526*, ed. O. Corazzini (Florence: G. C. Sansoni), pp. 141–4. Translated from the Italian by Jill Burke. Copyright © The Open University 2007.

I remember how the Signoria of Florence ordered that they make a beautiful feast on this year's day of St John the Baptist, as is the custom of the city. It's true that they have not made a more beautiful feast than this one for more than 25 years. First they appointed five people in charge of the festivities (*festaiuoli*) . . . And these men had the authority to make a beautiful festival at the expense of the commune of Florence . . . And the *festaiuoli* made a proclamation throughout the city, that they ordered that one do the following; that everyone who wanted to stay in their workshops would have to go to their office for a license, paying such money as the *festaiuoli* see fit. . . . It cost for a dispensation, to stay in our shops at this time, for an artisan of the minor guilds, that is one like us, from 7 to 10 soldi . . .

[On 21st June] all the artisans of Florence, made a beautiful display of all their merchandise: and this was a day before it was normally done in other years: and they did this because there was little time for so many things they had to do. The day after, that was on the 22nd of the said month, they had a solemn and beautiful procession, and this was in the morning, as is usual in the city. And afterwards, after lunch, a *fusta* [a kind of row-boat] of wood on a cart went through all of Florence, pulled by two pairs of oxen . . . and on it were men with all the apparatus that a similar boat would contain; and they had placed there on it certain mad people, or really half-mad people, to give pleasure to the people. And behind this *fusta* were around 30 people dressed up as devils, with some hooks and little bells in their hands; and with these they would take someone and put him in the *fusta*, and if he wanted to get out, they would make him pay a tribute. And afterwards on the 23rd, through the whole of Florence went 16 or 17 triumphs, and these were called the triumphs of Camillus the Roman, and these went around in the day after lunch; and the same morning they went in the Piazza [della Signoria], and there they staged six or really seven other triumphs, that used to be done in the past, that is the triumph of the Annunciation, and that of the Archangel Michael, and the one they call the 'Madia' and similar triumphs, which were a most beautiful thing, both of adornment and of gentility, and of beauty, that everyone said that they had never seen in their days more beautiful triumphs than these and better arranged. And afterwards on the 24th, which was the day of Saint John the Baptist . . . in the morning they made the tribute of the Signoria and of all the Offices of Florence. And afterwards in the day, after lunch, they ran the horse race (palio) of St John, as is the custom; and in the evening, after dinner, they had fireworks, which was one of the most beautiful firework displays that any one could ever remember. And after, the following day . . . they had a beautiful hunt on the Piazza della Signoria in Florence; and all around the piazza was full of benches . . . It was a beautiful hunt, and there were these types of animals that I will recount: first hares and foxes and dogs, and afterwards wild goats and deers; and to hunt the goats there were two leopards that ran about in such a way that in a few steps they had taken their prey. And then there were two horses and a mule and a mare; these beasts made a big scuffle together with kicks and bites. And afterwards they put in a bear and they wanted to bring two lions, but they could only bring one, because the other one was so ill spirited, that the men who guided him were too scared . . . and [there were] bulls and buffalo and these were killed by men with short arms in their hands, that is a sword, or really it seemed to be a dagger. And in the middle of the piazza, they had made a beautiful fountain, which spurted water, so that all these beasts could go and

drink... [Then on 26th and 27th June] they had a beautiful joust on the Piazza Santa Croce which lasted two days: and these jousters were men at arms, organized by lords and great Florentine masters.

3.2.3
Fra Girolamo Savonarola warns Florentines against the dangers of the new type of painting

The Dominican friar Girolamo Savonarola (1452–98) was made prior of the convent of San Marco in Florence in 1491 and enjoyed the patronage of Lorenzo de' Medici. After the expulsion of the Medici family from Florence in 1494, he exercised great influence over the composition of the new republican government, and his sermons, which were attended by thousands, railed against political corruption, materialism and superficiality, which he believed were the bane of modern society. He prophesied that after a time of social purgation, Florence would be the centre of a renewed Christianity. He was burnt at the stake for heresy in the Piazza della Signoria in 1498. Savonarola was very aware of the potential power of imagery, both as an aid to religious devotion and as a possible distraction from a pious life. He touched on a nerve with his denunciation of new types of imagery, learning and music, which he argued could be ungodly, giving the external appearance of piety without corresponding to any inner spirituality. The following extracts come from a number of his sermons given in Florence between 1494 and 1497. [JB]

Sources: Girolamo Savonarola (1969), *Prediche sopra i Salmi*, ed. V. Romano (Rome: Angelo Belardetti), vol. 1, sermon XII, 19 May 1494, p. 189. Savonarola, *Prediche Italiane ai Fiorentini* III/1, ed. R. Palmarocchi (Florence: La Nuova Italia, 1933), sermon XVIII, 5 March 1496, selection from pp. 388–91 (a section is translated in C. Gilbert (ed.), *Italian Art: Sources and Documents* (Englewood Cliffs, NJ: Prentice-Hall), pp. 157–8). Savonarola, *Prediche sopra Ezechiele*, ed. R. Ridolfi (Rome: A. Berladetti, 1955), vol. 1, sermon XXVII, given 3rd Sunday in Lent, 1497, pp. 357–8; vol. 2, sermon XXXII, 4 March 1497, pp. 51–2 and 184; vol. 2, sermon XXXII, delivered on 4 March 1497, pp. 48–63; vol. 2, sermon XXXIX, delivered on 11 March 1497. Translated from the Italian by Dario Tessicini and Jill Burke. Copyright © The Open University 2007.

Sermon XII

By contemplating only the appearance of things, the ancients sinned and became slaves of their senses. These earthly objects can be considered in two ways. Firstly, as images representing Him who created them, and this means to meditate on earthly things as images of God, as you do with the Crucifix and the cross, which represent God and draw man to the contemplation of God. The other way is to consider them as a representation of the craft that is within them, as when you say: 'The man who made this image was a good master', that is, when you only consider the craftsmanship. Therefore, I want to give you some good advice: 'Flee those things made with artifice, as if they were riches'. Look at the figures they nowadays make for churches, which are done with such craftsmanship, and are so ornate and elaborate, that they obscure the light of God and true contemplation, and people do not consider God, but only the craft within the image. Polyphony and organ music have the same effect. Nevertheless, you must give yourself to simplicity, and not to such crafted things, and you must remain firm in the contemplation of God only.

Sermon XVIII

In effect, there is no longer any respect for divine worship, and if people do good works outwardly, it is done for the sake of their own honour, and everybody builds chapels with their coats of arms on them. What does this mean? If I said to you, 'Give me ten ducats to give to a poor man', you wouldn't do it. Yet if I say to you, 'Spend 100 ducats on a chapel here in San Marco', you would do it so that you could put your arms on it, and you would do it for your own honour, not in honour of God. However, when He sees this, He says: *Though ye offer me burnt offerings and your meat offerings, I will not accept them; neither will I regard the peace offerings of your fat beasts.*[1] I will not look upon your vows and your fasts, and though the celebrations do not require abstinence, it is not, however, ordained that you should eat. Go and behold your feast of Saint John . . . how you have reduced it to fireworks, men on stilts and a thousand other wanton acts. But God says: 'I will not look upon your celebrations' [. . .]

[1] This is a quote from the Old Testament book of Amos 5:22. Savonarola quoted the original in Latin, as he did with all passages from the Bible.

Look at the habits of Florence, at how Florentine women marry off their daughters. They show them around and dress them up as if they were nymphs, and first, they take them to Santa Liperata [the Duomo]. These are your idols and you have placed them in my temple.

The images of your gods are the pictures and likenesses you have had painted in churches. And so young men go around saying about this man or woman, 'she is Mary Magdalen, and this other one is Saint John', because you have had painted in your churches figures in the likeness of this or that woman. This is very ill-done, and in contempt of God's property. You painters, you do wrong; if you knew the scandal that follows, and what I know, you wouldn't want to paint like this. You put all kinds of vanities in churches. Do you really believe that the Virgin Mary went around dressed in the way you have painted her? I tell you she was dressed as a poor woman, with simplicity, and so covered that you could barely see her face; likewise, Saint Elizabeth was dressed simply too.

You would do great good erasing those figures, since they are so dishonestly painted. You make the Virgin Mary appear as though she was dressed as a whore. And this is because religion is now corrupt and no one cares about anything anymore but his own honour. Look anywhere in the convents: you will find them full of the arms of those who have built them. I look up over that door thinking I will find a crucifix, and instead there is a coat of arms. I move on, lift my head and there is another coat of arms. Everything is full of arms. I wear a vestment. I think there is a crucifix painted on it, and instead there are more arms. And do you know why they put the arms on the back of the vestment? So that when the priest stands at the altar the arms can be seen by the whole congregation.

Sermon XXVII

Children and women respond like plants do, with their bodies, and through physical stimulation. Paintings in churches are their books, and we should provide for them better than the pagans did. The Egyptians did not allow indecent figures to be painted. The first thing we should do is remove the dishonest figures, and the crude scenes that make people laugh shall not be painted. And in churches no one should paint unless they are good masters who paint honest things. If they paint the Virgin, she has to be painted with all decency, as she really was.

Sermon XXXII

Call a painter over here for a little while. Come forward, painter. Do you know how to paint a bunch of grapes? First, I want it made by a woodcarver; or, that it shall be painted, and made by a sculptor. Would you know how to paint the grapes with colours that make them seem real? Painters, especially the good ones, have certain colours which give lustre and make things seem alive. Now, take a woodcarver and have him carve a bunch of grapes and make them resemble real grapes and then [get] a painter to paint them with the same colour a natural grape has. Then put it in a vineyard and wait for a bird to come. Where do you think the bird will go? It will go to the real grapes and not the painted ones, because even the most perfect art cannot perfectly imitate nature in everything. There is a certain liveliness, a certain something, in nature that art cannot express.

Sermon XXXIX

A funerary monument is the embodiment of the sinner [...] These great masters have those beautiful tombs made, and they want to rot amongst marble and silk. Since they are going to Hell, they at least want to stay here in their tombs sculpted and painted with figures of the Virgin and saints – *and their sepulchre shall remain their home for all eternity.*[2] This is why a man who has a beautiful body but a soul dead through sin is called 'caught in a monument'. But the Saviour has said: *Woe unto you, scribes and Pharisees, hypocrites! for ye are like unto whited sepulchres!*[3] These tombs, painted with figures, are the ceremonies of the Church. Many feast themselves on these figures and these ceremonies and they are caught in the monument, that is in the arms of sin.

[2] From Psalm 48, line 12.

[3] This is a quote from Matthew 23:27. The verse continues, 'which indeed appear beautiful outward, but are within full of dead men's bones, and of all uncleanness'.

3.2.4

The cloth merchants' guild commission a new sculpture for the Florentine Baptistery

This document is a translation of the contract for Gianfrancesco Rustici's *John the Baptist with a Levite and a Pharisee* (1506), which is above the north doors of the Florence baptistery. The preamble is significant in that it harks back to a time of flourishing patronage in the baptistery, and implicitly seeks to renew this. Alongside other large communal commissions of the first decade of the sixteenth century (including the decoration of the Hall of the Great Council and Michelangelo's *David*) we can see this as part of a concerted effort to revitalize civic patronage after the Medici expulsion. [JB]

Source: G. Milanesi (1860), 'Documenti riguardanti le statue in marmo e di bronzo fatte per le porte di San Giovanni di Firenze da Andrea del Monte San Savino e da Gio. Francesco Rustici, 1502–1524', *Giornale Storico degli Archivi Toscani*, IV, pp. 69–70. Translated from the Italian by Dario Tessicini. Copyright © The Open University 2007.

The present lord consuls, having deliberated, with the records of the esteemed Officials of the Mosaic of this guild, [noted] how in the church and oratory of Saint John the Baptist in Florence (which is under the protection and care of this guild) many beautiful, decent and praiseworthy works have been made not long ago for this church, for the honour of God the Almighty and his Most Glorious Mother, for the divine cult and for the strengthening of devotion. Above all, the number of chaplains and clerics in the choir has increased, and these chaplains and clerics are obliged to say mass, vespers and other divine offices on many solemn saints' days, that were not normally celebrated before the year 1500. Moreover, [they have the duty to celebrate] on each Saturday the vespers with organ music and other rituals. And as their income and alms grew [. . .] as the said consuls obtained them, so they made [these funds] available, and similarly [they provided] singers for the days when the priors take up office,[1] for Saint John's Day and the day of Saint John's pardon,

[1] The change of government of the eight priors, leaders of the Florentine Republic under the guidance of the head of state, the *Gonfaloniere a Giustizia*, took place every two months.

their eves and other days, as they should be observed. And they made many vestments. And, moreover, at the time of the present Officials of the Mosaic, they have had made many beautiful and worthy vestments of brocade which will be finished shortly, with luck in their period of office, or at least in the time of their immediate successors. For this work it has been decided and officially stated that it is possible to spend 400 golden florins. And in this way, the divine cult has firstly been provided for, which is the most important thing we must do. Secondly, it seems appropriate that we should consider and have regard for making some beautiful and worthy adornment to the said church and temple of Saint John, as, when one considers everything, one does not find another more beautiful, or as beautiful, not only in Italy but in the entire world. And all this increases the fame, honour and reputation of your city and, particularly, of your guild.

And the present lord Consuls, desiring to make some praiseworthy and fitting work for the adornment of such a temple, have judged that the three marble statues which are above the door in front of the Opera of Saint John,[2] to be clumsy and badly-made in comparison with the doors and other worthy works in the church, and it seems that by being in such a visible position they sooner bring shame than honour and reputation to the city and our guild. Moreover, they are so ravaged that in places they have started to fall apart. And if these figures were made in bronze and beautifully, they would correspond to the bronze doors of the said church, which are beautiful and fitting things, it would undoubtedly be praiseworthy. Since it is not possible to do this within one year, it should be done in two or more, according to the money and finances available to the said church and *opera*. And to conduct this work, a certain master Giovanni Francesco Rustici of Florence offered his services to the Consuls and officials, and the officials discussed this with him, and having seen his works, and had some advice about them, judge him to be qualified and capable of doing the job. And in order to go ahead, he has asked to be given little by little the bronze and other materials as he should need them for these figures and their ornamentation, and any supplies, while he works on the figures, that seem and will seem appropriate to the Consuls and the Officials of the Mosaic, or a two-thirds majority of them. Similarly, once all, or some, of the figures are completed he will content himself that the price, salary and provision will be determined at the discretion and will of the Consuls and the Officials of the Mosaic of the said guild presently in office, or by a two-thirds majority of them [. . .]

[2] This is the building where the *opera*, or works committee, of the baptistery met – above Ghiberti's north doors.

3.2.5
A meeting about where to place Michelangelo's *David*

Michelangelo's *David* was originally commissioned by the Board of Works (*opera*) of the cathedral of Florence in August 1501, and was to be placed somewhere high up on the cathedral façade. It was revealed to the public in June 1503, and it seems that at some time between that date and January 1504 it was decided that the cathedral might not be the most suitable place for the sculpture. Meetings of knowledgeable advisors, called *pratiche*, were common in Florentine government and traditional for discussing sculptural and architectural changes to the cathedral. The minutes of this meeting are particularly interesting because of the political sensitivity of the *David* for Florentines and because of its artistic novelty – the first colossal nude sculpture since antiquity. [JB]

Source: C. Seymour, Jr. (1967), *Michelangelo's David: A Search for Identity* (Pittsburgh: University of Pittsburgh Press), pp. 141–55. © 1967 by University of Pittsburgh Press. Reprinted by permission of University of Pittsburgh Press.

1503/04, January 25.

Considering that the statue of David is almost finished, and desiring to install it and to give it an appropriate and acceptable location, with the installation at a suitable time, and since the installation must be solid and structurally trustworthy according to the instructions of Michelangelo, master of the said Giant, and of the consuls of the Arte della Lana, and desiring such advice as may be useful for choosing the aforesaid suitable and sound installation, etc., they decided to call together and assemble, to decide on this, competent masters, citizens, and architects, whose names are listed below in the normal style, and to record their opinions, word for word.

Andrea della Robbia
Giovanni Cornuola
Attavante, miniature painter[1]
Francesco, First Herald of the Signoria
Giovanni Cellini, fife-player
Francesco, d'Andrea Granacci

[1] See 3.3.2.

Biagio d'Antonio Tucci, painter
Piero di Cosimo, painter
Guasparre di Simone, goldsmith
Ludovico, goldsmith and master of bronze-casting
Andrea, called il Riccio, goldsmith
Gallieno, master-embroiderer
Davide Ghirlandaio, painter
Simone del Pollaiuolo
Filippino Lippi, painter
Lorenzo dalla Golpaia [maker of a famous astronomical clock]
Salvestro, worker in precious stones
Michelangelo Bandinelli, goldsmith
Cosimo Rosselli
Chimenti di Francesco Tassi
Sandro Botticelli, painter
Giuliano da San Gallo
Antonio da San Gallo
Andrea da Monte a San Savino, painter [*sic*] (in the margin: at present in Genoa)
Leonardo da Vinci
Pietro Perugino, in Borgo Pinti, painter
Lorenzo di Credi, painter
Bernardo di Marco della Cecca, wood-carver

All of these men listed above appeared in the premises of the said Opera, and after two of the Operai had admonished and advised them on the proper presentation and deposition of their opinions, they gave advice as to where, and in what place, the said statue was to go; their statements are recorded below verbatim in their own words, beginning with the first witness.

1. Messer Francesco, First Herald of the Signoria

I have gone over and over in my mind whatever my judgment offers. There are two places where such a statue might be erected. The first is where the Judith is, and the second the center of the courtyard of the Palace, where the David is. The reason for the first is because the Judith is an emblem of death, and it is not fitting for the Republic – especially when our emblems are the cross and the lily – and I say it is not fitting that the woman should kill the man. And even more important, it [the group] was erected under an evil star, for from that day to this, things have gone from bad to worse: for then we lost Pisa. The David of the courtyard is a figure that is not perfect, because

the leg that is thrust backwards is faulty. For these reasons I would advise putting this statue in one of the two places [indicated] but with my preference for where the Judith now is.

2. Francesco Monciatto, wood-carver,

He answered and said: I believe that all things that are made are made for a definite purpose. And I believe this because it was made to be placed on the pilasters outside [sic] the church, or else on the buttresses around it [sic]. I don't know your reasons for not wanting to put it there, especially since I feel that it would be an ornament to the church, and to the consuls; but now the location has been changed. Seeing that it will be taken away from the place first intended, I think it would be for the best either in the palace, or outside the church. But my mind is not really made up, and I should listen to what the others say, because I have not really thought about the most suitable place for a long enough time.

3. Cosimo Rosselli

Both Messer Francesco and Francesco have spoken so well that I too believe that inside the palace would be a good place. However, I had been thinking of putting it on the steps of the Cathedral, on the right-hand side, and on a pedestal at the corner of those stairs, together with a high, ornamented base. And there is where I think it should go.

4. Sandro Botticelli

Cosimo has hit upon the place where I think it can best be seen by passers-by, with a Judith at the other corner. Perhaps also in the Loggia of the Signoria – but preferably at the corner of the Duomo; indeed, I judge it would go well there, for it is the best place of all.

5. Giuliano da San Gallo

My judgment too was much inclined in favor of the corner of the Duomo that Cosimo mentioned, where it would be seen by the people. But, consider that this is a public thing, and consider the weakness of the marble, which is delicate and fragile. Then, if it is placed outside and exposed to the weather, I think that it will not endure. For this reason as much as any, I thought that

it would be better underneath the central arch of the Loggia of the Signoria: either underneath the center of the vault, so that you can go in and walk around it; or else at the back by the wall, in the middle, with a dark niche behind it as a sort of tabernacle. Remember that if it is put outside, it will soon weather badly. Therefore, it should be under cover.

6. Angelo, the Second Herald, and a nephew of Messer Francesco

I have listened carefully to all these opinions, and everyone has put forth good suggestions, for many reasons. Now in thinking of these places with reference to frost and cold weather, I have been mindful of the need for shelter. The site should be inside the Loggia just mentioned, but beneath the arch nearest the palace. There it would be covered, and ennobled by its proximity to the palace. If you put it immediately underneath the central arch, it will disrupt the order of the ceremonies that the Signoria and the other magistrates conduct there. *In the margin* [this was added later, at the end of the session]: Before your Excellencies decide where it is to go, discuss it with the Signoria, for there are good men of sound judgment in that body.

7. Andrea, called il Riccio, goldsmith

I agree with what Messer Francesco the herald [*sic*] said, because it would be well sheltered there [in the loggia]. Besides, it will win more respect and esteem than if it were spoiled [by the weather]. It is better under cover, because the people would go to see it, rather than having such a thing confronting the people; as if we and passers-by should go to see it, rather than having the figure come to see us.

8. Lorenzo dalla Golpaia

I agree with the opinions of the herald who has just spoken, with il Riccio, and with Giuliano da San Gallo.

9. Biagio d'Antonio Tucci, painter

I think these opinions are sound. I am of the opinion that the best place is where Giuliano advised, provided it is put far enough back so that it does not spoil the ceremonies held by the officials in the Loggia; or perhaps [it might stand better] on the stairs.

10. Bernardo di Marco della Cecca

I side with Giuliano da San Gallo, for it seems sensible, and I am with this Giuliano for the reasons he gave.

11. Leonardo da Vinci

I agree that it should be in the Loggia, where Giuliano said, but on the parapet where they hang the tapestries on the side of the wall, and with decency and decorum, and so displayed that it does not spoil the ceremonies of the officials.

12. Salvestro, worker in precious stones

Almost all the places have been talked about, and much has been said one way or the other. But I believe that the man who made it did so to be worthy of giving it the best possible location. Though for my part I favor the place outside the palace, yet, as I said, he who made it surely knows better than anyone the place best suited to the appearance and character of the figure.

13. Filippino Lippi

Though everyone has argued well, I believe that the master-sculptor would know best, because he has spent much time in thinking of a place where he intended to put it. All the same, I approve of all that has been said, for all have talked sensibly.

14. Gallieno, embroiderer

As for me, according to my own views, and in view of the quality of the statue, I think that it would go well where the Marzocco of the piazza is, with a richly decorated pedestal. This place is convenient for such a statue. The Marzocco can be put by the side of the doorway of the palace, on the corner of the parapet.

15. Davide Ghirlandaio, painter

It seems to me that Gallieno has pointed out the most worthy place of all, and that would be an acceptable and appropriate location. And the Marzocco could go where he said, or in another place; whatever seems best.

16. Antonio da San Gallo, wood-carver

If the marble were not delicate, the place where the Marzocco is would be right. But I think that it would not survive being placed outside for many years. Seeing that the marble is delicate, I feel it should go inside the Loggia. Besides, if it is not even exactly on the street, passers-by would take the trouble of going to see it there.

17. Michelangelo Bandinelli, goldsmith

All these experts have spoken well, but Giuliano da San Gallo best of all. The Loggia seems like a good place to me. If this is not suitable, then in the Sala del Consiglio [presumably of the Palazzo della Signoria].

18. Giovanni Cellini, fife-player

Since I value your opinions, let me say that I would support Giuliano's judgment if it [the statue] could be seen all around; but it cannot be seen thus. We must think of [several factors: the question of] proportion, of climate, [size] of opening [of the arch], of the wall [behind it], and of covering. [If in the Loggia], it would be necessary to go round it there, and, besides, some wretch might damage it with a stave. I myself think that it would go well in the courtyard of the palace, as Messer Francesco the herald advised; furthermore, it would be a great triumph for the artist to have such a statue in a place worthy of it.

19. Giovanni Cornuola

I had considered putting it where the Marzocco is, but I had not though that the marble might be delicate and would be damaged by rain and cold. For these reasons I judge that inside the Loggia is a good place, as Giuliano da San Gallo said.

20. Guasparre di Simone

I was thinking of putting it in the Piazza of S. Giovanni, [i.e. at the façade of the Duomo] but now the Loggia seems a more suitable place, since the stone is weak.

21. Piero di Cosimo, painter

I agree with the opinion of Giuliano da San Gallo. Even more I would approve an opinion in agreement with him who made it, since he knows best where he wants it to be.

The other dignitaries nominated and summoned submitted opinions, but these, being very brief, are not herein recorded. Moreover, their opinions were the same as those cited above; all agreed with one or another of the above opinions, without any [substantial] difference.

Illuminated Manuscripts

3.3.1
The manuscripts in the library of the Duke of Urbino

In his life of Federigo da Montefeltro (duke 1444–82), Vespasiano da Bisticci (1421–98) described the duke's extensive library, which he claims constituted an unrivalled range of works. It consisted not of printed books but exclusively of manuscript editions, prepared by a team of 30 or more scribes, which underlines the collection's material value as a luxury commodity as much as its intellectual worth. Nevertheless, the library was open to scholars who wished to consult books in the collection. Vespasiano's praise for the duke and his library and his knowledge of its contents comes from the fact that, as a bookseller, it was he who had helped the duke compile the collection, devoting 14 years to the task. The scribes employed by the duke were in fact part of Vespasiano's own firm. He also helped Cosimo de' Medici and Nicholas V acquire books, though the Urbino library, its collection and their catalogue, was his largest undertaking. Vespasiano retired in 1480, closing his bookshop in Florence which had served as an informal meeting place for intellectuals. One of the reasons for his retirement was competition from printed books of which, as he makes clear in his life of the Duke of Urbino, he did not entirely approve. [CMR]

Source: *The Vespasiano Memoirs: Lives of Illustrious Men of the XVth Century*, trans W. George and E. Waters (Toronto: University of Toronto Press, 1997), pp. 102–5. Reprinted by permission of the University of Toronto Press.

We come now to consider in what high esteem the Duke held all Greek and Latin writers, sacred as well as secular. He alone had a mind to do what no one had done for a thousand years or more; that is, to create the finest library since ancient times. He spared neither cost nor labour, and when he knew of a fine book, whether in Italy or not, he would send for it. It is now fourteen or more years ago since he began the library, and he always employed, in Urbino, in Florence and in other places, thirty or forty scribes in his service. He took the only way to make a fine library like this: by beginning with the Latin poets, with any comments on the same which might seem merited; next the orators, with the works of Tully and all Latin writers and grammarians of merit; so that not one of the leading writers in this faculty should be

wanted. He sought also all the known works on history in Latin, and not only those, but likewise the histories of Greek writers done into Latin, and the orators as well. The Duke also desired to have every work on moral and natural philosophy in Latin, or in Latin translations from Greek.

As to the sacred Doctors in Latin, he had the works of all four, and what a noble set of letters and writings we have here; bought without regard of cost. After the four Doctors, he was set on having the works of S. Bernard and of all the Doctors of old, without exception, Tertullian, Hilarius, Remigius, Hugh de S. Victor, Isidore, Anselm, Rabanus and all the rest. After Latin works came Greek writings done into Latin, Dionysius the Areopagite, Basil, Cyril, Gregory Nazianzen, John of Damascus, John Chrysostom, Gregory of Nicea, all the works of Eusebius, of Ephrem the monk, and of Origen, an excellent writer. Coming to the Latin Doctors in philosophy and theology, all the works of Thomas Aquinas, and of Albertus Magnus; of Alexander ab Alexandro, of Scotus, of Bonaventura, of Richard of Mediavilla, of the Archbishop of Antoninus and of all the recognised modern Doctors, down to the Conformità of S. Francis: all the works on civil law in the finest text, the lectures of Bartolo written on goat-skin. He had an edition of the Bible made in two most beautiful volumes, illustrated in the finest possible manner and bound in gold brocade with rich silver fittings. It was given this rich form as the chief of all writings. With it are all the commentaries of the Master of the Sentences, of Nicolao di Lira, and of all the Greek and Latin Doctors, together with the literal glossary of Nicolao di Lira. Likewise all the writers on astrology, geometry, arithmetic, architecture and *De re Militari*; books on painting, sculpture, music and canon law, and all the texts and lectures on the *Summa* of Ostiensis and other works in the same faculty. In medicine all the works of Avicenna, Hippocrates, Galen, the *Continenti* of Almansor and the complete works of Averroes in logic and natural philosophy. A volume of all the Councils, held since ancient times, and the logical, phiolosophical and musical works of Boethius.

There were all the works of modern writers beginning with Pope Pius; of Petrarch and Dante in Latin and in the vulgar tongue, of Boccaccio in Latin; of Coluccio and of Lionardo d'Arezzo, original and translations; of Fra Ambrogio, of Giannozzo Manetti and Guerrino; the prose and poetical works of Panormita, and Francesco Filelfo, and Campano; as well as everything written by Perrotto, Maffeo Vegio, Nicolo Secondino (who was interpreter of Greek and Latin at the Council of the Greeks in Florence), Pontano, Bartolomeo Fazi, Gasparino, Pietro Paolo Vergerio, Giovanni Argiropolo (which includes the Philosophy and Logic of Aristotle and the Politics besides), Francesco Barbaro, Lionardo Giustiniano, Donato Acciaiuoli, Alamanno,

Rinuccini, Cristofano da Prato, Vecchio, Poggio, Giovanni Tortello, Francesco d'Arezzo and Lorenzo Valla.

He added to the books written by ancient and modern doctors on all the faculties all the books known in Greek, also the complete works of Aristotle and Plato (written on the finest goat-skin); of Homer in one volume, the *Iliad*, the *Odyssey*, and the *Batrachomiomachia*; of Sophocles, Pindar and Menander, and all the other Greek poets; a fine volume of Plutarch's lives and his moral works, the *Cosmography* of Ptolemy illustrated in Greek, and the writings of Herodotus, Pausanius, Thucydides, Polybius, Demosthenes, Æschines and Plotinus. All the Greek comments, such as those upon Aristotle, the *Physica de Plantis* and Theophrastus; all the Greek vocabulists – Greek into Latin; the works of Hippocrates, Galen, Xenophon, S. Basil, S. John Chrysostom, S. Athanasius, S. John Damascenas, S. Gregory Nazianzen, S. Gregory of Nicea, Origen, Dionysius the Areopagite, John Climacus, S. Ephrem the monk, Æneas the Sophist, the Collations of John Cassianus, the book of Paradise, *Vitæ sanctorum patrum ex Ægypto*, the Life of Barlaam and Josaphat, a wonderful psalter in Hebrew, Greek and Latin, verse by verse, and all the Greek works on geometry, arithmetic, and astrology. Finding that he lacked a vast number of Greek books by various writers, he sent to seek them so that nothing in that tongue which could be found should be lacking; also whatever books which were to be had in Hebrew, beginning with the Bible and all those dealt with by the Rabbi Moses and other commentators. And besides the Holy Scriptures, there are books in Hebrew on medicine, philosophy and the other faculties.

The Duke, having completed this noble work at the great cost of thirty thousand ducats, beside the many other excellent provisions that he made, determined to give every writer a worthy finish by binding his work in scarlet and silver. Beginning with the Bible, as the chief, he had it covered with gold brocade, and then he bound in scarlet and silver the Greek and Latin doctors and philosophers, the histories, the books on medicine and the modern doctors, a rich and magnificent sight. In this library all the books are superlatively good, and written with the pen, and had there been one printed volume it would have been ashamed in such company. They were beautifully illuminated and written on parchment. This library is remarkable amongst all others in that, taking the works of all writers, sacred and profane, original and translated, there will be found not a single imperfect folio. No other library can show the like, for in all of them the works of certain authors will be wanting in places. A short time before the Duke went to Ferrara it chanced that I was in Urbino with His Lordship, and I had with me the catalogues of the principal Italian libraries: of the papal library, of those of S. Marco at

Florence, of Pavia, and even of that of the University of Oxford, which I had procured from England. On comparing them with that of the Duke I remarked how they all failed in one respect; to wit, they possessed the same work in many examples, but lacked the other writings of the author; nor had they writers in all the faculties like this library.

3.3.2
The contract between Attavante and a Florentine merchant for an illuminated manuscript

Getting a manuscript completed, with its many and various parts, was important for a patron who chose to invest considerable sums in such books. On 23 April 1494 Attavante (1452 to c.1525), one of the leading manuscript illuminators in Florence (see 3.2.5), entered into a contract with a Florentine merchant to illuminate a Bible and commentary by Nicholas of Lyra. Despite Attavante's experience and reputation, the Florentine merchant wanted to keep a close eye on him, inspecting his work and checking progress every day, with penalties for late work, as the contract makes clear. Attavante often collaborated with painters, among them Domenico Ghirlandaio, who had a profound effect on his work. Attavante's mixed antique motifs, and references to Netherlandish and Florentine paintings in his illuminations, made him particularly popular amongst wealthy patrons. In this case the merchant was commissioning the Bible and commentary for a high status patron, King Manuel I of Portugal.[1] It was completed by 1497 with the help of assistants and is preserved today in the Arquivo Nacional da Torre do Tombo in Lisbon. [CMR]

Source: Reproduced in Jonathan J. G. Alexander (1992), *Medieval Illuminators and their Methods of Work* (New Haven and London: Yale University Press), pp. 181–2 (no. 6), from G. Milanesi, *Nuovi documenti per la storia dell'arte Toscana dal XII al XV secolo* (Florence, 1901; repr. 1973), pp. 164–6 (no. 185). Translated from the Italian by Dario Tessicini. Copyright © The Open University 2007.

[1] Albinia de ala Mare (2000), 'Notes on Portugese Patrons of the Florentine Book Trade in the Fifteenth Century', in K.J.P. Lowe, ed., *Cultural Links Between Portugal and Italy in the Renaissance* (Oxford: Oxford University Press), pp. 167–81.

On the 23rd of April 1494, the revered master Chimenti, of the late Cipriano di Sernigi, citizen and merchant of Florence, as one party, and Vante di Gabriele Attavanti, illuminator, as the other, agreed to the following contract, in the form and content as it is established below in the vernacular, that is:

[In the name of] Jesus, the 23rd of April 1494

With the present document it is made public that Chimenti di Cipriano di Sernigi commissions several copyists to write up a manuscript of the Bible in seven volumes with the commentaries by Nicholas de Lyra, and a volume with the Master of the Sentences [Peter Lombard's *Sentences*], that is, eight volumes in total, which today, the date as above, the said Chimenti has entrusted for decorations and miniatures to the illuminator Vante di Gabriele Attavanti according to the following terms and conditions.

First, the said Vante binds himself without exception to decorate and illuminate in every part, on behalf of the said Chimenti, the said books according to the quality of the figures, decorations and colours of the first quire of the said work, which the said [Vante] has already illuminated, although it is not yet completely finished, since coats of arms and insignia are still missing. But he will have to finish it, and this will serve as a model for the rest of the work. On which exemplar, or better, he will have to work on, supervise and complete the said work, according to the judgement of the said Chimenti, or anybody he will appoint as a deputy, who will have to establish whether [the work] is done and carried out according to the exemplar, or better. And if it is decided that it is worse [than the model], then the said Vante will have to pay 100 golden ducats to the said Chimenti, according to his requests and will and without exception, and more if it is considered to be worse than the model in the quire mentioned above. The said Vante promises and binds himself, without exceptions, to hand in the said books completed with decorations and miniatures as above, which he is expected to do. [He shall hand in] a volume by the first month after he has received from the copyists the last quire of the said volume, that is, if in the next eight months he will have received four or five volumes, he shall have to hand them in, complete with everything, within nine months. Effectively, this means that whenever he receives them, he will have one month to complete as many volumes as he has received. And the said Chimenti shall deliver each day to the said Vante, or arrange for its delivery, the quires of the said volumes and books as he receives them from the copyists, and after they have been revised and corrected of the mistakes, in order that the said Vante shall be able to do his work every day. And in case the said Vante will not meet the said terms in completing the books at the said time, he shall incur a penalty of 200 golden ducats,

to be paid without exception at the request of the said Chimenti. Nonetheless he shall also be bound to hand them in within the next month or otherwise the said Chimenti will be entitled to pass the work to whoever else he wishes, at the expenses of the said Vante. And the said Chimenti shall pay the said Vante for his work a sum [established] according to the terms outlined in the following.

First, he shall receive 25 golden ducats for the beginning of each volume, that is a frontispiece with the rubric, that has to be done with that decoration, or better, that was done in the aforementioned frontispiece used as a model and how it is said above. He shall hand in at least one of the frontispieces every two months, and the rest as is specified above.

Next, he shall illuminate the prologues, epistles, introductions, glosses, preambles according to what he has done in the first quire chosen as a model, that is a decoration on top of the page, one through the columns, and one on one side, each with the figures that are appropriate. And he shall receive three-quarters of a golden ducat for each of these.

Next, he shall illuminate the borders all along the columns of the supplements and the arguments which are in the said volume, with a figure as he has done in the first quire mentioned above. All the rubrics in the said books should be decorated with foliage. He shall receive one-quarter of a golden ducat for each of these.

Next, for each frontispiece to the books, that is at the top of each book, he shall make a figure occupying one third [of the page] similarly to the one made for the epistle of Saint Jerome in the first quire, with the same decorations and figures, or better. He shall receive 3 golden ducats for each of these.

Next, at the beginning of the chapters of the Bible, he shall make initials in a squared frame, decorated with foliage, according to what he has done in the above mentioned quire. And he shall receive 4 *soldi piccoli* for each.

Next, he shall make decorated initials in a squared frame to the chapters of the commentaries, as he has done, or better than this, in the said first quire. And he shall receive 2 *soldi piccoli* for each.

Next, at the beginning of each chapter of the commentary by Nicholas de Lyra, he shall make letters and a figure with decorations worth, at least, $^1/_2$ golden ducat each. He shall receive one-half golden ducat for each of these.

Next, for the commentaries of the prologues, forewords, epistles, preambles, he shall make letters with figures and decorations with foliage, along the entire length of the page, and on the top of the page in that shape he has used for the first quire. He shall receive one-quarter of golden ducat for each of these.

Next, for the paragraphs of the Psalms, he shall make initials in a squared frame, with bodies in powdered gold. He shall receive 4 *denari piccoli*, that is a *quattrino*, for each of these.

Moreover, for the volume of the Master of the Sentences [Peter Lombard's *Sentences*], he shall make a frontispiece with the rubric, with the same diligence, quantity and skill, or better, of the figures and decorations that he has done in the first frontispiece to Nicholas de Lyra's [Expositions]. He shall receive 16 golden ducats.

Next, for the said Master of the Sentences at the beginning of each book, he shall make a frontispiece, extending over one-third of the page, with foliage, figures and decorations in the shape of the first quire of Nicholas de Lyra's [Expositions] to Saint Jerome's Epistle. He shall have one and a half golden ducats for each of these.

Next, for the main chapters, he shall make an initial letter in a squared frame with foliage in the shape of the first quire of Nicholas de Lyra's [Expositions]. He shall receive 4 *soldi piccoli* for each.

The said Chimenti shall pay the said Vante in this way, that is, 25 golden ducats for each month and in weekly instalments according to a variable amount that will suit the said Chimenti, since in case the copyists are not able to hand in each month the number of quires they promised, the said Vante will not need a large quantity of workers and therefore it would not be appropriate to give him such an amount of money each month. Therefore, as has been said, it shall be left to the judgement of the said Chimenti, who will have the right to inspect himself, or through someone else, every day the work done by the said Vante, so that he shall not make a profit by receiving more money than he has rightfully earned. Moreover, by the end of the whole work, the said Vante wants to have earned at least 200 golden ducats, and the said Chimenti shall be bound to pay in a single instalment the sum that will be missing.

3.3.3
The chequered history of the Sforza Hours

The priest and illuminator Giovan Pietro Birago's loss of a substantial part of an illuminated book of hours constitutes one of the earliest recorded examples of art theft. This incident has much to tell us about the value of such a

manuscript at the end of the fifteenth century (the precise date of the theft is unknown). The exorbitant sum of 500 ducats is mentioned which, as Mark Evans has pointed out, was five times the value that Leonardo later placed on his famous Virgin of the Rocks.[1] That there was an eager audience and market for the illuminated manuscript beyond Bona Sforza (d. 1503), its original patron, is demonstrated by the 'Excellency' to whom Birago addresses his letter of complaint and who had evidently acquired the stolen goods, and secondly by Margaret of Austria (1480–1530), who valued the incomplete and second-hand manuscript that she had inherited sufficiently highly to pay for the completion of text and images 1517–20. The resulting combination of miniatures by the Italian Birago and the 16 miniatures and two borders by Margaret of Austria's court painter the Fleming Gerard Horenbout (fl. 1487 to c.1540) makes illumination of the so-called Sforza Hours (BL Add Ms 34294) every bit as unique as its history. The three brief extracts below are Birago's letter of complaint to the 'Excellency' and the payments for the completion of the manuscript. [KWW]

Source: Mark L. Evans and Bodo Brinkmann, eds. (1995), *Das Stundenbuch der Sforza* (Lucerne: Facsimile Verlag Luzern), pp. 831–2, 834–7. Based on partial translations by Mark Evans (pp. 490–1, 494).

1) Letter from Giovan Pietro Birago

Jesus Christ

Illustrious and Excellent Sir etc. . . .

The incomplete book of hours, which was recently presented to your Excellency, was stolen from me by your Fra Johanne Jacopo, who used to be a friar in the convent of San Marco at Milan. The aforementioned is in the prison of the Rocha de Porta Nova. The aforementioned book of hours is that which Duchess Bona had made. Payment of 1,220 lire is due to me for the above. The part which your Excellency has is worth more than 500 ducats. The other part is with the illustrious Duchess. At the time when I was injured by Boca-zino, the said Fra Johanne Jacobo visited me several times with many offers and learned so much . . . about the house, and one time when I was out of the house, entered furtively and stole the said book of hours. Then he went to

[1] M. Evans (1992), *The Sforza Hours* (London: British Museum Press), p. 9.

Rome and sold the said book of hours to a Fra Biancho: and Fra Biancho gave it to the reverend monsignor Juan Maria Sforzino, etc. I beg your Excellency not to permit the said Fra Johanne Jacobo to be released until he has paid for the said book of hours and provided satisfaction for the damage and the interest sustained by the said crime.

Illustrious Excellency, I remain your loyal intercessor to God and to the glorious Virgin Mary, Presbiter Johannes Petrus, Biagus, Illuminator.

2) Accounts of Margaret of Austria

Master Jehan de Marnix, our treasurer and receiver general, we order you to pay . . . to Etienne de Lake, servant of our master secretary Jehan Lalemand, the sum of 20 livres, which we have ordered to be paid for his pain and trouble in having written several vellum leaves for those hours, made in the Italian style and with Italian pictures, which came from the late Madame Bonne of Milan, which hours had lost the said leaves in various places, and is now put back in order. And also to be paid to the said Etienne the sum of 3 livres 10 solz which he confirmed had been spent on vellum for the said leaves, for their preparation and cutting as pertains to them . . . Witness that we have signed this with our own hand at Middleburg in Zeeland, the 19th day of July the year 1517.

<div align="center">Marguerite</div>

1520

Jehan de Marnix our treasurer and receiver general, we order you to pay and deliver to Gerard Horenbout, painter and illuminator, resident in this place, the sum of 30 livres . . . Securely and on good account that which we owe him for works according to his craft, which we have ordered him to do . . .

Concluded at Ghent, this the fourth of June, the year 1520

<div align="center">Marguerite</div>

1521

Owing to Master Gerard Horenbout, painter and illuminator residing in Ghent, for the results of his labour which, by ordinance of Madame [Margaret of Austria], he has completed and delivered, as is hereafter declared:

First, for having made 16 beautiful miniatures well illuminated in the rich hours on parchment for my said Lady, at a price of 75 sols each as agreed with him and my said Lady, amounting to the sum of 60 livres.

Item, for having made for the said hours 700 letters of gold at a price of 12 sols per hundred, agreed as above, the total of 4 livres 4 sols.

Item, to be paid to the said Master Gerard for the writing of some leaves of those hours which he did not have time to write himself and so arranged for them to be taken to be written in Brussels. 40 sols

Item, for having made two text illustrations for my said Lady in those hours, priced at 28 sols each. The total 56 sols

3.3.4
The preface to Sala's poetry book

The preface reproduced here introduces the collection of brief writings accompanied by illuminations that form the main body of the 'Little Book of Love', a small but lavish manuscript now in the British Library (Stowe 955). It was written by Pierre Sala, a native of Lyons and a royal employee, and is dated somewhere between 1500 and 1519. The preface makes it clear that Pierre Sala and Marguerite Bullioud, for whom the manuscript was made, had known one another for some time; their children from their first marriages, Élénore and Hector, had already married one another. Sala is believed to have married his Marguerite after 1519 when he was about 60 years old. She was his second wife and was herself the widow of Antoine Buatier, a treasurer for the French court. Her sister was a favourite lady in waiting of Anne of Brittany. The preface is most significant for what it reveals of the purpose of such a manuscript, to stir up memories and emotions in the viewer. [CMR]

Source: Petit Livre d'Amour: Stowe MS 955, facsimile and commentary, eds J. Backhouse and Y. Giraud, Faksimile Verlag Luzern (Lucerne: Fine Art Facsimile Publishers of Switzerland, 1994), pp. 364–79. Reprinted by permission of Faksimile Verlag Luzern, www.faksimile.ch.

Let him come to the sliding window

To my dearest and most honoured lady, Madame [. . .], you who since my childhood I have always wanted to love, serve, esteem and honour to the best of my ability more than any other lady alive for the great qualities you possess, as the most illustrious and most perfect, she who, in my opinion, has always surpassed all others in feeling, honour and worth, since in your person are to be found all the fine qualities one could wish for in a woman. Your most humble and loyal servant, who for ever wishes to consider you as his sole lady and mistress with all his heart and as humbly as is possible, commends himself to your kindly grace, informing you that the great sweetnesses, beauties and courtesies with which your noble body is replete are constantly before his eyes or in his thoughts; therein they obstinately remain and for this reason he is constantly reopening and aggravating the incurable wound you inflicted upon him in the past, from which he cannot be healed and which leads him to endure and suffer much sorrow and pain – suffering he gladly bears most uncomplainingly and patiently since it comes from you from whom he would rather receive pain and torment than pleasure and joy from any other, because you alone are his succour, his well-being and his nourishment; you are the only medicine which can cure him if you so wish. You hold his life and his death in your hands: do with them as you will, all is yours, body, soul and worldly possessions. There is nothing but the desire to serve you that he retains as his own until death. He does not dare disobey you by visiting you, for it seems to him that you take pleasure in his long estrangement, like one who has more consideration for the increase of his worldly fortune than you have for his poor life, which is dwindling away day by day for lack of your company. Take pity on him by ordering your most obedient subject to come and serve you, keeping him by you like the good, well-proven slave who has never failed in his duty. You know full well that a single glance from your beautiful eyes, with the sweet words at the window which he cannot forget, will cure him and make him forget all his ills, of which he has so many that he cannot suffer more; these could bring about his death, which ought to grieve you when by your own fault you might lose the best you ever possessed. Therefore I clench my hands and beseech you, my sole lady and mistress, that my situation which is so pitiful be restored and swiftly remedied by your feeling lest you long repent it. And, in order to refresh your memory, I am sending you this little book containing pictures and words which are the two ways by which we can enter the house of memory, since pictures are for the eye and words for the ear, and both make past things seem as if they were present. And thus, since by means of these two things we can make present

what is absent, and since in the course of the long period of waiting of which you are the cause, your good servant had somewhat lost track of this noblest memory, may these pictures and words put him back on the path so surely that he might never leave it again.

Art and Monarchy in France

3.4.1
The tomb of Louis XI

Documentation concerning the design of the tomb of Louis XI (d. 1483) is unusually extensive for a royal monument during this period. It is reasonably clear that the king himself took an unusual interest in it. The first document shows that two of the leading artists of the period were approached in 1474 to make designs for the monument, though what they envisaged seems to have been rejected. The sculptor Michel Colombe, whose workshop subsequently executed many royal projects, such as the tomb of the parents of Queen Anne of Brittany at Nantes, made a small model of his design, while the leading painter and illuminator Jean Fouquet was paid for making a drawing of it. From the document it is not entirely clear whether the designs of these two artists were independent of each other, or whether Fouquet perhaps made the initial design, which was worked up into a three-dimensional model by Colombe, just as later tombs carved by Colombe and his assistants are known to have been based on designs by another royal painter, Jean Perréal.

The second document shows that another leading painter and illuminator, Colin d'Amiens, was charged in 1481 with making a further set of designs for the statue of the king that was intended to form the upper part of the king's tomb at Cléry and cast in bronze. The instructions sent to Colin by Jean Bourré – the king's agent and a leading patron in his own right – were illustrated by a drawing by an unknown artist, presumably to ensure that Colin fully understood what was required. Various additional comments added to the sheet suggest clarifications to the proposal, possibly stemming from the king's own views. All these instructions may have been necessary because what the king envisaged was unprecedented for the tomb of a monarch in France. Instead of a recumbent effigy the king was to be shown kneeling, as though in prayer, and depicted in the dress of a hunter, rather than in the traditional royal attire. The monument was destroyed during the religious wars of the sixteenth century. [TT]

Source: (a) F. Avril (ed.) (2003), *Jean Fouquet. peintre et enlumineur du XVe siècle* (Paris: Bibliothèque national de France/Hazan), p. 420, no.10; (b) Charles Sterling (1990), *La peinture médievale à Paris*, II (Paris: Bibliothèque des Arts), p. 92. Translated from the French by Isabelle Dolezalek and Thomas Tolley. Copyright © The Open University 2007.

a) Payments for Designs to Fouquet and Michel Colombe (1474)

To Michau [*sic*] Colombe, carver of images, and [to] Jehan Fouquet, painter at Tours, 22 pounds *tournois* [i.e. in the currency of Tours]: that is to say, 13 pounds and 15 sous [shillings] to the said Colombe, for having sculpted in stone a small model of a tomb, made on the orders of the king, together with his portrait and likeness, so that the king may form an opinion of the tomb that he is going to order to be made for his final resting place; and also to the said Fouquet 8 pounds and 5 sous for having designed and painted another model on parchment for the same purpose.

b) Instructions given to Colin d'Amiens (1481)

Master Colin d'Amiens, you are required to make a portrait of the king our lord. It should be noted that he must be [depicted] kneeling on a square block as shown below, with his dog beside him, his hat clasped between his joined hands, his sword at his side, his horn hanging from his shoulders on his back, both ends showing; and with boots, not of little value, in the most respectable manner possible; [the king must be] dressed like a hunter, with the most handsome of faces, youthful and broad, that you can manage; with a slightly longish and high-set nose, as you are aware. And don't make him bald!

[Below the drawing, probably written by another hand:] the nose aquiline. The hair longer behind. The collar slightly lower. The insignia longer and lower: a well-made [image of] Saint Michael. *Item*, the horn put on like a sash. The sword shorter and as in a display of arms. *Item*, the thumbs bigger: the hat well turned over.

3.4.2
Bourdichon: 'Painter to the King'

This selection of documents recording payments made to Bourdichon around 1480 enable us to reconstruct something of the painter's activities for Louis XI, probably his first royal patron. As well as illumination, Bourdichon (d. 1520) was required to satisfy the king's desire for objects relating to his

devotional interests by painting a tabernacle housing a revered image of the Madonna and also a group representing St Martin (patron saint of Tours) and the beggar.

The sums paid to Bourdichon for this and related work, however, pale into insignificance in comparison with what Queen Anne of Brittany agreed to pay him for her book of hours. This manuscript is among the most lavishly illuminated books of the period. It is clear from the document and from the surviving illuminations that Bourdichon went to considerable trouble to please the queen, in terms of the variety and ingenuity of the decoration, and also by providing a suitable visual focus for her devotional enthusiasms. The sum appears to have been so excessive that the artist only received payment years later, after the accession of Francis I, the fourth monarch to employ him in the capacity as 'king's painter'.

The third extract provides an important insight into the devotional atmosphere at the French court in the decades around 1500, and Bourdichon's role within this. Francis of Paola, the Calabrian hermit, had first come to France at the request of Louis XI and became a much-revered figure at the French court. The document explains how Bourdichon knew Francis and how he made a likeness of the saint on more than one occasion. Reproducing the saint's features as accurately as possible was evidently considered a priority, presumably because such images were expected to play an important role in propagating the saint's cult. [TT]

Source: (a) David MacGibbon (1933), *Jean Bourdichon: A Court Painter of the Fifteenth Century* (Glasgow), pp. 135–6; (b) ibid., pp. 50–1; (c) R. Fiot (1961), 'Jean Bourdichon et Saint François de Paule', *Mémoires de la Société archéologique de Touraine*, LV, pp. 108–12. Translated from the French by Isabelle Dolezalek and Thomas Tolley. Copyright © The Open University 2007.

a) Accounts of Payments to Bourdichon for Decorations in the King's Chapel at Plessis (1478–81)

To Jehan Bourdichon, painter, the sum of 20 pounds, 17 shillings and 1 penny in the currency of Tours, for having painted the tabernacle made for the chapel of Plessis du Parc with fine gold and azure.

To Jehan Bourdichon, painter and illuminator, resident in Tours, the sum of 81 pounds, 12 shillings and 6 pence in the currency of Tours, ordered [to be paid] to him in the said month of March 1478. That is: for six sheets of fine gold for burnishing to use for the embellishment of a wooden tabernacle,

which the said lord [the king] had had set up in the chapel of Plessis du Parc and which houses an ancient image of Our Lady that the said lord had brought near him for his devotion; the sum of 45 pounds of Tours.

Item, to reward his and his fellow craftsman's efforts, both of whom have laboured on the tabernacle and occupied themselves for 15 whole days: for having gilded and embellished it, 25 pounds in the currency of Tours.

For having painted in green the side, the wings and the back; the sum of 64 shillings and 2 pence in the currency of Tours.

For the purchase of burnished gold and the provisions made of colours and other necessary materials 40 shillings in the currency of Tours.

For all this, with reference to the said decree of the king and as payment to the said Bourdichon, written on the last day of March 1478, is herewith given the sum of 24 pounds, 12 shillings, and 6 pence in the currency of Tours.

To Jaquet François, image maker, and Jehan Bourdichon, painter and illuminator, the sum of 109 pounds, 1 shilling and 8 pence in the currency of Tours, promised them for the said following month of April [1478], in 18 *écus d'or* [gold coins]. That is: to the said Jaquet for a wooden sculpture of *Our Lord Saint Martin on horseback with the pauper*, which he made and delivered on the orders of the said lord to be put in the chapel of Plessis du Parc: 18 *écus d'or*. To the said Bourdichon for having decorated and painted the said Saint Martin, the horse and the pauper, with fine ground gold and azure and other precious colours; 20 *écus d'or*. Also, to the said Bourdichon, for having arranged the writing on parchment of a book called *The Papalist*, and having illuminated the latter with gold and azure and made nineteen magnificent pictures in it and for having it bound and covered: 30 *écus d'or*. For all this, with reference to the said order of the King and as a payment to the abovementioned, written on the 5th of April after Easter 1480, is herewith given the sum of 109 pounds, 1 shilling, 8 pence in the currency of Tours.

To Jehan Bourdichon [. . .] the sum of 24 pounds, 1 shilling, 3 pence in the currency of Tours, in 15 *écus d'or*, each coin [worth] 32 shillings and 1 penny in the currency of Tours, promised him by the said [lord the king] in the said month of April 1480, for having written and painted in azure 50 large scrolls, which the said lord had placed in several places in Plessis du Parc and on which is written: *Misericordias domini in aeternum cantabo* ['I will sing the mercies of the Lord forever']. And for having painted and depicted with gold, azure and other colours, three angels, about 3 feet high, each of whom carry in their hands one of the said scrolls inscribed with the said *Misericordia*. For all this, with reference to the said order of the king and as a payment of the said Bourdichon, written on the 21st April 1480 before Easter.

b) Original Mandate for Payment to Bourdichon for the Hours of Anne of Brittany (1507)

Anne, Queen of France through the grace of God and Duchess of Brittany, presents greetings and affection to our beloved and faithful councillor and general treasurer of our finances, Master Raoul Hurault. We wish and authorize that, out of the funds and revenue of our dower for the present year, which began on the first day of October recently passed, you shall pay, deliver and hand over to our dear and well-loved Jehan Bourdichon, painter and *valet de chambre* of our lord [the king], the sum of 1050 pounds in the currency of Tours in 600 *écus d'or* [gold coins], to him we are obliged and entrust it. Herewith we oblige and entrust, both to recompense him for the large Book of Hours for our own use and service that he has richly and sumptuously historiated and illuminated for us – in which he has invested and taken up much time – as well as in return for other services that he previously undertook for us. And with regard to the above-mentioned, signed by our own hand with the payment to the said Bourdichon, which is intended for this purpose only, we wish the said sum of 1050 pounds of Tours to be allocated to your accounts by your receiving a [corresponding] withdrawal from our beloved and faithful people of the accounts of my above-said lord, in Paris, without hindrance, because such is our pleasure.

Issued at Blois on the 14th day of March, in the year of grace 1507 by the Queen and Duchess Anne.

G. de Forestz

c) Bourdichon's Evidence at the Enquiry into the Canonization of Francis of Paola (1513)

Here follows the testimony of the first witness:

That of the honourable man Jean Bourdichon, Painter to Our Lord the King, member of the [royal] household and citizen of Tours, aged about 56 years.

The witness, present before the notary Master Jacques Tillier together with us, Pierre Cruchet and Pierre Chabrion, has been received by us, the commissaries and above-mentioned representatives, was sworn in on the Holy Gospels of God, [which was] laid down before us and for this reason touched by the witness. He was thereafter questioned in the city of Tours, on the 19th day of June in the year of the Lord 1513, about the life, reputation and the

miracles of the late brother François of Paula, formerly General of the Order of the Minims.

He states that he had known him by sight and in conversation. This is now about 15 years ago. But he saw him at the time when he arrived in the kingdom of France and from that time onward he always heard that the same had a very praiseworthy reputation and that he led a solitary life. [. . .]

He states further that in the said time of 12 years he saw the said brother François of Paula on several occasions in his convent of the Order of the Minims near Plessis du Parc and near this city of Tours.

He also states that the life of the same brother François expired on a Good Friday, the year of which, however, he cannot recall. After his death, the witness giving evidence came to the said convent of the Minims and saw the lifeless body of the deceased brother François. And he made a cast (or took an impression) so as to paint a likeness of his face directly from the body. And he also participated in the funeral of the same deceased. [. . .]

He then states that [. . .] it was decided by the brothers of the said convent [. . .] that the said body be extracted from the ground where it was put to rest, and be lifted up into a coffin made of stone [. . .], which was done 10 or 12 days after his burial. And the above-mentioned witness was present [. . .] and saw the face of the said deceased, those 10 or 12 days already having gone by, so healthy, so preserved and uncorrupted, just as it was at the time when the body was first buried; and it did not smell. And he knows this, having examined it for a specific purpose, because he came so close to the face of the said deceased that they were actually face to face: and [because of this experience] he believes that all this proceeded miraculously.

In addition to this he states that he cast (or impressed) the face of the said deceased once more, so that he might then paint it more accurately and better. [. . .] And this is his [true] statement, only inconsequential details having been omitted.

3.4.3
Jean Robertet's poem about the worst painter in the world

Jean Robertet (died c.1502) was a leading official at the court of Louis XI and, that of the dukes of Bourbon. He and other members of his family took an unusual interest in the visual arts, and often refer to them in their writings.

At the time this poem was written the painters mentioned in it – Rogier van der Weyden, Pietro Perugino and the painters of 'the late king of Sicily' (King René of Anjou), like Barthélemy d'Eyck, Coppin Delf and Georges Trubert – enjoyed considerable reputations. Paintings from the workshops of Rogier and Perugino, for example, featured in royal collections in France, and Coppin Delf entered French royal service after the death of King René.

The poem may be read as a joke at the expense of a typical image-maker practising in France during the period. His productions are routine and hardly merit comparison with these leading artists, but the poet mocks his aspirations by doing exactly this. Despite an impossibly long apprenticeship, the range of experience of Robertet's invented artist is limited and rather demeaning. Saint-Lo is hardly among the most prestigious artistic centres in France, and inn signs are likely to have ranked well below either ordinary devotional images, or paintings for the aristocracy. His pigments are cheap and it appears that he never learned how to use them properly. The crux of the mockery hinges on the term 'masterpiece'. For many ordinary craftsmen, like the unnamed artist of the poem, 'masterpiece' signified a work that demonstrated the competency of a craftsman on completion of his apprenticeship. But for those like Robertet, a masterpiece had assumed a new meaning – closer to the one employed today – denoting a matchless creation of considerable originality. In juxtaposing these two attitudes towards the visual arts, the poet leaves the reader in no doubt that the named artists offered viewers the more rewarding experience. [TT]

Source: C. M. Zsuppán (ed.) (1970), *Jean Robertet: Oeuvres* (Geneva: Librairie Droz), pp. 185–6, no. XXI. Translated from the French by Isabelle Dolezalek and Thomas Tolley.

On a bad painting, made with poor colours, by the worst painter in the world, [composed] by Master Jehan Robertet, with tongue in cheek

> One could hardly compare the achievements of Master Rogier,
> Nor those of Perugino, that great artist,
> Nor those of the painters of the late king of Sicily,
> To the absolute masterpiece you see before you.
> But it seems that he's no bungler,
> Our artist; he's a man of genuine ability.
> His perspective may be defective,
> And modelling a sweet face may be beyond him;

But he told me himself that it is the custom in Saint-Lo
To make them just like this for the inns,
And that he was an apprentice in his profession
No less than thirty-six years – without holidays.

3.4.4
Henri Baude: 'Moral Sayings for Making Tapestries'

The poems (*dictz*) translated below are selected from a series that seems to have been conceived as an elaborate programme for the subject-matter of tapestries. Fragments of tapestries relating to the series have been identified, sections are known in various painted media, but the best visual form is a series of drawings in three manuscripts, the most artistically skilful of which is associated with the Robertet family. Baude was an official in service to the duke of Bourbon at Moulins and died shortly after 1496. The poems take the form of a dialogue and contain many allusions that are hard to convey in modern translation. Most of them are proverbial in character, and offer commentaries on the social and political framework of life in France at the time of Louis XI and Charles VIII, often with an allegorical or moral dimension. Baude uses animals to highlight human foibles or aspirations, and his tone frequently appears to mock those in positions of authority.

The audience for such poems, and presumably the works of art they were written to inspire, was certainly lay, and probably aristocratic. Designs for earlier tapestries had generally illustrated narratives of clear, identifiable subjects. By contrast the subject-matter in this programme is intentionally much more poetic and undefined in spirit, presenting and juxtaposing a wide range of images that draw on many literary traditions as well as on common parlance. An effort seems to have been made to persuade the audience to think about social issues, which artists in France had previously only addressed on rare occasions. [TT]

Source: J.-L. Lemaître (1988), *Henri Baude: Dictz moraulx pout faire tapisserie. Dessins du Musée Condé et de la Bibliothèque nationale* (Paris: Musée du pays d'Ussel), pp. 40, 42, 51, 54. Translated from the French by Isabelle Dolezalek and Thomas Tolley. Copyright © The Open University 2007.

XV

The Three Estates
You, who occupy the highest rung of society,
Who bring confusion at court
And dictate policy,
Enhance your reputation, for your own ends.

The Gentry
You ask for justice and understanding
But don't expect them,
Since we're so well blindfolded,
By God, that we cannot see at all.

XXI

The Donkey:
Clear off and graze elsewhere,
You senseless animals,
Out of the compound of this dwelling
Which is reserved for those showing deference.

The Animals:
If here we find favour,
This is because we hold our tongues
And in all things find ourselves compliant
With the wishes of the gentry.

The Fox:
Since donkeys aspire to be governors,
And beasts pretend understanding,
The fox can gobble up many a goose
In the shade of all this affectation

XLII

A chandelier which has one candle lit;
Around which moths circle
And burn their wings;

And there are two men of which the first says:
Everyone wants to climb without a ladder
Up to the light because of its radiance,
Just like the moth
That plummets after burning the tips of its wings.

The Candle:
They all come without my asking them,
And I burn those attracted to me;
The wise, however, will flee from me:
Such is the way of the court.

The Other Man:
They take the side of the well-off,
They flatter whoever's the centre of attention,
They do whatever to lead
The moth to the candle.

XLV

A man striking a sleeping dog with a stick:
Master Canis, you sleep too much
And sleeping's not in your nature.

The dog:
If I'm sleeping it shouldn't displease you;
You are wrong to rouse me.

Someone else:
People like this who wake up sleeping dogs
Would do much better just to shut up:
When it's sleeping it can't do any harm,
But when it's not asleep it bites.

3.4.5
Jean Lemaire de Belges

Jean Lemaire de Belges was a leading poet and historiographer active at the courts of France and the Netherlands in the early sixteenth century. Much of

his writing shows an interest in the mechanics of artistic production that few in his position had previously considered worthwhile or of value. He claims to have executed some works in painting himself, a clear indication of his fascination with artistic processes. He also made a point of knowing not only about contemporary artists who enjoyed extensive reputations across western Europe, but also artists from the past. He betrays an unusual early concern with viewing the visual arts in terms of their historical development, which is rare outside of Italy. It seems that much of his knowledge of artistic matters may have been encouraged through his friendship with Jean Perréal, to which several of his writings testify.

The extracts here are taken from two long poems written as extended laments on the deaths of important patrons. In *La plainte du Désiré*, which commemorates the Count of Ligny, Lemaire introduces personifications of Painting and Rhetoric, who provide alternative discourses on which is best suited to representing the mourning of their mistress, Nature. Painting lists some of the most remarkable artists of the recent past and present who are well qualified to depict Nature. Another, more extended list of celebrated artists features in *La Couronne Margaritique*, written for Margaret of Austria in commemoration of her husband, Philibert, Duke of Savoy. In this poem Lemaire lists artists who might be required to create an allegorical crown, so goldsmiths assume a more important role. The second passage presented below is taken from another section of this poem, which describes the workshop of the painter Martia, who designs the crown. Although Martia and many of the other characters mentioned in the poem are essentially fictional, the items described are evidently based on first-hand knowledge of the appearance and organization of real workshops. That such material could form part of the subject-matter of a major poem indicates how courtly audiences were beginning to take more interest in artistic practices. Previously, royal and aristocratic audiences had often been reluctant to engage with such material, probably because of old prejudices concerning the manual nature of the visual arts. Margaret of Austria, who had received some training as an artist herself, perhaps encouraged Lemaire to present the visual arts in a more positive light. [TT]

Source: (a) D. Yabsley (ed.) (1932), *Jean Lemaire de Belges: La Plainte du Désiré* (Paris), pp. 71–2, nos XV–XVI; (b) J. A. Stecher (ed.) (1891), *Oeuvres completes de Jean Lemaire de Belges*, 4 vols (Paris), IV, pp. 158–9. Translated from the French by Isabelle Dolezalek and Thomas Tolley. Copyright © The Open University 2007.

a) An Account of Famous Painters from *La plainte du Désiré* (1503–4)

And though I have neither Parrhasius nor Apelles,
Whose fame since ancient times still resonates,
I have some new and original talents here,
Esteemed more highly because of their fine brushwork
Than even [Simon] Marmion, once active in Valenciennes,
Or than Fouquet, who attained such glories,
Or even Poyer, Rogier [van der Weyden], Hugo of Ghent [van der Goes],
Or Johannes [van Eyck], who was so refined.

So get to work, then, my contemporary luminaries,
My handsome children nourished at my breast:
You, Leonardo [da Vinci], with your supreme grace;
Gentle Bellini, whose praise is eternal;
And Perugino, who mixes colours so well:
And you, Jean Hay, are you resting your noble hand?
Come and see Nature with Jean [Perréal] de Paris
To give her shading and feeling.

b) A Description of a Painter's Workshop from *La Couronne Margaritique* (1504–5)

Their workshop is brimming full with pictures,
Some painted, some still to be finished, and with many special utensils.
There are charcoals, [chalk or wax] crayons, pens, hair pencils,
Heaps of brushes, piles of [mussel] shells [for mixing colours],
Silver-point styluses, for drawing most delicately,
Polished marbles, as glossy as Beryl,
India, green azure, Polish azure,
Ultramarine, that risks nothing from fire,
And vermilion, which fills several containers.

And there are other pigments in abundance:
Lake, sinopia and purple of high value;
Powdered gold, mosaic gold, orpiment [yellow];
Flesh colour, well and properly made:
Ochre of Ruth, lead yellow, verdigris,
Mountain green, and Paris pink,

Good lead white, colour from madder,
With shiny varnish in two or three casks
And black from lamps, truly the blackest.

3.4.6
Jean Perréal de Paris: painter and poet

Perréal (active c.1480 to c.1530) was one of the leading painters and designers of artistic projects in France in the later fifteenth and early sixteenth centuries. He is mentioned in several literary sources of this period and was especially commended for the striking naturalism of his art. This prompted contemporaries to compare him with Apelles, know as one of the most life-like artists of antiquity. Queen Anne of Brittany employed Perréal to design the tomb of her parents at Nantes, which was executed by the sculptor Michel Colombe (see 3.4.1 and 3.4.7). Perhaps as a result of the success of this commission, and because of his friendship with the poet and historiographer Jean Lemaire de Belges (see 3.4.5), Perréal became involved in work on the Augustinian monastery at Brou in eastern France, commissioned by Margaret of Austria, widow of Philibert, Duke of Savoy, and Lemaire's patron at this time. Perréal was asked to design the deceased duke's tomb. A series of surviving letters (one of which is translated below), document the progress of this venture and provide a rare insight into the complexities of realizing an elaborate sculptural project. Perréal was primarily concerned with procuring what he considered were the most fitting kinds of stone for carving the tomb. Margaret eventually dismissed him, in part because he showed insufficient concern over the cost of his plans.

Soon after the accession of Francis I, Perréal presented the new king with a manuscript describing in verse how Nature (personified) reprimanded an erring alchemist for failing to follow her principles. In the prologue to his poem (translated below) Perréal's name appears in the form of an acrostic signature. Such wordy devices were used by the artist on other occasions and show him to have relished his expertise in the literary arts. In turning his creative energies to the writing of poetry, Perréal probably hoped to lend dignity to his status by showing his abilities in an art form that was often considered of superior intellectual value to the visual arts. The acrostic signature originally appeared opposite a miniature evidently by Perréal himself, depicting Nature appearing to the alchemist standing outside his laboratory. This illumination may be considered the most securely documented of all Perréal's surviving paintings and has been used as the starting-

point for further attributions to the artist. It is clear that the principles Perréal advocates in his poem on alchemy, especially concerning the value of imitating nature, were ones that he also espoused as a practising artist. [TT]

Source: (a) M. Pradel (1964), 'Les autographes de Jean Perréal', *Bibliothèque de l'École de chartes*, vol. 121, pp. 175–7, no. IV; (b) A. Vernet (1943), 'Jean Perréal, poète et alchimiste', *Bibliothèque d'Humanisme et Renaissance*, III, p. 247. Translated from the French by Isabelle Dolezalek and Thomas Tolley. Copyright © The Open University 2007.

a) A Letter to Margaret of Austria (4 January 1511)

Madame, entirely and most humbly may I recommend myself to your good grace.

Madame, with all my heart I wish to thank you for the letters you wrote me and from which I completely understand your excellent desire and the aim and honour for which you strive. And I also know, from the letters of my lord Master Loys and [those of] of Master Jehan Lemaire, of the doubt you have concerning the alabaster and its expense.

Madame, regarding the alabaster, it is beautiful and white, of large uncontaminated blocks, and the whitest that I saw for a long time, hence its great value. But it is not hard, and the material is good, since it has been recently extracted and, in its quarry, it was kept in damp conditions which kept it soft; but it gets harder with time.

Madame, my said lord Master Loys wrote, asking me to inform him at length of the worth and quality, which I have done, and you shall understand what I say of it and truly know, if you kindly read the whole letter. Also, he will go to Dijon, as he wrote me, and there he can enquire about the stone as well as the cost. And as you said, it would be a shame to waste money for a sumptuous work if the material is not good.

Madame, I would advise you to have the work done in marble rather than anything else and, if you please, understand the reasons for which I say this from the letters of the said Master Loys.

Madame, I have shown Master Loys the model I made for the tomb of the Duke of Brittany. I have given him a written estimate of the cost and how we have laboured on it and you can do the same, if only you wait a while. With regards to the cost, please refer to what I have written about it in the said letters, and you will see my true intention, and be not suspicious because I am yours as well and even better for two shillings a day than someone for one hundred shillings. And I will demonstrate you this every time you will choose to engage me, because I am bound to you through an ancient and noble love, which you cannot understand because I am not present, and if God please

that I may be, at least when one confers about what I know and am able, because I would answer this better than by letter and more assertively in front of you.

Madame, I pray, wait just another year, then you can resolve how your work would be best to fulfil your desires and honour.

Madame, regarding the construction of a roof for the church, I am delighted to employ myself with it and I can draw from all that I have seen in Italy regarding convents, where the world's most beautiful are to be found, and I shall fulfil your wishes without exceeding your will, although the extant lodging is so large and so magnificent that I do not know what will be said besides that the religious are more worthy than God to be sumptuously housed; nevertheless, all will go well and we shall make it small and good, and may it please God that I am the right one to conduct such work.

Madame, regarding the craftsman or master who had come to an arrangement, one can make him earn the little money that he has received for working within his craft upon many things that the unrefined masons do, which is too bad – as I have seen how your arms, standards and other attributes hang on the keystones; it is not their craft and they spoil it all and the said master will do it well making the money he has received worthwhile.

Madame, I beg you to consider well what I have written to Master Loys Barangier about the quality of the alabaster and what I know about it, also regarding the cost; because to speak the truth, I understand that you should be treated as a princess and that the work should pass through the hands of great craftsmen. I have addressed the whole at length in writing. May God favour he who you favour, I do not care for any others.

Madame, I pray to our Lord to give you a good and long life and the fulfilment of your desires. Written in Lyon, this 4th day of January.

From your
Very humble and obedient servant, Jehan Perréal of Paris, your *valet de chambre* and unworthy painter.

b) Acrostic Verse Prologue from the *Complainte de Nature à l'alchimiste errant* (1515)

It happened one day that Nature,
Eagerly disputing with an alchemist,
Harshly exclaimed: 'Creature,
Abandon you the fruit for flowers, but why?
Never do you feel rueful of your folly?

Part with your falsehood, for the sake of God,
Entertain the thought of your mistake.
Reason requests thus and Truth
Relent and side with subtlety
Espy well my book and lay trust in it
Any other course shall be your poverty.
Leave everything, take up philosophy.
On this, I assure you –
For Ethereal am I, so believe me –
Persons exist not to verify its
Authorship other than I.
Reality allows for nothing to have ever seen it
I have made it for you to receive
Should you understand it well, much wisdom will you retrieve.'

3.4.7
Michel Colombe's contract for a tomb project at Brou

Michel Colombe (d. 1512), the brother of celebrated manuscript illuminator Jean Colombe, was recognized as the head of the most distinguished workshop of sculptors active in France in the later fifteenth and early sixteenth centuries. He was invited to submit a proposal for the tomb of Louis XI (see 3.4.1) and had collaborated with Perréal on the tomb of the parents of Queen Anne of Brittany at Nantes, a work that is mentioned, with evident satisfaction, in this document.

The present contract, drawn up by Jean Lemaire de Belges, acting as Margaret of Austria's agent, concerns the tomb of her former husband, Duke Philibert de Savoy (d. 1504), and is primarily to do with negotiating and agreeing the form and materials of the tomb with the patron, Margaret of Austria. She was to be furnished with a convincing scaled model of the design, simulating the materials, so that she could see how spectacular and appropriate the final monument would look. While acknowledging that he was too old to carve the actual tomb himself (something that the contract reveals was to be left to his nephews), Colombe did go out of his way to carve an image of St Margaret's face as a gift to the patron using the particular alabaster that his collaborator, Perréal, recommended. This was evidently a ploy to convince Margaret that this was the right material to use. In fact Colombe died not long

after the contract was drawn up, and political events of 1512 encouraged Margaret to turn away from her French connections and appoint German and Netherlandish artists instead. It seems likely, however, that many elements of Perréal's designs were retained in the tomb in the form in which it was eventually realized. The references to 'Master *Claux*' (either Claus Sluter or Claus de Werve) and Master *Anthoniet* (Antoine le Moiturier), 'sculptors of the first rank', show how earlier generations of notable sculptors remained well known and much respected in the circles in which Lemaire moved. [TT]

Source: adapted from the text in Wolfgang Stechow (1966), *Northern Renaissance Art, 1400–1500: Sources and Documents* (Englewood Cliffs, NJ: Prentice-Hall), pp. 147–50. Reprinted by permission of Northwestern University Press.

And for this tomb, I [. . .] shall make with my own hand, without anybody else but myself touching it, the terracotta models, in the size and extension indicated in the two sketches I am sending to my said lady, one a ground plan showing the *gisant*, the other an elevation, said drawings having been made by the hand of the aforesaid François Coulombe, illuminator, and Bastyen François, mason, my nephews. And said Bastyen shall make of hard stone the entire masonry used in said small-scale tomb in correct proportions and measurements, in such a way that by converting [in her mind] the small scale to the large, Madame will be able to see the whole tomb of the said late Seigneur of Savoy, within the period before Easter, provided no trouble or accident befalls said Coulombe during that time; and of these models I faithfully promise, with the help of God, to make a masterpiece according to the possibilities of my art and skill.

In addition [. . .] [I] testify that the sculptor Guillaume Regnault, my nephew, is able and experienced enough to execute in large scale the carving of the figures used in said tomb, following my models; for he has served and aided me in such matters during 40 years or so, in all large, small, and medium-sized undertakings which [. . .] I have had in mind up to now [. . .] Specifically, he has served and aided me very well in the latest work I have finished – that is, the tomb of Duke François of Brittany, father of the queen, of which tomb I am sending Madam a sketch [. . .]

After these models have been finished [. . .] and covered with white and black colour, as required by the nature of the marble [. . .] and after the tablet of gilt bronze and the borders, ermine-coated arms, flesh tones of faces and hands, inscriptions, and all other pertinent materials have been furnished wherever required, I [. . .] promise to have [Regnault and Bastyen] take said small-scale tomb to Madame [. . .]

[...] Lemaire has brought us a piece of alabaster from Saint-Lothain-lès-Poligny, in the county of Burgundy, where he has recently discovered a quarry [...] As we have learned on reliable authority, this was once held in great repute and esteem; and at the Carthusians at Dijon, several of the tombs of the late noble dukes of Burgundy have been made from stone quarried there, particularly by Master *Claux* and Master *Anthoniet*, sculptors of the first rank [...] And at the request of [...] Lemaire, I have carved, with my own hand, a face of St Margaret [...] Of this I am making a small present to my said lady and pray that she be pleased to receive it graciously.

3.4.8
The travel journal of Antonio de Beatis

The descriptions translated below are extracts from a journal recording the tour of northern Europe made by Luigi, Cardinal of Aragon, in 1517 to 1518. The journal's author was Antonio de Beatis, who as the Cardinal's secretary accompanied him on his journey. De Beatis had a good eye and descriptive powers. Since much of what they saw is now lost, the account is extremely valuable. Only a fragment of the château at Gaillon now survives, but de Beatis provides a description of this important residence dating not long after most of the work had been completed. Commissioned by Guillaume d'Amboise (d. 1510), Cardinal of Rouen and chief minister to Louis XII, Gaillon was designed as one of the most spectacular country residences then to be seen in France, in which Italian painting and sculpture, French craftsmanship and technical expertise, and the most magnificent Netherlandish tapestries were brought together.

The visit to the shrine of St Francis of Paola at Plessis is a valuable record of how this saint's cult, which was actively propagated at the French court, was promoted by the display of authentic portraits (see 3.4.2) and the sale of prints based on them, one of which was included in the journal in its final form. The visit to Leonardo da Vinci at Amboise is a unique record of what this artist was doing after he settled in France at the request of Francis I. The account indicates that the king did not expect any particular works of the artist but was happy to allow Leonardo to pursue whatever interests he wished. Such freedom seems rarely to have been granted to other artists in royal service.

The visit to Blois draws particular attention to the royal library. This had been greatly expanded under Louis XII, who brought together collections formed by his ancestors, the dukes of Orléans, with important bibliographical acquisitions originally assembled by the dukes of Milan, by Louis de Gruuthuse (a major Netherlandish patron of illuminated manuscripts), and by others. What is intriguing is how the selection of books to be shown to visitors seems to have been made on the basis not of their literary aspects but of their visual merits (especially illumination), emphasizing variety, presumably so that viewers might appreciate the distinctions between Greek, Netherlandish, Italian and French styles. [TT]

Source: adapted from J. R. Hale (ed.) (1979), *The Travel Journal of Antonio de Beatis: Germany, Switzerland, the Low Countries, France and Italy, 1517–1518*, trans J. R. Hale and J. M. A. Lindon (London: The Hakluyt Society), pp. 113–14; 131–5. Reprinted by permission of The Hakluyt Society.

a) A Description of the Château at Gaillon

In the middle of the garden is a very beautiful fountain with marble urns chased with figures and a *putto* on top; water is thrown very high from a number of sources. It is enclosed in a large pavilion of carved wood, very richly decorated in pure azure and gold. It has eight sides, each terminating in a half-dome, and is very spacious and magnificent. Inside the garden, opposite the park entrance, is a building, also octagonal, of wood filled in with bricks. It is skilfully painted and decorated in azure and gold with eight windows, one in each façade, which are filled with very lovely glass. It is roofed like the pavilion and as, indeed, the palace is. The lodge is used for sleeping in the middle of the day in summer. In each quarter of the garden are a few trees, but mostly shrubs, rosemary and box. These are worked into a thousand whimsical shapes: men and horses, ships and a variety of birds and animals; in one quarter the royal arms and some antique lettering is laid out most cunningly in a number of varieties of small plants.

From the garden you pass on to the lawn and thence (via a drawbridge), as I have said, into the courtyard in the middle of the palace. This forms a large square, and the courtyard in the middle is also spacious; all that shows, both inside and out, is of excellently worked stone. And the stone mouldings of windows and doors all have heads modelled after ancient marbles, and these are over the doors and on the façades facing the courtyard, which has in the

middle a sumptuous marble fountain with huge pillars, each made of one piece and carved with many beautiful figures; its jet throws very high.

In the palace itself, which is made into a fortress by a wide moat that surrounds it, are a vast number of rooms, and two most elegant loggias, one above the other, on the same side as the perspective described above, which are tall and airy, with their lofty marble columns. In one of them are effigies from the life of King Charles, King Louis and his queen, Monseigneur de Rouen, of the Princess of Bisignano, and of a number of other French lords and ladies, all in coloured relief, though whether of wood or stone I do not know. There is also a beautiful chapel, suited in size to the palace, containing stone sculptures round its inner walls, made as in the life, of all the lords of the house of Amboise, to which the aforesaid Monsignor de Rouen belonged. The ceilings of the public apartments and the bedrooms and dressing rooms are, in their different ways, carried out very richly and with a high degree of craftsmanship. One, where my Lord stayed for a night on the invitation of the Archbishop of Rouen (nephew of the aforesaid Cardinal) after the king had left, was of oak carved in arrowhead vaults and the whole of the walls were panelled in the same wood so elaborately that though the room was not large it cost 12,000 francs. To complete their furnishings every single one of the public rooms is hung with the finest tapestries and the bedrooms with velvet, cut velvet, damask or brocade, with bed hangings to match. The windows are so numerous and so beautifully figured that they cost 12,000 *écus*. We saw, too quite a fine library with books bearing the arms of Aragon that had belonged to the late King Ferdinand the First, sold in France in her extreme need by the most unfortunate queen, wife of King Frederick of sainted memory.

The palace is as fine and beautiful as any I have seen, especially from without with its carved stone, brass ornamentation and series of roofs, and being built, as I have said, on a hill, much of which had to be cut away, cost 700,000 francs according to the opinion of authoritative Frenchmen; to anyone who has seen it this will not seem impossible. All the same, it cannot be denied that both the rooms and the façades looking on to the courtyard have been poorly designed [. . .]

b) Descriptions of Visits to Plessis, Amboise and Blois

[. . .] near [Tours] we had to ferry across the river Loire [. . .] in order to see the body of the Blessed Francis of Paula of Calabria, called 'The Good Man' and deeply revered by all Frenchmen. He rests in a church called after

him, which is near the park of the Most Christian King. [. . .] We saw the pallet and stone on which he died, and also, on panel, the Good Man's portrait from life. He had a great white beard, was very thin and had a grave and most pious countenance, as may be partially appreciated from the print placed and fastened here.

[. . .] [Amboise] lies in the plain, but it has a castle on a knoll which, if not a fortress, has comfortable apartments and a delightful prospect. Here King Charles [VIII], who was at Naples, loved to reside, as his father, King Louis [XI], loved Tours, and King Louis [XII] his successor, Blois. Our master went with the rest of us to one of the suburbs to see Messer Leonardo da Vinci of Florence, an old man of more than 70, the most outstanding painter of our day. He showed the Cardinal three pictures, one of a certain Florentine woman portrayed from life at the request of the late Magnificent Giuliano de' Medici, another of the young St John the Baptist as a young man, and one of the Madonna and Child set in the lap of St Anne. All three works are quite perfect, though nothing good can now be expected from his brush as he suffers from paralysis in the right hand. He has successfully trained a Milanese pupil, who works extremely well. And although Messer Leonardo cannot colour with his former softness, yet he can still draw and teach. The gentleman has written on anatomy in a manner never yet attempted by anyone else: quite exhaustively, with painted illustrations not only of the limbs but of the muscles, tendons, veins, joints, intestines, and every other feature of the human body, both male and female. We saw this with our own eyes, and indeed he informed us that he has dissected more than thirty corpses, including males and females of all ages. [. . .]

[. . .] [Blois] is in some degree ennobled by having once been the favourite residence of King Louis. [. . .] The castle is not a fortress, but there are some very fine apartments and some delightful facades, internal and external, carved in soft stone. [. . .] In the castle, or rather palace, we saw a library consisting of a sizeable room not only furnished with shelves from end to end but also lined with book-cases from floor to ceiling, and literally packed with books – to say nothing of those put away in chests in an inner room. These books are all of parchment, handwritten in beautiful lettering and bound in silk of various colours, with elaborate locks and clasps of silver gilt. We were shown the *Trionfi* of Petrarch illustrated by a Flemish artist with quite excellent illumination, the *Remedium contra adversam fortunam* [Remedies for Fortune Fair and Foul] also by Messer Francesco [Petrarch], a large-format historiated Book of Hours, the *Mysteries of the Passion* containing Greek painting of great beauty and antiquity, a lavishly-illustrated *Metamorphoses* in both Latin and French, and many other very fine books which

we did not have time to look at. One of those which we did see was bossed at its corners and in the middle with ten large oval cameos of most subtle workmanship. Among these books are many which the arms of the clasps show to have formerly belonged to King Ferdinand I or to Duke Ludovico Sforza: the former bought in France from that most unhappy lady, Queen Isabella, after the death of King Frederick, the latter won during the invasion of the Duchy of Milan. There was also an oil painting from life of a certain lady of Lombardy: a beautiful woman indeed, but less so, in my opinion, than Signora Gulalana. We were also shown a very fine large astrolabe, with the whole universe painted on it, and in one of the two inner rooms there is a most ingenious clock showing many astrological phenomena, signs of the Zodiac and the like.

The palace overlooks three gardens full of fruit-trees and foliage, access to which is by a gallery adorned on either side with real stags' antlers set on imitation stags carved from wood and coloured quite realistically. However, they are built into the wall at a height of about 10 spans, one opposite the other, with only the neck, breast and forelegs showing. There are also many wooden dogs – hounds and greyhounds – set in facing pairs on projecting stones, which are lifelike not only in size and form but also in their coats, and some falcons set in similar fashion on hands which are also built into the wall, dogs and falcons having been the favourites of King Louis. There is also an imitation reindeer with real antlers which extend in branches [. . .]; the rest of the animal has all the features of a stag, except that it is longer and has a great beard under its muzzle. In the garden, to the left of the entrance, is an imitation of a hind with a great pair of horns that came from a real hind which, according to the inscription, was killed by the Marquis de Bau [. . .]

The great garden is completely surrounded by galleries, which are wide and long enough to ride horses down at full gallop. They have fine pergolas resting on wooden trellises [. . .] In the middle is a domed pavilion over a beautiful fountain which supplies the water for those in the other gardens [. . .] All these gardens have been created from barren hillside by a certain Don Pacello, a Neapolitan priest who, because he was such a dedicated gardener, was brought back to France by King Charles when he went to Naples. They contain almost all kinds of fruit to be found in Terra di Lavoro [Campania] [. . .]

The Market in Icons

3.5.1
John of Damascus on images

John of Damascus was a Greek monk writing in a monastery near Jerusalem during the reign of the Byzantine Emperor Leo III. He was vehemently opposed to the destruction of images, which Leo III had ordered in 726. His first treatise on images probably dates from around that time. He went on to write two further treatises on images before his death around 750. The extracts included here are taken from the first and the third of these treatises. The other extracts are from *The Fount of Knowledge*, a huge theological treatise that John of Damascus wrote towards the end of his life. In part II, entitled *Heresies*, he included the Iconoclasts. In the third section – *The Exact Exposition of the Orthodox Faith* – he included a justification of images. Writing during the period of Byzantine Iconoclasm, John of Damascus was concerned to demonstrate that venerating an image was not at all the same thing as idolatry. In defending images, he rehearses arguments that had been used by St Basil and others, and provides valuable insights not only into the controversy over images but also into the way that icons were used. Central to his defence of images is the concept of images making visible the otherwise hidden and invisible world of the spirit just as Christ, as a human being, made God visible. Although obviously he was writing much earlier than the Renaissance, John of Damascus's understanding of icons remained valid, and his arguments in defence of images were rehearsed in the sixteenth-century controversy over images (see section 3.7) [KWW]

Source: St John of Damascus (2003), *Saint John of Damascus: Three Treatises on the Divine Images*, trans. Andrew Louth (New York: St Vladimir's Seminary Press), pp. 26, 31–2, 95–6, 101, 118–19, 132, 157–8; St John of Damascus (1970), *Writings*, trans. Frederic H. Chase Jr (Washington, DC: Catholic University of America Press), pp. 160, 370–3. Used with permission of The Catholic University of America Press, Washington DC.

Treatise I

I say that everywhere we use our senses to produce an image of the Incarnate God himself, and we sanctify the first of the senses (sight being the first of the senses), just as by words hearing is sanctified. For the image is a memorial. What the book does for those who understand letters, the image does for the

illiterate; the word appeals to hearing, the image appeals to sight; it conveys understanding. Therefore God ordered that the ark should be made of acacia wood and gilded within and without, and that the tablets, the rod, the golden jar containing manna should be placed in it as a memorial of what had happened and to prefigure what was to come.

And who will say that these images are not loudly sounding heralds? And these were not placed at the side of the tabernacle, but right in front of the people, so that those who saw them might offer veneration and worship to God who had worked through them. It is clear that they were not worshipping them, but being led by them to recall the wonders they were offering veneration to God who had worked marvels. For images were set up as memorials, and were honored, not as gods, but as leading to a recollection of divine activities. [...]

Treatise III

The Lord blessed his disciples, saying, 'Many kings and prophets longed to see what you see, and they did not see, and to hear what you hear, and they did not hear. Blessed are your eyes, because they see, and your ears, because they hear.' Therefore the apostles saw Christ bodily and what he endured and his miracles and they heard his words; we also long to see and to hear and to be blessed. They saw face to face, since he was present to them bodily; in our case, however, since he is not present bodily, even as we hear his words through books and are sanctified in our hearing and through it we are blessed in our soul, and venerate and honor the books, through which we hear his words, so also through the depiction of images we behold the form of his bodily character and the miracles and all that he endured, and we are sanctified and assured, and we rejoice and are blessed, and we revere and honor and venerate his bodily character. Beholding his bodily form, we also understand the glory of his divinity as powerful. For since we are twofold, fashioned of soul and body, and our soul is not naked but, as it were, covered by a mantle, it is impossible for us to reach what is intelligible apart from what is bodily. Just as therefore through words perceived by the senses we hear with bodily ears and understand what is spiritual, so through bodily vision we come to spiritual contemplation. For this reason Christ assumed body and soul, since human kind consists of body and soul; therefore also baptism is twofold, of water and the Spirit; as well as communion and prayer and psalmody, all of them twofold, bodily and spiritual, and offerings of light and incense. [...]

Firstly, what is an image?

An image is therefore a likeness and pattern and impression of something, showing in itself what is depicted; however, the image is certainly not like the archetype, that is, what is depicted, in every respect – for the image is one thing and what it depicts is another – and certainly a difference is seen between them, since they are not identical. For example, the image of a human being may give expression to the shape of the body, but it does not have the powers of the soul; for it does not live, nor does it think, or give utterance, or feel, or move its members. And a son, although the natural image of a father, has something different from him, for he is son and not father. [. . .]

Secondly, what is the purpose of the image?

Every image makes manifest and demonstrates something hidden. For example, because human beings do not have direct knowledge of what is invisible, since their souls are veiled by bodies, or [knowledge] of future events, or of things distant and removed in space, since they are circumscribed by space and time, the image was devised to guide us to knowledge and to make manifest and open what is hidden, certainly for our profit and well-doing and salvation, so that, as we learn what is hidden from things recorded and noised abroad, we are filled with desire and zeal for what is good, and avoid and hate the opposite, that is, what is evil. [. . .]

We know therefore that the nature of neither God nor angel nor soul nor demon can be seen, but by a certain transformation these beings are beheld, since the divine providence bestows figures and shapes upon beings that are incorporeal and without figure or any bodily shape so that we might be guided to an approximate and partial knowledge of them, lest we remain in complete ignorance of God and the incorporeal creatures.

For God is by nature completely incorporeal; angels and souls and demons, in comparison with the alone incomparable God, are bodily, but in comparison with material bodies are incorporeal. God, therefore, not wishing that we should be completely ignorant of the incorporeal beings, bestowed on them figures and shapes and images that bear some analogy with our nature, bodily shapes seen by the immaterial sight of the intellect, and we depict these beings and give them shapes, just as the cherubim were depicted and given shapes. But Scripture has shapes and images of God, too. [. . .]

St Basil, from his commentary on Isaias:

Since [the devil] saw human kind in the image and likeness of God, not being able himself to betake himself to God, he poured out his wickedness on the image of God. Just as if someone is enraged [against the emperor], he

throws stones at the image, since he cannot touch the emperor, he hits the wood that bears the likeness.

St Athanasius, from the hundred chapters written to Antiochus the ruler in the form of question and answer, chapter 38:

For we faithful people do not venerate images as gods, like the Greeks, not at all, but we declare the relationship only and the longing of our love for the character of the person of the image. Whence frequently, when the character has been smoothed away leaving bare wood, we burn up what was once an image. Therefore, just as Jacob, when he was about to die, 'made veneration, bowing down over the head of his staff,' honoring not the staff, but the one who held the staff, just so, we faithful people do not embrace images in any other way, just as also our children kiss their parents, but that we may declare the longing of our souls. Just as the Jew venerated the tablets of the Law then and the two cherubim of cast gold, not honoring the nature of stone and gold, but the Lord who had ordered these things. [. . .]

The same:

For neither by us are the icons and types of holy figures venerated as gods. For if we venerated as God the wood of the icon, then we would certainly be ready to venerate any other wood, and not, as often happens, burn in the fire the icon of a figure that has worn away. And again, so long as the pieces of wood are bound together in the form of a cross, I venerate the form because of Christ who was crucified on it; but if they are separated from each other, then I throw them away and burn them. And just as one who receives the sealed command of the emperor and kisses the seal does not honor the wax, or the papyrus, or the lead, but assigns the reverence and veneration to the emperor, so also the children of Christians, when they venerate the form of the cross, do not venerate the nature of the wood but, seeing the seal and ring and figure of Christ himself, through him embrace and venerate the one who was crucified on it.

The same:

Therefore I depict and delineate Christ and the sufferings of Christ in churches and houses and marketplaces and on icons and shrouds and reliquaries and clothes and in every place, that seeing these things continually I may remember them and not forget them, as you always forgot the Lord your God. And just as when you venerate the book of the Law, you do not venerate the nature of the parchment or the ink, but the words of the Lord contained in them, so when I venerate the icon of Christ, I do not venerate the nature of the wood or the colors – God forbid! – but, venerating

the lifeless form of Christ, through it I seem to hold and venerate Christ himself. [...]

The Holy Synod that met under Justinian concerning the Holy Fifth Synod:
 In certain paintings of the sacred icons, a lamb is depicted, to which the Forerunner points with his finger, a lamb which is taken, as a figure of grace, prefiguring to us through the Law the true Lamb, Christ our God. While we embrace the ancient figures and shadows handed down in the Church, as symbols and foreshadowings of the truth, we prefer grace and truth, which we receive as the fulfilment of the Law. Since it is what is perfect that is to be depicted for the eyes of all in colored work, we decree that henceforth in icons the Lamb who takes away the sin of the world, Christ our God, is to be presented in his human form instead of as the ancient lamb, so that, coming to understand through his humility the greatness of God the Word, we may be led to a memory of his life in the flesh and his passion and the redemption of the world that consequently came about. [...]

On Heresies – Part 2 of *The Fount of Knowledge*

The *Christianocategori*, or *Accusers of Christians*, are such and are so called, because those Christians who worship one living and true God praised in Trinity they accused of worshiping as gods, after the manner of the Greeks, the venerable images of our Lord Jesus Christ, of our immaculate lady, the holy Mother of God, of the holy angels, and of His saints. They are furthermore called *Iconoclasts*, because they have shown deliberate dishonor to all these same holy and venerable images and have consigned them to be broken up and burnt. Likewise, some of those painted on walls they have scraped off, while others they have obliterated with whitewash and black paint. They are also called *Thymoleontes*, or *Lion-hearted*, because, taking advantage of their authority, they have with great heart given strength to their heresy and with torment and torture visited vengeance upon those who approve of the images. This last name they have also received from their heresiarch. [...]

The Exact Exposition of the Orthodox Faith – Part 3 of *The Fount of Knowledge*

Since there are certain people who find great fault with us for adoring and honoring both the image of the Saviour and that of our Lady, as well as those of the rest of the saints and servants of Christ, let them hear how from the

beginning God made man to His own image. For what reason, then, do we adore one another, except because we have been made to the image of God? As the inspired Basil, who is deeply learned in theology, says: 'the honor paid to the image redounds to the original,' and the original is the thing imaged from which the copy is made. For what reason did the people of Moses adore from round about the tabernacle which bore an image and pattern of heavenly things, or rather, of all creation? Indeed, God had said to Moses: 'See that thou make all things according to the pattern which was shewn thee on the mount.' And the Cherubim, too, that overshadowed the propitiatory, were they not the handiwork of men? And what was the celebrated temple in Jerusalem? Was it not built and furnished by human hands and skill?

Now, sacred Scripture condemns those who adore graven things, and also those who sacrifice to the demons. The Greeks used to sacrifice and the Jews also used to sacrifice; but the Greeks sacrifice to the demons, whereas the Jews sacrificed to God. And the sacrifice of the Greeks was rejected and condemned, while the sacrifice of the just was acceptable to God. Thus, Noe sacrificed 'and the Lord smelled a sweet savor' of the good intention and accepted the fragrance of the gift offered to Him. And thus the statues of the Greeks happen to be rejected and condemned, because they were representations of demons.

But, furthermore, who can make a copy of the invisible, incorporeal, uncircumscribed, and unportrayable God? It is, then, highly insane and impious to give a form to the God-head. For this reason it was not the practice in the Old Testament to use images. However, through the bowels of His mercy God for our salvation was made man in truth, not in the appearance of man, as He was seen by Abraham or the Prophets, but really made man in substance. Then He abode on earth, conversed with men, worked miracles, suffered, was crucified, rose again, and was taken up; and all these things really happened and were seen by men and, indeed, written down to remind and instruct us, who were not present then, so that, although we have not seen, yet hearing and believing we may attain to the blessedness of the Lord. Since, however, not all know letters nor do all have leisure to read, the Fathers deemed it fit that these events should be depicted as a sort of memorial and terse reminder. It certainly happens frequently that at times when we do not have the Lord's Passion in mind we may see the image of His crucifixion and, being thus reminded of His saving Passion, fall down and adore. But it is not the material which we adore, but that which is represented; just as we do not adore the material of the Gospel or that of the cross, but that which they typify. For what is the difference between a cross which does not typify the Lord and one which does? It is the same way with the Mother of God, too, for the honor

paid her is referred to Him who was incarnate of her. And similarly, also, we are stirred up by the exploits of the holy men to manliness, zeal, imitation of their virtues, and the glory of God. For, as we have said, the honor shown the more sensible of one's fellow servants gives proof of one's love for the common Master, and the honor paid to the image redounds to the original. This is the written tradition, just as is worshiping toward the east, adoring the cross, and so many other similar things.

Furthermore, there is a story told about how, when Abgar was lord of the city of Edessenes, he sent an artist to make a portrait of the Lord, and how, when the artist was unable to do this because of the radiance of His face, the Lord Himself pressed a bit of cloth to His own sacred and life-giving face and left His own image on the cloth and so sent this to Abgar who had so earnestly desired it.

And Paul, the Apostle of the Gentiles, writes that the Apostles handed down a great many things unwritten: 'Therefore, brethren, stand fast: and hold the traditions which you have learned, whether by word or by our epistle'; and to the Corinthians: 'Now I praise you, brethren, that in all things you are mindful of me and keep my ordinances as I have delivered them to you.'

3.5.2
The will of Andreas Cornaros

The rather lengthy will of Andreas Jacomo Cornaros, a wealthy Cretan, includes a paragraph regarding one of the icons in his possession, which included the letters 'IHS' and representations of scenes within these letters. He makes it clear that it is a precious item of Greek painting (*pittura greca*). Furthermore, he wishes that this icon should be sent to Venice, to Alvize Tzorti, 'our illustrious master' (*illustrissimo signor*), and asks his brother Kavaliero to make sure that his wish is met. [AL]

Source: S. G. Spanakis, Σ.Γ. Σπανάκης (1955), 'Η Διαθήκη του Ανδρέα Κορνάρου (1611)', *Κρητικὰ χρονικὰ* [Kretika Chronika], vol. 9, pp. 379–478 (passage quoted from p. 427). Translated from the Latin by Dario Tessicini. Copyright © The Open University 2007.

Next, the small icon with wings [i.e. triptych], called in Greek *sfaglistari*, and the other one with the painted letters IHS, that I keep in my bedroom. Both

are valuable images for Greek painting and together with the marble head that I keep in my study, shall be sent to Venice as soon as possible to the Most Revered Sir Alvise Zorzi, our patron, as a modest sign of my enduring loyalty and respect. And in this instance I entrust my brother, Sir Cavalliere, with the task and care of having them sent safely.

3.5.3
Three Cretan painters are commissioned to make 700 icons of the Virgin

Two dealers, named Giorgio Basejo from Venice and Petro Varsama from the Peloponnese in Greece, commissioned 700 icons of the Virgin from three different Cretan painters. They were all given the same deadline for delivery, 15 August 1499, which allowed them only 42 days to accomplish the task. The first painter, master Migiel Fuca (active 1493–1500, died before 1504), was asked to produce 200 icons. The second painter, Nicolò Gripioti (active 1491–1525), was commissioned for 300 icons. The third painter master, Giorgio Miçoconstantin, was to deliver 200 icons.

Source: M. Cattapan (1972). 'Nuovi Elenchi e Documenti dei Pittori in Creta dal 1300 al 1500', Θησαυρίσματα [Thesaurismata], vol. 9, pp. 211–13, nos 6–8. Translated from the Latin by Dario Tessicini. Copyright © The Open University 2007.

1

(Notary Giorgio Cumno, ivi, b. 31, f. 191*v*)
4 July 1499

On the fourth day of July, Master Migiel Fuca, painter, and his heirs, declare to Sir Giorgio Basejo and Sir Petro Varsama, and to their heirs, that the said Master Migiel promises to make and finish [*apatar*] the icons depicting Our Lady, as follows: 100 of a first type, and half of them shall be dressed with deep blue gold brocade and the other half with purple gold brocade, in the shape that the said Master Migiel has shown to the aforesaid [Giorgio Basejo and Petro Varsama]. These [icons] will be completed by the next fifteenth of August, each priced 48 *bezzi*. Next, by the same date, the said Master Migiel

promises to hand over to the aforesaid [Giorgio Basejo and Petro Varsama] another 100 icons of the first, second and third type according to the model that will be made by Master Nicolò Gripioti, painter, in the Latin fashion, at a price of 42 *bezzi* for the first type, 1 *yperperi* for the second, and 1 *marçelo* for the third. And if this is not complied with, the aforesaid [Giorgio Basejo and Petro Varsama] shall be entitled to buy the same quantity from others without being liable for damage or loss of profit to the said Master Migiel. And as an advance payment Master Migiel has received 5 ducats. He who was asked to do so.

2

(Ibidem)
Same date

Master Nicolò Gripioti, painter, and his heirs declare to Sir Giorgio Basejo and Sir Petro Varsama, both present, and to their heirs that the said Master Nicolò promises to make and finish by the next fifteenth of August 300 icons of the first, second and third type, all in the Latin fashion and painted in gold, both below and above. And as a payment for these icons the sum of 40 *bezzi* each is agreed for those of the first type, 1 *yperperi* each for those of the second, and 1 *marçelo* each for those of the third. And if this is not complied with, the said Sir Giorgio shall be entitled to buy the same quantity of similar condition, without being liable for damage or loss of profit to the said Master Nicolò. And as an advance payment the said Master Nicolò has received from Sir Giorgio 600 golden leaves at the price of 12 *yperperi* for every 100 and 5 ducats. He who was asked to do so.

3

(Ibidem)
Same date

Master Giorgio Miçocostantin, son of the priest Andrea, with the agreement of the said father, declares to Sir Giorgio Basejo and Sir Pietro Varsama, both present, and to their heirs, that the said [Master Giorgio Miçocostantin] promises to make and finish by the next fifteenth of August 200 icons representing Our Lady of the first, second and third type according to the outline given by the said Master Giorgio to the said Sir Giorgio. And as a payment

for these icons the sum of 2 *marçeli* is agreed for the first type, 34 *bezzi* for the second and 1 *marçeli* for the third. And if this is not complied with, Sir Giorgio [Basejo] shall be entitled to buy the same quantity of similar type and condition without being liable for damage or loss of profit to the said Master Giorgio [Miçocostantin]. And as an advance payment the said Master Giorgio [Miçocostantin] has received from the said Sir Giorgio [Basejo] 117 *yperperi*, 14 *piçoli*, equal to 14 ducats and 6 *bezzi*, adding that all icons will be painted in gold, with the exception of 30 icons, which should have a red ground. And half of these shall be in the Greek fashion and the other half in the Latin fashion. He who was asked to do so.

3.5.4
Contract for employment of a painter in the workshop of another

In this contract, the painter Nikolaos Bianco declares that he is going to work in the workshop (*botega*) of the painter Manousos Fucas for one year. During this period, Bianco does not have the right to work for anybody else, while Fucas, in addition to food expenses, has to pay him 10 ducats. This and the following document are examples of the collaboration between painters for the production of works of art that probably included icons. [AL]

Source: M. Constantoudaki (1973), Μ.Γ. Κωνσταντουδάκη, 'Οι Ζωγράφοι του Χάνδακος κατά το πρῶτον ἥμισυ του 16ου αιώνος οι μαρτυρούμενοι εκ των νοταριακὼν αρχείων', *Θησαυρίσματα* [Thesaurismata], vol. 10, p. 360 (A). Translated from the Latin by Dario Tessicini. Copyright © The Open University 2007.

11 October 1503
I, Nicola Bianco, son of the late Michele, of my own will, declare together with Master Manusso Fucha, painter, here present and content, that I will bind myself to serve in your workshop in my capacity of painter for the period of one year and six months, and I will do as much as I can in your service. And at the end of the said period you are bound to give me 10 ducats in all, and also to pay the expenses for my food, that is lunch and dinner. And I declare to have already received one ducat, so that nine are left, that you are bound to pay to me little by little, until the end of the said period. And within

this period I am not allowed to work for anyone but you, under the below penalty, with exception of the evenings, when I can do as I please. And you can declare me at fault through the office of the guild's magistrate [*gastaldo*] for a sum of 50 *perperi*.

Witnesses: the noble Sir Joannes Cornario, of the late Sir Michele, and Sir Antonio Madioti.

3.5.5
Contract for employment of a painter in the workshop of another

This contract informs us that the painters Konstantinos Loureas and Antonios Fucas have agreed to stop fighting and instead work together. Furthermore, Loureas promises to work for Fucas for six months and in return will receive money for food, shoes and clothes worth 3 ducats.

Source: M. Constantoudaki, Μ.Γ. Κωνσταντουδάκη, 'Οι Ζωγράφοι του Χάνδακος κατὰ το πρῶτον ἥμισυ του 16ου αιῶνος οι μαρτυροὐμενοι εκ των νοταριακὼν αρχεἰων', Θησαυρίσματα [Thesaurismata], vol. 10, pp. 367–8 (H). Translated from the Latin by Dario Tessicini. Copyright © The Open University 2007.

The same day [9 October 1509, the thirteenth indiction, Candia on the Isle of Crete]

Konstantinos Loureas, of the late Giorgio, painter, as one party, and Master Antonios Fucas, as the other party, with their heirs, declare that they reach this agreement and pact in order to cease all past litigations and disputes among each other. The said Konstantinos promises to work at the service of the said Master Antonio in his said art as well and as accurately as he can, according to his knowledge and skills starting from now and for the next six months, during which period the said Master Antonios will have to reimburse the said Konstantinos with expenses for food and provide him with shoes. For this service both parts have agreed that for the said period the remuneration shall be 3 ducats. And the said Master Antonios shall also provide clothing to the said Konstantinos by the next 15 November. And if the latter does not comply with [this], the said Master Antonios may find another

worker to cover for the same period and all damages, and be content with this, under the penalty of 25 *yperperi*. This contract being valid etc. He who was asked to do so.

The above witnesses [= Lanbriano Janopulo, Migiel Suiro]

3.5.6
Commission for 10 triptychs

The painter Georgios Strilitzas promises to deliver 10 *sfalistaria* (triptychs) to his nephew, Theofylaktos Strilitzas. His payment was agreed as one ducat per triptych and he was given just over two months to complete the commission. This tight deadline is in keeping with the multiple production of icons for sale revealed in document 3.5.3. [AL]

Source: M. Constantoudaki, Μ.Γ. Κωνσταντουδάκη, ʽΟι Ζωγράφοι του Χάνδακος κατὰ το πρῶτον ἥμισυ του 16ου αιώνος οι μαρτυρούμενοι εκ των νοταριακὼν αρχείων', Θησαυρίσματα [Thesaurismata], vol. 10, pp. 365–6 (ΣΤ). Translated from the Latin by Dario Tessicini. Copyright © The Open University 2007.

[19 April 1509, the twelfth indiction, Candia on the Isle of Crete. The first day of the month was a Sunday]

I, Georgios Strilitzas, painter and citizen of Candia, with my heirs, declare to you, Sir Theofilactus Strilitzas, my nephew, here present together with your heirs, that I am content, and promise to make ten icons, that is 10 double *sfalistaria* with their own wings and for each wing, on the outside one saint and on the inside two saints and in the icon as many saints as I want and those that you wish, painted beautifully, piously, and according to the width and height of the icons. I promise to deliver these icons, completed in all parts, at my expense, including the wood, by the end of July 1509 and as a payment and compensation for those, we agree on the sum of one ducat for each icon and I am entrusted by you, at the presence of the witnesses and the underwritten notaries, 5 ducats and the remaining 5 gold ducats [will be paid] when I will hand over the completed [icons]. And if I do not comply with [this], you are entitled that I shall make them at my expenses and you can claim them through a guild's magistrate [*gastaldo*].

The above witnesses [= Sir Leonardus Castrofilaca, Sir Angelus de Petrarubea] notaries.

3.5.7

Vasari's views on the 'Greek' style

Giorgio Vasari clearly wrote with the concerns of Florentine art in mind when he described the style of fourteenth-century Greek artists as 'rough', 'clumsy' and 'rude', claiming that they had nothing to do with the 'good manner of ancient Greece'. What he offers is an interesting but artificial distinction between the 'good' ancient and the 'bad' contemporary Greek or Byzantine style. He does not take into consideration the long-established religious and artistic conventions that dictated the style of Greek art. [AL]

Source: Giorgio Vasari (1996), *Lives of the Painters, Sculptors and Architects*, trans. G. du C. de Vere, intro. and notes D. Ekserdjian, 2 vols (London: Everyman's Library; David Campbell) (this ed. first published 1927 by Dent), vol. 1, pp. 17, 21–3.

Preface to Part I

The admirable sculptures and paintings buried in the ruins of Italy remained hidden or unknown to the men of this time who were engrossed in the rude productions of their own age, in which they used no sculptures or paintings except such as were produced by the old artists of Greece, who still survived, making images of clay or stone, or painting grotesque figures and only colouring the general outline. These artists were invited to Italy for they were the best and indeed the only representatives of their profession. With them they brought the mosaic, sculpture, and painting as they understood them, and thus they taught their own rough and clumsy style to the Italians, who practised the art in this fashion up to a certain time, as I shall relate. [. . .]

Cimabue, Painter of Florence (1240–1302)

The endless flood of misfortunes which overwhelmed unhappy Italy not only ruined everything worthy of the name of a building, but, what is more serious,

completely extinguished the race of artists. Then, as it pleased God, there was born in the year 1240 in the city of Florence, Giovanni, surnamed Cimabue, of the noble family of the Cimabui, to shed the first light on the art of painting. As he grew up he appeared to his father and others to be a boy of quick intelligence, and accordingly he was sent to receive instruction in letters to a relation, a master at S. Maria Novella, who then taught grammar to the novices of that convent. Instead of paying attention to his lessons, Cimabue spent the whole day in drawing men, horses, houses, and various other fancies on his books and odd sheets, like one who felt himself compelled to do so by nature. Fortune proved favourable to this natural inclination, for some Greek artists were summoned to Florence by the government of the city for no other purpose than the revival of painting in their midst, since that art was not so much debased as altogether lost. Among the other works which they began in the city, they undertook the chapel of the Gondi, the vaulting and walls of which are to-day all but destroyed by the ravages of time. It is situated in S. Maria Novella, next the principal chapel. In this way Cimabue made a beginning in the art which attracted him, for he often played the truant and spent the whole day in watching the masters work. Thus it came about that his father and the artists considered him so fitted to be a painter that, if he devoted himself to the profession, he might look for honourable success in it, and to his great satisfaction his father procured him employment with the painters. Then, by dint of continual practice and with the assistance of his natural talent, he far surpassed the manner of his teachers both in design and in colour. For they had never cared to make any progress, and had executed their works, as we see to-day, not in the good manner of ancient Greece, but in the rude style of that time. Although Cimabue imitated the Greeks he introduced many improvements in the art and in a great measure emancipated himself from their stiff manner, bringing honour to his country by his name and by the works which he produced. The pictures which he executed in Florence bear testimony to this, such as the reredos of the altar of St. Cecilia, and a Madonna on a panel in S. Croce, which was then and still is fastened to a pillar on the right hand side of the choir. Subsequently he painted on a panel a S. Francis, on a gold ground. He drew this from nature, to the best of his powers, although it was a novelty to do so in those days, and about it he represented the whole of the saint's life in twenty small pictures full of little figures, on a gold ground. He afterwards undertook a large picture for the monks of Vallombrosa in their abbey of S. Trinità at Florence. This was a Madonna with the Child in her arms, surrounded by many adoring angels, on a gold ground. To justify the high opinion in which he was already held, he worked at it with great industry, showing improved powers

of invention and exhibiting Our Lady in a pleasing attitude. The painting when finished was placed by the monks over the high altar of the church, whence it was afterwards removed to make way for the picture of Alesso Baldovinetti, which is there to-day. It was afterwards placed in a minor chapel of the left aisle in that church. Cimabue next worked in fresco at the hospital of the Porcellana, at the corner of the via Nuova which leads to the Borgo Ognissanti. On one side of the façade, in the middle of which is the principal door, he represented an Annunciation, and on the other side, Jesus Christ with Cleophas and Luke, life-size figures. In this work he abandoned the old manner, making the draperies, garments, and other things somewhat more lifelike, natural and soft than the style of the Greeks, full as that was of lines and profiles as well in mosaics as in painting. The painters of those times had taught one another that rough, awkward and commonplace style for a great number of years, not by means of study but as a matter of custom, without ever dreaming of improving their designs by beauty of colouring or by any invention of worth.

After this was finished Cimabue again received a commission from the same superior for whom he had done the work at S. Croce. He now made him a large crucifix of wood, which may still be seen in the church. The work caused the superior, who was well pleased with it, to take him to their convent of S. Francesco at Pisa, to paint a picture of St. Francis there. When completed it was considered most remarkable by the people there, since they recognised a certain quality of excellence in the turn of the heads and in the fall of the drapery which was not to be found in the Byzantine style in any work executed up to that time either in Pisa or throughout Italy.

Art and Death

3.6.1

Leonardo Bruni condemns the tomb of the poet Bartolommeo Aragazzi

In this letter from Leonardo Bruni (1370–1444) to Poggio Bracciolini (1380–1459), both Florentine humanists, Bruni is highly critical of making a tomb to preserve the memory and reputation of a man he claims had few merits worth remembering. No monument could make up for a mediocre life. Such carping was not uncommon among humanists, most of whom depended on the same limited field of patrons. Bruni's harsh words may relate to the fact that Bartolommeo Aragazzi was also a successful member of the court of Pope Martin V (reigned 1417–34). Aragazzi's monument was a particularly fine work, many of its parts inspired by antique Roman reliefs, dated 1427–36, and credited as among the masterpieces of the Florentine sculptor and architect Michelozzo (1396–1472). It was originally set up in the church that is now Montepulciano Cathedral but was dismantled after 1618 and some parts of it are now part of the collection of the Victoria and Albert Museum, London. [CMR]

Source: C. E. Gilbert (1980), *Italian Art, 1400–1500: Sources and Documents* (Englewood Cliffs, NJ and London: Prentice-Hall), pp. 165–7. Reprinted by permission of Creighton E. Gilbert.

Something worth instantly laughing about happened to me the other day, while I was on the road to Aretine territory, I met panting oxen pulling wagons. In the wagons marble columns were being pulled, and two unfinished statues, and bases and blocks, and architraves, and by chance the wagons were stuck in difficult thickets and couldn't proceed. The drivers were standing around with pickaxes, clearing the way and helping. So I was surprised by the unusualness of the thing, since people don't normally drive wagons through those woods or bring in marble, and so I came up and asked what was going on, and where such awkward loads were being taken. Then one of the drivers, seeing me, and at the same time wiping the sweat from his face, tired I presume of the labor, and also angry, said: 'May the gods damn all poets, those who ever were and those who are to be.' Hearing his answer, I said: 'What do you have against poets, in what way did they ever do you harm?' 'In this way,' he said, 'that this poet who died recently, well known to be stupid and puffed up with conceit, ordered a marble tomb to be made for

himself. For that reason these marbles are being taken to Montepulciano. But I think they never can be got through, considering the difficulty of the roads.' And I, wishing to understand more clearly, said 'What are you saying, did some poet die at Montepulciano?' 'Not there,' said he, 'but at Rome, but he provided in his will for making his tomb in his native town. And this is his face which you see here, the other is of a relative, whom he ordered to be placed next to him.' Then I, basing a conjecture on the death and the native town, had in fact heard that a certain Bartolommeo of Montepulciano had recently died in Rome, and left I don't know how much money. I asked the driver whether he was speaking of him, and he nodded that it was the very same man. 'In that case,' said I, 'why do you curse poets on account of this ass? Do you think he was a poet, who never became acquainted with opinion or learning? He did indeed utterly surpass all men in stupidity and vanity.' 'I didn't know him when he was living,' said he, 'and never even heard him mentioned, but his fellow townsmen judge him to be a poet, and if he had left behind just a bit more money, they would have thought him a god. But if he was not a poet, I have no wish to curse poets.'

And then I, going away, began to think over the words of the driver, who had called that man stupid and conceited who had ordered a marble tomb built for himself in his native town when he died in Rome. For in fact no one who was confident of his glory ever thought of having a tomb made for himself. He, content with the fame of his praiseworthy works and the distinction of his name, will think himself quite enough approved by posterity on that account. In what way can a tomb, a dumb thing, help a wise man? And what is more vile than for a tomb to be remembered and a life to be passed over in silence? Three emperors are held to have been most eminent in various centuries, Cyrus, Alexander, Caesar. Of whom Cyrus, who was the oldest, by no means sought for a grand tomb, but commanded in his will that no tomb should be built for him, and that he should be buried in the earth, recalling that the earth produces flowers and foods, and brings forth most pleasant and valuable trees, and no finer material for a tomb is to be found; therefore he ordered that his body be buried in the bare ground, wholly without anything of marble or any monument or building. Rightly so, for his virtues and good deeds assured his lasting memory. [An account of Cyrus's achievements follows.] The same view was held by Caesar and Alexander, of whom, we see, neither thought of making a tomb for himself; I am insulting these great lives, whom I bring as witnesses in rebuking this worthless man. For if the most excellent men have, with praise, avoided this ambitious vanity, how greatly is this pride to be made fun of in this turd of a man? You in your will order marble to be brought to you from far off, do you, a tomb to be made, and

statues to be set up for yourself? With what basis, I ask? In your learning, which was nothing, your letters, of which you hardly grasped four? In your life and habits? you who, being of no consequence and full of remarkable stupidity, pursued everything without advice but with rash folly? Then indeed if your conduct does not make you worthy of a statue and a marble tomb, your family does, by its respectability. Born of a father who was a seller of wares in the market square, your grandmother a midwife, your mother a religious fanatic! Or did you think yourself worthy of a statue because of the money buried under ground? That alone was left, as far as anything true is concerned, and after your death when it at length come to light, the pope demanded back that same money, as being abstracted from him illegally. What will you write on your tomb, I wonder, what actions, what deeds will you have inscribed? That your father drove asses and goods around the fairs? That your grandmother helped the mothers giving birth when she took up the infants as they came into the world? That your mother fluttered around churches with her hair down? That you piled up money by stealth? That the pope demanded that money back? That is the sum of your deeds, that is your own and your family's glory, which are such that you, if you knew anything, if you were not carried away by stupidity and rashness when dying, as all through life, would have specified in your will that, just as you had done with the money, so they should hide you underground yourself, lest the vanity and ambition of this your tomb be the cause of laughter and grievance.

3.6.2

John Lydgate's version of 'The Dance of Death' for the cloister of St Paul's Cathedral, London

The *Dance of Death*, or *Danse macabre*, was a combination of text and images used to decorate the walls of the cloister at the cemetery of Les Innocents, Paris, before 1425. John Lydgate, a Benedictine monk from Bury St Edmunds, was in Paris in 1426 and translated the verses from the French, as he states at the beginning and end of the poem. This text was then used to accompany paintings in the cloister of St Paul's Cathedral, London, around 1440 (destroyed 1549). The words and pictures of the *Dance of Death* became hugely popular in the fifteenth century throughout western Christendom,

particularly in areas north of the Alps. They were reproduced in frescoes, panel paintings, manuscripts and printed books. The morbid but often humorous images depicted people from all levels of society being approached by death, represented as a skeleton and sometimes playing a musical instrument, inviting its prey to join the dance. In the strict social hierarchy of the time the message was shocking – that popes and princes will meet exactly the same fate as paupers. They should all be ready to face death, the great leveller, which could come at any moment. [CMR]

Source: 'The Daunce of Machabree: wherein is lively expressed and shewed the state of manne, and how he is called at uncertayne tymes by death, and when he thinketh least thereon, made by Dan John Lydgate, Monk of S. Edmunds Bury', in William Dugdale (1818), *The History of Saint Paul's Cathedral in London, From its Foundation* (London: Lackington and Longman), pp. 419–27. Note: the English has been left in its original form so as to preserve Lydgate's poetic voice.

THE PROLOGE.

O YE folks hard hearted as a stone,
Which to the world have all your advertence,
Like as it should ever lasten in one,
Where is your wit, where is your providence,
To seen aforne the sodayn violence
Of cruel death that be so wise and sage,
Which slayeth, alas, by stroke or pestilence
Both young and old of low and high parage.

Death spareth nought low ne high degre,
Popes, Kings, ne worthy Emperours,
When they shine most in felicity
He can abate the freshness of her flours,
Her bright Sun clipsen with his shours,
Make them plunge fro her sees lowe.
Mauger the might of all these Conquerours,
Fortune hath them fróm her whele ythrow

Considereth this ye folkes that been wise,
And it imprinteth in your memorial,
Like thensample which that at Parise,
I fonde depict ones in a wall
Full notably as I rehearse shall,

Of a French Clerke taking acquaintance,
I took on me to translaten all
Out of the French Macchabrees daunce.

By whose advise and counsail at the last,
Through her stiering and her motion,
I obeyed unto her request
Thereof to make a playn translacyon
In English tonge, of entencion
That proud folkes that been stout and bolde,
As in a mirrour toforne in her reason
Her ugly fine there clearly may behold.

By ensample that thei in her entents,
Amend her life in every maner age,
The which Daunce at Saint Innocents,
Portrayed is with all the surplusage;
Yoven unto us our lives to correct,
And to declare the fine of our passage,
Right anone my stile I will direct
To shew this world is but a pilgrimage.
 The End of the Prologe.

The Words of the Translator.
O CREATURES ye that been reasonable,
The life desiring which is eternal,
Ye may seen heer doctrine full notable
Your life to lead, which that is mortal,
Thereby to learne in special
How ye shall trace the daunce of Machabree,
To man and woman ylike natural,
For death ne spareth high ne low degree.

In this myrrour every wight may fynde,
That him behoveth to gone upon this daunce,
Who goeth toforne,[1] or who shall go behind,
All dependeth in Goddes ordinance;
Wherefore lowly every man his chance,
Death spareth not poor, ne yet Blood-royall,

[1] 'toforne' – in front.

Every man therfore have this in remembrance,
Of oo matter God hath yforged all.

[…]

*Death fyrst speaketh unto the Pope, and
after to every Degree, as followeth.*
YE that been set most in high dignity,
Of all estates in earth spiritual,
And like as Peter hath the soveraintee
Over the church and states temporall,
Upon this daunce ye first begin shall,
As most worthy lord and governour,
For all the worship of your estate Papall,
And of Lordship to God is the honour.

The Pope maketh aunswer.
FYRST me behoveth this daunce for to lede,
Which sat in earth highest in my See,
The state full perillous who so taketh heed,
To occupie Peters dignity,
But for all that death I may not flee,
On this daunce with other for to trace,
For which all honour who prudently can see,
Is little worth that doth so soon passe.

Death speaketh to the Emperour.
SYR Emperour, lord of all the ground,
Sovereine prince and highest of noblesse,
Ye mot forsake of gold your apple round,
Scepter and swerd, and all your high prowesse;
Behind letten your treasour and your riches,
And with other to my daunce obey
Against my might is worth none hardinesse,
Adams children all they must deye.

The Emperour maketh aunswer.
I NOTE to whom that I may appeal
Touching death which doth me so constrein,
There is no gin to helyen my querell
But spade and pickoys my grave to atteyne;

A simple sheet there is no more to seyn,
To wrappen in my body and visage,
Whereupon sore I me compleyne,
That great Lordes have little auvantage.

Death speaketh to the Cardinal.
Yᴇ been abashed it seemeth and in drede,
Syr Cardynal it sheweth by your chere,
But yet forthy ye follow shall indeed,
With other folke my daunce for to lere,
Your great aray all shall leaven here.
Your hat of red, your vesture of great cost,
All these thinges reckoned well in fear.
In great honour good advise is lost.

The Cardinal maketh aunswer.
I ʜᴀᴠᴇ great cause, certes this is no faile,
To be abashed and greatly dread me
Sith death is come me sodainly to assaile
That I shall never hereafter clothed be
In grise nor ermine like unto my degree,
Mine hat of red leuen eke in distresse,
By which I have learned well and see,
How that all joy endeth in heavinesse.

[...]

Death speaketh to the Bishop.
Mʏ Lord sir Bishop, with Miter and Cross,
For all your riches soothly I ensure,
For all your treasure kept in closse
Your worldly goods, and goods of nature,
Of your sheep the dreadfull ghostly cure,
With charge committed to your prelacy,
For to accompt ye shall be brought to lure,
No wight is sure that climbeth over high.

The Bishop maketh aunswer.
Mɪɴᴇ heart truly is nother glad ne mery,
Of sodein tidinges which that ye bring,
My feast is turned into simple fery,

That for discomfort me list nothing syng,
The world contraries to me now in working,
That all folks can so disherit,
He all with halt (alas) at our parting,
All thing shall pass, save only our merit.

Death speaketh to the Squire.
Come forth sir Squire right fresh of your aray,
That con of daunces all the new guise,
If ye bate harnes freshly horsed yesterday,
With spere and shield at your uncouth devise,
And took on you so many high emprise,
Daunseth with us it will no better be,
There is no succour in no maner wise,
For no man may fro deaths stroke flee.

The Squire maketh aunswer.
Sithence that death holdeth me in his lase,
Yet shall I speak oo word ere I passe,
Adue all mirth, adue now all solace,
Adue my Ladies whilom so fresh of face,
Adue beauty, pleasaunce, and all solace,
Of deaths chaunge every day is prime,
Think on your souls ere the death manace,
For all shall rot, and no man wot what time.

[...]

Death speaketh to the Marchant.
Ye rich marchant ye mot look hitherward,
That passed have full many divers lond,
On horse and foot, having most regard
To lucre and winning as I understond,
But now to dance you mot give me your hond,
For all your labour full little avayleth now,
Adue vainglory both of free and bond,
None more covet then thei that have ynough.

The Marchant maketh aunswer.
By many a hill, and many a strong vale
I have travailed with many marchandise,
Over the sea down carrie many a bale,

To sundry Iles more then I can devise:
Mine heart inward ay fretteth with covetise,
But all for nought now death doth me constrein,
For which I see by record of the wise,
Who all embraceth litle shal constrein.

[...]

Death speaketh to the Monke.
Sir Monke also with your black habite
Ye may no lenger hold here sojoure,
There is nothing that may you here respite,
Agein my might you for to do succour.
Ye mot accompt touching your labour,
How ye have spend it in dede word and thought.
To earth and ashes turneth every floure,
The life of man is but a thing of nought.

The Monk maketh aunswer.
I had leaver in the cloyster be
At my book and study my service,
Which is a place contemplatif to see,
But I have spent my life in mony wise,
Like as a foole dissolute and nice;
God of his mercy grant me repentance,
By chere outward hard is to devise
All be not merry which that men see daunce.

Death speaketh to the Usurer.
Thou Usurer looke up and behold,
Unto thy winning thou settest ay thy paine,
Whose covetise never waxeth cold,
Thy gredy thrust so sore doth the constrein.
But thou shalt never to thy desyre attaine,
Such an Etick thy heart freten shall,
But that of pity God his honde refraine
One perilous stroke will make thee losen all.

The Usurer maketh aunswer.
Now behoveth sodeinly to dye,
Which is to me great paine and eke grevance.

Succour to fynde I see no maner way,
Of gold nor silver by none chevisance.
Death through his hast abideth no purveiance
Of folkes blinde, that can nought loke well,
Full oft happeth by kinde of fatall chaunce,
Some have fayre eyen that see never adell.[2]

 The Poor Man borroweth of the Usurer.
 Vsurer to God is full great offence,
And in his sight a great abusion,
The poor borroweth percase for indigence,
The rich lend by false collusion,
Onely for lucre in his intention.
Death shall both to accompts fet,
To make reckoning by computation,
No, no man is quit that is behind of dette.

 Death speaketh to the Physitian.
 Master of Phisike which on your urine,
So loke and gase and stare against the sun,
For all your craft and study of medicine,
All the practike and science that ye cun.
Your life course so far forth is yrunne,
Aye in my might your craft may not endure,
For all the gold that thereby you have wunne,
Good leech is he that himself can recure.

 The Physitian maketh aunswer.
 Full long agon that I unto Phisike
Set my wit and eke my diligence,
In speculatife, and also in practike,
To great a name through mine excellence.
To fynd out against Pestilence,
Preservatives to staunche it and to fine,
But I dare shortly in sentence,
Say that against death is worth no medicine.

 Death speaketh to the amerous Squire.
 Ye that be gentle so fresh and amerous,
Of yeres young, flouring in your grene age,

[2] 'adell' – a deal or part.

Lusty, fre of hert, and eke desirous,
Full of devises and chaunge in your courage,
Pleasant of port, of loke, and of visage,
But all shall turne into ashes dead,
For all beauty is but a faynt ymage,
Which stealeth away, or folks can take hede.

[. . .]

Death speaketh to the Labourer.
Thou Labourer, which in sorrow and peyn
Hast lad thy life in great travayle,
Ye must eke dance, and therefore nought disdein,
For if you do it may thee nought avayle,
And cause why that I thee assayle,
As onely this fro thee to discever
The false world that can so folkes fayle
He is a fool that weneth to liven ever.

The Labourer maketh aunswer.
I have wished after death full oft,
Albe that I would have fled him now,
I had lever to have lyen unsoft,
In wind and rain to have gon at the plow,
With spade and pikoys laboured for my prow,
Dolven and ditched and at the cart gone;
For I may say and tell platly how,
In this world there is rest none.

Death speaketh to the Frere menor.
Sir Cordelere to you mine hand is raught,
You to this daunce to convey and lead,
Which in your preaching han ful oft ytaught
How that I am most gastful for to drede,
Albe that folke take thereto none heed,
Yet is there none so strong, ne so hardy,
But death dare him rest, and let for no mede,
For death every houre is present and ready.

The Frere maketh aunswer.
What may this be that in this world no man
Here to abide may have no surety,

Strength, riches, nor what so that he can,
Of worldly wisedom all is but vanity:
In great estate nor in poverty,
Is nothing found that may his death defend,
For which I say to high and low degree,
Wise is that sinner that doth his life amend.

Death speaketh to the Child.
Litle Faunte that wert but late borne,
Shape in this world to have no plasaunce,
Ye must with other that gone herebeforne,
Be lad in hast by fatal ordinance,
Learne of new to gone on my daunce;
There may none age escape in soth therefro,
Let every wight have this in remembrance,
Who lengest liveth most shall suffer woe.

The young Child maketh aunswer.
A, a, a, a, woorde I canot speake,
I am so yonge I was borne yesterday,
Death is so hasty on me to be wreak,
And list no lenger to make no delay.
I am but now borne, and now I go my way,
Of me no more to tele shall be told,
The will of God no man withstond may,
As soon dyeth a yong as an old.

[...]

The King eaten of Worms.
Ye folke that look upon this portrature,
Beholding here all estates daunce,
Seeth what ye have been, and what is your nature
Meat unto worms nought els in substance:
And have this mirrour aye in remembrance,
How I lye here whilom crowned King,
To all estates a true resemblance,
That worms food is the fine of your living.

Machabree the Doctour.
Man is nought els platly for to think,
But as wind which is transitory,
Passing ay forth, whether he wake or winke,

Toward this dance, haveth this in memory.
Remembring ay there is no better victory,
In this life here then fly sin at the least:
Then shall ye reign in paradise with glory,
Happy is he that maketh in heaven his feast.

YET there be folke mo than six or seven,
Recheles of life in many maner wise,
Like as there were hell none nor heaven,
Such false errour let every man despise.
For holy saincts and old clerkes wise
Written contrary her falseness to defame,
To liven well take this for the best emprise,
Is worth much when men should hence pass.

Lenvoy of the Translatoure.
O YE my Lords and Masters in all fear
Of aventure, that shall this daunce reade,
Lowly I pray with all my heart entere,
To correct whereas you see nede.
For nought elles I aske for my mede,
But goodly support of this translacion,
And with favour to suppowaile drede,
Beninglye in your correction.

OUT of the French I drough it of intent,
Not word by word, but following in substance,
And froum Paris to England it sent
Only of purpose you to do pleasance.
Have me excused, my name is John Lidgate,
Rude of language, I was not borne in France,
Her curious Miters in English to translate,
Of other tong I have no suffisance.
 Here endeth the Daunce of Machabree.

3.6.3

The foundation statutes of the chantry at Ewelme

William and Alice de la Pole became Duke and Duchess of Suffolk in June 1448 as a reward for their loyalty to the Lancastrian cause. Alice was the granddaughter of the poet Geoffrey Chaucer and enjoyed considerable wealth and power in her own right. In 1448 the couple established a chantry at Ewelme, part of the Chaucer estates, to demonstrate their good deeds in life and ensure that their souls were prayed for after they died. This extract from the statutes describes the form and purpose of the chantry – 2 priests and 13 poor men to pray for the souls of the patrons, their ancestors and all Christian souls in the daily cycle of prayers and masses at Ewelme. The Ewelme Foundation also included an almshouse, chapel and other buildings. Among other things, the statutes describe how the tomb of Thomas and Maude Chaucer, Alice's parents who had established the chapel of St John the Baptist adjoining the parish church, was incorporated into the cycle of prayer. Alice's own lavish tomb, its gisant and cadaver effigies carved in alabaster, and the tomb chest and chapel decorated with armorial bearings, was added in the early 1470s, just before her death in 1476. In return for praying for the souls of the patrons, the 2 priests and 13 poor men were accommodated at the almshouse and received a pension – as long as they obeyed the rules and led honest and exemplary lives. [CMR]

Source: J. A. A. Goodall (2001), *God's House at Ewelme: Life, Devotion and Architecture in a Fifteenth-Century Almshouse* (Aldershot: Ashgate Publishing), pp. 223–55. Reprinted by permission of Dr J. Goodall. Note: modern English is used where necessary for clarity.

In the name of God be it known to all Christian people the contents of this present foundation saying, hearing and understanding. We William de la Pole, Duke of Suffolk and Alice my wife, Duchess of Suffolk, desire health in body, grace in soul, and everlasting joy to obtain. Because all Christian people meekly and devoutly considering how by the upholding and maintaining of divine service. And by the exercise of works of mercy in the state of this deadly life in the last dreadful day of doom, they shall with the mercy of Our Lord take here part and portion of joy and bliss with them that shall be saved aught

of reason have a great and fervent desire and a busy charge in mind to uphold and maintain divine service and to exercise, fulfil and do works of mercy before the end of their deadly life. And namely to such persons that may by no faculty of lawful craft get here bodily sustenance. But furthermore been between with so great penury of poverty for that lack of sustenance and they were not by alms relieved they should lightly perish. This we devoutly considering we William and Alice above said have built, erected and founded a house of alms for two priests and thirteen poor men to dwell and be sustained in the same all times to come in perpetuity set and edified upon a certain ground of ours pertaining to our manor and lordship of Ewelme in the county of Oxford annexed unto the church yard of the parish church of Ewelme in the west side of the said church being the east side of the said house of alms. But for more clear and plainer foundation and ordinance and establishment of the said house and persons the which shall be sustained, founded and relieved in the same. The might of the Father, the wisdom of the Son, the goodness of the Holy Ghost, three persons in one godhead: humbly we beseech of his grace principally be our help, succour and speed, the which called in and aspired: we proceed in this manner.

1. First licence granted and authority of the most noble lord and king, Harry, the sixth, king of England and of France. We will and ordain principally to God's worship, to the increase of our merits that now at this time be and shall be and aught to be for ever in perpetuity in the said house of alms dwelling and sustained two priests and thirteen poor men after the whole discretion and good conscience of the providers, founders and patrons of the said house in this present writing afterwards to be rehearsed to be provided and admitted the which daily shall pray after due opportunity of time for quick and dead as it shall be in this present writing afterwards rehearsed. Of which priests, one principally to be preferred in power and reverence, we will that he be called master of the alms house to whose office it shall belong and pertain the goods of the said house the which shall come into his hands well and truly to minister such ways that the said goods [by] any manner dispersed he shall gather together and then [the] goods I get and gathered together he shall to the profit of the said house safely keep. Also he shall be busy and do his true diligence that charity, peace and rest be had and kept among the brethren good examples of virtues in his living and speaking he shall virtuously and sadly show to the which foresaid master we will and ordain that the other priest and poor men of the said house now present and to come in all things the which pertain to the honest worship and profit of the said house that they truly obey and intend as it seems in any way wise that is lawful and expedient [. . .].

2. Also we will and ordain as for the second priest that there be provided a well disposed man, apt and able to teach grammar, to whose office it shall long and pertain diligently to teach and inform children in the faculty of grammar. Provided that all the children of our chapel of the tenants of our lordship of Ewelme and of the lordships pertaining to the said alms house now present and all times come freely be taught without exaction of school fees [. . .]

10. Also we will and ordain that the said minister and his successors and every of the said poor men and their successors have and hold a certain place by themselves within the said house of alms that is to say a little house, a cell, or a chamber and other necessaries in the same, in which every of them may by himself eat and drink and rest and sometimes among attend to contemplation and prayer [. . .]

16. [. . .] the said master and teacher of grammar and poor men and their successors, we devoutly desire that every one of them in their part be founded in good and sad living in himself and endued with godly and spiritual occupation of very true, trusty and devout daily prayer in the which we have great trust and hope to our great relief and increase of our merit and joy finally. Therefore first and before all other things and because that God will that man intend and desire principally so to be demeaned in his living and that he may thereby at the last have and obtain the Kingdom of Heaven, we will and ordain that every minister and poor man and their successors daily in their uprising kneeling before their beds and shall say three Our Fathers, three Hail Marys and a Creed, desiring inwardly in their souls that our sovereign lord king of England, King Harry the sixth, and we their said founders and all other Christian people will so be demeaned in our living that at the last we will have and obtain the Kindom of Heaven. And for that same good intent we will that the master and the teacher of grammar shall say daily in their uprising this Psalm: 'Deus misereatur'.

17. Also we will and ordain that every ferial and work day soon after six at the clock in the morning shall with the common bell of the house by the ordinance of the said minister a peel be rung to Matins then afterwards as it may seem to the discretion of the master of the said house that the said poor men will be arrayed and ready to come to church. The second peel rung, the master shall proceed and begin his Matins and continue to the end with Prime and Hours in the said parish church at Ewelme. [. . .]

22. Also we will and ordain that every minister and poor man aforesaid and their successors within the said church or Ewelme [. . .] shall say daily for the most noble estate of our said sovereign lord the king, during his life and for the good estates of us their said founders during our lives and for the

states of all them that [have] been alive, and for the soul of our said sovereign lord after his decease, and for the souls of our both fathers and mothers and all Christian souls [. . .]

23. Also we will and ordain that every said master, minister and poor men every day to come the which may well do it and every holy day the teacher of grammar after the said Mass to be said by the said master shall gather themselves together about the tomb of our father and mother, Thomas Chaucer and Maude, his wife, where they shall say this psalm 'Deus misereatur' with the common suffrages used to be said for the quick with this Collect: 'Deus qui caritas' [. . .] the which done the Master if he be present or the teacher of grammar or the minister or one of the brothers shall openly and distinctly say in the English tongue during the lives of our said sovereign lord and of us both: 'God save in body and soul our sovereign lord the king my lord William Duke of Suffolk my lady Alice, Duchess of Suffolk, his wife, our founders, my lord John their son, and all Christian people', the brothers answering, 'Amen'. And after the decease of our sovereign lord and of us both we will that the said psalm, 'Deus misereatur', and the suffrage following be said for them that shall succeed unto us as founders of the aforesaid house for time of their deadly life and for all Christian people. [. . .]

26. Also we will and ordain that after our decease the master and the teacher of grammar yearly keep our anniversary with Placebo and Dirge and commendation and mass of requiem at the which Dirge and mass we will that the minister and all the brothers be present in their devotions from the beginning to the end.

27. Also we will and ordain that the anniversary of Thomas Chaucer and Maude his wife our father and mother yearly be kept after the form aforesaid.

3.6.4
The will of John Baret of Bury St Edmunds

John Baret was a wealthy cloth merchant, well connected with the abbey of Bury St Edmunds. Social convention dictated that a man in such a position should be prepared for his death. He commissioned a tomb monument in the 1450s and this was evidently already in place when he wrote his will

some four years before his death in 1467. Such preparation did not suggest paranoia on the part of the living but was seen as a public service – an example to all to think about their lives and conduct so that they might be prepared for death. The formerly polychromed limestone effigy set on a marble tomb chest still survives in the church of St Mary, Bury St Edmunds, and the representation of Baret as an emaciated corpse seems designed to shock the viewer into action. In Baret's will his goods are to be distributed among friends, acquaintances and, in particular, clergy, who would pray for his soul at his funeral and regularly thereafter. [CMR]

Source: Samuel Tymms (ed.) (1850), *Wills and Inventories from the Registers of the Commissary of Bury St Edmunds and the Archdeacon of Sudbury, Camden Society*, vol. 49, pp. 15–44. Note: the spelling of the will has been modernized and modern English is used where necessary for clarity.

In the name of Almighty God, Amen. I, John Baret, of Saint Edmunds Bury, of good mind and memory, being at Saint Edmunds Bury the Saturday next following the feast of the Nativity of Our Lady, the year of our Lord Christ, 1463, make my testament in this way: First I bequeath and commit my soul to our Lord God Almighty and to our Lady Saint Mary and to all the Saints. And my body to be buried by the altar of Saint Martin, named also Our Lady's altar, in Saint Mary Church at Bury, under the perclose[1] of the return of the candle beam, before the image of Our Saviour, and no stone to be stirred on my grave, but a pit to be made under the ground. There my lady Schardelowe was wont to sit, the stool removed, and the body put in as near under my grave as may be without hurt of the said grave. And I bequeath unto the high altar of the said church, in recompense of my duties to holy church not paid duly – 20s.

Item I bequeath to my Lord Abbot of Bury[2] a good purse and 6s and 8d therein, and for a token of remembrance my beads[3] of white amber with the ring of silver and over gilt belonging thereto and my gilt standing cup, to him and to his successors after him. Also I bequeath to the Prior a good purse and halfpenny of gold therein, with a double seal with two prentys[4] hanging by a chain of silver. [. . .].

[1] 'perclose' – a screen between a chapel and the main body of a church.
[2] The Abbey of St Edmund was close to the much smaller church of St Mary. It was devastated by fire in 1465.
[3] A rosary.
[4] Apprentices.

Item to each monk in the place to have 12d and a pittance among them, each man a French loaf and a quart of wine.

Item I bequeath to each of my lord abbot's chaplains a purse of silk and gold and to each of them 12d therein.

Item to every gentleman of my lord abbot which be coming and going as officers and menial men belonging to the household of my fellowship, each gentleman a purse of silk and gold and 12d therein.

Item to each woman of [the] household 8d and a pair [of] beads of amber and jet. And to each groom and page 6d and [a] pair of beads of mystill.[5]

Item I beqeath to Adam Newhawe my girdle of leather barred with silver with buckle and pendant and my little bag of black leather with a chain and toret[6] of silver.

Item to Raffe Otle sometime my man a black gown and 20d [towards] the making. And to Robert Otle a black gown and 20d to the making.

Item to John Hert my girdle with a buckle and pendant of silver, 'Grace me govern'[7] written therein, and a bag of green silk with gems of green.

Item I give and bequeath to William Hussher 3s 4d and he to have his contract of his apprenticeship which I had in keeping with a quittance of his maist sythe;[8] and if John Hert and William Housher do service at my interment, I will that they be rewarded beside and all those that do service there by the discretion of my executors.

Item I bequeath to the parish priest of St Mary church 6s 8d.

Item to Saint Mary priest a black gown and as follows.

Item to the parish clerk that belongs to the ward I dwell in 12d.

Item I will that each priest that be at first dirge and burying have 4d and each of the parish clerks 2d and each child with a surplice 1d. Also in like ways I will that every priest that be at my solemn exequies have a pair of beads with a little purse and therein 4d, brothers and all others that have taken the full order of priesthood and each of the parish priests to have 6d and each of the Saint Mary priests and the chanters to each of them 6d.

Item each acolyte, dean and subdean, and parish or ward clerk 2d a person and each child that has a surplice a 1d.

5 Probably a white bead.
6 Probably a form of decoration.
7 This was the motto of the Lancastrian party and was also written on the ceiling above the tomb.
8 Master's satisfaction?

Item I will that Master Thomas Harlowe say the sermon at my interment, if he vouchsafe, and he to have 6s 8d to pray for me. And if he may not do it, by his advice another to be chosen at Cambridge to make the sermon and to have the [. . .] costs paid for.

Item I will no common dole, but on the evening of my solemn dirge shall be kept each poor man and each poor woman being there have 1d to pray for me, and 2 children 1d, to be given out after the discretion of my executors, and the same day before noon each sick man and woman that can be found within Bury have 2d to pray for my soul.

Item I will the prisoners in the jail have [. . .] bread, meat and drink, and each prisoner 1d and the keeper to have 2d.

Item I will that each laseer[9] of man and woman or child within Bury have 2d and a loaf of bread and halfpenny.

Item I will have at mine interment at my dirge and mass five men clad in black in worship of Christ's five wounds and five women clad in white in worship of our Lady's five joys, each of them holding a torch of clean wax [. . .].

Item I will my executors, my kindred, my friends, and my servants have gowns of black as many as have been expressly named in this my said will, and my executors will add any more thereto I grant them full power.

Item I will that on the day of my interment be sung a mass of [. . .] song at Saint Mary's altar in worship of Our Lady at 7 of the clock in the morning or soon after so that the requiem mass may begin forthwith when it is done [. . .]; the which mass of Our Lady I will the priest keep in a white vestment which is already made [. . .] bought and paid for, with a remembrance of my arms [. . .] 'Grace me gouerne', and I will have another vestment made of white cotton and my cloth of gold [. . .]. For what day God fortune that I decease that each week in the year I will Saint Mary priest say or do say a mass of Our Lady at Saint Mary altar in the said vestment, and after the gospel to stand at the altar's end and rehearse John Baret's name openly, saying *De profundis* for me, for my father and my mother, and for all Christian souls, and to have mind on us [. . .].

Item I will that the image of Our Lady that Robert Pygot painted be set up against the pillar next to the percloos of Saint Mary altar [. . .]

[9] Leper.

3.6.5

The choice of artist for the monument to Cardinal Niccolò Forteguerri in Pistoia

Cardinal Niccolò Forteguerri died on 21 December 1473 and was buried in Santa Cecilia, his titular church in Rome. His brothers commissioned a tomb from Mino da Fiesole (1429–84). The cardinal was a native of Pistoia in Tuscany and had been a generous benefactor of the city, establishing a school there. On 2 January 1474, the town council of Pistoia (the Consiglio) decided to commemorate the cardinal's death with a requiem mass and a monument, for which they set aside 300 florins (1,100 *lire* in the document).[1] By May 1476 five designs had been submitted in a competition held to find the best sculptor to undertake the work. Andrea del Verrocchio (1435–88), the head of an important workshop in Florence, won the competition, but he demanded 350 instead of the original 300 florins set aside for the project by the council. The Board of Works (*operai*) established to oversee the project managed to get the original sum raised to 380 florins, but then offered it to Piero Pollaiuolo (c.1441–c.1496), a member of a rival Florentine workshop. Meanwhile, the Consiglio chose Verrocchio. Lorenzo de' Medici, who was often called in to advise on artistic issues, especially in Tuscany, where he held considerable sway, was approached to decide the matter. He decided that Verrocchio should complete the monument, and on 17 March the Board of Works replied to him diffidently conceding to his decision. Complex local politics in Pistoia may well have been the reason for all the trouble and why Verrocchio never completed the monument. The Consiglio was controlled by the Florentine overlord of Pistoia while the members of the Board of Works were locals. [CMR]

Source: D. S. Chambers (1970), *Patrons and Artists in the Italian Renaissance* (London: Macmillan), pp. 99–101. Reprinted by permission of Palgrave MacMillan.

Magnificent Sir and our singular benefactor [after the accustomed recommendations etc.]

[1] A. Butterfield (1997), *The Sculptures of Andrea del Verrocchio* (New Haven and London: Yale University Press), pp. 137–57, 223–8.

We need to trouble Your Magnificence with our present problems. The matter is as follows: after the death of Monsignor [Niccolò Forteguerri] of Thiene, our most esteemed compatriot of blessed memory, it occurred to this community to make some public act in memory of his most reverend Lordship, and because of the benefits this city received from him. Upon our advice it was resolved that 1100 *lire* should be spent on his tomb and memorial, and it was committed to us citizens to have five models made. When these were ready, they were to be referred to the council, and whichever the council chose should be commissioned. Thus five models were presented to the council, among them one by Andrea del Verrocchio, which was liked more than the others; and the council commissioned us to discuss the price with the said Andrea. On our doing this, he asked for 350 ducats, whereupon we took our leave without committing ourselves, because we had no commission to spend more than 1100 *lire*. And being anxious that the work should go forward, we returned to the council saying that we needed more money for the said work than 1100 *lire* if a worthy thing was desired. The council, on hearing the facts, deliberated again and gave us authority to spend whatever sum of money we saw fit for the said work so long as it was beautiful, and allowed us to commission it from the said Andrea or from any other we saw. Wherefore because we understood Piero del Pollaiuolo was here, we went to see him and asked him to make a model of the work, which he promised to do, so that we postponed commissioning the work. It now transpires that our commissaries have commissioned the work, in order to ensure its execution, from the said Andrea for the said price and manner of design; and we, as obedient sons concerning everything they do and decide, will be content to obey, and thus we have written to them. Now Piero del Pollaiuolo has made the model we asked him for, which seems more beautiful and more worthy artistically, and is more pleasing to messer Piero, brother of the said Monsignore, and all his family, as it is to us and to all the citizens of our city who have seen it, than is Andrea's or anyone else's. For this reason we have begged the said commissaries to make some compensation to Andrea but to accept Piero's model: this will give us satisfaction and much pleasure. We are now sending the said models to you as our protector, because you have very deep understanding of these things as of everything else, and because we are sure that you desire the honour of the said Monsignore and his family and all our city. If, as it seems to us, we are right, lend us your help and favour; our desire has no other motive than the honour of the city and the memory of the said Monsignore. From Pistoia, 11 March 1477.

Your servants the *Operaii* of San Jacopo, officials of the Sapientia and citizens elected as the council concerning the said work in Pistoia.

To the magnificent Lorenzo de' Medici, our special benefactor in Florence.

3.6.6

Cardinal Francesco Todeschini Piccolomini prepares for his death

Francesco Todeschini Piccolomini (1439–1503) was a cardinal from 1460 until 1503 when he was elected pope and took the name Pius III. The cardinal had ensured that his uncle, Pius II, was properly commemorated by completing his altar of St Andrew and commissioning a tomb for St Peter's basilica in Rome. When he came to write his own will, Francesco secured permission from the current pope, Sixtus IV, that he too would be buried in St Peter's. The extract given here concerns the cardinal's preparation for his death and his provision for his funeral and tomb. The admission that one should always be prepared for death and the limits set on the expenditure of the funeral ceremonies are standard among the strict conventions for wills and commemoration at that time, though here it is put in a particularly elegant way, befitting a cardinal. During his lifetime Francesco made arrangements for his burial in either Siena or Rome, commissioning an altar in Siena Cathedral and a tomb slab for St Peter's. However, he was eventually commemorated by yet a third monument, designed to match the one he had commissioned for his uncle in St Peter's. The two papal monuments were later moved to Sant'Andrea della Valle in Rome, when the nave of the old basilica was replaced at the beginning of the seventeenth century. [CMR]

Source: Carol M. Richardson (1998). 'The Last Will and Testament of Cardinal Francesco Todeschini Piccolomini (1439–1503)', *Papers of the British School at Rome*, vol. 66, pp. 200–2. Translated from the Latin by Jeremy G. Taylor. Copyright © The Open University 2007.

If it is fitting for any man to live his life in constant contemplation of the fate that hangs over him and presents itself at every moment – which is the

mark of both philosophers and believers – then it is surely fitting for the Christian man, who is sustained in the secure belief of a second life, and fitting above all for bishops, whose duty is to instruct by word and example the people entrusted to them. For undoubtedly the man who does not perceive the fragility of human nature and fails to consult the interests of his soul, himself and his household while time permits, but is heedless of what will happen tomorrow, thinking of anything rather than his final day – that man seems to misunderstand the coming age and be too indifferent to future events. For amid the many and varied dangers which hourly threaten our life, who can guarantee himself even so much as a day? We know not what the night will bring; it is altogether uncertain whether we are to be called away at cock-crow or morning. Turning these things over frequently in my mind, I Francesco, unworthy Cardinal Deacon of Siena of the sacred Roman Church of St Eustace, have been greatly stirred by the words of our Father Jesus Christ, who declared that blessed would be the servant whom the Lord found awake when he knocked on the door. And again, 'be ready because you do not know the hour at which the Lord will come',[1] otherwise I shall be caught by surprise in the company of the thoughtless and foolish virgins and their lamps without oil, while mind and body flourish by the gift of heaven, and as the hour of death approaches I shall be forced to think of something other than the salvation of my soul, namely the earthly talent entrusted to me by God, and I am now to distribute a good part of it, arrange the domestic estate which remains and compose my last will and legal testament.

First of all, since I was a sinner when enrolled into the holy senate of cardinals in my 20th year through divine dispensation rather than through my own services which are none, and was stationed amongst the princes of the church, though I was unworthy, and was ignorant of how my life would end, I affirm my faith with a clear voice and a pure heart so that no one may be in any doubt about my affirmation – I believe in and I confess my Catholic faith in the holy and indivisible Trinity which the Holy Roman Church and the Apostolic Seat of Peter uphold and teach, and which I declare I have upheld and sincerely believed completely and perfectly in all things from an early age, after I received the light of divine grace, right up to this hour. In this faith I wish and desire to die. And through this faith I confidently hope to be saved. I declare to be anathema every heresy which raises itself up against the Holy Apostolic faith and all of its opponents and detractors.

[1] Matthew 24:44; Luke 12:40.

Secondly, from this hour I prostrate myself on the ground as a suppliant and beg for divine forgiveness that God may not remember the sins and ignorance of my youth. But mindful of his ancient sufferings may he deign to raise up my spirit which he created from nothing, when it pleases him that it fly from the prison of this body and the shadowy gaol of the world, in the embrace of his majesty with his elected saints in accordance with his infinite mercy.

My body, which is accountable for many acts of wickedness as is the way of sinners, should be honoured – not because it deserves any honour, but by reason of the dignity which the Roman Church has permitted for burial – with those trappings and ceremonies which the custom of our order has laid down in such a way that everything affirms not so much a celebration of life as a humility appropriate to death. I leave the nature of this moderation to the good sense and discretion of the executors to be named at the end of the will [. . .]

If I happen to die in Rome, I choose a place of burial in the basilica of the Prince of the Apostles within the chapel of St Andrew the Apostle amongst the bones of my uncle Pope Pius, so that he who brought me up from child-hood and advanced me to this rank when alive may even in death tend the ashes of his nephew [. . .] up to the great day of the Resurrection. I order that my body be laid in the ground at the feet of my uncle's tomb on his right between the sepulchre and the wall of the basilica covered only by a marble sculpted in my likeness, but I do not wish the tomb to be decorated with any sculptures except that a marble tablet is to be inserted into the wall three braccio[2] from the ground above the tomb which has an epitaph incised with beautiful letters as follows:

Sacred to God/ to Francesco Piccolomini/ deacon of St Eustace/ Cardinal of Siena/ nephew of Pope Pius II/ in accordance with his will/ lived . . . [left blank] years.

But if I die outside Rome in Italy but beyond the river Paglia which flows through the valley of Aquapendente [. . .] I desire to be brought back to the city and interred in the tomb I have mentioned. But if it pleases God for me to die elsewhere in Italy or unexpectedly I ask that it not be a burden to my executors and heirs to take my body back to the city of Siena

[2] *Ulna*, the elbow or the forearm, roughly equivalent to the braccio (or ell), a standard unit of measurement in Italy of between 55 and 70 cm. Every Italian city had its own measure and a braccia for measuring cloth could be different to that used in building. In this case the marble tablet was to be roughly 180 cm above the ground.

under their own care and supervision. Because I want to be buried in my chapel at my metropolitan church wherever I die except in the places mentioned, I wish the instructions of my will which follows to be thoroughly observed.

3.6.7
The wills of the 'Catholic Monarchs', Isabella and Ferdinand

Ferdinand II (1451–1516), King of Aragon and Sicily (from 1479) and Isabella (1451–1504), Queen of Castile and León after 1474, were cousins who married in 1469. Reigning together, they united a vast and powerful kingdom which became the basis of modern Spain. On 13 September 1504, prompted by the fact that the queen was dying, they published their intention to make a burial chapel in Granada, not Toledo as initially planned. Granada held particular significance because in 1492 it had been captured from the Moors who had held the province since the eighth century. The chapel was built adjoining the cathedral in Granada between 1506 and 1521. In her will, written on 12 October 1504, just before her death on 26 November, Isabella requested burial in the monastery of St Francis in the Alhambra of the city of Granada. Her body was to be dressed in the habit of a Franciscan and placed in a floor tomb. However, she requested that if Ferdinand chose to be buried elsewhere, in a different monastery or church, that her body should be moved to join his. This is exactly what happened. In his will of 1516 Ferdinand requested burial in the Capilla Real (Royal Chapel), which he had commissioned for Granada Cathedral in Isabella's memory. But the chapel was not completed by the time Ferdinand died, so his body was taken to join that of Isabella at San Francisco. On 10 November 1521, their remains were finally brought to the Capilla Real. In 1512, Domenico Fancelli (1469–1519) is documented in Carrara sourcing the fine white marble for the tombs. Between 1514 and 1517 Fancelli is documented in Genoa making the tombs, which were then shipped to Granada. [CMR]

Source: Diego Iosef Dormer (1683), *Discursos varios de historia con muchas escrituras reales antiguas, y notas a algunas dellas*, Zaragotha, pp. 319–24, 397–402. Translated from the Spanish by David Ward. Copyright © The Open University 2007.

[From the Will of Isabel]

I wish, and I order, that my body be entombed in the Monastery of Saint Francis which is in the Alhambra of the City of Granada, being a monastery of the Friars, or Nuns of the said order. My body will be clothed in the habit of the Blessed Poor Man of Jesus Christ and will be put in a low tomb without any sculpture whatsoever, with a low flat gravestone with letters sculpted upon it. But I desire and order that if my Lord, the King were to choose a tomb in some other church, or Monastery in some other part or place of these my kingdoms, that my body should be translated there and be entombed with the body of his Lordship, so that the union which was ours when we were alive may, I hope, by the mercy of God, be restored to us in heaven, as expressed by our bodies in the ground.

And I desire and command that nothing showy be raised up for me, and that the funeral rites held for me, wherever my body should be, should be carried out without excesses – no steps up to the coffin, no spires, no mourning awnings in the church, no excess of candles, of which there should be thirteen of each side so that the divine office may be said and the Masses and vigils be celebrated on the day of the obsequies; and that what might be spent in mourning at these obsequies should be converted and given as clothing to the poor and the wax that might be used in these ceremonies should be burnt before the Blessed Sacrament in some poor churches, wherever those who carry out my will see fit.

[. . .] Similarly, I command that the will of my Lord and father, King Juan – may he be in holy paradise – in as much as it touches on what he commanded to honour his tomb in the devout Monastery of Saint Mary of Miraflores. In this regard information must be sought from the religious of the said Monastery as to what has been fulfilled and what remains to be fulfilled, since it has not come to my notice what else remains from that Will to be carried out, to which I am obliged by law. If such be found at any time to which I am obliged, I order that it be carried out. At the same time I command that any further testamentary disposition which in any way I may have accepted, or which I may be obliged to fulfil, must be carried out.

[From the Will of King Ferdinand of Aragon]

Firstly, we commend and offer with great devotion and contrition, our soul to our Lord God, the Almighty, who created it. We humbly beg Him in His infinite clemency, and by the most sacred passion of his blessed Son, who redeemed us by his precious blood, that it may please Him to have mercy on my soul, to receive it and accept it into his holy glory.

While choosing a place of burial for our body, we desire, order and command that it be taken as soon as we have died to be entombed in our Royal Chapel which we and the Most Serene Lady, Queen Isabel, my most dear and well beloved wife – may she be in glory – have ordered to be made and endowed in the principal church of the City of Granada. In our own times, it pleased Our Lord to accept me as the instrument, although unworthy and a sinner, whereby this city was conquered and removed from the power of the infidel Moors, enemies of the Holy Catholic faith.

It is then our wish that, for this favour done to us, that our bones shall rest in that place forever. Here also the bones of the said Most Serene Lady, Queen Isabel, are to be entombed, that both may lie together and bless God's holy name.

If it should happen that at the time that we should pass from this life that the said Royal Chapel should not be completed nor had the bones of the said Most Serene Lady the Queen should not have been moved to the said chapel, we desire that our body be deposited and placed jointly with hers in the same tomb in the Monastery of Saint Francis of the Alhambra of the said city, where she is at present entombed until the said chapel is at the time of my death completed. Once this work is done, they are to bring our body together with that of the Most Serene Lady, the Queen, to the said chapel and they are to place them together in one tomb. If at the time of our death, the body of the said Most Serene Lady, the Queen, has already been translated and placed in the said chapel and tomb, in accordance with what she laid down in her will, it is our will that our body should be entombed in the same chapel and the same tomb immediately.

Once we have been placed in the said chapel, let my executors and heirs take the vestments, all of silk, of brocade and damask from our chapel, that is to say copes, chasubles, dalmatics, vestments, albs, altar hangings, beds, tapestries, tiles and whatever by way of accoutrements which may be lacking for this our chapel at the time of our death, together with the tapestries of the seven joys of Our Lady and the tapestries of the history of the three estates. Let all these things (taken from what we have left, in the following chapter of this document, to the Monastery of Poblet) to be given and handed over through an official inventory and in the manner laid down and ordered by the said Most Serene Lady, Queen Isabel – may she be in glory – whereby similar things which she left to the said chapel and church be handed over as a gift, that the same order and form must be observed, preserved and followed as to every other thing which we will leave to the said chapel.

The Reform of Images

3.7.1
Andreas Karlstadt, On the removal of images

Andreas Bodenstein (c.1480–1541), known by the name of his place of birth, Karlstadt, was a Wittenberg theologian who radicalized the reforming agenda during Luther's absence from the city in the winter of 1521–2. His treatise, published in January 1521, justified rather than caused the recent iconoclasm and removal of images in the city. It is in two parts, the first dealing with the removal of images, the second maintaining that there should be no beggars (meaning the poor) in a Christian society. For him, the issue of expenditure on images was crucial. Karlstadt's somewhat repetitious arguments depended heavily on the scripture with which he wished to replace the visual culture of the Catholic Church. He pursued his key points persuasively, using increasingly extreme language, but his rhetoric was not without flaws, as his opponents were quick to point out. His main arguments were that images offend against the second commandment (Exodus 20:4); that the concept of images as a 'Bible for the Poor' is utterly mistaken; that the saints whose images are venerated would have been horrified at the practice; that images have a power that even Karlstadt confessed himself vulnerable to, and therefore their removal is the only possible response. [KWW]

Source: Andreas Rudolff-Bodenstein von Karlstadt (1991), *A Reformation Debate: Karlstadt, Emser and Eck on Sacred Images. Three Treatises in Translation*, trans. B. D. Mangrum and G. Scavizzi (Ottawa: Dovehouse Editions), pp. 19–25, 28, 30, 35–6. Reprinted by permission of Dovehouse Editions, Canada.

We could never deny that it is out of love that we have placed the so-called saints in churches. If we had not loved them, we would not have set them up where God alone should dwell and rule. Had we been opposed to them, we would have fled them rather than embraced them. Our deeds convict us of loving images. Have we not shown them the honour which we show exclusively to great lords? Why have we caused them to be painted and coloured, to be adorned with velvet, damask, silver, and golden robes? Why do we deck them out with golden crowns? With precious stones? And offer them that honour and love that we do not willingly give our children, our wives, our parents, our most exalted princes and lords? Who can believe us when we say:

We have not loved the idols, the carved and painted images? When our actions have betrayed us? God hates and is jealous of pictures, as I will demonstrate, and considers them an abomination, and proclaims that all men in his eyes are like the things they love. Pictures are loathsome. It follows that we also become loathsome when we love them. [. . .]

I would like to know what answer we could give to true Christians and Jews, who have an understanding of the Bible, or even to God, who has given us his teaching through the Holy Spirit, when they or he asks: How is it that you are so audacious as to set up images and idols in my house? How can you be so bold and impudent that in my house you bow down and kneel before pictures which have been made by the hands of men? Such honours belong to me. You light candles before them. But if you want to set candles burning and blazing, you should do so [only] for me. You bring them wax offerings in the form of your afflicted legs, arms, eyes, head, feet, hands, cows, calves, oxen, tools, house, court, fields, meadows, and the like, just as if the pictures had healed your legs, arms, eyes, heads etc. or had bestowed upon you fields, meadows, houses, honours, and possessions.[1] [. . .]

I cannot deny, but must confess, that God might in all justice say to our supposed Christians what he said to the Jews. For they run to the idols like crows and ravens after a carcass and fly to a lifeless cadaver. They seek them in particular places, such as Wilsnack in the Brandenburg Mark, Grimmenthal, Rome, and similar places.[2] They bring them tools, silver, gold, wax, and goods as if they were their gods who have delivered them, who have protected them and they are far blinder than the ox in Leipzig or the ass in n.n. who indeed know what good is given them and from whom it comes.[3] So they invoke idols in the house of God and seek health, support, and counsel from insensate dummies. And the people vilify God in his house, which is a good and important enough reason to drag idols out of the churches. Not to mention that many a man doffs his cap, which he would wear if his man-made god were not before him. I do not regard it lightly that they bend a knee before the saints. [. . .]

God said (immediately after he gave the commandment, Thou shalt have no other gods before me): Thou shalt make no carved or graven image. Thou shalt make no likeness of anything in the heavens above or the earth below

[1] The reference is to *ex-voto* offerings, often of precious objects, which were left beside images by those who believed that images had conferred some benefit on them.

[2] These are references to pilgrimage places.

[3] The 'ox' and 'ass' are evidently opponents of Karlstadt.

or that is in the water. Thou shalt not worship them. Thou shalt not venerate them. I am your God, a strong and vengeful God, a jealous God who punishes the sons for the sins of their fathers (Exodus 20:4ff.).

See how God prohibits any kind of image because men are frivolous and are inclined to worship them. For this reason God said: Thou shalt not worship them, thou shalt not honour them. Thereby God prohibits all veneration and smashes the refuge of the papists who at all times do violence to Scripture through their subtlety and make black out of white, evil out of good. Thus if one were to say: Indeed, I do not worship images; I do not venerate them for themselves, but for the sake of saints which they signify. God's answer is short and clear.

Thou shalt not worship them. Thou shalt not venerate them. Make whatever gloss you can, thou shalt absolutely not worship them, thou shalt not bend thy knee before them, thou shalt not light a candle before them. God says: If I had wanted you to venerate me or my saints in pictures, I would not have forbidden you to make pictures and likenesses. [. . .]

Moses says: You shall teach your children the Word of God from their youth. But Gregory says: The laity shall use images for books.[4] Tell me, dear Gregory, or have someone else tell me, what good things could the laity indeed learn from images? Certainly you must say that one learns from them nothing but the life and the suffering of the flesh and that they do not lead further than to the flesh. More they cannot do. For example, from the image of the crucified Christ you learn only about the suffering of Christ in the flesh, how his head hung down and the like. Now Christ says that his own flesh is of no use but that the spirit is of use and gives life [John 6:64]. Thus Peter too says that Christ had words of eternal life and spirit [John 6:69]. Since, then, images are deaf and dumb, can neither see nor hear, neither learn nor teach and point to nothing other than pure and simple flesh which is of no use, it follows conclusively that they are of no use. But the Word of God is spiritual and alone is of use to the faithful.

Therefore it is not true that images are the books of the laity. For they may learn nothing of salvation from them, and take absolutely nothing from them which serves salvation or is necessary to a Christian life. [. . .]

Therefore I must again speak of the uselessness of images. But everything according to Scripture, for I do not desire anyone to believe me or accept my authority. Indeed, may the Devil thank you if you believe me and accept my

[4] The theory of the *Biblica pauperum* was outlined in the writings of John of Damascus (see 3.5.1), but went back to Pope Gregory I (pope from 590 to his death in 604).

authority. Turn your ears and eyes to Scripture, which says: The makers of images are nothing and there is no profit in the most precious and most cherished thing [Isaiah 44:9].

They themselves witness that their images see and understand nothing [Isaiah 44[:9]]. Here make note, you idolatrous unbeliever, that the maker of an image is nothing and that his very best work avails nothing. Yes, certainly, they are of no use for salvation. You yourself must confess that you will not ask an image-maker what profits you for salvation because he is an image-maker. How, therefore, can Pope Gregory make so bold as to say, Images are the books of the laity, when artists can teach nothing useful for salvation? Note that your artists can see, hear, and understand and bear witness to the fact that their images can neither see nor hear, nor have understanding. And you do not and ought not to want image-makers as books. How, then, could you take images for books? [. . .]

Look! You have permitted the laity to light candles before images of St Paul, Peter, and Barnabas and bring them offerings, something which the saints themselves, in their lifetimes, shunned like the plague. Nevertheless, if you are the super-clever philosopher, if you are such an erudite fellow, I beg you, in a friendly way, to tell me whether Paul, Peter, and Barnabas would themselves have permitted us to place them [their images] on altars? You must say no and no again. Why do you set their forbidden images on altars, images which they would not have accepted? [. . .]

Now I want and shall say to all pious Christians that all those who stand in awe before pictures have idols in their hearts. And I want to confess my secret thoughts to the whole world with sighs and admit that I am faint-hearted and know that I ought not so stand in awe of any image and am certain that God expects of his people that they should not stand in awe of images, as it is written: You should not fear other gods, not worship, not venerate and should not make offerings to them, but only to God (Judges 6[:10], 2 Kings 17[:35]). And I know that God dwelling in me is as small as my fear of idols is great. For God wants to fill our whole heart and will in no way tolerate that I should have a picture before my eyes. And again, when I put my trust in God with my whole heart, I need not ever fear his enemies.

Therefore God or his Spirit in sacred Scripture says: You shall not fear other gods. You shall not pray to them. You shall not venerate them. And he teaches us that it is the same thing to venerate images or to be in awe of them. For this reason I should not fear any image, just as I should not venerate any. But (I lament to God) from my youth onward my heart has been trained and grown up in the veneration and worship of pictures. And a harmful fear has

been bred into me from which I would gladly deliver myself and cannot. As a consequence, I stand in fear that I might not be able to burn idols. I would fear that some devil's block of wood [i.e. an idol] would do me injury. Although, on the one hand, I have Scripture and know that images have no power and also have no life, no blood, no spirit, yet, on the other hand, fear holds me and makes me stand in awe of the image of a devil, a shadow, the noise of a small leaf falling, and makes me flee that which I should confront in a manly way. Thus I might say, if one pulls a man's hair, one finds out how firmly it is rooted. Had I not heard the spirit of God cry out against the idols and read his Word, I would have thought: I do not love any image; I do not stand in awe before any image. But now I know how I, in this case, stand toward God and images, and how strongly and deeply images are rooted in my heart.

May God confer his grace upon me so that I no longer venerate the devil's heads (so one commonly calls the images of saints in the church) more than stone and wood. And God grant that I not venerate stone and wood with the appearances and names of saints. Amen.

3.7.2
Extracts from Hieronymus Emser's response to Karlstadt

The main thrust of this treatise by the theologian Hieronymus Emser (1478–1527) was to refute Karlstadt's arguments on the removal of images. Emser did admit, however, that religious images were open to criticism in some respects, and conceded that some of the money spent on them would be better devoted to relieving the poor. Emser evidently regarded artistic skill as a potential distraction, and the worldly representation of saintly figures as a potential temptation. In expressing an aesthetic preference for simplicity, Emser provides us with a rare judgement, not just about the role of religious images, but about the manner in which they should be made. [KWW]

Source: Andreas Rudolff-Bodenstein von Karlstadt (1991), *A Reformation Debate: Karlstadt, Emser and Eck on Sacred Images. Three Treatises in Translation*, trans. B. D. Mangrum and G. Scavizzi (Ottawa: Dovehouse Editions), pp. 86–7. Reprinted by permission of Dovehouse Editions, Canada.

First, our ancestors, as I have seen in many old cloisters and collegiate churches, placed quite simple images in the churches. This was not done because of any decline of art (for in earlier times there were no doubt capable painters, although they were not so common as they are now) but for two other reasons, namely that the people preferred to give the vast amounts of money which we spend on pictures today, often paying six, seven, eight, and even a thousand guilders for a single panel, to the blessed poor. The other reason is that the more artfully images are made the more their viewers are lost is contemplation of the art and manner in which the figures have been worked. We should turn this contemplation from the images to the saints which they represent. Indeed, many are transfixed before the pictures and admire them so much that they never reflect on the saints. Therefore, it would be far better for us to follow the old custom and have simple pictures in the churches so that expense would be spared and God and the saints would be venerated more than in this new manner which we now have.

The second abuse is that the painters and sculptors make images of the beloved saints so shamelessly whorish and roguish that neither Venus nor Cupid were so scandalously painted or carved by the pagans. The holy Fathers would not have approved of this. For when we look at the old picture, it is an honourable thing and all the limbs are covered so that no one can conceive from it an evil desire or thought. Therefore I believe that God will now punish the painters and forbid them the practice of their craft if they do not abandon these scandalous ways. For it would be far better to lay such improper and shameless images in the fire than to set them up on altars or in the churches. Indeed, even secular pictures should not be painted so shameless and naked, for they greatly stimulate the desires of the flesh, sin, and scandal. But that is the fault of a perverted world, not of images, and therefore not all images should be removed.

The third abuse is that we are too ready to burst in and offer candles and other things to images. Thus one should not believe in miracles or other signs unless they have been examined, evaluated, and authenticated by pope and bishops. That monks and priests foolishly allow such things in their churches is inexcusable and one is afraid that they, for the sake of their own advantage, are more diligent regarding their images (so that the churches will be decorated and have great congregations) than they are in caring about the living images, which are the souls of men who were created in God's image (Gen. 1[:26]). These and similar misuses are not, in my opinion, to be defended, but, rather, all the leaders and prelates of the Church ought to establish and enforce, in accord with God's will, those rules governing the use of images which were established by the holy Fathers and the councils. Then the heretics

will not find reason so mercilessly to rebuke, burn, and hack images to pieces as has happened in various places and perhaps because of the abuses mentioned above. For where one uses images as they were used and set up in earlier times, they are, as I said in the beginning, praiseworthy, Christian, and divine. They cannot justly be removed, for had God wanted them removed, the matter would not have been reserved for Karlstadt, for much serious effort has gone into this matter. Moreover, Scripture has also never forbidden images, as even Christ did not say the image of the emperor on the coin which the Jews gave to him should be expunged, because the emperor's image was struck there not as an idol but as an emperor, and Scripture only forbids images of idols, as I have convincingly demonstrated above.

3.7.3
Ulrich Zwingli's criticisms of religious images

This extract is taken from the case against religious images prepared by Ulrich Zwingli (1484–1531) for a public debate that took place in 1523 in Zurich, where Zwingli was a preacher. In deriding the protective powers attributed to saints, Zwingli gives an insight into the way images of saints were used, and his condemnation of the fine apparel of images of St Barbara recalls Emser's comments a year earlier. Zwingli's apparently sterile discussion of 'dulia', 'hyperdulia' and 'latria' is intended to expose as false the claim, often made by Catholic defenders of the veneration of saints and images of saints, that the quality of veneration offered to images is different from that offered to God. [KWW]

Source: G. R. Potter (1978), *Huldrych Zwingli* (London: Edward Arnold), pp. 26–8.

24–6 Objections to Images in Churches: 'Commentary on the Sixty-seven Theses', July 1523

24

[A simple man] thought, indeed, that if only he ostentatiously wore a silver or gold image of St Sebastian on the front of his hat he would be safe from

all gun-shots and diseases; or if he recited an Ave Maria to St Christopher every day he would be safeguarded from all misfortunes; or if he had an image of St Barbara, got up fine like a prostitute, set on the altar (the mass-priest being not too particular), he would not die without the last sacraments. And in all his vices, just as if the saint had died so that he himself could sin, it's as if he had said, 'I know that the beloved saint has served God so well that he can give me everything.' The lying, greedy maggots [i.e. false preachers] have thus put wicked ideas into men's heads by their fairy-tale preaching, and this not entirely unsuccessfully: on the feast of St Sebastian the farmers have come dancing to the altar, to the delight of the whole convent.

25

So now the papists cannot talk about their *dulia* and *hyperdulia* (for what does it matter to us what they say about *dulia* and *hyperdulia*?). It is indeed true that one should pray to God alone, first and foremost, and that is called *latria*. But [they go on to maintain that] one may call on the saints and so worship God through them, which they call *dulia*. They also apply this to the mother of God as the highest of all God's servants, naming it *hyperdulia*. Not being able to effect anything with their made-up stories, the first thing to note is that they have invented both words, *dulia* and *hyperdulia*. And in the whole Bible they cannot find *dulia* used anywhere for praying to or calling on the saints. *Hyperdulia* they find absolutely nowhere. But we often find *latria* in the word *latreuein* [λατρεύειν] which means to serve or to honour. Thus Christ uses it [Matt. 4.10] when he says, 'And you shall serve him alone,' or 'You shall honour him alone.' *Latria* is thus used in this place as meaning honour and service, so that a man treats God as goodness in whom he has confidence. About this, Christ says, 'You shall worship the Lord thy God and serve him alone.' That is, you shall not put your trust in any man but in God alone.

26

Two enemies come to [an image of] St George and both ask him to give them the victory. To which of them is he to give it? Or the Spaniards invoke their St James and the French their St Michael. If either of the saints comes to the aid of the ones who have called on him, he must oppose the other side. You

must leave such folly, submit yourselves to the mighty hand of God and stop judging and estimating our exposition by your own prejudices.

[...]

3.7.4
Zurich council orders the removal of images from churches

This decree condemns religious images on grounds of the idolatry forbidden in the second commandment. The identification of the poor as the true images of God recalls the creation of Adam in the image of God (Genesis 1:26) and the seven works of mercy (derived from Matthew 25:31–46), which were to be performed as if to Christ himself. The final sentence, and the way in which biblical language pervades the edict, are symptomatic of the swing from the authority of the church and its culture of images to the sole authority of scripture. This document shows how the orderly removal of images was intended to proceed; what happened in practice could be very different. [KWW]

Source: G. R. Potter (1978), *Huldrych Zwingli* (London: Edward Arnold), p. 28.

Zurich Council: Decree about Images, 15 June 1524

The burgomaster, council and great council have been instructed from holy writ and by their own and other scholars in the recent disputation and have found no other solution than that the almighty God in the Old and New Testaments has forbidden the fabrication of representations or idols and the paying of honour to them. And so the said lords having been so advised, in order to praise and honour God, and so that he should be honoured and prayed to in men's hearts alone, have recognized and concluded that pictures or images should be removed from all the places where they were honoured. Instead, people should turn entirely away from the idols to the living and true God and seek help and comfort in one God through our Lord Jesus Christ upon whom alone they should call and whom they should hold in honour. The goods and money bestowed upon such pictures should be given to poor and needy men, the true images of God. Although our aforesaid lords do not

compel any one to do this, yet their intention is as follows: when a parish has collectively made pictures at common charge, then what is agreeable to the majority shall have preference and they shall agree with one another what to do. Next, in the presence of their minister and other appointed persons they shall be quietly put away in a seemly and orderly manner. Any one who has made an image at his own costs can take it into his own hands without interference from any one. Our aforesaid gracious lords by virtue of their authority have bidden all stipendiary priests and preachers sincerely and earnestly to proclaim the true word of God and all Christian teaching. Thus God's word, rather than the ordinances of men, will prevail.

3.7.5
Luther states his own position on religious images

This section of Martin Luther's treatise 'Against the Heavenly Prophets' (1525) was designed to counter Karlstadt's attack on religious images and specifically to oppose iconoclasm. Here Luther (1483–1546) denounces the enforced removal of images as a form of idolatry in itself because it involved acquiring merit through specific actions. He also suggests that Karlstadt's use of the second commandment in his condemnation of religious images was, in fact, unbiblical. This extract shows that Luther was ambivalent in his attitude to images. Although he talks of 'tearing them from the heart', he maintains the traditional didactic value of religious narratives, whether illustrating his translation of the Bible or in paintings on walls. He realizes that the alternative to religious art might be 'shameless worldly things'. Whereas reformers such as Karlstadt and Zwingli utterly condemned actual images in favour of images of Christ or God 'in the heart', for Luther the natural human tendency to form mental pictures provided qualified justification for actual images as well. His tolerant stance was enough to ensure that in some Lutheran territories, such as Sweden, there was very little destruction or removal of religious art. [KWW]

Source: D. Englander, D. Norman, R. O'Day and W. R. Owens (1990), *Culture and Belief in Europe 1450–1600* (Oxford: Blackwell), pp. 169–71. Reprinted by permission of Blackwell Publishing Ltd.

I approached the task of destroying images by first tearing them out of the heart through God's Word and making them worthless and despised. This indeed took place before Dr Karlstadt ever dreamed of destroying images. For when they are no longer in the heart, they can do no harm when seen with the eyes . . . Which of these two forms of destroying images is best, I will let each man judge for himself.

For where the heart is instructed that one pleases God alone through faith, and that in the matter of images nothing that is pleasing to him takes place, but is a fruitless service and effort, the people themselves willingly drop it, despise images, and have none made. But where one neglects such instruction and forces the issue, it follows that those blaspheme who do not understand and who act only because of the coercion of the law and not with a free conscience. Their idea that they can please God with works becomes a real idol and a false assurance in the heart. Such legalism results in putting away outward images while filling the heart with idols.

. . .

Furthermore, I have allowed and not forbidden the outward removal of images, so long as this takes place without rioting and uproar and is done by the proper authorities. In the world it is considered foolish to conceal the true reason for a good venture out of fear that it may fail. However, when Karlstadt disregards my spiritual and orderly putting away of images and makes me out to be only a 'protector of images', this is an example of his holy and prophetic art, though I only resisted his factious, violent, and fanatical spirit. Now since the evil spirit sits so firmly in his mind I am less inclined than ever to yield to obstinacy and wrong. I will first discuss images according to the law of Moses, and then according to the gospel. And I say at the outset that according to the law of Moses no other images are forbidden than an image of God which one worships. A crucifix, on the other hand, or any other holy image is not forbidden. Heigh now! you breakers of images, I defy you to prove the opposite!

In proof of this I cite the first commandment [Exodus 20:3]: 'You shall have no other gods before me.' Immediately, following this text, the meaning of having other gods is made plain in the words: 'You shall not make yourself a graven image, or any likeness . . .' [Exodus 20:4]. This is said of the same gods, etc. And although these spirits cling to the little word 'make' and stubbornly insist, 'Make, make is something else than to worship,' yet they must admit that this commandment basically speaks of nothing else than of the glory of God. It must certainly be 'made' if it is to be worshipped, and unmade if it is not to be worshipped. It is not valid, however, to pick out one word and

keep repeating it. One must consider the meaning of the whole text in its context. Then one sees that it speaks of images of God which are not to be worshipped. No one will be able to prove anything else. From subsequent words in the same chapter [Exodus 20:23], 'You shall not make gods of silver to be with me, nor shall you make for yourselves gods of gold,' it follows that 'make' certainly refers to such gods.

. . .

Now that we are under our princes, lords, and emperors, we must outwardly obey their laws instead of the laws of Moses. We should therefore be calm and humbly petition them to put away such images . . .

However, to speak evangelically of images, I say and declare that no one is obligated to break violently images even of God, but everything is free, and one does not sin if he does not break them with violence. One is obligated, however, to destroy them with the Word of God, that is, not with the law in a Karlstadtian manner, but with the gospel. This means to instruct and enlighten the conscience that it is idolatry to worship them, or to trust in them, since one is to trust alone in Christ. Beyond this let the external matters take their course. God grant that they may be destroyed, become dilapidated, or that they remain. It is all the same and makes no difference, just as when the poison has been removed from a snake.

Now I say this to keep the conscience free from mischievous laws and fictitious sins, and not because I would defend images. Nor would I condemn those who have destroyed them, especially those who destroy divine and idolatrous images. But images for memorial and witness, such as crucifixes and images of saints, are to be tolerated. This is shown above to be the case even in the Mosaic law. And they are not only to be tolerated, but for the sake of the memorial and the witness they are praiseworthy and honourable, as the witness stones of Joshua [Joshua 24:26] and of Samuel [1 Samuel 7:12].

. . .

I have myself seen and heard the iconoclasts read out of my German Bible. I know that they have it and read out of it, as one can easily determine from the words they use. Now there are a great many pictures in those books, both of God, the angels, men and animals, especially in the Revelation of John and in Moses and Joshua. So now we would kindly beg them to permit us to do what they themselves do. Pictures contained in these books we would paint on walls for the sake of remembrance and better understanding, since they do no more harm on walls than in books. It is to be sure better to paint pictures on walls of how God created the world, how Noah built the ark, and

whatever other good stories there may be, than to paint shameless worldly things. Yes, would to God that I could persuade the rich and the mighty that they would permit the whole Bible to be painted on houses, on the inside and outside, so that all can see it. That would be a Christian work.

Of this I am certain, that God desires to have his works heard and read, especially the passion of our Lord. But it is impossible for me to hear and bear it in mind without forming mental images of it in my heart. For whether I will or not, when I hear of Christ, an image of a man hanging on a cross takes form in my heart, just as the reflection of my face naturally appears in the water when I look into it. If it is not a sin but good to have the image of Christ in my heart, why should it be a sin to have it in my eyes?

3.7.6
Sir Thomas More defends the use of images

In 1529, the year in which Sir Thomas More (1478–1535) was made Henry VIII's chancellor, he published *A Dialogue Concerning Heresies* at the behest of Bishop Tunstall of London. This text was designed to convince the ordinary man of the errors of the reformers' arguments. In true humanist fashion, it was couched in terms of a dialogue between a 'messenger' tempted by reformist arguments and a defender of the faith, effectively the voice of More himself. The two extracts here are taken from the second and third chapters of the first book of the dialogue. Extraordinarily for a literary humanist, More defends religious images as a more immediate and memorable medium than the written word, and he has none of Emser's reservations about artistry, arguing instead that the better crafted the image, the more affecting it will be. For the reformist argument that people do not distinguish between the image and the saint the image represents, More has nothing but scorn: even dogs know better than that, he states. [KWW]

Source: Sir Thomas More (1981), *The Complete Works of St Thomas More*, vol. 6 (A Dialogue Concerning Heresies), ed. T. M. C. Lawler, G. Marc'hadour and R. C. Marius (New Haven and London: Yale University Press), pp. 45–7, 56. Reprinted by permission of the publisher, Yale University Press. Note: the text has been transcribed using modern English spelling.

But I suppose neither scripture nor natural reason doth forbid that a man may do some reverence to an image, not fixing his final intent in the image but referring it further to the honour of the person that the image representeth; since that in such reverence done unto the image there is none honour withdrawn, neither from God nor good man, but both the saint honoured in his image and God in his saint. When a mean man an ambassador to a great king hath much honour done him, to whom does that honour redound – to the ambassador or to the king?

When a man at the receipt of his prince's letter putteth off his cap and kisseth it, doth he this reverence to the paper or to his prince?

In good faith to say the truth these heretics rather trifle than reason in this matter. For where they say that images be but layman's books, they cannot yet say nay but they be necessary if they were but so. Howbeit me thinketh that they be good books, both for layman and for the learned too. For as I somewhat said unto you before, all the words that be either written or spoken be but images representing the things that the writer or speaker conceiveth in his mind: likewise as the figure of the thing framed with imagination and so conceived in the mind is but an image representing the very thing itself that a man thinketh on. As for example, if I tell you a tale of my good friend your master, the imagination that I have of him in my mind is not your master himself but an image that representeth him. And when I name you him, his name is neither himself nor yet the figure of him, which figure is in mine imagination, but only an image representing to you the imagination of my mind. Now if I be too far from you to tell it you, then is the writing not the name itself but an image representing the name. And yet all these names spoken and all these words written be no natural signs or images but only made by consent and agreement of man to betoken and signify such thing, whereas images painted graven or carved may be so well wrought and so near to the quick and to the truth that they shall naturally and much more effectually represent the thing than shall the name either spoken or written. For he that never heard the name of your master shall if ever he saw him be brought in a rightful remembrance of him by his image well wrought, and touched to the quick. And surely saying that men cannot do it else if it might commodiously be done, there were not in this world so effectual writing as were to express all thing in imagery. And now likewise as a book well made and well written better expresseth the matter than doth a book made by a rude man that cannot well tell his tale and written with an evil hand: so doth an image well workmanly wrought better express the thing than doth a thing rudely made, but if it move a man for some other special cause as peradventure for some great antiquity or the great virtue of the workman or for that God

showeth at the place some special assistance of his favour and grace. But now as I began to say, since all names spoken or written be but images, if you set aught by the name of Jesus spoken or written: why should you set nought by his image, painted or carved, that representeth his holy person to your remembrance as much and more to as doth his name written? Nor these two words Christus Crucifixus do not so lively represent us the remembrance of his bitter passion as doth a blessed image of the crucifix, neither to layman nor unto a learned. And this perceive these heretics themselves well enough. Nor they speak not against images for any furtherance of devotion but plainly for a malicious mind to diminish and quench men's devotions. For they see well enough that there is no man but if he love another but he delighteth in his image or anything of his. And these heretics that be so sore against the images of God and his holy saints would be yet right angry with him that would dishonestly handle an image made in remembrance of one of themselves, where the wretches forbear not villainously to handle and cast dirt in despite upon the holy crucifix, an image made in remembrance of our saviour himself, and not only of his most blessed person but also of his most bitter passion. [. . .]

Nor the flock of Christ is not so foolish as those heretics bear them in hand, that whereas there is no dog so mad but he knoweth a very cony [rabbit] from a cony carved and painted, Christian people that have reason in their heads and thereto the light of faith in their souls should ween [suppose] that the images of Our Lady were Our Lady herself. Nay they be not I trust so mad but they do reverence to the image for the honour of the person whom it representeth, as every man delighteth in the image and remembrance of his friend. And albeit that every good Christian man hath a remembering of Christ's passion in his mind and conceiveth by devout meditation of form and fashion thereof in his heart, yet is there no man I ween so good nor so well learned nor in meditation so well accustomed but that he findeth himself more moved to pity and compassion upon the beholding of the holy crucifix than when he lacketh it. And if there be any that for the maintenance of his opinion will peradventure say that he findeth it otherwise in himself he should give me cause to fear that he hath of Christ's passion neither the one way nor the other but a very faint feeling, since that the Holy Fathers before us did and all devout people about us do find and feel in themselves the contrary.

3.7.7
William Tyndale responds to Sir Thomas More

When William Tyndale (c.1494–1536) wrote his answer to Sir Thomas More's dialogue he was in exile in the Netherlands, where his English translation of the New Testament was published in 1526. In the first of the extracts here, Tyndale's outrage that more is spent on a coat for a wooden image ('post') than 'the lively image of God' (the poor) recalls the practice of adorning statues with real clothing. His doubts that riches lavished on a statue will inculcate in viewers a Christ-like attitude to wealth countered More's assertion in the first book of his *Dialogue* that God deserved the richest offerings. In this, and the second extract, Tyndale revealed that, unlike Karlstadt and Zwingli, he was not implacably opposed to images, but just the abuse of them. Tyndale's comment about Serenus, Bishop of Marseilles, and Pope Gregory the Great refers to a famous letter in which Gregory exhorted Serenus to abandon iconoclasm and preserve images for their didactic power. Although Tyndale evidently recognized this point, he remained unable to sanction the use of images while they presented a spiritual stumbling block to others. [KWW]

Source: William Tyndale (2000), *An Answer unto Sir Thomas Mores Dialoge*, ed. A. M. O'Donnell and J. Wicks (Washington: Catholic University of America Press), pp. 57–9, 61, 184. Used with permission of the Catholic University of America Press, Washington DC. Note: the text has been transcribed using modern English spelling.

Now let us come to the worshipping or honouring of sacraments, ceremonies images and relics. First images be not God and therefore no confidence is to be given them. They be not made after the image of God, nor are the price of Christ's blood, but the workmanship of the craftsman and the price of money and therefore inferior to man.

Wherefore of all right man is Lord over them and the honour of them is to do man service and man's dishonour it is to do them honourable service as unto his better. Images then and relics ye and as Christ sayeth the Holy Day too are servants unto man. And therefore it followeth that we cannot but unto our damnation put one coat worth an hundred coats upon a post's [statue's] back and let the image of God and the price of Christ's blood go up

and down thereby naked. For if we care more to clothe the dead image by man and the price of silver than the lively image of God and price of Christ's blood then we dishonour the image of God and him that made him and the price of Christ's blood and him that bought him.

Wherefore the right use, office and honour of all creatures inferior unto man is to do man service, whether they be images, relics, ornaments, signs or sacraments, holidays, ceremonies or sacrifices. And that may be on this manner and no doubt it so once was. If (for an example) I take a piece of the cross of Christ and make a little cross therefore and bear it about me to look thereon with a repenting heart at times when I am moved thereto to put me in remembrance that the body of Christ was broken and his blood shed thereon for my sins and believe steadfastly that the merciful truth of God shall forgive the sins of all that repent for his death sake and never think on them more, then it serveth me and I not it and doeth me the same service as if I read the testament in a book or as if the preacher preached it unto me. And in like manner if I make a cross in my forehead in a remembrance that God hath promised assistance unto all that believe in him for his sake that died on the cross, then doth the cross serve me and I not it. And in like manner if I bear on me or look upon a cross of whatsoever matter it be or make a cross upon me in remembrance that whosoever will be Christ's disciple must suffer a cross of adversity, tribulations and persecution, so doth the cross serve me and I not it. And this was the use of the cross once and for this cause it was at the beginning set up in the churches.

And so if I make an image of Christ or of anything that Christ hath done for me in a memory, it is good and not evil until it be abused.

And even so, if I take the true life of a saint and cause it to be painted or carved to put me in remembrance of the saint's life, to follow the saint as the saint did Christ and to put me in remembrance of the great faith of the saint to God and how true God was to help him out of all tribulation, and so see the saint's love toward his neighbour in that he so patiently suffered so painful a death and so cruel martyrdom to testify the truth for to save other, and all to strength my soul withal and my faith to God and love to my neighbour, then doth the image serve me and I not it. And this was the use of images at the beginning and of relics also.

And to kneel before the cross and to the word of God which the cross preacheth is not evil. Neither to kneel down before an image in a man's meditations, to call the living of the saint to mind for to desire God of like grace to follow the example is not evil. But the abuse of the thing is evil and to have a false faith: as to bear a piece of the cross about a man thinking that so long as that is about him spirits shall not come at him, his enemies shall do him

no bodily harm, all causes shall go on his side even for bearing it about him, and to think that if it were not about him it would not be so, and to think if any misfortune chance that it came for leaving it off, or because this or that ceremony was left undone, and not rather because we have broken God's commandments or that God tempteth us to prove our patience. [...]

And as for the riches that is bestowed on images and relics, they cannot prove but that it is abominable as long as the poor are despised and uncared for and not first served, for whose sakes and to find preachers offerings, tithes, lands, rents and all that they have was given the spirituality. They will say we may do both. May or not may, I see that the one most necessary of both is not done: but the poor are bereaved of the spirituality of all that was in time past offered unto them. Moreover though both were done, they shall never prove that the sight of gold and silver and of precious stones should move a man's heart to despise such things after the doctrine of Christ. Neither can the rich coat help to move thy mind to follow the example of the saint, but rather if he were portrayed as he suffered in the most ungodly wise. [...]

In so much that when Cirenus [Serenus], the Bishop of Masilia [Marseille], offended with the superstitiousness of the people, burnt them St Gregory wrote that he should not destroy the images but teach only that the people should not worship them. But when it was so far come that the people worshipped them with a false faith (as we now know no other use) and were no longer memorials only, then the Bishops of Greece and the Emperor gathered them together to provide a remedy against that misuse[1] and concluded that they should be put down for the abuse, thinking it so most expedient, having for them first the example of God, whom a man may boldly follow, which commanded in beginning of all his precepts that there should be no image used to worship or pray before, not for the image itself but for the weakness of his people: and having again before their eyes that the people were fallen unto idolatry and image serving by the reason of them.

Now answer me, by what reason canst thou make an heretic of him that concludeth nought against God but worketh with God and putteth that block out of the way whereat his brother, the price of Christ's blood, stumbleth and loseth his soul. They put not down the images for hate of God and of his saints, no more than Ezechias broke the brazen serpent for envy of the great miracle that was wrought by it, or in spite of God that commanded it to be kept for a memorial. But to keep the people in the true faith only. Now seeing we may be all without images, and to put them down is not against God's commandment but with it, namely if they be abused to the dishonour of God

[1] Original 'Misheue'.

and hurt of our neighbours, where is charity if thou which knowest the truth and canst use thine image well wilt not yet forbear thine image and suffer it to be put out of the way for thy weak brother's sake whom thou seest perish there through? Yea, and what thing maketh both the Turk and the Jew abhor our faith so much as our image service?

List of Sources and Acknowledgements

The editors and publisher gratefully acknowledge the permission granted to reproduce the copyright material in this book:

1.1.1: Cennino Cennini (1960), *The Craftsman's Handbook: The Italian 'Il libro dell'arte'*, trans. D. V. Thompson (New York: Dover Publications), pp. 4–5. Reprinted by permission of Dover Publications, Inc.

1.1.2: Leon Battista Alberti (1991), *On Painting*, trans. C. Grayson, intro. and notes M. Kemp (Harmondsworth: Penguin), pp. 72–3.

1.1.3: Creighton E. Gilbert (1992), *Italian Art 1400–1500* (Evanston, IL: Northwestern University Press), p. 34. Reprinted by permission of Creighton E. Gilbert, translator, and the publisher, Northwestern University Press.

1.1.4: V. van der Haeghen (1914), 'Notes sur l'atelier de Gérard Horenbault vers la fin du XVIème siècle', *Bulletijn der Maatschappij van Geschied en Oudheidkunde te Gent*, I, vol. 22, pp. 29–30. Translated from the Flemish by Rembrandt Duits. Copyright © The Open University 2007.

1.1.5: Camillo Boselli (1977), *Regesto artistico dei notai roganti in Brescia dal'anno 1500 all'anno 1560*, 2 vols, Brescia, vol. 1, pp. 80–1. Translated from the Latin by Dario Tessicini. Copyright © The Open University 2007.

1.1.6: Leonardo da Vinci (1954), *The Notebooks of Leonardo da Vinci*, ed. and trans. E. MacCurdy, 2 vols. (London: The Reprint Society), vol. 2, pp. 218, 221, 222, 240, 241, 260. Reprinted by permission of Mr Alec McCurdy [sic].

1.1.7: W. M. Conway (1958), *The Writings of Dürer* (London: Peter Owen), pp. 120–1. Reprinted by permission of Peter Owen Ltd, London.

1.1.8: W. M. Conway (1958), *The Writings of Dürer* (London: Peter Owen), p. 181. Reprinted by permission of Peter Owen Ltd, London.

1.1.9: W. M. Conway (1958), *The Writings of Dürer* (London: Peter Owen), pp. 136–9. Reprinted by permission of Peter Owen Ltd, London.

1.2.1: Cennino Cennini (1960), *The Craftsman's Handbook: The Italian 'Il libro dell'arte'*, trans. D. V. Thompson Jr (New York: Dover Publications), pp. 56–7. Reprinted by permission of Dover Publications, Inc.

1.2.2: Leon Battista Alberti (1991), *On Painting*, trans C. Grayson, intro. and notes M. Kemp (Harmondsworth: Penguin), pp. 37, 39–44, 46–9, 53–4, 58–9, 64–7.

1.2.3: Lorenzo Ghiberti (1967), *I Commentari*, ed. O. Morisani (Naples: Riccardo Ricciardi, Editore), pp. 58–9. Translated from the Italian by Rahel Nigussie and Carol M. Richardson. Copyright © The Open University 2007.

1.2.4: Filarete (1965), *Treatise on Architecture*, trans. and ed. J. R. Spencer (New Haven and London: Yale University Press), vol. 1, pp. 302–4. Reprinted by permission of the publisher, Yale University Press.

1.2.5: Piero della Francesca (1984), *De Prospectiva Pingendi*, ed. G. Nicco-Fasola (Florence: Casa Editrice), pp. 63–6. Translated from the Italian by Rahel Nigussie and Carol M. Richardson.

1.2.6: Antonio di Tuccio Manetti (1970), *Life of Brunelleschi*, ed. H. Saalman, trans. C. Enggass (University Park and London: Pennsylvania State University Press), pp. 42–6. © 1970 by The Pennsylvania State University. Reproduced by permission of the publisher.

1.2.7: Leonardo da Vinci (1938), *The Notebooks of Leonardo da Vinci*, ed. and trans. E. MacCurdy, 2 vols (London: Jonathan Cape), vol. 2, pp. 343, 345–6, 352–3. Reprinted by permission of Mr Alec McCurdy [sic].

1.3.1: E. J. Soil de Moriamé (1912), *Les anciennes industries d'art tournaisiennes à l'exposition de 1911* (Tournai), pp. 24–6. Translated from the French by Isabelle Dolezalek. Copyright © The Open University 2007.

1.3.2: D. S. Chambers (1970), *Patrons and Artists in the Italian Renaissance* (London: Macmillan), pp. 63–5. Reprinted by permission of Palgrave Macmillan.

1.3.3: D. S. Chambers (1970), *Patrons and Artists in the Italian Renaissance* (London: Macmillan), p. 66. Reprinted by permission of Palgrave Macmillan.

1.3.4: H. Nieuwdorp (1981), 'De oorspronkelijke betekenis en interpretatie van de keurmerken op Brabantse retabels en beeldsnijwerk', in *Archivum Artis Lovaniense, Bijdragen tot de Geschiedenis van de Kunst der Nederlanden. Opgedragen aan Prof. E. Dr K. J. Steppe* (Leuven: Uitgeverij Peeters), p. 93. Translated from the Dutch by Rembrandt Duits. Copyright © The Open University 2007. Reprinted by permission of Uitgeverij Peeters.

1.3.5: Leon Battista Alberti (1972), *On Painting and Sculpture: The Latin Texts of 'De Pictura' and 'De Statua'*, ed. and trans. C. Grayson (London: Phaidon), pp. 122–5, 129. © 1972 by Phaidon Press Limited.

1.3.6: J. B. van der Straelen (1855), *Jaerbock der vermaerde en Kunstryke Gilde van Sint Lucas binnen de Stad Antwerpen* (Antwerp), pp. 13–16. Translated from the Dutch by Ria de Boodt, Kim W. Woods and Rembrandt Duits. Copyright © The Open University 2007. Reprinted by permission of Uitgeverij Peeters.

1.3.7: W. Halsema-Kubes, G. Lemmens and G. de Werd (1980), *Adriaen van Wesel, een Utrechtse beeldhouwer uit de late middeleeuwen* (The Hague: Staatsuitgeverij (exhibition catalogue)), pp. 57–9. Translated from the Dutch by Rembrandt Duits. Copyright © The Open University 2007. Reprinted by permission of Rijksmuseum, Amsterdam.

1.4.1: Filarete (1965), *Treatise on Architecture*, trans. and ed. J. R. Spencer (New Haven and London: Yale University Press), vol. 1, pp. 6, 7, 94–5, 96, 97, 99, 102. Reprinted by permission of the publisher, Yale University Press.

1.4.2: Antonio di Tuccio Manetti (1970), *Life of Brunelleschi*, ed. H. Saalman, trans. C. Enggass (University Park and London: Pennsylvania State University Press), pp. 34, 36, 50, 52, 54, 94–8, 120–6. © 1970 by The Pennsylvania State University. Reproduced by permission of the publisher.

1.5.1: Cennino Cennini (1960), *The Craftsman's Handbook: The Italian 'Il libro dell'arte'*, trans. D. V. Thompson (New York: Dover Publications), pp. 49–50. Reprinted by permission of Dover Publications, Inc.

1.5.2: Cennino Cennini (1960), *The Craftsman's Handbook: The Italian 'Il libro dell'arte'*, trans. D. V. Thompson (New York: Dover Publications), pp. 64–5. Reprinted by permission of Dover Publications, Inc.

1.5.3: Cennino Cennini (1960), *The Craftsman's Handbook: The Italian 'Il libro dell'arte'*, trans. D. V. Thompson (New York: Dover Publications), pp. 69–70. Reprinted by permission of Dover Publications, Inc.

1.5.4: Cennino Cennini (1960), *The Craftsman's Handbook: The Italian 'Il libro dell'arte'*, trans. D. V. Thompson (New York: Dover Publications), pp. 91–3. Reprinted by permission of Dover Publications, Inc.

1.5.5: M. H. Laurent (1935), 'Documenti Vaticani intorno alla "Madonna della Neve" del Sassetta', *Bullettino senese di storia patria*, XLII, pp. 260–1. Translated from the Latin by Dario Tessicini. Copyright © The Open University 2007.

1.5.6: M. H. Laurent (1935), 'Documenti Vaticani intorno alla "Madonna della Neve" del Sassetta', *Bullettino senese di storia patria*, XLII, pp. 262–3. Translated from the Latin by Dario Tessicini. Copyright © The Open University 2007.

1.5.7: M. H. Laurent (1935), 'Documenti Vaticani intorno alla "Madonna della Neve" del Sassetta', *Bullettino senese di storia patria*, XLII, pp. 263–4. Translated from the Latin by Dario Tessicini. Copyright © The Open University 2007.

1.5.8: M. H. Laurent (1935) 'Documenti Vaticani intorno alla "Madonna della Neve" del Sassetta', *Bullettino senese di storia patria*, XLII, pp. 265–6. Translated from the Latin by Dario Tessicini. Copyright © The Open University 2007.

1.5.9: E. Gilmore Holt, ed. (1957), *A Documentary History of Art*, vol. 1: *The Middle Ages and the Renaissance*, 2 vols (New York: Doubleday), pp. 298–302. © 1981 Princeton University Press. Reprinted by permission of Princeton University Press.

1.6.1: Jan van der Stock (1998), *Printing Images in Antwerp: The Introduction of Printmaking in a City, Fifteenth Century to 1585* (Rotterdam: Sound & Vision Interactive), doc. 3, pp. 305–6. Translated from the Dutch by Ria de Boodt and Rembrandt Duits. Copyright © The Open University 2007.

1.6.2: (a) Victor Scholderer (1966), 'The Petition of Sweynheym and Pannarz to Sixtus IV', in D. E. Rhodes (ed.), *Fifty Essays in Fifteenth- and Sixteenth-Century Bibliography* (Amsterdam: Menno Hertzberger, pp. 72–3; (b) Massimo Miglio, ed. (1978), *Giovanni Andrea Bussi. Prefazioni alle edizioni di Sweynheym e Pannartz. Prototipografi Romani* (Milan: Edizioni di Polifilo), pp. 82–4. (List of books with dates from Edwin Hall (1991), *Sweynheym and Pannartz and the Origins of Printing in Italy: German Technology and Italian Humanism in Renaissance Rome* (Oregon: Bird and Bull Press for Phillip J. Pirages), pp. 16–17.) Translated from the Latin by Dario Tessicini. Copyright © The Open University 2007.

1.6.3: A. A. Renouard (1803), *Annales de l'Imprimerie des Aldus*, Paris, vol. 2, pp. 207–11. Translated from the Latin by Dario Tessicini. Copyright © The Open University 2007.

1.6.4: H. Rupprich (1956), *Dürer Schriftlicher Nachlass*, vol. 1 (Berlin: Deutsche Verein für Kunstwissenschaft), pp. 72–3. Translated from the German by Susanne Meurer. Copyright © The Open University 2007.

1.6.5: A. Biff (1892), 'Rechnungsauszüge, Urkunden und Urkundenregesten aus dem Augsburger Stadtarchive, I, 1442–1519', *Jahrbuch der Kunsthistorischen Sammlungen des Allerhöchsten Kaiserhauses*, vol. 13, part 2, pp. xvii–xviii. Translated from the German by Susanne Meurer. Copyright © The Open University 2007.

1.6.6: Jan van der Stock (1998), *Printing Images in Antwerp: The Introduction of Printmaking in a City, Fifteenth Century to 1585* (Rotterdam: Sound & Vision Interactive), doc, 13, p. 319. Translated from the Dutch by Ria de Boodt and Rembrandt Duits. Copyright © The Open University 2007.

1.6.7: Erasmus Desiderius (1985), *Collected Works*, ed. J. K. Sowards, vol. 26 (*Literary and Educational Writings 4: De recta pronuntiatione*), trans. Maurice Pope (Toronto: University of Toronto Press), pp. 398–9, and p. 597 for notes. Reprinted by permission of the University of Toronto Press.

1.6.8: Jan van der Stock (1998), *Printing Images in Antwerp: The Introduction of Printmaking in a City, Fifteenth Century to 1585* (Rotterdam: Sound & Vision Interactive), doc. 17, pp. 328–9. Translated from the French by Isabelle Dolezalek. Copyright © The Open University 2007.

1.6.9: Giorgio Vasari (1996), *Lives of the Painters, Sculptors and Architects*, trans. G. du C. de Vere, intro. and notes D. Ekserdjian, 2 vols (London: David Campbell (Everyman's Library); this edition first published 1927 by Dent), vol. 2, pp. 78–9, 81–2, 84–5.

1.7.1: Lorenzo Ghiberti (1912), *Denkwürdigkeiten: I Commentarii*, ed. Julius von Schlosser Magnino, 2 vols (Berlin: Julius Bard), vol. 1, pp. 3–8 and vol. 2, p. 99. Translated from the Italian by Dario Tessicini with footnotes translated from the German by Gerald Schmidt. Copyright © The Open University 2007.

1.7.2: Antonio di Tuccio Manetti (1970), *Life of Brunelleschi*, ed. H. Saalman, trans. C. Enggass (University Park and London: Pennsylvania State University Press), pp. 56–62. © 1970 by The Pennsylvania State University. Reproduced by permission of the publisher.

1.7.3: Leonardo da Vinci (1954), *The Notebooks of Leonardo da Vinci*, ed. and trans. E. MacCurdy, 2 vols (London: Reprint Society), vol. 2, p. 258. Reprinted by permission of Mr Alec McCurdy [sic].

1.7.4: Leonardo da Vinci (1954), *The Notebooks of Leonardo da Vinci*, ed. and trans. E. MacCurdy, 2 vols (London: Reprint Society), vol. 2, pp. 507–11. Reprinted by permission of Mr Alec McCurdy [sic].

1.7.5: Baldassare Castiglione (1967), *The Book of the Courtier: Baldassare Castiglione*, trans. G. Bull (Harmondsworth: Penguin), pp. 96–101, 350. © 1967 by George Bull. Reproduced by permission of Penguin Books Ltd.

2.1.1: C. E. Gilbert (1980), *Italian Art, 1400–1500: Sources and Documents* (Englewood Cliffs, NJ and London: Prentice-Hall), pp. 4–5. (Original text in G. Gaye (1839), *Carteggio Inedito d'Artisti*, vol. 1, pp. 136–7.) Reprinted by permission of Creighton E. Gilbert.

2.1.2: D. S. Chambers (1970), *Patrons and Artists in the Italian Renaissance* (London: Macmillan), pp. 20–1. Reproduced with permission of Palgrave Macmillan.

2.1.3: D. S. Chambers (1970), *Patrons and Artists in the Italian Renaissance* (London: Macmillan), pp. 21–2. Reproduced with permission of Palgrave Macmillan.

2.1.4: D. Corvi (1969), 'Botticelli and Pope Sixtus IV', *Burlington Magazine*, vol. 111, p. 617. Translated from the Latin by Dario Tessicini. Copyright © The Open University 2007. Reprinted by permission of the Burlington Magazine.

2.1.5 D. S. Chambers (1970), *Patrons and Artists in the Italian Renaissance* (London: Macmillan), p. 23. (Original text in E. Müntz (1889), *Archivio storico dell'arte*, vol. 2, p. 484.) Reproduced with permission of Palgrave Macmillan.

2.1.6: D. S. Chambers (1970), *Patrons and Artists in the Italian Renaissance* (London: Macmillan), pp. 24–5. Reproduced with permission of Palgrave Macmillan.

2.1.7: C. E. Gilbert (1980), *Italian Art, 1400–1500: Sources and Documents* (Englewood Cliffs, NJ and London: Prentice-Hall), p. 139. Reprinted by permission of Creighton E. Gilbert.

2.1.8: Michelangelo (1987), *Life, Letters and Poetry* (Oxford: Oxford University Press), p. 77. Reprinted by permission of Oxford University Press.

2.1.9: Girolamo Porcari (1497), *Tuscus et Remus adversus Savonarolam* (Rome). (Latin text in A. Modigliani (1998), 'Roma e Firenze "Tuscus et Remus": Due modelli oppositione?', *Studi Romani*, vol. 46, nos 1–2, pp. 23–8.) Translated from the Latin by Jeremy G. Taylor. Copyright © The Open University 2007.

2.1.10: C. E. Gilbert (1980), *Italian Art, 1400–1500: Sources and Documents* (Englewood Cliffs, NJ and London: Prentice-Hall), pp. 102–3. Reprinted by permission of Creighton E. Gilbert.

2.2.1: M. Letts (ed.) (1926), *Pero Tafur: Travels and Adventures 1435–1439* (London: Routledge), ch. 24, pp. 198–204. Reprinted by permission of Routledge.

2.2.2: J. Berg Sobré (1989), *Behind the Altar Table: The Development of the Painted Retable in Spain, 1350–1500* (Columbia, MO: University of Missouri Press), pp. 290–2.

2.2.3: W. Stechow (1966), *Northern Renaissance Art 1400–1500: Sources and Documents* (Evanston, IL: Northwestern University Press), pp. 8–9. Reprinted by permission of Northwestern University Press.

2.2.4: M. Baxandall (1964), 'Bartolomaeus Facius on painting', *Journal of the Warburg and Courtauld Institutes*, vol. XXVII, pp. 102, 104–5.

2.2.5: From T. Frimmel (1896), 'Der Anonimo Morelliano', *Quellenschriften für Kunstgeschichte und Kunsttechnik*, new series, vol. i, pp. 16, 20, 54, 94, 98, 100, 102, 104. Translated from the Italian by Dario Tessicini. Copyright © The Open University 2007.

2.2.6: F. Nicolini (1925), *L'Arte Napoletana del Rinascimento* (Naples), pp. 161–3. Translated from the Italian by Dario Tessicini. Copyright © The Open University 2007.

2.3.1: A. Wauters (1878), *Les tapisseries bruxelloises. Essai historique sur les tapisseries et les tapissiers de haute et de basse-lice de Bruxelles* (Brussels: Julien Baertsoen), note 1, pp. 35–40. Translated from the Dutch by Ria de Boodt and Elizabeth Cleland. Copyright © The Open University 2007.

2.3.2: C. Conti (1875), *Ricerche storiche sull'arte degli arazzi in Firenze* (Florence: G. C. Sansoni), appendix doc. 1, pp. 95–6. Translated from the Latin by Dario Tessicini. Copyright © The Open University 2007.

2.3.3: A. Wauters (1878), *Les tapisseries bruxelloise. Essai historique sur les tapisseries et les tapissiers de haute et de basse-lice de Bruxelles* (Brussels: Julien Baertsoen), note 1, pp. 48–9. Translated from the Dutch by Ria de Boodt and Elizabeth Cleland. Copyright © The Open University 2007.

2.4.1: Lorenzo Ghiberti (1912), 'The Commentaries of Lorenzo Ghiberti', in J. von Schlosser (ed.), *Lorenzo Ghiberti's Denkwürdigkeiten (I Commentarii)*, translated by the staff of the Courtauld Institute of Art, 2 vols (Berlin), pp. 18–19.

2.4.2: M. Eisenberg (1981), 'The First Altar-piece for the "Cappella dei Signori" of the Palazzo Pubblico', *Burlington Magazine*, CXXIII, pp. 135–6. Reprinted by permission of the Burlington Magazine.

2.4.3: Pius II (1936–7), *The Commentaries of Pius II*, trans. F. Alden Gragg with notes by L. C. Gabel, *Smith College Studies in History* (Northampton, MA), XXII, pp. 51–62. Reprinted with the publisher's permission.

2.4.4: Pius II (1947), *The Commentaries of Pius II*, trans. F. Alden Gragg with notes by L. C. Gabel, *Smith College Studies in History* (Northampton, MA), XXX, p. 391. Reprinted with the publisher's permission.

2.4.5: Pius II (1951), *The Commentaries of Pius II*, trans. F. Alden Gragg with notes by L. C. Gabel, *Smith College Studies in History* (Northampton, MA), XXXV, pp. 601–3. Reprinted with the publisher's permission.

2.5.1: M. I. Μανούσακας (1960–1), Ἡ Διαθήκη του᾿ Αγγελου Ακοτάντου (1436), ἀγνωστου Κρητικοῦ Ζωγράφου᾿, Δελτιον της Χριστιανικῆς Αρχαιολογικῆς Εταιρείας [M. I. Manousakas, 'The Testament of Angelos Akotantos (1436), an Unknown Cretan Painter', *Deltion tis Christianikis Archaiologikis Etaireias*], vol. 4, ser. 2, pp. 146–9. Translated from the Greek by Dimitra Kotoula. Latin notes translated by Dario Tessicini. Copyright © The Open University 2007.

2.5.2: M. Cattapan (1968), 'Nuovi Documenti Riguardanti Pittori Cretesi dal 1300 al 1500', *Πεπραγμένα του Β΄ Διεθνοὺς Κρητολογικοῦ Συνεδρίου*, τ. Γ (Τμῆμα Μεσαιωνολογικὸν) [Pepragmena of the II Diethnous Kretologikou Synedriou, vol. III, Tmima Mesaionologikon] (Athens), pp. 42–3. Translated from the Latin by Dario Tessicini. Copyright © The Open University 2007.

2.5.3: M. Cattapan (1968), 'Nuovi Documenti Riguardanti Pittori Cretesi dal 1300 al 1500', *Πεπραγμένα του Β΄ Διεθνοὺς Κρητολογικοῦ Συνεδρίου*, τ. Γ (Τμῆμα Μεσαιωνολογικὸν) [Pepragmena of the II Diethnous Kretologikou Synedriou, vol. III, Tmima Mesaionologikon], (Athens), pp. 44–5. Translated from the Latin by Dario Tessicini. Copyright © The Open University 2007.

2.5.4: M. Cattapan (1972), 'Nuovi elenchi e documenti dei pittori in Creta dal 1300 al 1500', *Θησαυρισματα* [Thesaurismata], vol. 9, p. 221. Translated from the Latin by Dario Tessicini. Copyright © The Open University 2007.

2.5.5: M. Cattapan (1977), 'I Pittori Pavia, Rizo, Zafuri da Candia e Papadopoulo dalla Canea', *Θησαυρισματα* [Thesaurismata], vol. 14, no. 15, p. 215. Translated from the Latin by Dario Tessicini. Copyright © The Open University 2007.

2.5.6: M. Cattapan (1972), 'Nuovi elenchi e documenti dei pittori in Creta dal 1300 al 1500', *Θησαυρισματα* [Thesaurismata], vol. 9, pp. 209–10. Translated from the Latin by Dario Tessicini. Copyright © The Open University 2007.

2.5.7: P. Hetherington (ed. and trans.) (1974), *The 'Painter's Manual' of Dionysius of Fourna* (London: Sagittarius Press), p. 5.

2.5.8: P. Hetherington (ed. and trans.) (1974), *The 'Painter's Manual' of Dionysius of Fourna* (London: Sagittarius Press), p. 14.

2.6.1: D. Chambers and B. Pullan with J. Fletcher (eds.) (1992), *Venice: A Documentary History* (Oxford: Blackwell), pp. 281–5. Reprinted by permission of Blackwell Publishing Ltd.

2.6.2: D. S. Chambers (ed.) (1970), *Patrons and Artists in the Italian Renaissance* (London: Macmillan), pp. 79–80. Reproduced with permission of Palgrave Macmillan.

2.6.3: Patricia Fortini Brown (1988), *Venetian Narrative Painting in the Age of Carpaccio* (New Haven and London: Yale University Press), p. 54. Reprinted by permission of the publisher, Yale University Press.

2.6.4: Patricia Fortini Brown (1988). *Venetian Narrative Painting in the Age of Carpaccio* (New Haven and London: Yale University Press), p. 273. Translated from the Latin by Dario Tessicini. Reprinted by permission of the publisher, Yale University Press.

2.6.5: Patricia Fortini Brown (1988), *Venetian Narrative Painting in the Age of Carpaccio* (New Haven and London: Yale University Press), p. 274. Translated from the Latin by Dario Tessicini. Copyright © The Open University 2007. Reprinted by permission of the publisher, Yale University Press.

2.6.6: D. S. Chambers (ed.) (1970), *Patrons and Artists in the Italian Renaissance* (London: Macmillan), pp. 80–1. Reproduced with permission of Palgrave Macmillan.

2.6.7: D. Chambers and B. Pullan with J. Fletcher (eds) (1992), *Venice: A Documentary History* (Oxford: Blackwell), pp. 6–7, 9–10, 11, 13. Reprinted by permission of Blackwell Publishing Ltd.

2.6.8: S. Kinser (ed.) (1969), *The Memoirs of Philippe de Commynes*, trans. I. Cazeaux, 2 vols (Columbia, SC: University of South Carolina Press, and New York: Harper Torchbooks). Extracts from vol. 2, bk 7, ch. 18, pp. 489–90 and 500–1.

2.6.9: P. Fortini Brown (2000), 'Behind the Walls: The Material Culture of Venetian Elites', in J. Martin and D. Romano (eds), *Venice Reconsidered* (Baltimore: Johns Hopkins University Press), pp. 295–338 (passage cited on p. 296). © 2000 by Johns Hopkins University Press. Reprinted with permission of the Johns Hopkins University Press. Fortini Brown's source was M. Margaret Newett (1907), *Canon Pietro Casola's Pilgrimage to Jerusalem in the Year 1494* (Manchester: Manchester University Press), pp. 128–9.

2.6.10: D. S. Chambers (ed.) (1970), *Patrons and Artists in the Italian Renaissance* (London: Macmillan), pp. 56–7. Reproduced with permission of Palgrave Macmillan.

2.6.11: Patricia Fortini Brown (1988), *Venetian Narrative Painting in the Age of Carpaccio* (New Haven and London: Yale University Press), pp. 392–3. Translated from the Italian by Dario Tessicini. Copyright © The Open University 2007. Reprinted by permission of the publisher, Yale University Press.

2.6.12: D. S. Chambers (ed.) (1970), *Patrons and Artists in the Italian Renaissance* (London: Macmillan), p. 58. Reproduced with permission of Palgrave Macmillan.

2.6.13: the nineteenth-century translation of Dürer's letters by Sir Martin Conway in T. Sturge Moore (1905–11), *Albert Dürer* (London: Duckworth), 1905/11. The extracts are from pp. 80–91.

2.6.14: D. Chambers and B. Pullan with J. Fletcher (eds) (1992), *Venice: A Documentary History* (Oxford: Blackwell), pp. 391–3. Reprinted by permission of Blackwell Publishing Ltd.

2.7.1: Vitruvius (1999), *Ten Books on Architecture*, trans. I. D. Rowland, with commentary and illustrations by T. Noble Howard and additional commentary by I. D. Rowland (Cambridge: Cambridge University Press), pp. 1, 25, 26, 47, 48, 54, 55. Reprinted by permission of the authors and of Cambridge University Press.

2.7.2: Leon Battista Alberti (1988), *On the Art of Building*, trans. and eds J. Rykwert, N. Leach and R. Tavernor (Cambridge, MA: MIT Press), pp. 154–9, 182, 195, 196–7, 211–12, 230–2, 292–4, 307–8, 309, 317. Reprinted by permission of the publisher, MIT Press.

3.1.1: Léon de Laborde (1849–52), *Les ducs de Bourgogne. Études sur les lettres, les arts et l'industrie pendant le XVe siècle et plus particulièrement dans les Pays-Bas et le duché de Bourgogne*, 3 vols (Paris: Plon frères), vol. 2. Translated from the French by Isabelle Dolezalek and Rembrandt Duits. Copyright © The Open University 2007.

3.1.2: C. Mazzi (1900), 'La casa di Maestro Bartolo di Tura', in *Bulletino Senese di Storia Patria*, 3. Translated from the Italian by Dario Tessicini and Rembrandt Duits. Copyright © The Open University 2007.

3.1.3: M. Spallanzani and G. Gaeta Bertelà (eds) (1992), *Libro d'inventario dei beni di Lorenzo il Magnifico* (Florence: Associazione 'Amici del Bargello'). Translated from the Italian by Dario Tessicini and Rembrandt Duits. Copyright © The Open University 2007.

3.2.1: Giovanni Rucellai (1960), *Giovanni Rucellai ed il suo Zibaldone*, ed. A. Perosa, vol. 1: *Il Zibaldone Quaresimale* (London: Warburg Institute), pp. 120–2. Translated from the Italian by Dario Tessicini and Jill Burke. Copyright © The Open University 2007. Reprinted by permission of the Warburg Insitute.

3.2.2: Bartolommeo Masi (1906), *Ricordanze di Bartolommeo Masi, Calderaio fiorentino dal 1478 al 1526*, ed. O. Corazzini (Florence: G. C. Sansoni), pp. 141–4. Translated from the Italian by Jill Burke. Copyright © The Open University 2007.

3.2.3: Girolamo Savonarola (1969), *Prediche sopra i Salmi*, ed. V. Romano (Rome: Angelo Belardetti), vol. 1, sermon XII, 19 May 1494, p. 189. Savonarola, *Prediche Italiane ai Fiorentini* III/1, ed. R. Palmarocchi (Florence: La Nuova Italia, 1933), sermon XVIII, 5 March 1496, selection from pp. 388–91 (a section is translated in C. Gilbert (ed.), *Italian Art: Sources and Documents* (Englewood Cliffs, NJ: Prentice-Hall), pp. 157–8). Savonarola, *Prediche sopra Ezechiele*, ed. R. Ridolfi (Rome: A. Berladetti, 1955), vol. 1, sermon XXVII, given 3rd Sunday in Lent, 1497, pp. 357–8; vol. 2, sermon XXXII, 4 March 1497, pp. 51–2 and 184; vol. 2, sermon XXXII, delivered on 4 March 1497, pp. 48–63; vol. 2, sermon XXXIX, delivered on 11 March 1497. Translated from the Italian by Dario Tessicini and Jill Burke. Copyright © The Open University 2007.

3.2.4: G. Milanesi (1860), 'Documenti riguardanti le statue in marmo e di bronzo fatte per le porte di San Giovanni di Firenze da Andrea del Monte San Savino e da Gio. Francesco Rustici, 1502–1524', *Giornale Storico degli Archivi Toscani*, IV, pp. 69–70. Translated from the Italian by Dario Tessicini. Copyright © The Open University 2007.

3.2.5: C. Seymour, Jr. (1967), *Michelangelo's David: A Search for Identity* (Pittsburgh: University of Pittsburgh Press), pp. 141–55. © 1967 by University of Pittsburgh Press. Reprinted by permission of University of Pittsburgh Press.

3.3.1: *The Vespasiano Memoirs: Lives of Illustrious Men of the XVth Century*, trans W. George and E. Waters (Toronto: University of Toronto Press, 1997), pp. 102–5. Reprinted by permission of the University of Toronto Press.

3.3.2: Reproduced in Jonathan J. G. Alexander (1992), *Medieval Illuminators and their Methods of Work* (New Haven and London: Yale University Press), pp. 181–2 (no. 6), from G. Milanesi, *Nuovi documenti per la storia dell'arte Toscana dal XII al XV secolo* (Florence, 1901; repr. 1973), pp. 164–6

(no. 185). Translated from the Italian by Dario Tessicini. Copyright © The Open University 2007.

3.3.3: Mark L. Evans and Bodo Brinkmann, eds. (1995), *Das Stundenbuch der Sforza* (Lucerne: Facsimile Verlag Luzern), pp. 831–2, 834–7. Based on partial translations by Mark Evans (pp. 490–1, 494).

3.3.4: Petit Livre d'Amour: Stowe MS 955, facsimile and commentary, eds J. Backhouse and Y. Giraud, Faksimile Verlag Luzern (Lucerne: Fine Art Facsimile Publishers of Switzerland, 1994), pp. 364–79. Reprinted by permission of Faksimile Verlag Luzern, www.faksimile.ch.

3.4.1: (a) F. Avril (ed.) (2003), *Jean Fouquet. peintre et enlumineur du XVe siècle* (Paris: Bibliothèque national de France/Hazan), p. 420, no.10; (b) Charles Sterling (1990), *La peinture médievale à Paris*, II (Paris: Bibliothèque des Arts), p. 92. Translated from the French by Isabelle Dolezalek and Thomas Tolley. Copyright © The Open University 2007.

3.4.2: (a) David MacGibbon (1933), *Jean Bourdichon: A Court Painter of the Fifteenth Century* (Glasgow), pp. 135–6; (b) ibid., pp. 50–1; (c) R. Fiot (1961), 'Jean Bourdichon et Saint François de Paule', *Mémoires de la Société archéologique de Touraine*, LV, pp. 108–12. Translated from the French by Isabelle Dolezalek and Thomas Tolley. Copyright © The Open University 2007.

3.4.3: C. M. Zsuppán (ed.) (1970), *Jean Robertet: Oeuvres* (Geneva: Librairie Droz), pp. 185–6, no. XXI. Translated from the French by Isabelle Dolezalek and Thomas Tolley. Copyright © The Open University 2007.

3.4.4: J.-L. Lemaître (1988), *Henri Baude: Dictz moraulx pout faire tapisserie. Dessins du Musée Condé et de la Bibliothèque nationale* (Paris: Musée du pays d'Ussel), pp. 40, 42, 51, 54. Translated from the French by Isabelle Dolezalek and Thomas Tolley. Copyright © The Open University 2007.

3.4.5: (a) D. Yabsley (ed.) (1932), *Jean Lemaire de Belges: La Plainte du Désiré* (Paris), pp. 71–2, nos XV–XVI; (b) J. A. Stecher (ed.) (1891), *Oeuvres completes de Jean Lemaire de Belges*, 4 vols (Paris), IV, pp. 158–9. Translated from the French by Isabelle Dolezalek and Thomas Tolley. Copyright © The Open University 2007.

3.4.6: (a) M. Pradel (1964), 'Les autographes de Jean Perréal', *Bibliothèque de l'École de chartes*, vol. 121, pp. 175–7, no. IV; (b) A. Vernet (1943), 'Jean Perréal, poète et alchimiste', *Bibliothèque d'Humanisme et Renaissance*, III, p. 247. Translated from the French by Isabelle Dolezalek and Thomas Tolley. Copyright © The Open University 2007.

3.4.7: Adapted from the text in Wolfgang Stechow (1966), *Northern Renaissance Art, 1400–1500: Sources and Documents* (Englewood Cliffs, NJ: Prentice-Hall), pp. 147–50. Reprinted by permission of Northwestern University Press.

3.4.8: Adapted from J. R. Hale (ed.) (1979), *The Travel Journal of Antonio de Beatis: Germany, Switzerland, the Low Countries, France and Italy, 1517–1518*, trans J. R. Hale and J. M. A. Lindon (London: The Hakluyt Society), pp. 113–14; 131–5. Reprinted by permission of The Hakluyt Society.

3.5.1: St John of Damascus (2003), *Saint John of Damascus: Three Treatises on the Divine Images*, trans. Andrew Louth (New York: St Vladimir's Seminary Press), pp. 26, 31–2, 95–6, 101, 118–19, 132, 157–8; St John of Damascus (1970), *Writings*, trans. Frederic H. Chase Jr (Washington, DC: Catholic University of America Press), pp. 160, 370–3. Used with permission of The Catholic University of America Press, Washington DC.

3.5.2: S. G. Spanakis, Σ.Γ. Σπανάκης (1955), 'Η Διαθήκη του Ανδρέα Κορνάρου (1611)', *Κρητικὰ χρονικὰ* [Kritika Chronika], vol. 9, pp. 379–478 (passage quoted from p. 427). Translated from the Latin by Dario Tessicini. Copyright © The Open University 2007.

3.5.3: M. Cattapan (1972). 'Nuovi Elenchi e Documenti dei Pittori in Creta dal 1300 al 1500', *Θησαυρίσματα* [Thesaurismata], vol. 9, pp. 211–13, nos 6–8. Translated from the Latin by Dario Tessicini. Copyright © The Open University 2007.

3.5.4: M. Constantoudaki (1973), Μ.Γ. Κωνσταντουδάκη, 'Οι Ζωγράφοι του Χάνδακος κατὰ τὸ πρῶτον ἥμισυ του 16ου αιώνος οι μαρτυρούμενοι εκ των νοταριακῶν αρχείων', *Θησαυρίσματα* [Thesaurismata], vol. 10, p. 360 (A). Translated from the Latin by Dario Tessicini. Copyright © The Open University 2007.

3.5.5: M. Constantoudaki, Μ.Γ. Κωνσταντουδάκη, 'Οι Ζωγράφοι του Χάνδακος κατὰ τὸ πρῶτον ἥμισυ του 16ου αιώνος οι μαρτυρούμενοι εκ των νοταριακῶν αρχείων', *Θησαυρίσματα* [Thesaurismata], vol. 10, pp. 367–8 (H). Translated from the Latin by Dario Tessicini. Copyright © The Open University 2007.

3.5.6: M. Constantoudaki, Μ.Γ. Κωνσταντουδάκη, 'Οι Ζωγράφοι του Χάνδακος κατὰ τὸ πρῶτον ἥμισυ του 16ου αιώνος οι μαρτυρούμενοι εκ των νοταριακῶν αρχείων',

Θησαυρίσματα [Thesaurismata], vol. 10, pp. 365–6 (ΣΤ). Translated from the Latin by Dario Tessicini. Copyright © The Open University 2007.

3.5.7: Giorgio Vasari (1996), *Lives of the Painters, Sculptors and Architects*, trans. G. du C. de Vere, intro. and notes D. Ekserdjian, 2 vols (London: Everyman's Library; David Campbell) (this ed. first published 1927 by Dent), vol. 1, pp. 17, 21–3.

3.6.1: C. E. Gilbert (1980), *Italian Art, 1400–1500: Sources and Documents* (Englewood Cliffs, NJ and London: Prentice-Hall), pp. 165–7. Reprinted by permission of Creighton E. Gilbert.

3.6.2: 'The Daunce of Machabree: wherein is lively expressed and shewed the state of manne, and how he is called at uncertayne tymes by death, and when he thinketh least thereon, made by Dan John Lydgate, Monk of S. Edmunds Bury', in William Dugdale (1818), *The History of Saint Paul's Cathedral in London, From its Foundation* (London: Lackington and Longman), pp. 419–27.

3.6.3: J. A. A. Goodall (2001), *God's House at Ewelme: Life, Devotion and Architecture in a Fifteenth-Century Almshouse* (Aldershot: Ashgate Publishing), pp. 223–55. Reprinted by permission of Dr J. Goodall.

3.6.4: Samuel Tymms (ed.) (1850), *Wills and Inventories from the Registers of the Commissary of Bury St Edmunds and the Archdeacon of Sudbury, Camden Society*, vol. 49, pp. 15–44.

3.6.5: D. S. Chambers (1970), *Patrons and Artists in the Italian Renaissance* (London: Macmillan), pp. 99–101. Reprinted by permission of Palgrave MacMillan.

3.6.6: Carol M. Richardson (1998). 'The Last Will and Testament of Cardinal Francesco Todeschini Piccolomini (1439–1503)', *Papers of the British School at Rome*, vol. 66, pp. 200–2. Translated from the Latin by Jeremy G. Taylor. Copyright © The Open University 2007.

3.6.7: Diego Iosef Dormer (1683), *Discursos varios de historia con muchas escrituras reales antiguas, y notas a algunas dellas*, Zaragotha, pp. 319–24, 397–402. Translated from the Spanish by David Ward. Copyright © The Open University 2007.

3.7.1: Andreas Rudolff-Bodenstein von Karlstadt (1991), *A Reformation Debate: Karlstadt, Emser and Eck on Sacred Images. Three Treatises in Translation*, trans. B. D. Mangrum and G. Scavizzi (Ottawa: Dovehouse Editions), pp. 19–25, 28, 30, 35–6. Reprinted by permission of Dovehouse Editions, Canada.

3.7.2: Andreas Rudolff-Bodenstein von Karlstadt (1991), *A Reformation Debate: Karlstadt, Emser and Eck on Sacred Images. Three Treatises in Translation*, trans. B. D. Mangrum and G. Scavizzi (Ottawa: Dovehouse Editions), pp. 86–7. Reprinted by permission of Dovehouse Editions, Canada.

3.7.3: G. R. Potter (1978), *Huldrych Zwingli* (London: Edward Arnold), pp. 26–8.

3.7.4: G. R. Potter (1978), *Huldrych Zwingli* (London: Edward Arnold), p. 28.

3.7.5: D. Englander, D. Norman, R. O'Day and W. R. Owens (1990), *Culture and Belief in Europe 1450–1600* (Oxford: Blackwell), pp. 169–71. Reprinted by permission of Blackwell Publishing Ltd.

3.7.6: Sir Thomas More (1981), *The Complete Works of St Thomas More*, vol. 6 (A Dialogue Concerning Heresies), ed. T. M. C. Lawler, G. Marc'hadour and R. C. Marius (New Haven and London: Yale University Press), pp. 45–7, 56. Reprinted by permission of the publisher, Yale University Press.

3.7.7: William Tyndale (2000), *An Answer unto Sir Thomas Mores Dialoge*, ed. A. M. O'Donnell and J. Wicks (Washington: Catholic University of America Press), pp. 57–9, 61, 184. Used with permission of the Catholic University of America Press, Washington DC.

Index